LIVING PICTURES MISSING PERSONS

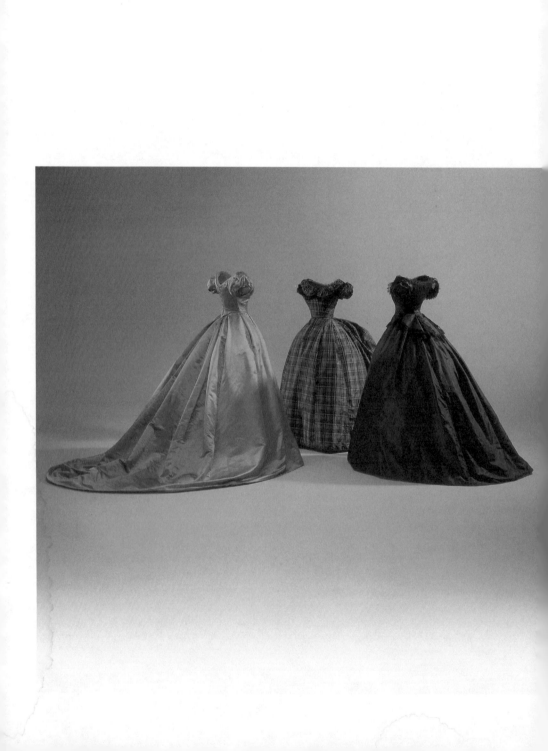

LIVING PICTURES MISSING PERSONS

MANNEQUINS,

MUSEUMS,

AND MODERNITY

Mark B. Sandberg

PRINCETON UNIVERSITY PRESS

PRINCETON AND OXFORD

Copyright © 2003 by Princeton University Press
Published by Princeton University Press,
41 William Street,
Princeton, New Jersey 08540
In the United Kingdom: Princeton University Press,
3 Market Place, Woodstock, Oxfordshire OX20 1SY

Library of Congress Cataloging-in-Publication Data

Sandberg, Mark B., 1958–
Living pictures, missing persons : mannequins,
museums, and modernity / Mark B. Sandberg.
p. cm.
Includes bibliographical references and index.
ISBN 0-691-05073-2 (alk. paper) —
ISBN 0-691-05074-0 (pbk. : alk. paper)
1. Waxworks—Scandinavia—History—19th century.
2. Ethnological museums and collections—
Scandinavia—History—19th century. 3. Popular
culture—Scandinavia—History—19th century.
4. Scandinavia—Intellectual life—19th century. I. Title.
GV1836 .S36 2002
948′.07—dc21 2002024345

British Library Cataloging-in-Publication Data
is available

This book has been composed in Galliard
and Helvetica Neue

Printed on acid-free paper.∞

www.pupress.princeton.edu

Printed in the United States of America

10 9 8 7 6 5 4 3 2 1

CONTENTS

LIST OF ILLUSTRATIONS

ACKNOWLEDGMENTS

THE GATHERING of information for this book spanned several separate stays in Scandinavia. These research trips provided me with the best practical understanding I could have obtained about the material limits of mobility and mechanical reproduction, since my research sources—objects, buildings, photographs, display spaces, newspaper reports, program guides, and tour-guide practices, both historical and current—lay spread across many separate archives and museum sites. My interest in the physical conditions of spectating required that I, too, make the circuit in order to experience many of my research objects in situ. From my own circulation from archive to archive and tour to tour, I learned to think carefully about nineteenth-century collection and museology as a profoundly interesting form of mediated mobility. Mixing with present-day tourists in the course of my investigations further kept me thinking about the current stakes of the museum projects of a century ago. The rewarding insights gained thereby have far exceeded my initial expectations, having affected the fundamental ways I think about not just turn-of-the-century literature, film, and cultural history in Scandinavia but also issues of materiality and virtuality more broadly, issues whose relevance continues to the present day.

I should note from the start that musing about forms of spectatorship in the way that I do in this study would not have been possible without the recent centenary documentary work of Scandinavian museum historians, on the one hand, and the early museum founders' own keen interest in self-documentation, on the other. The former has provided me with reliable historical survey accounts of each institution, which made possible a responsible comparative perspective of Scandinavian museum forms in the late nineteenth century. The latter provided me with an already collected set of early spectating experiences, preserved in archival scrapbooks. The curatorial staffs of the various museums gave me generous access to these, and without this preexisting meticulous source material, the present analytical study of spectating practices would quite simply have been impossible.

In this regard, I owe a great debt to specific members of the research staffs at various Scandinavian museums and libraries, without whose generous conversation and collaboration I would have remained even more of an outside observer than I necessarily was. Discussions of the practical concerns that arise when designing displays and presenting material to the public helped keep my analysis grounded in everyday museum practice and profoundly influenced my take on the notion of material mobility. Especially helpful in this regard was an ongoing exchange of ideas with Mette Skougaard of the Danish National Museum, Brede, whose research interest in both the panoptikon and the folk museum in Denmark was formative for my own approach. Karen Jacobi, museum assistant and mannequin designer for the same institution, gave me an impromptu slide show during one visit, demonstrating various historical solutions to problems of mannequin display. This perspetive gave my thinking about effigy and corporeality a productively practical turn. Jakob Ågotnes, who at the time of this research was my contact with the research staff at Maihaugen in Lillehammer, Norway, was also extremely accommodating and hospitable. He, too, shared a lively interest in historical issues of museum spectating and the public presentation of folk-museum material, and helped me see things from the perspective of the curatorial staff. Mats Janson of Skansen in Stockholm introduced me to the ongoing research by members of the Association of European Open-Air Museums and gave me access to Skansen's rich archival resources.

In addition, I thank the staff of the Swedish and Danish Royal Libraries and the City Museums in Stockholm and Copenhagen for their help in locating program material from the now-defunct wax museums and traveling wax cabinets. Reference librarians there who were extremely knowledgeable about the libraries' holdings in historical pamphlets and programs made this research possible in the most fundamental way; the excellent help I received in chance encounters there seems an indication to me of a generally high level of professional competence at those institutions.

Since a basic goal of this study is a recovered sense of museum spectating space one hundred years ago, I also owe an enormous debt to those managing photographic collections at a wide variety of archives across Scandinavia. Several of these staff members have responded generously to research questions, e-mail queries, and multiple requests for publication permissions, including Bjarne Skramstad, Annette Vasström, Åsa Abrahamsson, and Åsa Torbech. These institutions, which have also generously waived publication fees due to the academic nature of this research, include The National Museum of Denmark (Brede); The Copenhagen City Museum; The Danish Royal Library (Copenhagen); The Hirschsprung Collection (Copenhagen); The National Museum of Fine Art (Statens

Museum for Kunst, Copenhagen; Nordisk Film (Copenhagen); The Norwegian Folk Museum (Oslo); The Grand Hotel (Oslo); Maihaugen—De Sandvigske Samlinger (Lillehammer, Norway); The Nordic Museum (Stockholm); The Swedish Royal Library; The Stockholm City Museum; and the National Museum (Stockholm). Costs of initial photographic duplication have been subsidized by the Wigeland Fund at the University of Chicago and by research funds at the University of California, Berkeley. The cost of reproducing many of these photographs in the final publication of this book has further been supported financially by the Barbro Osher Pro Suecia Foundation in San Francisco.

Research leave and financial support from my home academic institutions helped significantly at crucial stages both early and late in this project. I received both a Junior Faculty Fellowship and a Humanities Institute Fellowship from the University of Chicago in the earlier stages of the project; I received similar support from the University of California, Berkeley, in the form of a fellowship at the Townsend Center for the Humanities and a Junior Faculty Research Grant. I also received two summer travel grants to Norway and Sweden from the Society for the Advancement of Scandinavian Studies.

It is difficult to name all one's interlocutors in a long-term research project of this sort, but several significant colleagues have read earlier stages of this work and given me valuable feedback. At the University of Chicago, I thank Tom Gunning, Miriam Hansen, James Lastra, Martha Ward, and especially Katie Trumpener for invaluable friendship and mentorship during my extremely valuable and formative time on the faculty there. I also thank the members of the Displaying Cultures Workshop for discussion of this project, as well as the Chicago Film Seminar participants from around the Chicago area. At the University of California, Berkeley, I thank a most outstanding set of colleagues for critique, feedback, and hallway discussion of ideas for this book, with Carol Clover, Karin Sanders, Linda Rugg, John Lindow, and Anne Nesbet foremost among them. John Peters, who has remained my colleague in roundabout ways for many years, gave me a sense of the larger stakes of the argument in media history. Vannessa Schwartz was my close colleague in wax-museum studies, as we liked to call it, and gave considerable depth to my understanding of late-century international developments in the display of wax figures. Numerous other film colleagues have contributed as well to my understanding of early cinema spectatorship, the field that forms the intellectual backdrop for this project.

Portions of this research material have been written up and published in two previous, substantially different versions. The first, entitled "Effigy and Narrative: Looking into the Nineteenth-Century Folk Museum," in *Cinema and the Invention of Modern Life*, ed. Leo Charney and Vanessa

Schwartz (Berkeley: University of California Press, 1995), first presented the argument and some of the material that is now spread out over chapters 6 through 9. The second, "Ibsen and the Mimetic Home of Modernity," *Ibsen Studies* 1.2 (spring 2001): 32–58, used some of the Maihaugen material as an introduction to a discussion of Ibsen's later plays.

Finally, I dedicate this book to my children, Ben, Jonathan, and Michael, who had to make real-life accommodations to a process of writing much too abstract and drawn-out to make much sense to them ("So is it finally done *now?*"), and to my wife, Betts, for the days, weeks, months, and years of emotional support for this project. I thank her for her understanding, her partnership, and for never once doubting that this book would get written—at the last possible moment.

LIVING PICTURES MISSING PERSONS

THE IDEA OF EFFIGY

JUST INSIDE the entrance of the Grand Café on the central boulevard of present-day Oslo, there is a table reserved for a missing person. The awaited guest is that café's most famous historical diner, the playwright Henrik Ibsen, who for most of the 1890s came punctually to the Grand every noon and late afternoon, always sitting at the same table for an aperitif and a newspaper. The restaurant has been waiting for Ibsen to return since 1978, when the management of the restaurant reenshrined his reserved table in a museum-like display. They implied in the arrangement of traces and artifacts around the table (his hat, his cane, a yellowed newspaper, and reading glasses) that he might still be expected at any moment.[1] Imagined to be present while historically absent, Norway's best-known literary celebrity now makes his appearance in the café as an evocative spatial effigy—a missing person. In this placeholder mode of display, Ibsen has been equated with the space in which he would fit were he to return.

This arrangement has a certain appeal for those diners who notice the restaurant's historical gesture off in the corner of the room. The space reserved exclusively for Ibsen, that is, also provides viewers with an imaginary kind of participation, an implicit invitation to try that space on for size in their minds, measuring body for body, imagining their own fit to his obviously well-worn chair (isolated here in a publicity photo for the café, fig. 1.1).[2] The missing-person effect thus works both ways: the absence of Ibsen's body makes way for the spectator's potential presence within the scene, but viewers must also absent themselves from their own bodies in order to participate in the representational game. The display creates missing persons on both sides of an imaginary divide; it encourages spectators to be border dwellers, both inside and outside the display (and their own bodies) at the same time.

Picture for a moment some alternative display scenarios. The dynamic of the given scene would shift substantially if, say, a wax effigy of Ibsen were used to fill the absence in the chair. It is easy to imagine the uncanny

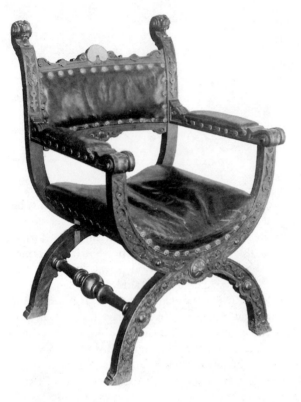

FIGURE 1.1. Ibsen's chair, isolated for publicity photograph purposes, ca. 1974. Now positioned at the reserved table at the Grand Café. Photo courtesy of the Grand Hotel Driftsselskap. Photographer unknown.

effects that such a materially present body would introduce by staring blankly at the diners sharing the room with the mannequin. The current, more subtle invocation of Ibsen's historical presence would be turned into something else, the cultural profile of the upscale café perhaps giving way to that of a theme restaurant. Ibsen would still be missing, of course, but in a less obvious way. Instead of encountering an evocatively empty space that encourages them to perform the imaginary substitution of bodies, viewers would be asked to negotiate the presence of a corpselike body with uncanny properties.

Yet another possibility would be a living-history display, with a role-playing actor making up for Ibsen's absence. This has in fact been the practice at the Grand on special occasions, such as reopenings of the café after renovations in 1978 and 1994. In both cases, a costumed Ibsen impersonator once again walked down the Karl Johan Boulevard precisely at noon, Ibsen's habitual time, stopped to set his watch by the clock on the street, and took up his reserved table at the café, filling temporarily what would from that moment forward be Ibsen's reserved, empty space. The actor was served dark beer and port, Ibsen's customary drinks, in the arti-

fact drinking glasses engraved with his name. The various guests at the café's reopening were then given the opportunity to mingle with "Ibsen" and to half imagine themselves as historical patrons in the Grand Café's bohemian heyday in the 1890s.[3]

A joke moment staged at the 1994 event suggests still another possibility, with the hotel's marketing director humorously usurping Ibsen's place at the reserved table for a photo opportunity. Doing so, he momentarily ignored the chair's inscribed metal plate, which explicitly marks off the space for Ibsen. In the staff's private photo album, the caption reads, "But Mr. Hasselknippe—you know that this is a reserved seat!" It is easy to appreciate this joke of the good-natured interloper, the person who flouts the invisible social boundaries and behavioral conventions that keep the rest of us out. For a brief moment, too, one becomes aware of an entire set of assimilated assumptions about the qualities of display space—about the in-between status of objects that are only apparently in use, about the imperative to look but not touch, about the ways in which one routinely inhabits space in the imagination that is technically off-limits.

Rounding out these scenarios with a final one makes the usual invisibility of those assumptions even more obvious. Imagine an ordinary patron in the café doing the same as the marketing director, deliberately ignoring the implicit lines marking off the Ibsen table as display, separate from the rest of the room. The clues are many—the difference in furniture style, the fact that hat, cane, newspaper, and reading glasses are mounted to the wall, or the little sign on the table cautioning, "The glasses are glued on. Please don't touch." Suppose someone, in the course of a visit to the restaurant on a less ceremonious day, decided to inhabit this space more literally by taking a seat at the table, trying on Ibsen's hat, reading his newspaper, testing out the cane, and ordering a meal. That spectator, who otherwise would of course be more than welcome to participate in a more subtle, halfway game of inhabitation, would at that moment turn rube or transgressor, and the delicate ontological balance of the display space would collapse.

Thinking through the various possibilities of display in this way, it is striking to note how easily spectators today negotiate this complex game of oblique access to the living scene of a missing person. None of the preceding scenarios are unfamiliar, each having earned a place in a repertoire of public behaviors easily called up when one is interacting with modern forms of display. Comingling with representational bodies presents no particular conceptual challenge to spectators accustomed by a wide range of late twentieth-century media experience to thinking of themselves as simultaneously inside and outside the world of representation, and of bodies on display as both convincingly present and conveniently absent. Our visual culture quite simply demands broad compe-

tency in effigies—not simply the mannequin kind but an entire range of recorded and digital bodies.

Our familiarity with an ever-expanding effigy practice may prevent us from noticing the particular variety represented in the missing-person display. For here, the body appears as space, not substance or image. Literally surrounded by evocative traces and signifiers, Ibsen's missing body is purely a display effect. Like the body of H. G. Wells's invisible man, or the concave bodily indentations left in Pompeii's volcanic ash, Ibsen's body is evoked as a trace space, a negative impression taken in the medium of its surrounding things.[4] His corporeal form is outlined not by flesh, bone, and skin but by the array of objects and clothing that mark the boundaries of where it should be, but is not. This book's cover photo shows that effect in a contemporary display of historical costumes at the National Museum in Denmark, where the missing bodies are conjured up by a painstaking display technique designed specifically to make them appear substantial in absentia.[5] The range of ready analogies reminds that the missing-person display at the Ibsen table is of course not the invention of the Grand Café. The very familiarity of the idea, however, raises an interesting series of questions: What is at stake in effigy effects of this kind? Does this kind of display have a history, a moment of invention or proliferation, and how does that relate to the more general history of effigy? Most important, what are the possible social resonances of this practice of imagining missing persons?

A turn to the longer history of the term *effigy* reveals connections from embalming to statuary, from portraiture to public demonstration.[6] The most familiar meaning is the latter, the political substitution of likeness for body, originally for symbolic punishment (in cases of escaped criminals) or for ritualized protest (burning leaders or enemies in effigy). The wider range of meaning, according to the entries in the *Oxford English Dictionary*, encompasses any practice of corporeal image production but is reserved especially for "habited," or clothed, figures. Wax and plaster mannequins would seem to be at the heart of this category, set off as they often are from other forms of sculpture by realistic costuming and theatrical techniques of mise-en-scène.

Late nineteenth-century modernity probably comes to mind as a likely place to look for this more obvious kind of effigy practice. One senses intuitively that the mannequin had a particular claim on this period; these lifelike yet staring figures seem tightly linked to the social context of commodified bodies and urban crowds in the late nineteenth century. The claim would not be one of invention—there is of course a much longer cultural history of mannequin display—but instead of degree and scale. During the period in question, from about 1880 up to the time of World War I, lifelike plaster and wax figures proliferated throughout many of

the visual-cultural venues of European urban life. They could be found increasingly in storefront windows, at international exhibitions, and in several interrelated forms of popular museum display. The visual-cultural repertoire of the time required abilities in mannequin viewing; as urban spectators found themselves negotiating an increasingly frequent contact with these lifelike figures, they were forced to sift through the mannequin's sometimes inconspicuous, finely nuanced ontological distinctions between the living and the dead.

Still, one senses that there is more to the idea of effigy than mannequins, and a final *OED* entry provides a hint of the larger semantic field. As a now-obscure transitive verb form, "to effigy" is glossed as "to serve as a picture of, to 'body forth.'" This is an evocative phrase. It suggests a more extended conceptualization of effigy, one that encompasses but is not necessarily limited to a material representation of the body. I will argue this point at length in what follows, namely, that it was a combination of mannequin display, new recording technologies, and missing-person effects that served to "body forth" a convincingly lifelike yet mobile body in late nineteenth-century visual culture. More than an age of mannequins, the period in question could more productively be seen as an effigy culture in this broader sense. Mannequins were but one tangible manifestation of a wider array of circulating corporeal traces and effects that worked to "body forth" at seemingly insignificant ontological cost to the original body and helped form the late nineteenth century's reputation as the era of a newly mobilized body. This broader sense of "effigy" helps us understand the means by which these bodies were circulated, capturing as it does both the presence effects that made them convincing and the absences that made them portable.

It ups the ante of this claim a notch to realize that it was not simply the bodies on display that could claim a new degree of circulation. "Mobility" is perhaps too cheerful a term for some of the correlative social experience of urban in-migration or poverty-induced emigration, since it skews the notion too much in the direction of the expanding systems of middle-class travel and tourism. But the fact remains that in the closing decades of the nineteenth century, the European population had access to sensations of displacement on a wider scale, even if reactions to the experience of finding oneself elsewhere ranged fully from regret to delight. This study will deal carefully with both possibilities, showing how "uprooting" got marketed as "access" in popular museum displays. At this introductory point, however, it is enough to register the fact that the impulse to "body forth" arose in a widespread social context of real bodies out of place.

The preconditions of this corporeal mobility and effigy culture were new possibilities for imagining space and time. The testimony of late nineteenth-century cultural commentators is not bashful about making claims

for a radically new kind of spatiotemporal experience. After all, this was the self-proclaimed era of the "annihilation of space and time," a phrase repeated in reaction to everything from railroad travel to phonography.[7] Subsequent historical studies have further enshrined that idea; for example, Stephen Kern's *Culture of Time and Space, 1880–1918*, proceeds precisely from the phenomenological assumption that "sweeping changes in technology and culture created distinctive new modes of thinking about and experiencing time and space."[8] Recent studies of pre- and paracinematic visual culture (as disparate as they may be, given everything those terms pull into their orbit) generally agree on this point: time and space were remade by urban modernity.[9]

It is easy to object that one buys into modernity's own rhetoric when one assumes that these were *novel* experiences of space, time, and body. "New" is an intellectually seductive word, especially for historicizing accounts interested in locating crucial moments of paradigm shift, a tendency that suggests the need for caution in making these kinds of claims. The world was not simply static before, nor fully mobilized after the transitions we call urban modernity. If nothing else, the continued "annihilation" of time and space throughout our own century, right up to the Internet age and its own dreams of universal access, suggests that some sifting of claims is in order. Paul Valéry's statement, "For the last twenty years neither matter nor space nor time has been what it was from time immemorial," may indeed deserve pride of place as the opening epigraph of Walter Benjamin's most famous essay on modernity, but it nevertheless seems late compared with other claims when one realizes Valéry was describing the twentieth century in his 1928 essay on ubiquity.[10] Benjamin's own position on the cultural effects of mechanical reproduction admits to many incremental advances in the practice prior to the nineteenth century. Furthermore, any notion that aura had "withered" definitively and finally when he wrote his essay in 1936 needs only a reminder of the public's continued marvel at more recent media transformations of time and space to realize that there is no clear before and after in this process.[11]

What remains after these cautionary remarks is the discursive claim that many commentators in the late nineteenth century were in fact caught up in the exhilaration of mobility and called it new. The impression of simultaneous presence in multiple places or durable presence through time sparked a collective, public imagination of access and visual availability, even if commentators tended to mistake effects of cultural acceleration for absolute movement. Far from invalidating the claim of "newness," however, these adjustments make it even more useful and interesting to delineate the particular characteristics of that moment of corporeal imagination—which factors had in fact recently been added to the mix, and which had not yet made their arrival.

A useful point of departure is Anne Friedberg's claim in *Window Shopping: Cinema and the Postmodern* that the central achievement of nineteenth-century visual culture was the wedding of virtuality and mobility. Cinema is not the only destination of this combination in her argument, but she does see film as the most successful and enduring of the late nineteenth century's virtual mobility systems. The resulting "imaginary flânerie," she writes, "produced a new form of subjectivity—not only decorporealized and derealized, but detemporalized as well. For the cinematic observer, the body itself is a fiction, a site for departure and return."[12] The coming and going of the spectator's body turns out to be the crucial link between modern and postmodern spectatorship in Friedberg's argument, the link upon which she builds her discussion of space, time, and shopping.

The present study shares Friedberg's interest in modernity's cultural fantasies of mobility but is more inclined to emphasize the alterity of that moment. Now that the period we confidently used to call *the* turn of the century has become simply *a* turn of the century, it may be possible to see the historicity of that moment in a new way. That is, instead of asking what was new about that visual culture in order to draw lines of continuity to the present, it might be helpful now to ask in retrospect: What seems *old* about it? The key to that question resides in a slight objection to the first term of Friedberg's equation: virtuality. Granted, she is primarily concerned with a spectatorial experience of mobility, not that of the field of display. But what strikes me about the dominant forms of late nineteenth-century visual entertainment (cinema excepted) is precisely that spectators' impressions of their own mobility still depended so insistently on the actual mobility and assembly of objects and bodies in the physical world. That period's obsession with authentic chains of reference to real time and space does not get its best account through use of the term "virtual."

Museum-related display practices of the time force this point: at natural history museums, folk-ethnographic museums, open-air museums, and even wax museums, there is an allegiance to the object and original space that sets their brand of mobility apart both from other more simulative media, on the one hand, and from the efficiently circulating and mechanically reproducible recording media, on the other. This is not surprising, given that the very idea of a museum carries with it a long-standing institutional commitment to unique objects and authenticated traces. The mobility of museum artifacts has long been dependent on processes of collection and physical relocation—an elaborate choreography of bodies and objects that necessarily plays itself out in real space and time.[13]

A new development in the museum of the late nineteenth century, however, was the rejection of taxonomic display principles in favor of living, contextualized scenes. The growing, concurrent popularity of the natural

history museum's "life group," the wax museum's tableau, and the folk-ethnographic museum's genre scene demonstrates this common interest in a compensatory project of mise-en-scène that gave displaced objects and bodies a new kind of scenic home.[14] If one adds the observation that animal display at zoos was similarly moving from principles of menagerie to living habitat display during the same period,[15] a broad cultural trend comes into focus. Erasing the traces of the collection process, these various kinds of curators increasingly presented objects in use and bodies in context, allowing spectators an impression of direct physical access to previously distant times and spaces. As museums strove to make available not just distant objects but original scenic space as well, museum visitors easily mistook the inventory's mobility for their own. Enthusiasm grew for the idea of a portable scene, for space that seemed to have been moved intact and placed at the viewer's feet, due to the careful coordination of the collected objects within it.

The power to become just missing enough to enjoy these ambiguous mobility effects depended on the revivification made possible by elaborate scenification techniques. It is in this way that the popular museums of the late nineteenth century fit into a larger cultural fascination with "living pictures"—a ubiquitous term throughout the visual culture of the time, covering everything from *tableau-vivant* posing to stereographs, from museum scenes to the cinema.[16] A central concern of the current study is in fact to make sense of the common spectatorial exclamation "Why, it's just like a living picture!" and to understand the appeal of the underlying sensation that made the idea so popular across various media.

Such was not the case everywhere. Research within the field of early cinema studies, for example, suggests an interesting cultural variability, at least where film was concerned. Yuri Tsivian's work on the reception of early cinema among the intellectual elite of St. Petersburg and Moscow reveals a distinct cultural response to film in that setting, one that would be much less inclined to link the words "living" and "picture."[17] The famous, now-canonical account of Maxim Gorky and his first encounter with the early Lumière films in St. Petersburg depicts film instead as a "kingdom of shadows," filled with ghosts, phantoms, and death: "This is not life but the shadow of life and this is not movement but the soundless shadow of movement."[18] The overwhelming impressions of the filmic world for him are its macabre grayness and its grotesquely silent inhabitants. Gorky's response, Tsivian shows, was foundational for the symbolist-influenced, intellectual viewers who left behind the most articulate early reactions to film in Russia. Viewers in that cultural setting seized upon the aspects of the film image that conveyed loss—the loss of speech, of color, of dimensionality—and embraced the cinematic medium more for its estrangement effects than for its powers of revivification.

For contrast, take the inaugural accounts of film viewing from Denmark and Sweden, where the same Lumière films were marveled at primarily for their liveliness instead of their ghostliness. When reports of the Paris cinematograph's debut first filtered up to Scandinavia, the new experience was apprehended in a way more typical of its international reception.[19] This report, which appeared in the leading Swedish journal of amateur photography three months after film's debut, sets the pattern for the Scandinavian reception:

> All of Paris is presently making a pilgrimage to Boulevard de la Madeleine in order to take in a new wonder, the so-called cinematograph. It is being shown at a little theater and the performance lasts only twenty minutes. But within this tight frame and this short space of time one sees a whole world pass by. Not dead pictures [*döda bilder*], without life and movement, but a world that lives and moves altogether as it does in reality.[20]

When these same Lumière films traveled to Scandinavia for the first time, the reaction was similar. In Denmark, the most frequently cited account of the first showing in Copenhagen, from early June 1896, begins its description thus: "One sits in darkness staring at a large piece of white, outstretched linen. Then it begins. The linen comes to life, and various fashionable scenes are unfurled for us," scenes whose intensity reportedly gave the writer a powerful experience of sequential, convincing immersion.[21] In Sweden, the debut of the Lumière films three weeks later at the Malmö Exhibition elicited an even more appreciative response: "One actually sits there completely surprised to see the photograph fully alive. In one picture [*tafla*], for example, we see the workers streaming out of a factory. These are not automata we see there in front of us, but fully living figures— every little movement, every twitch of a muscle stands out so clearly that we seem to see the picture [*taflan*] in real life."[22]

In each of these accounts, it is the living presence of the image that impresses the writers—its power to supplement and animate the photograph. Among these Scandinavian journalists, at least, the screen image found a receptive ground for the notion that the image was alive, and that the recorded status of the image would keep it alive in perpetuity. That was the potential wonder of the new machine; these were not dead images but living, breathing, twitching beings. To these viewers, the bodies did not seem mediated by technology (they were not "automata") but organic and natural instead.

Here we arrive at a central paradox of modernity's visual mobility systems: the more radical representational absence of recording-based media allowed for correspondingly greater mobility of the depicted world (the Lumières' backyard home movies of feeding the baby preserved and sent to St. Petersburg or Stockholm), yet at the ontological cost of lost color,

tangibility, and spatial depth. The "living pictures" in late nineteenth-century museums, by contrast, seem far more limited in range due to their commitment to the unreplicable object, necessarily entrenched in a single location and time yet able to convey to veiwers substance, color, and three-dimensional form. The idea of the living picture subsumes these and other possibilities at the time, hovering above them all as some kind of composite attraction to liveness and immediacy made visually available.

I will proceed from the assumption that there is value in teasing out the distinctive subset of the museological from the cinematic in this shared culture of living persons. The balance between moving the world and keeping it alive met different media demands in the museum. It was especially the fact of shared space, as Alison Griffiths has also emphasized in her study of the natural history museum, that set museological practices apart from those fitting more properly under the rubric of virtual mobility.[23] A photograph could bring the Alps to the viewer without moving mountains, so to speak, but a museum display had to do just that to be true to its object. The museum version of scene grabbing, unlike those of other forms of recording, entailed dragging original space along with the object. The anchor in the material world placed these efforts of mise-en-scène on a hyperbolic trajectory, which required that entire milieus be disassembled in real time and space only to be resassembled elsewhere, again in real time and space. The fascinating thing is that some late-century museums, undeterred by the physical intransigence of the medium, attempted mobility effects with what must be considered very large objects: buildings, groups of buildings, and extended architectural and natural settings. The easy flow of digital bits in our own era only makes such dogged manipulation of the material world seem all the more fascinating in retrospect.

The shared tangibility of this kind of museum space and the sheer effort required to assemble it necessarily give it a peculiar social dimension unavailable to recording media such as photography. Even realists among photographic theorists like Roland Barthes acknowledge that the photographic medium's "certificate of presence," to use his term, is always accomplished in delay. Presence in a recording-based medium is always *former* presence, and the material world so carefully preserved has always in some important sense already expired.[24] Not so for the late nineteenth-century museum's scenic sensibility: the remarkable effect of these elaborately staged and reconstructed scenes was their tantalizingly shared space, their combination of tangibility and remoteness that provided spectators with unique effects of both presence and mobility. Unlike photography's "reality one no longer can touch," to cite Barthes again, late nineteenth-century museum practice teased spectators with games of voyeurism that could quite conceivably become games of immersion in-

stead. When the only boundaries separating off display space from specta-
tors were those of social protocol, and not ontological difference, there
was nothing fundamental to prevent scenarios like the one mentioned at
the outset here, in which a marketing director can seat himself in Ibsen's
chair at the Grand Café.

My interest in the museums of turn-of-the-century modernity thus pro-
ceeds from the way they embrace notions of mobility and circulation yet
attempt these effects with the most material of means. Their loyalties are
split between older models of collection, preservation, and authentication,
on the one hand, and the promise of unlimited access and visual availabil-
ity, on the other. This puts them at the intersection of the traditional and
the modern, not only in their social function but also in their representa-
tional strategies. Though profoundly informed by the living-picture logic
of recording technologies and other new media, the museums of the time
could never quite achieve the scenic flexibility or reproducibility of some-
thing like cinema. The present study parts company with other studies of
precinematic visual culture, however, in seeing the museum's commit-
ment to real space not as a dead-end limitation of the medium, a clunky
approximation of effects better accomplished by film (as a cinematic teleol-
ogy would have it). Instead, I take the idea of mobility in real time and
space to be an interesting mode of spectatorship in its own right, one that
was not as much "replaced" or "superseded" by cinema as it was diverted
to the side, where it has continued to evolve into other forms of theme
space and immersive environments.

Nowhere are these issues more interesting than in Scandinavia at the
end of the nineteenth century. Because Denmark, Sweden, and Norway
experienced a comparatively belated modernization on the northern pe-
riphery of Europe, the juxtaposition of traditional and modern forms of
experience there was at times quite striking. Commentators from the pe-
riod describe powerful sensations of overlap in which folk-cultural and
metropolitan fantasies existed side by side. In countless descriptions of
situations there, Scandinavian spectators consistently imagined themselves
in threshold positions, voyeurs of both the old and the new. The claim
that Marshall Berman makes about all moments of modernization is espe-
cially true of Scandinavia's compressed experience of modernity; he speaks
of a public that "can remember what it is like to live, materially and spiritu-
ally, in worlds that are not modern at all. From this inner dichotomy, this
sense of living in two worlds simultaneously, the ideas of modernization
and modernism unfold."[25]

Models of visual culture developed with the larger European cities in
mind might easily forget that claim in the embrace of urbane notions of
flânerie and distraction, but an account of Scandinavia's modern visual
experience has a harder time doing so. The social context of display space

there made the spectator's position at the border particularly fraught, with the appetite for lost coherence competing forcefully with the taste for distraction. One of the most useful generalizations about late nineteenth-century Scandinavia, in fact, is that a significant part of its cultural production, ranging from the naturalist theater stage to museums to the cinema, demonstrated a profound respect for the integrity of original space. Ibsen's and Strindberg's dramaturgy of minutely realistic illusionism is perhaps best known in this regard, but the early Scandinavian cinema's innovative use of deep staging and early bias against editing and reversal of field was equally indebted to this tradition.[26] To borrow some filmic terms, this was broadly speaking more a culture of mise-en-scène than of montage.

The idea of the portable scene at the museum accommodates both this disposition and the attractions of multiple views. With modernity played out representationally at the level of the scene, as it frequently was in Scandinavia, spectators could indulge in fantasies of grounding and ubiquity simultaneously. This observation seems key to Scandinavia's museum culture of the time. In fact, only in Scandinavia are there such close institutional ties between what seems like a quintessential purveyor of modern amusement and distraction (the wax museum) and the more serious representation of folk culture in the ethnographic and open-air museums. Despite differences in their institutional profiles, the wax and folk museums nevertheless shared an interest in vicarious scenic experience and often borrowed display techniques from each other, at times making them nearly interchangeable in terms of spectator experience.

In Copenhagen, the connection was quite insistently literal: the first wax and folk museums opened within a week of one another in the mid-1880s in the same building in the rapidly developing Vesterbro entertainment district, shown in an illustration from 1880 (fig. 1.2). This area was the heart and soul of an urban expansion project intended to create a Continental-style entertainment district for Copenhagen's middle class. Here one could find the convergence of the 1879 international exhibition site, many kinds of museums, new variety theaters, a circus, a panorama, the Tivoli amusement park, and the city's main railroad station, all set along Vesterbrogade, a newly constructed Parisian-style boulevard. By the end of the century, in fact, the mental geography of Copenhagen had shifted to the city's newly developed west side. The illustrator of this 1897 depiction (fig. 1.3) uses this recently transformed district to make the case for the city's essential modernity, surveying the historical Copenhagen city center through the foregrounded space of Vesterbro, with the train station, the amusement locales, the new city hall, and the wide boulevard all magnified in importance.

Dead center in this illustration, just to the right of the obelisk and immediately across the street from the railroad station, is Vesterbrogade 3,

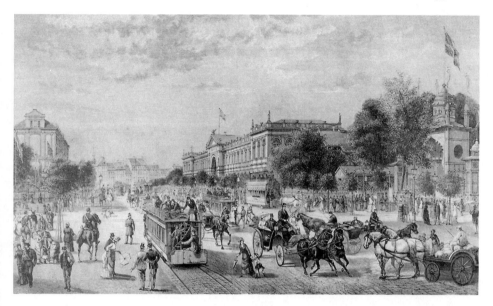

FIGURE 1.2. Illustration of the boulevard Vesterbros Passage in 1880, with the entrance to the Tivoli amusement park to the right. *Illustreret Tidende* (15 August 1880). Photo courtesy of the Royal Library (Copenhagen).

the "Panoptikon building." In August 1885, spectators were welcomed into the new wax museum on street level, the Scandinavian Panoptikon (Skandinavisk Panoptikon), in order to interact with its mannequin effigies of famous celebrities, its historical tableaux, and its games of optical illusion.[27] Six days later, they were similarly invited to visit the new Danish Folk Museum (Dansk Folkemuseum), located immediately above the panoptikon on the next floor (fig. 1.4). Here visitors could find painstakingly re-created rural interiors that allowed for a temporary immersion in the material remnants of vernacular Danish culture in surround-style, whole-room displays.

It is not just the immediate spatial proximity of this folklife sanctuary and Copenhagen's most modern amusements that is so evocative, but the fact that the two new museums opened under the direction of the same man, Bernhard Olsen. The folk museum (along with its later offshoot open-air museum, Frilandsmuseet) became his longer-lasting legacy, the one that arguably established him as the father of modern museology in Denmark. His wax museum, often characterized as a youthful indiscretion, has by contrast receded somewhat both in his official biographical profile and in public consciousness.[28] Yet at their inception, his two museums shared more than the address at Vesterbrogade 3. They relied on a shared genealogy of display practices emphasizing objects and effigies in

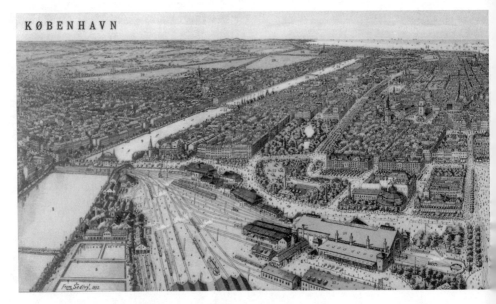

KØBENHAVN

FIGURE 1.3. Perspectival illustration of Copenhagen, 1897, seen through the Vesterbro district in the foreground. The Panoptikon building is to the right of the obelisk at center, the old train station to the left. *Illustreret Familiejournal* 40 (1897). Photo courtesy of the Royal Library (Copenhagen).

carefully contextualized scenes. These two institutions, in fact, linked by Olsen's leadership, form an especially interesting pair for examining the mix of voyeurism and immersion in modern visual culture and the fate of the scenographic imagination. Both institutions shared a fascination with the authentic corporeal trace, with elaborate systems of effigy, and with the spectator's relationship to themed space. They drew on the same Vesterbro public for their visitors; it is even likely, given their close proximity, that many spectators made an afternoon of it and visited both in succession.[29]

In the other Scandinavian countries, the spatial juxtaposition of modern and traditional display content was not as conveniently literal as it was in Copenhagen, but the conceptual affiliation of new folk museums with the panoptikon tradition was just as pronounced in display practice, if not more so. In Sweden, plaster mannequins became something of a folk-museum specialty, with extremely detailed and sophisticated genre scenes becoming quite popular in Stockholm and renowned at all the important international exhibitions late in the century. The use of what were seen as wax museum techniques in the more respectable ethnological institutions touched off a fierce museological debate in Scandinavia, one that goes right to the heart of the model of spectatorship described here: Should

objects be presented in a theatricalized context? Does the literal reconstitution of missing persons in effigy violate long-established standards of museum display?[30]

The identity of the museum, the fate of the scene, the desire for immersion in the space of display—all these issues are played out along the axis of comparison between the wax and folk museums. Both museums attempted innovative display techniques designed to investigate the boundary between spectator and display. The Scandinavian wax museums did tend toward voyeuristic models, but they still played extensively with the threshold space of display and with decoy joke figures in the spectating space. The immersion remained imaginary, even if the wax tableaux were designed to simulate transportation of spectator to scene (or vice versa). The Scandinavian folk museums, by contrast, while perhaps not inventing the idea of theme space and immersive spectatorship, certainly helped establish it as a dominant mode of twentieth century visual culture. The voyeuristic models of mannequin display that played an important part in these museums' early development eventually came into conflict with the goal of the folk museum—the continued, imagined viability for the museum visitor of traditional folk-cultural forms. An emerging aesthetic of immersion gave rise to the missing-person display and placeholder techniques of spatial effigy (which the Grand Café's Ibsen table now perpetuates faithfully). Allowing the spectator to cross the threshold and enter the display space held out the promise of a more successful replacement of previously lived connections to folk life.

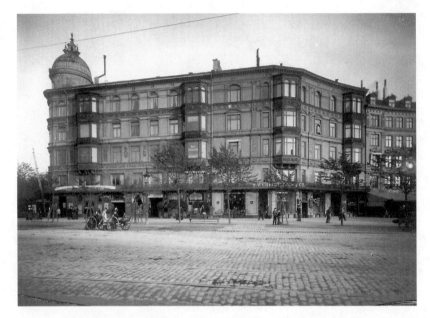

FIGURE 1.4. Exterior photograph of the Panoptikon building, located at Vester-brogade 3 in Copenhagen, ca. 1903. The entrance to the Panoptikon is to the left; a sign advertising the Danish Folk Museum is visible in the second-floor window. Photo courtesy of the Royal Library (Copenhagen).

The study that follows presents two parallel sections of four chapters each to force the point of a composite visual experience embracing both the rural and the urban, both grounding and ubiquity. This approach to Scandinavian visual culture does more than delineate that region's interestingly unique cultural characteristics; the situation of compressed cultural change there also helps recover a fuller sense of modernity's connection to tradition. In more purely metropolitan models of modernity, one might, by contrast, be inclined to focus exclusively on the mannequin's ready theoretical appeal for thinking about urban anonymity. Georg Simmel's comments on the peculiar mixture of proximity and distance that characterized increased interaction with strangers in 1903 Berlin spring to mind; like the encounter with the stranger in the crowd, meeting mannequins required skills of ontological assessment and detection.[31] Mannequins, shopping, and *flânerie* also seem suitable as companion concepts, emphasizing as they do the way issues of visual commodification and consumption can be played out on an objectified body. In no other cultural setting, however, are these more modern uses of the mannequin body intertwined with the reconstitution of folk culture, as they are most emphatically in Scandinavia. For spectators there in the late nineteenth cen-

tury, the sight of a mannequin would likely have called up competing connotations of the urban and the rural.

The public attraction to a visually available folk culture thus forces an issue that is less obvious in mainstream models of modernity. When a situation like that in Copenhagen raises the possibility of spectators taking in both the modern and the traditional in a single afternoon's outing, it becomes clear that content is less important in thinking about spectatorship than the *mode* of display. A central claim of this study will be that apparently dichotomous cultural responses to modernity in Scandinavia— both the celebratory embrace and regret-filled cultural nostalgia—nevertheless relied together on the quintessentially modern notion of availability in their presentation to the public. The accessibility of both as visual alternatives helped establish a fundamentally modern relationship to the traditional past. Folk culture became a place to visit, a modality of visual experience that now found itself in series with other kinds of urban visual mobility. If the larger world of the late nineteenth century came to be seen as fundamentally moveable through new media or virtual travel systems, then it stood to reason that the same might be true of folk culture: it might be preserved past its impending demise and relocated around these newly mobile spectators. The constant suggestion of both wax- and folk-museum scenes was the idea that the movable world was somehow capable of retaining its coherence and continuity. The strong presence of folk culture in the overall visual-mobility system of Scandinavian modernity thus provides a compelling example of how the idea of access was given a conceptual safety net.

The following discussion pays close attention to the spatial experience of museum visitors at the time, derived for the most part from the extensive public commentary elicited by these profound changes in museological practice. What emerges is a nuanced picture of a certain kind of social space at a particular historical moment, one that can serve as an important chapter in international media history. In a visual culture that today similarly promises both authentic visual sensation and infinite variety, it seems especially worthwhile to examine those historical precedents where questions of "here" and "there" seemed absolutely crucial, and when it still mattered when a person went missing.

UPSTAIRS, DOWNSTAIRS

AT THE WAX MUSEUM

The disgusting "Chambers of Horror," which
play such an important role in all of the foreign
"panoptika," where by piling up frights one spec-
ulates in unhealthy excitement and stimulates the
masses' craving for scenes of murderers and their
dismembered victims, or even of the murder it-
self, are avoided here. We have tried to make our
panoptikon cheerful and light, to give it a tinge
of whimsy and good humor.
—Bernhard Olsen (1885)

The "thingness" inherent in the idea of
display is nowhere more evident than in the wax museum. After all, man-
nequins provide a particularly fleshy sort of simulation; even as they seem
to transport viewers into the presence of fame, or celebrities to the specta-
tor's feet, wax figures provide continual reminders of that display's mate-
rial means: staring eyes, the immobility of the pose, the embalmed sheen
of the wax. Sensations of visual mobility and variety play off the scandalous
physicality of the figure, leaving behind a vague discomfort, a whiff of
seediness that clings to wax figures to this day. As most historical accounts
would have it, this insistent materiality is what doomed the wax museum
to eventual obsolescence in the face of more supple means of effigy, pho-
tography and cinema foremost among them. In the next few chapters, I
will examine how the materiality of the wax museum's display practices
first flourished and then came to be seen as such a liability. Along the way,
I advocate a reconsideration of mannequin forms of effigy, suggesting a
certain intellectual value in those forms of visual mobility that remain
"stuck" in real space and time.

The wax museum has long been closely associated with the cultural set-
ting of the late nineteenth century. Public presentation of wax manne-
quins was not a new development at the time, but the formation of the
wax museum as a middle-class institution of the visible most emphatically

was. Across Europe, more stable locations, larger capital investment, improved display techniques, and extended systems of advertisement gave the more familiar, often itinerant "wax cabinet" a new prestige. Later cultural commentators, continually drawn to the mimetic hyperbole and intriguingly macabre effects of the individual wax effigy, have not always recognized the shift and flux of the wax display's cultural standing over time, treating it more as a general idea than as a social institution subject to historical forces.

My interest in the following chapters is both a time and a place in the wax museum's varied history, namely, its intersection with an early phase of urban modernity in Scandinavia. At the late-century wax museums considered here, the mannequin's oft-recognized uncanny qualities of presence and absence got enlisted for a particularly modern project: the exploration of threshold space. In Scandinavia, where modernity's transition from old to new was rather more dramatic than elsewhere in Europe, the idea of the threshold was particularly resonant with a widespread experience of cultural simultaneity and juxtaposition. In this context, the wax display's specialty games of subject and object, of "here" and "there," gained added cultural resonance every time it placed spectators at the boundary of a tableau. The virtuality of the scene, when combined with an augmented notion of visual availability, seemed to access both grounding and mobility in the same gesture, an appealing notion for turn-of-the-century Scandinavians straddling a stark cultural divide.

My intent is to think broadly about issues of wax display while at the same time pursuing this specific historical case of the late nineteenth-century Scandinavian panoptikon. This dual focus has a methodological motivation: only a broader, more comparative institutional analysis makes theorization of these Nordic wax museums possible and meaningful, yet without the fine-grained evidence of primary sources and the identification of active cultural discourses, any proposed model of spectatorship would remain an unsatisfactory abstraction. Mannequin bodies on display in Scandinavia at the turn of the century did express a generally shared sense of modern corporeality, but they also articulated an experience of body and space formed by the compressed, simulated, and imported experience of modernity on the northern periphery of Europe.

This is a specific history worth recovering. Although the display of wax effigies has been of interest to visual-cultural historians for some time, the past fifteen years have seen a resurgence of historicizing interest in waxwork display. This renewed scholarly attention has increased the theoretical stakes of both the wax effigy and the wax museum.[1] The general rise of museology as a field of interest for cultural studies plays a part here, as does the proliferation of "body studies" that has followed in the wake of Michel Foucault's work. At the intersection of these two developments lie

the corporeal implications of the idea of collection—an extended sense of
effigy that accounts for the tension between the "naturalized" whole of
the collection and the miscellany of the collected parts. These two possi-
bilities, I offer, form two competing traditions of corporeal display in the
nineteenth-century wax museum: that of the body consolidated and the
body in pieces.[2]

Today the wax museum as an institution is perhaps best known for the
Chamber of Horrors. At Madame Tussaud's in the mid-nineteenth cen-
tury, this most notorious of wax-museum rooms was the place to see
bloody relics from the French Revolution, death masks of guillotine vic-
tims, and effigies of notorious criminals and serial killers. Eventually, as
the mise-en-scène of wax display became more complex and the chamber
of horrors idea spread to other wax museums, it also became the place to
go to see the seminude, dismembered bodies of victims in tableau displays,
as well as deformed monsters and other frights. Here one could find on
display macabre torture instruments and illustrations of their use on
waxen body parts. In short, the chamber of horrors has been the part of
the wax museum where the body in pieces is the main attraction. More
than a marginal compartment of the wax museum, the chamber of horrors
could be said to ensconce the traumatized body in the default position
of wax display, regularizing a crucial strand of institutional practice that
even today gives wax museums a slight air of corporeal transgression and
seediness.

Not so generally well known is the late nineteenth-century emphasis on
the body consolidated, a shift in display practice that for a time made
possible the wax museum's upwardly aspiring, middle-class identity as an
institution of popular education and enlightenment. This elevated tradi-
tion of wax display, which despite the notoriety of the Chamber of Horrors
was in fact the main emphasis of Tussaud's and other European wax muse-
ums of the time, followed the lead of the illustrated press in bringing all
the world's sights and celebrities to the viewer, providing national-histori-
cal and international knowledge in effigy, and, in the tradition of the *ta-
bleau vivant*, re-creating famous paintings in three dimensions. The lo-
cales were self-consciously elegant and advantageously situated in capital
cities. Promotional discourse emphasized that these were *museums*, some-
thing quite apart from the less reputable wax cabinets and anatomical dis-
plays that traveled the fairs and marketplaces of Europe.

When one recovers a sense of this other historical strand in the develop-
ment of the wax museum, it occurs that it was perhaps the containment
of the dismembered body in a separate space that made this respectable
reputation possible. The yoking of the two display possibilities (consol-
idating uplift and dismembering violence) can be found even at the earli-
est stages of the wax museum's development. In the decade before the

French Revolution, Philippe Curtius (Madame Tussaud's mentor) founded two separate Parisian wax museums, one devoted to elite cultural figures and the other to criminal effigy.[3] At Madame Tussaud's first permanent museum in London, established in 1835, the crowd-attracting criminal effigies were incorporated into the same location as the historical figures, even if segregated into what she first called the "Separate Room," or as one newspaper put it, "that ghastly apartment into which ladies are not advised to enter."[4] (The eventual term "Chamber of Horrors" was popularized later by the London press in 1846.)[5] Only in 1884, when the museum moved into a custom-designed building in Marylebone Road, did the gruesome chamber get its more familiar vertical separation from the main display in a basement location.[6] The new arrangement simply underscored spatially what had been implicit all along, namely, that the Chamber of Horrors took on the function of the wax museum's museological-historical unconscious. This upstairs-downstairs segregation of subject matter has now become a standard feature of many wax museums: typically, there are warning signs and other indications that the marked-off downstairs space abandons the upstairs propriety in order to revel in body parts and the fleshiness of wax display. "Not for weak nerves," as the Stockholm wax museum cautioned at the turn of the century.[7]

By contrast, the typical upstairs bodies—effigies of kings, politicians, cultural luminaries, historical figures—were presented as firmly consolidated and worthy of emulation. As will be shown, these pedagogical bodies achieved their impression of solidity in part through elaborate theatrical staging effects that helped them to pass as living bodies of real substance. But they benefited as well from the ready-at-hand contrast with the abject body in the basement, the body more likely to fly apart than hold together. Otto von Bismarck's upstairs effigy "held together" not only because its live referent was admired for the exemplary firmness of his nineteenth-century character, but also because his gathered body contrasted so strongly with the dispersal of the bodies downstairs: the slashed-throat corpses, the decaying body-effigies being unearthed by grave-robber mannequins, or the heads in the guillotine basket.

Those heads, in fact, are key to this binary between upstairs and downstairs, since the wax museum in its nineteenth-century form arose so directly from the violence of the French Revolution and Madame Tussaud's experience of it.[8] The close ties of both Marie Tussaud and her uncle to the royal court before the Revolution and to the Jacobins afterward have received lengthy comment elsewhere, but their interest for this argument is that the founding moment of the wax museum is so closely tied to the spectacle of public violence and dismemberment. This is true on the personal level, since Marie's service to the Revolution as a modeler of death masks did not prevent a brief imprisonment and her own near miss with

the guillotine. Her museum displayed the lingering effects of that personal and political trauma for years to come, preserving everything from the wax castings made from those bloody death masks to the "original Knife and Lunette, the identical instrument that decapitated 22,000 persons," reportedly procured at great cost and still promoted in her 1873 catalogue as "the most extraordinary relic in the world."[9] During Marie Tussaud's lifetime (and beyond), her museum remained a veritable monument to death and decapitation. The connection to the Revolution remains a central feature of many historical accounts as well. Although Marie Tussaud actually began her wax modeling career before the Revolution and continued it long after, the imagined scene of her at the foot of the guillotine receiving heads to model persists as a foundational, almost mythic scene for the birth of the modern wax museum; as Hillel Schwartz would have it, "At the side of the guillotine, basket in hand, was Marie Grosholtz." There is good reason to question the accuracy of this scene, but its iconic power is clear.[10]

If the obsessive replaying of the Revolution is understandable in Tussaud's case, less immediately apparent is the reason for the tenacious discursive presence of that event in other wax museums. Rare indeed is the modern wax museum that does not include some version of Marie Antoinette in effigy or a working guillotine display in its chamber of horrors. The entire plot of the 3-D film *House of Wax* (1953), starring Vincent Price, revolves around an obsession with a Marie Antoinette mannequin, the fiery destruction of which at the beginning of the film sets off a demented killing spree and the search for a perfect, living victim to take her place. Even the current Movieland Wax Museum in Orange County, limited by self-definition to the representation of movie stars and scenes from films, manages to work into its repertoire an embedded reference to the Tussaud trauma by depicting an effigy of Norma Shearer starring in the film *Marie Antoinette* (1938). The obligatory reference to the French Revolution has come to define the very idea of a wax museum.

There is a reason for this. If one thinks of the wax museum as being born of the French Revolution (with Madame Tussaud as midwife), then the traumatized corpse of the Chamber of Horrors can be seen as the central truth of the institution. Even if the Revolution eventually recedes as an overt theme in the various chambers of horrors, the other violent scenes of murderers, corpses, and torture there continue the fascination with dismemberment. One might say that the corpse is the hidden secret of the wax museum, hidden not only because the chamber of horrors is most often tucked away from immediate view in the lower recesses of the museum but also because the wax museum's bid for legitimacy depended on constructing vivacity, on distracting from the fact that all of the bodies on display were "corpses," that is, dead matter. But no matter how dressed

up, covered over, and revivified the effigy might become in the increasingly theatrical wax museums that proliferated later in the nineteenth century (and no matter how supplemented by technology that same effigy would become in the late twentieth century), the affinity of the mannequin itself to the dead body haunts the wax museum as an institution and has forever linked it, even if only subconsciously, to the macabre.

That connection was reinforced throughout the nineteenth century by the traveling wax cabinets and anatomy shows whose primary attraction was a pseudoscientific display of body parts marked by disease and trauma. One of the most famous of them at the turn of the century, Hartkopf's Museum, can give an indication of the subject matter. The proprietor of this massive traveling collection offered citizens throughout Europe the chance to view one thousand separate wax exhibits depicting different racial typologies, death masks, fetuses at various stages of development, and body parts shown in both disease and health (often shown dissected in cross section to show the effects of ulcers, tuberculosis, leprosy, heart disease, typhoid fever, and other degenerative diseases). The cumulative effect of viewing these exhibits along with wax models of albinos, dwarves, Siamese twins, or children with two heads (or three heads, four arms, or an eye in the middle of the forehead) was to test the idea of a gathered, normative body, and by pedagogical contrast to shore up the normalcy of that body.[11]

The same might be said of the torture instruments demonstrated at H. Düringer's Museum, another traveling display that visited Sweden in the 1890s. In paired displays, one could see the torture screws together with wax models of thumbs, feet, and legs depicting the effects of those instruments. The catalogue states dispassionately, "One sees clearly the impression of the spike on the other side of the thumb," or "One sees the marks of the needle, which marks are blood-red from the blood circulating underneath." The same section also included a faithful copy of an iron maiden, with this gruesome description appearing in the accompanying catalogue: "Underneath was an infernal machine that chopped the unfortunate victim completely to bits, and a canal flowing by carried the remains to a nearby river."[12] Such lurid, detailed depiction of the absolute disintegration of the body under torture is but the extreme case, I would argue, of the more general fascination of the "downstairs" museum and its body in pieces.

This tradition persisted in late nineteenth-century wax museums like Castan's Panoptikum in Berlin, founded 1871 in the Kaiser-Gallerie by the brothers Louis and Gustav Castan. The wax displays there were supplemented with wax-anatomy exhibits, the live display of freaks and ethnic "rarities," and curiosities such as elephant tusks, mummies, stuffed alligators, and gorillas, which all competed with wax figures for the interest of

the viewer.[13] This, one might say, was still a "museum in pieces," analogous in its museological form to the dispersed bodies often on display there.[14]

Much the same could be said of the other wax museums that sprang up soon after in German-speaking countries, which all continued to demonstrate a particular interest in displaying live "abnormalities." This included Herman Präuscher's Panoptikum in Vienna, also established in 1871, which in addition to its wax-mannequin displays included torture instruments from the Inquisition and an "anatomical, pathological, and ethnological museum." Johann Gassner's short-lived Munich Aquarium, which featured wax figures at its opening in 1881 along with a huge aquarium and vivarium, also continued an extensive display of curiosity objects.[15] In all these display contexts, the "body" of the museum, like the wax body exhibited there, retained a centrifugal logic.

One might even claim that the chambers of horrors, the anatomical museums, and the curiosity cabinets all came closest to expressing a general truth about the wax mannequin, namely, its essential dismemberment. A look into any wax-museum storage room confirms that suspicion; there one finds the trunkless heads and jumbled limbs from mannequins that either have been retired or are still in preparation. (The backroom glimpse of mannequins in their unconsolidated state, or depicted as an undifferentiated vat of bubbling melted wax, is in fact a stock scene of wax-museum horror films.)[16] Such behind-the-scenes views of mannequin production seem to have been equally obligatory for nineteenth-century journalistic accounts of the wax-museum openings, as well for later retrospective histories, a discursive pattern leading to one conclusion: when one pulls back the curtain at the wax museum, one finds the body in pieces.[17] That body has an enduring fascination because it underscores the fact that it is only in the display space that the artfully dressed, posed, equipped, and supplemented mannequin takes on the impression of bodily integrity—or, as one Swedish account puts it, "First they, like other civilized people, must be clothed, coifed, etc. Only then can they show themselves out in the rooms, where they frequently are initially taken for real people by the visitors, so illusionistic are many of them."[18]

If the tradition of dismemberment in the wax museum remains the dominant association with the institution to this day, then the lost strand of the tradition turns out to be this elegant, culturally aspiring display of wax figures that characterized the latter half of the nineteenth and the early decades of the twentieth century. Influential precedent can again be located in Madame Tussaud's museum, which initiated the wax museum's courting of the nineteenth century's growing middle-class audience by improving the museum's overall setting. As Richard Altick puts it, "Another main reason for the Tussauds' quick ascendancy was the pains taken with the showplace itself, to distinguish their exhibition from the fly-by-

night waxworks, which, like Mrs. Salmon's in later years, were housed in squalid, dark, cramped quarters repellent to a great portion of the middle-class clientele."[19] The relative elegance of the Tussauds' permanent locale, taken together with the museum's increasingly moralizing and educational tone, gave the wax display a new social standing as a "museum," which term should be understood as implying a new relationship with the middle class.

The most important impetus in this direction was the founding of the Musée Grévin in Paris in 1882. Its founders, the newspapermen Alfred Grévin and Arthur Meyer, saw in their wax museum the possibility of creating an even more elegant version of its famous London counterpart, aspirations that Vanessa Schwartz has documented in detail in *Spectacular Realities*, her study of the influential Parisian wax museum. She summarizes: "The museum also managed to embrace and capitalize on more traditional notions of art in order to bolster its legitimacy and separate it from Tussaud's or from lowbrow, almost pornographic, itinerant wax anatomy collections, which traveled the fair circuit."[20] From the new museum's poster art to its gilded interiors, from its high-art quotations to its urbane subject matter, Schwartz argues, the Musée Grévin went to great lengths to distinguish itself from its predecessors and place some conceptual distance between the new wax museum and the older wax cabinet and its scandalous effigies.[21]

One should hasten to add that there was a *sous-sol* at the Musée Grévin, a downstairs in which criminal effigies would often appear, but the separateness of the space was not emphasized, nor was the subject matter marked as any more "illicit" than similar subject matter in a newspaper.[22] The more striking aspect of the Grévin museum's crime tableaux, in fact, was their tendency to contextualize the criminal body in elaborate scenes and connected series of scenes. Where the Tussaud museum had relied heavily on the iconicity of an effigy and written documentation for its reality effect, the Musée Grévin discovered ways to create a kind of visual authentication, namely, the tableau's contextualization of the mannequin in a slice-of-life scene that implied a world beyond the frame of the display.[23] Further, the popular "History of a Crime" series, which made its debut at the Musée Grévin's opening in 1882 and depicted the apprehension, trial, and execution of a criminal, exerted enormous influence on other wax museums in the 1880s and 1890s and launched numerous imitations in the form of other interconnected tableaux.[24] When the "downstairs" body did make an appearance at the Musée Grévin, in short, it did so in a context.

One of the important contributions of the Musée Grévin, then, in addition to the contemporaneity of subject matter stressed by Schwartz, was that its emphasis on authentic details of costume and setting functioned

to supplement the "mannequin-in-pieces" with an elaborated theatrical context. The upward cultural aspirations went hand in hand with what we might term a *centripetal* logic of corporeal display, a trend toward gathering and consolidating the body by surrounding it with layer upon layer of representational cushion.

A Scandinavian Panoptikon

The 1880s and 1890s were boom years for the wax museum as a popular bourgeois entertainment. Partially rehabilitated from its midcentury disrepute by the efforts of Tussaud's and the Musée Grévin, the wax *museum* became something that cities, even those of more moderate population, aspired to possess. Many of them had grown in population to the point where sustaining a larger-scale wax museum had become financially feasible, and during these two decades, one could in fact find permanent wax museums in Amsterdam, Munich, Stuttgart, Hamburg, Vienna, Budapest, and St. Petersburg, among other places.[25] Many of these wax museums imitated the Musée Grévin by incorporating the more elegant decor, the naturalistic staging of tableau scenes, and the series display. For these smaller European cities, the founding of such an elegant new wax museum was seen as proof that they had entered the same league as the Parisian metropolis.

The founding of ambitious wax museums oriented to the middle classes in Copenhagen and Stockholm fit into this more general trend. The Copenhagen museum's founding in August 1885 came a mere three years after the opening of the Parisian wax museum. The original directorate for the new museum included three people: Bernhard Olsen, who took responsibility for the tableau sets and facilities; Vilhelm Pacht, who did the wax modeling itself; and Jean Hansen, who handled the financial arrangements. They called their new establishment the Scandinavian Panoptikon (Skandinavisk Panoptikon), with the intention that it should serve as the central wax museum for all of Scandinavia. The importance of the Musée Grévin model becomes clear in the introduction to the first printed catalogue in 1885: there, the new wax museum situates itself as the immediate European successor to the Musée Grévin, claiming (somewhat willfully) to be the "fourth and youngest large panoptikon" in Europe, counting as predecessors Tussaud's, Castan's Panoptikum, and the Musée Grévin.[26] The actual genealogy is considerably more complicated than that; a more accurate account ought to include previously established permanent wax museums in Vienna, Munich, Hamburg, and Amsterdam, at the very least.[27]

More important than the accuracy of the claim, however, is Olsen's pride in what he apparently saw as his precocious accomplishment in becoming the Musée Grévin's immediate successor. It is frankly a bit difficult from this historical remove to appreciate the civic satisfaction a new wax museum could bring, so far has its institutional profile fallen in public estimation by our day. But at that time the founding of a "panoptikon," as wax museums were called in all of the Germanic countries, was seen as nothing less than a developmental cultural milestone. Olsen also saw in his museum the next step in the evolution of the form: "It has attempted to learn from its predecessors, to discover their positive sides and to avoid their errors." One thing this meant for Olsen was increasing still further the artistic quality of the modeling process; he claims his main improvement on the tradition to be a fine-tuning of the reality effect of the tableau display that had been developing at the larger wax museums like Tussaud's and the Musée Grévin.

Olsen was no stranger to the world of entertainment and nascent mass media, having worked as an illustrator, as a set designer in the theater, and, just prior to his involvement with the wax museum, as director of Copenhagen's Tivoli amusement park. He also dabbled in panoramas when talk began of setting up a permanent establishment of that sort in Copenhagen. These activities put him in the same cultural orbit as many of the other European wax-museum proprietors, especially that of the Musée Grévin's founders.[28] But Olsen also had a lively interest in cultural history, giving his approach to the wax museum a somewhat more serious cast than most, a mind-set evidenced by scholarly cultural-historical treatises like his "Notes on the Ceroplastic Art and Wax Cabinets." His simultaneous development of "living-picture" display techniques at the Danish Folk Museum also put his activity at the panoptikon in a more earnest cultural constellation than the other European wax museums.

For the present argument, Olsen's drive for respectability is most interesting for the way it allied him firmly with the consolidated wax body of the "upstairs" tradition. Olsen positioned his new wax museum carefully, scrupulously avoiding sensationalism; in the preface to the Scandinavian Panoptikon's first printed catalogue, quoted at the outset of this chapter, he specifically equates what I have been calling the downstairs tradition with "unhealthy excitement" and "scenes of murderers and their dismembered victims."[29] To make his panoptikon "cheerful and light," he would only include scenes of violence taken from acceptably integrated cultural forms. A tableau mimicking a historical painting of the death of the Swedish king Carl XII was fine, as was the re-creation of a famous Norwegian genre painting by Tidemand showing a killing at a rural wedding, but not currently notorious criminals and bloody victims. There was no dedicated space for a repressed downstairs room in this newly respectable wax mu-

FIGURE 2.1. View of the "Moorish Hall" at the Scandinavian Panoptikon. *Illustreret Tidende* (2 August 1885). Photo courtesy of the Royal Library (Copenhagen).

seum; its museological "unconscious" would have to be found entirely outside the new panoptikon, perhaps by attending one of the other traveling wax shows that continued to tour the Danish capital. The bodies at the Scandinavian Panoptikon, Olsen decided, would generally be of one piece and situated in a compellingly realistic scene.

Vesterbrogade's growing middle-class public responded favorably to the shift in emphasis. The panoptikon, with its posh decor and twenty-four carefully orchestrated tableaux of wax mannequins posed in realistic, interactive scenes (fig. 2.1), drew widespread admiration and praise from opening-day visitors. What turned the opening into a highly touted public event in Copenhagen was the way the wax museum's cultural aspirations spoke to the local expansion of the urban middle class. As the noted Danish novelist Herman Bang put it, writing for the conservative newspaper *Nationaltidende*, " 'Panoptikum' sounds so nice, and one must admit that those who have re-created the wax cabinet in this way have at the same time given the old institution new life."[30] With the "dismembered victims" out of view and "unhealthy excitement" kept to a minimum, the new Copenhagen panoptikon offered up a respectable, consolidated body for display.

Ape in the Human

Olsen's new wax museum was initially quite popular, especially consider-
ing the relatively small domestic population base in Copenhagen.[31] In-
spired by the success of the large-scale panoptikon, a Danish entrepreneur
by the name of J. V. Salchow decided to develop the model in Sweden as
well. He recruited one of Olsen's wax modelers, E. Thod-Christensen, to
supervise the sculpting process and the staff in Stockholm. Their Swedish
Panoptikon (Svenska Panoptikon) opened its doors in 1889, four years
after the Copenhagen museum's debut. The promotional material there
apparently relied on Olsen's shaky genealogy and proudly proclaimed
their wax museum to be the fifth in European succession.[32] The name of
the museum was perhaps intended to win back some of the territory
claimed implicitly by Olsen when he named his the *Scandinavian* Panopti-
kon. One journalist, at any rate, found it important to reassure readers
that although the directorship was Danish, "The Swedish Panoptikon is
Swedish and is owned by a Swedish corporation," and had a thoroughly
Swedish staff.[33] This was not simple national chauvinism at work; it was
also a way to mark the new museum as native and permanent, to distin-
guish it socially from the still-active itinerant (and thus vaguely foreign)
tradition of wax display.

When it opened, the Swedish Panoptikon was greeted with the same
enthusiasm and advance publicity in Stockholm that the Scandinavian
Panoptikon had enjoyed in Copenhagen. At a special preview show just
before the opening, for example, the list of guests included "the Gover-
nor-general of Stockholm, together with a few representatives for other
authorities, editors of the larger newspapers, authors, performers, and
artists."[34] The new wax museum was located in Stockholm's Kungsträd-
gården district, which like Copenhagen's Vesterbro was fast becoming a
magnet for bourgeois entertainment during this period (fig. 2.2). The
large, rectangular park at the center of the district had been an upper-class
promenade area in the early 1800s (and before that a royal parade ground)
but was rapidly attracting more middle-class visitors to its growing num-
ber of theaters, restaurants, cafés, and art galleries. Venerable cultural
institutions nearby, such as the Royal Opera House and Royal Theater
[Dramaten], gave Stockholm's own long-anticipated wax museum distin-
guished company.

The Swedish Panoptikon positioned itself as a respectable complement
to these other institutions of the visible, more elevated in appeal than
previous forms of wax display. Here is how one journalist haltingly tries
to convey a sense of the wax museum's new cultural niche:

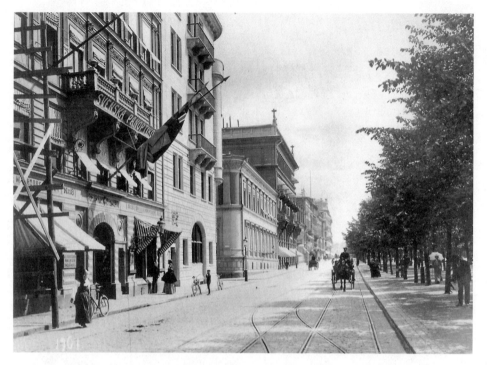

FIGURE 2.2. Exterior of the Swedish Panoptikon, located at Kungsträdgårdsgatan 18, facing out on the park, 1901. Photo courtesy of the Stockholm City Museum.

> But there are also places of amusement that attract people to the capital, places that so to speak stand on the border between amusement locales [*förlustelseslokaler*] and wholesome establishments [*nyttiga inrättningar*]—half cafés, half museums. Among the latter one might right off count establishments like Madame Tussaud's wax cabinet in London, Musée Grévin in Paris, and the Panoptikon in Copenhagen; that is, art-cabinets [*konstkabinett*], galleries, or whatever you want to call them.[35]

This account, which appeared in an illustrated journal pitched to the middle class, is clearly having difficulty reconciling this new wax museum with the more general disrepute of wax display, granting it half-legitimate status by using compound neologisms like "art-cabinets" to capture the still-hybrid status of the new institution.

Like the Scandinavian Panoptikon, the new Stockholm museum sought legitimacy in elegant decor and painstakingly staged tableau scenes. At the opening, visitors could visit Stanley in Africa, peek in on famous Swedish singers and actors in a re-created foyer from Stockholm's Royal Dramatic

Theater, or witness a discussion in the ship's cabin from Nordenskiöld's polar expedition. Even the few wax figures that made solo appearances at the Swedish museum's opening were depicted in carefully staged settings and not as isolated effigies on pedestals. Like the Danish wax museum, the Swedish Panoptikon saw this as an evolutionary process: "Just as Darwin's theory of evolution traces humankind's origins from the apes, one can deduce the rise of today's panoptika from the well-known wax cabinet of earlier days. But whereas Darwinistic evolution needed millennia to accomplish such a significant qualitative advancement as the one from ape to human, the contemporary panoptikon has only a 100-year period of development to look back on."[36] The compressed evolution from "primitive" antecedents was possible because of the effigy's new mise-en-scène, its placement in a complex system of costuming, scenery, and lighting effects. Like its immediate predecessors, the Swedish Panoptikon improved its cultural standing by adopting techniques of contextualization.

Not that everyone was convinced of the rehabilitation; the new panoptikon's relation to its predecessors in wax display appears somewhat more ironically in a depiction by Claës Lundin, himself a prominent liberal Swedish journalist and a prolific writer on Stockholm and its urban development in the 1880s and 1890s.[37] In his 1889 essay collection describing various city personalities and personal fates, with a title that translates as *Stockholm Types, Past and Present*, Lundin depicts an anonymous urban Everyman, an accountant in the civil service given the fittingly typical name of Andersson. An extended tongue-in-cheek account depicts the importance of the Stockholm panoptikon's founding for this unremarkable urban employee and his civic imagination: "One was going to set up a new and elegant wax cabinet in Stockholm, not the old kind with robbers and thieves, poisoners and other villains, but instead with proper and respectable people from our own society whom we could go and look at for decades as much as we want. It was going to called the Panoptikon, and that seemed very fine to the accountant."[38] On opening day Andersson tries to convince his cleaning lady to come with him to see the new wax museum, with author Lundin poking fun at the panoptikon's delusions of grandeur in this fictional tussle between middle- and working-class perspectives:

> "Fru Blom, you will see soon enough. I'm going to invite you to the panoptikon."
> The cleaning-woman asked if that was a new kind of snuff. The accountant tried to explain what it was about, and after many comments and interpretations, fru Blom burst out: "But that's nothing but a wax cabinet. I've seen one of those in Köping."

"Wax cabinet!" shouted the accountant annoyed. "Certainly not! This here is something much more elegant and dignified. Here one gets to see all of the great men in their real situations and with their actual coats and pants."[39]

Together, accountant Andersson's impatience and the narrator's ironic amusement underscore the new panoptikon's cultural pretensions.

For all their specifically bourgeois positioning, however, the new wax museums in Stockholm and Copenhagen seem to have attracted a much broader audience. One early Danish report from 1886 describes visitors at the Scandinavian Panoptikon as a mixed public of "children and adults, farmers and elegant Copenhageners."[40] Bernhard Olsen also hints at the class origins of his Copenhagen audience when he contrasts it with that of a typical eighteenth-century London waxworks: "In those days, when everything was divided up according to station and class, there was no possibility that the different classes could attend side by side, as at our panoptika."[41] The admission price at the Swedish Panoptikon in Stockholm (one krone for adults) was between 20 and 50 percent of a daily working-class wage, as high as any comparable museum attraction there, although many of the urban exhibitions, the panoptikon included, lowered their prices on Sundays and holidays to encourage working-class attendance.[42] These general impressions of a more egalitarian attendance at the panoptika seem likely to be accurate, if only because the class composition of Copenhagen as a whole in 1890 still featured a relatively small middle class (one estimate puts it at seventy-eight thousand).[43] The total attendance Olsen reports for the first three years of operation (five-hundred thousand) would not have been possible without broader support from the lower classes especially.[44]

These accounts of a mixed-class audience reveal the strategic, willful aspect of the panoptikon's promotional profile; it presented itself as the home of the middle or even upper classes yet needed broader audiences to survive financially in the face of a smaller available population base.[45] The advertisements included in the printed catalogues that were themselves priced at an extra thirty to thirty-five öre apiece, likely a bit out of range for the working class, promoted goods to the well-to-do classes: ladies' hats, flowers, life insurance, furniture, fine clothing, perfume, jewelry, pianos, and antiques. Although the opulent interior decor at the Copenhagen museum might seem garish today, at the time it was clearly meant to convey an impression of visual elegance (fig. 2.3). Moreover, the tone of the printed narration in the program guides was moralistic, educational, and at times apologetic for the strategic lapses in taste when the scenes displayed stronger content. The names of well-known artists who contributed to the enterprise were also emphasized in promotional material. As

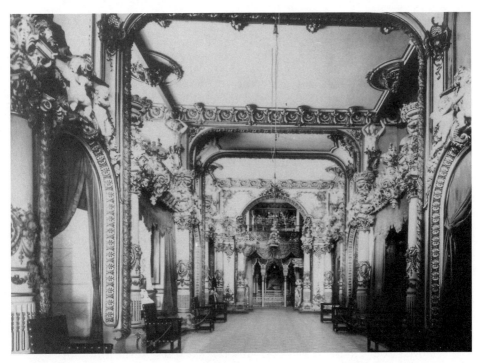

FIGURE 2.3. Interior from the "Marble Hall" at the Scandinavian Panoptikon (this may have been the hall that was converted to a movie theater in 1910), n.d. Photo courtesy of the Royal Library (Copenhagen).

the Swedish Panoptikon's 1890 catalogue claims, "In hardly any other panoptikon has one placed such great emphasis and devoted so much time to the artistic side of the business as at ours."[46]

The disparity between the actual composition of the audience and the class identity projected by the institution created interesting tensions within the display. No matter how much distance the new panoptika placed between their new institutions and motley displays like Castan's in Berlin, which the Swedes note for its tendency to "preserve traditions from the earliest times in the form of chambers of horrors, historical curiosities, and the like," the newly respectable museums were not entirely free of vestigial practices. Although the Swedish Panoptikon did not mark off a chamber of horrors at its opening, it did include a tableau depicting grave robbers stealing the corpse of "a young and previously beautiful young woman."[47] In an early journalistic account, this scene's placement in the basement clearly had the same effect as a visit to Tussaud's "separate room": "From this little room a tastefully decorated stairway leads up to the second floor, but before we go up there we take a hasty trip down to

the basement, where we are made witness to the ghastly scene [*det hemska skådespel*] offered by 'A Grave Robbery.' With a sigh of relief after coming up from there one greets the cheerful daylight and continues one's tour up to the second floor."[48] This momentary lapse in taste at the opening of the Stockholm wax museum eventually developed into a modest side attraction, since within five years of the opening other criminal effigies and scenes with stronger erotic content began to gather in the basement.[49] But the Swedish Panoptikon's *skräckkällare* was quite modest compared with Tussaud's Chamber of Horrors, never having more than four or five scenes, and seems to have been short-lived as a separated space.[50] The Swedish catalogue conveys a slightly sheepish attitude toward these traces of the macabre: "Naturally it must be admitted that something of the origin remains—just as much of the ape in the human as of the wax cabinet in the panoptikon."[51]

One might make the same claim for the other "legitimate" wax museums. Experiments with older display techniques continued off and on in the decades that followed; there was a kind of institutional give-and-take between the itinerant wax cabinet/anatomy shows and the cultural aspirations of this new class of wax museums. As Schwartz's work so convincingly demonstrates, even the Musée Grévin, due to its close historical relationship to the Morgue as a Parisian attraction, was never completely removed from a more "downstairs" display of corpses. At the Morgue one could find real "bodies in pieces," to cite the title of one prominent display there in 1876 (in which the public demand for visual access to the decaying corpse necessitated replacing it with a wax substitute).[52] An English visitor to the Paris Morgue made explicit the connection between it and the downstairs tradition of wax display by calling the Morgue's display of corpses a "chamber of horrors," using the Tussaudian term.[53]

It was likely the "ape in the human," the downstairs in the upstairs, that gave the panoptika their cross-class appeal. The late nineteenth-century wax museums were able to present the impression of a "gathered" body by keeping the two traditions careful balanced in the displays. Grave robbers—but in a carefully contextualized, theatrical scene. Dead bodies and serial killers—but as part of a morality-tale series of tableaux. Death masks—but with a history lesson. This was the formula that allowed the rapid proliferation of wax museums throughout Europe in the 1880s and 1890s. But it was a formula with a short life span for many of these wax museums, especially those in the middle-tier cities. After a successful first decade of operation, the two Scandinavian panoptika began to struggle to retain their respective audiences. One source claims that Stockholmers lost interest in the novelty of the institution after the initial period of operation, despite frequent attempts to update the subject matter of the displays.[54]

When the Scandinavian Panoptikon in Copenhagen began having its own financial troubles in the late 1890s, its new director, Vilhelm Pacht, tried to supplement the attractions of wax figures with the more sensational form of "living pictures"—early film. Cinema was not initially successful there as a side attraction, however, apparently even contributing to the Scandinavian Panoptikon's first operating deficit in 1898.[55] But the growth of autonomous cinematic exhibition sites in Copenhagen after 1906 eventually made plain that film could deliver more efficient forms of virtual mobility than the painstakingly mounted wax tableaux. It could also woo the middle class with an even more delicate balance of spectacle and narrative, of upstairs and downstairs bodies. In the end both of the large Scandinavian panoptika shared the same fate in 1924, when each was finally forced to close and auction off its inventory.[56] An announcement in the Danish press began with this blunt summary headline: "The Panoptikon is closing. The cinemas have replaced it."[57]

They had good company; most of the other regional European wax museums from the 1890s also closed in the years immediately following World War I. Costs had always been high for wax modeling, especially in the "upstairs" museums, with their elaborately staged tableau scenes. Additional economic pressures came from postwar inflation, which proved especially disastrous for the Berlin panoptika, with Castan's and the Passage Panoptikum closing in 1922 and 1923, respectively. The Amsterdam Panoptikum had already closed a few years earlier in 1919.[58] The 1924 closings of both Scandinavian wax museums were thus part of a general trend that marked the demise of the "classic" wax museum from the turn of the century—the historical apex of wax-museum popularity that is still most frequently depicted in both films and novels.

An important phase in the development of the wax museum had come to a close, but not the practice of wax display itself. Some of the museums in larger cities, like Tussaud's, the Musée Grévin, and the Hamburg Panoptikum, weathered the crisis and have remained in continual operation. In other cases, cities that lost their nineteenth-century wax museums opened new, updated versions in the 1970s and after. Wax museums continue to evolve to this day, and in some cases are only increasing in popularity, clustering in the same locations as virtual reality, IMAX theaters, and ride-simulation attractions. Recent openings of Tussaud affiliates in Times Square and in Las Vegas's own hyperbolic theme environment (at the Venetian) are but two prominent examples. The wax museum, now more often simply one of many high-tech simulation environments pitched at the mass-tourist market, no longer has many high-cultural pretensions. Correspondingly, the gathered effigy of the wax tableau has yielded once again to the amusement park's aesthetic of sensation and corporeal dispersal.

For a time, the wax museum pursued a different aesthetic, one that placed it in the company of other forms of urban entertainment courting a middle-class clientele. Most obvious are the parallels with cinema during its period of cultural assimilation in the years 1907–14. In that period, the stabilization of film content, of supplementary discourse, and of exhibition context allowed film to extend its audience base by winning over middle-class viewers with elegant exhibition sites and a "classical" system of narrative. The wax museum had undergone a similar process in the 1880s, anticipating many of the same strategies that would later help cinema negotiate the tensions between itinerancy and respectability, between spectacle and narrative.

It is telling that for many such forms of corporeal amusement, the tension between centripetal and centrifugal bodies proves to be crucial to their cultural standing. Film's own flirtation with the body in pieces, concentrated historically in such practices as early trick cinema's decapitations and incessant play with corporeal boundaries, had to be subordinated to the taken-for-granted, gathered body of narrative film in order for cinema to shake off its early cultural disrepute.[59] Like the wax mannequin, the silent-film body had to become an upstairs body in order to carry notions of character and create consistent regimes of cinematic time and space. The subsequent history of cinema, like that of the wax museum, charts a continuing oscillation of upstairs and downstairs bodies. The affinity of wax museum and cinema, and mannequin and screen image, will come under closer examination in the chapters that follow. The stakes, it turns out, are somewhat larger than simple institutional borrowing; instead, the affinities between both of these kinds of "body show" lead to the heart of modernity's visual culture and its models of access to time and space.

THE WAX EFFIGY AS

RECORDING TECHNOLOGY

> And after dinner, when you are drinking your cof-
> fee with the balcony door opened up onto the
> golden afternoon sky and the green trees of the
> [Vesterbros] Passage, you will watch a butterfly,
> the symbol of perishability, and dreaming in the
> cigar smoke that tickles your nose, lulled into
> drowsiness by the city's busy clamor outside,
> maybe for a moment you will have a melancholy
> thought about how everything, including your-
> self, will pass away. But even if you cannot com-
> fort yourself with the slightest hope of immortal-
> ity in the Panoptikon's wax, you will nevertheless
> soon come to the realization that life is worth liv-
> ing anyway.
> —*A reporter's musings after visiting the Scandina-
> vian Panoptikon on opening day* (1885)

IF THE LEGACY of early nineteenth-century wax display was the spectacle of violent death, then that of the classic wax museums at the century's close was the resurrection of the corpse. The traumatized body-in-effigy remained linked to the wax museum, either bracketed off in the chamber of horrors or through vague association. As the wax museum developed, however, proprietors and spectators showed increasing interest in the ways that the mannequin could preserve, immor-talize, and liberate the body from the confines of time and space. Perceived to be an unusually significant corporeal trace of a missing person, the wax effigy could create an impression of remarkable presence as easily as it could display lack and dismemberment, especially when shored up by the supplements of theatrical display techniques and promotional discourse. As the wax museum moved upstairs at the century's close, it turned in-creasingly to this elaborate, even hyperbolic, revivification project.

The discourse of recording ran a similar course in the same period. Technologies of photography from earlier in the century had already produced significant public consciousness of the idea of recording, but the addition of phonography to the mix in 1877 gave the cultural discussion of recording technologies new impetus. Together, photography and phonography held out the promise of the continued, durable presence of significant corporeal traces. If the body's essential absence in recorded media made mobility and reproducibility possible (by unbinding it from place and time), the enthusiastic testimonial discourse that accompanied recordings correspondingly emphasized the authenticity of the trace and its remarkable presence effects. Typical is this reaction in an early editorial on Edison's phonograph in *Scientific American*: "The orator in Boston speaks, the indented strip of paper is the tangible result; but this travels under a second machine which may connect with the telephone. Not only is the speaker heard *now* in San Francisco, for example, but by passing the strip again under the reproducer he may be heard tomorrow, or next year, or next century."[1] Another editorial in a turn-of-the-century recording technology journal, the *Phonoscope*, gives much the same impression: "It is by the voice that men communicate with each other in all the fullness of their individuality. The voice, formerly invisible and irretrievably lost as soon as uttered, can now be caught in its passage and preserved practically forever."[2] This phonographic discourse gave new life to similar earlier reactions to photography and stereoscopy; together, they encouraged a collective cultural imagining of the possibilities of immortality and mobility through a recorded trace.

Only with the help of such discourse could the recording perform its resurrections, preservations, and circulations convincingly and deflect awareness away from representational issues and their attendant diminishments. That is, each advance in technology and reproductive fidelity made clear the deficiencies of earlier stages, so that hiding just behind the enthusiastic promotion of technology is the potential recognition that the recording might not actually be up to capturing the fullness of the person or the scene. The public discussion and shared imagination of recording's possibilities helped defer that inevitable realization. Anchored in discourse instead of in the body itself, the corporeal trace made available by the photograph, the stereograph, or the phonograph recording needed backup in order to inspire confidence in the (former) presence of the source while vastly increasing its potential for circulation.

The two Scandinavian panoptika, invested as they were in the shored-up, revivified effigy, placed special emphasis on the wax display's immortalizing powers. The message apparently got through to the opening-day visitor to the Scandinavian Panoptikon quoted at the outset of this chapter, who consoles himself that although he does not have the "slightest

hope of immortality in the Panoptikon's wax," he can find compensation in the fleeting beauty of the Copenhagen scene outside the museum.[3] The contrast is clear: celebrities live on forever through their wax effigies, while common newspaper reporters, the butterfly, the city traffic, the fading afternoon light, and the cigar smoke will all pass away without a significant trace. The dissonance between the immortal and the ephemeral in this visitor's experience reveals a delicate push-pull between the marvels of enduring corporeal availability and anxiety about its opposite.

Claës Lundin's previously mentioned short story about the new Swedish Panoptikon, "The Path to Immortality," gets at the same issue. Lundin's anonymous accountant Andersson, having failed in every other avenue to distinction life has offered him, is desperate to leave some kind of trace for posterity. After considering his options (such as commissioning a life-size photograph of himself, or an oil portrait, or getting commemorated in the name of a boat or a brand of cigars), he finally decides that getting displayed in effigy at the new panoptikon with the great personalities of the day will give him his best shot at immortality. But did the wax effigy have sufficient powers to immortalize someone as ordinary as accountant Andersson? Could the wax effigy, like the photograph (which was making its amateur breakthrough at the time), record anybody and everybody for posterity?

The association between the wax effigy and other forms of recording was a discursive relationship as well. Photographs and phonograph recordings could themselves elicit effects of both unusual presence and absence because of their privileged reputation as indexical traces, at least in the first wave of public reception. The enthusiasm for their powers to preserve and immortalize was a carefully managed effect, though, one that depended on how the technologies were put into play in discourse. The same can be said of the wax effigy's association with the idea of recording at the end of the century—it was a shaky analogy at best, but for a time, it held the imagination of the public.

The arbitrariness of the wax effigy's potential as a recording technology is underscored by a simple cross-cultural comparison; the frequent associations of the wax effigy with immortality at the Scandinavian panoptika were apparently not the case everywhere. At the Musée Grévin, for example, the emphasis seems instead to have been on ephemerality. Schwartz quotes these very different journalistic reactions: "All is wax and all will melt, sooner or later. A clear expression of the futility of all objects," and "O glorious transitory wax figures! Celebrities of the day! Pantheon of the moment!"[4] Schwartz's argument makes clear that the ephemeral connotations of wax figures at the Parisian museum were an effect of its close association with the popular press; it was felt that the wax display, like the newspaper, could replicate the acceleration and constant change of mod-

ern urban life by keeping its display contents up to date. But there was nothing inherent in the medium of wax display that forced that connection; indeed, there were equally strong historical associations between wax and ideas of preservation and embalming. The wax effigy could signify differently in different contexts—an obvious observation, perhaps, but worth foregrounding at the beginning of this analysis.

Annihilation of Space and Time

The possibility of imagining the wax effigy as a form of recording depended mainly on the simple principle of physical proximity. Even if tableau-oriented wax museums like the Scandinavian panoptika curbed the presence of miscellaneous "curiosities" in their display space, they nevertheless reserved a special place for recording devices. Beginning in 1891 at the Scandinavian Panoptikon, for instance, Bernhard Olsen had phonograph recordings of local celebrities made available for visitors. The wax museum even rented out "salon-phonographs" for parties, according to one advertisement.[5] There were stereoscopic slides available for a "Trip around the World," in addition to other optical amusements. One could also have a "lifelike" photograph of oneself taken at the exit for fifty øre, half again the cost of admission.[6] At the Swedish Panoptikon, too, phonographs were available early on (fig. 3.1), as well as a graphophone described in this way: "The Graphophone is the most excellent improvement to date of the concert and speaking machine. In it you get to hear speech and song pieces presented and sung in the same way as they once in reality were presented by the speakers and singers whose voice the graphophone has preserved and which it reproduces."[7]

In this way the wax museum became a media nexus where visitors expected to encounter various forms of recording, and the wax figure's placement in series with these other technologies gave it the chance to borrow qualities by implication from the surrounding devices. The perceived spatial mobility of the mannequin helped as well; one of the most basic claims of the panoptikon was that in no other setting could one find such a concentration of famous and infamous bodies in one place, since its radical figural juxtapositions would be impossible with living people. Olsen, in coordinating the Copenhagen panoptikon's large-scale modeling effort, mentions the headaches involved: "To carry out this live study of over one hundred persons, to motivate them to submit themselves to the difficulties of the sculpting session and arrange to meet in artists' studios, usually in the city's out-of-the-way quarters, is in and of itself a work of patience."[8] The Swedish Panoptikon had similar difficulties orchestrating live bodies, emphasizing in its publicity material that the

FIGURE 3.1. The phonograph exhibit at the Swedish Panoptikon. *Ny Illustrerad Tidning* (5 January 1890). Photo courtesy of the Stockholm City Museum.

sculpting process for each effigy was continually interrupted due to the scheduling problems that arose when dealing with so many famous people at once.[9] Obtaining a sculptural likeness of a public figure was of course not the innovation of the panoptikon, but the number, variety, range, and orchestration of the resulting effigies was. As one of the first reporters at the Scandinavian Panoptikon put it, "Here you are in the Foyer of the Royal Theater. Can you make yourself comfortable there [*finde Dem til rette*]? Have you ever before been together with so many famous people at the same time?"[10]

The materiality of the display medium thus created an interesting resistance to the easy circulation of copies that would become a hallmark of recording technologies. The necessity of live modeling sessions and the painstaking process of mannequin construction, juxtaposed with the demand for variety implicit in the panoptikon idea (to make everything and everyone visually available), sent the wax museum on a paradoxical trajectory of visual practice. The attraction for spectators was precisely the sensation of being "together with so many famous people at the same time," but hiding behind that word "people" was the necessary effacement of the wax figure's representational status that makes the juxtaposition seem

both remarkable and attractive. It was because the effigies were objects that they could be choreographed in that way, but the obvious and insistent ties to the physical world required an especially willful spectatorship and supplemental discourse to create the impression of visual mobility.

Along with the panoptikon's apparent victory over space and the singularity of the original model's physical body came claims about the annihilation of time and, by extension, about victory over death. The introduction of photography and phonography (and later, of cinema) had been accompanied in many cases by a pseudoreligious discourse of resurrection and immortality: even if one died, it was claimed, one's recorded image or voice could live forever. The wax effigy held similar promise as an imagined durable bodily trace that would survive past death. This brings us very close to the discourse and practice of embalming, especially modern funereal cosmetology, where the elaborate treatment and display of corpses strives to preserve the last moment of life before death.[11] Indeed, the conversations at an open-casket viewing of a corpse might be easily exchanged with those of visitors to a wax museum: "It looks just like him," is the shared refrain.

The historical overlap between embalming and effigy production helps explain the late-century fascination with the idea of corporeal recording.[12] By stopping decay in its tracks, embalming, like recording-based forms of representation, attempted to preserve bodies outside of time, making them both temporally and spatially portable.[13] In the effigy-saturated culture of the late nineteenth century, this could give rise to rather fantastic speculation. Take the example of a report in Norway's illustrated press, an 1889 article entitled "The Transformation of Corpses to Marble."[14] The author describes a newly invented Italian process of embalming that had been nicknamed "marble-ization" because of its supposed success at petrifying corpses into a durable, lifelike form. She reports the story of one body, "changed into almost 'life-like' marble . . . so amazingly lively in complexion, contour, and expression that his loved ones could almost not get themselves to allow the coffin to be closed." Five years later, she goes on to report, the coffin was reopened to reveal a face "completely unchanged. He could have fallen asleep yesterday." Excited by these developments, the author speculates about a future in which such "petrified, cold effigies" could form a private family gallery, or even be mixed in with the living in a room on festive occasions: "We can hear the housewife in such a house say to her daughter, 'Anna, have you dusted your great-grandfather? Have you straightened the General's toupee and put a new cap on your grandmother?'"[15]

This fanciful domestic gallery of marbelized corpses sounds virtually interchangeable with a wax museum from the period. It finds an additional

counterpart in the discourse of recording at the time, such as a foundational Danish film treatise by Jens Locher in 1912, which similarly imagines a film archive of dead family members: "A hundred years from now, little Peter will know his grandfather, even though he has long been dead. Roll number 126 in the family's film archive is in fact grandfather as he lived and breathed. And what's more, here comes his voice on the phonograph cylinder!"[16]

In this cultural context, wax acquired its reputation as a form of recording. The close nineteenth-century connection between the wax museum and the morgue, documented by Vanessa Schwartz, strengthens the case. The display of the "woman in pieces," discussed in the previous chapter, implicitly acknowledged wax as a preservative form of realistic representation by substituting a wax effigy for the badly decaying corpse.[17] In the earliest years of this century, the Scandinavian Panoptikon took the next logical step by replacing all of the morgue's corpses with wax effigies for its own full-scale copy of the Paris Morgue, "with its eternally flowing stream of silent inhabitants."[18] One advantage enjoyed by the panoptikon's version of the morgue was that the display could be permanent; a popular figure could remain available to the public eye as long as it remained interesting, since the wax figure did not decay. In this respect, too, the wax figure stepped in as a "recorded" substitute for the more perishable body.

One is reminded of a more modern connection at this point as well, namely, the speculation surrounding Lenin's corpse and its display on Red Square. Recent political tension about the fate of Lenin in post-Soviet Russia has given rise to increased academic attention to the remarkable story of this most famous of corpses.[19] The official line has been that Lenin's remarkable preservation is the result of secret Soviet embalming techniques, but the popular imagination has long regarded his corpse as waxen, at least in some vague supplementary sense. The persistence of such rumors is interesting evidence of a stubborn association of the wax effigy with the idea of preservation. Since wax figures could give the impression of a substantive corporeality while sidestepping the usual organic vulnerability to death and disease, their display is in some senses the practice most adjacent to the idea of embalming. As the contemporary scholar Marina Warner writes in her essay on Madame Tussaud's "Sleeping Beauty" display, "Wax preserves by sealing matter from air, so the very substance can be understood to bring about imperishability, to stall the passage of time, and prevent its marks."[20]

The ability to depict disease without contagion was important for the wax displays in the late nineteenth-century anatomical museums as well, where the subject matter was often pathological in nature. Hartkopf's trav-

eling show, for instance, underscored in its promotional material the sanitary advantages of viewing disease in wax. The Danish-language printed guide from this internationally touring wax exhibit tells an anecdote of an English father who impressed on his sons a lesson about the wages of sin by taking them to various clinics housing victims of sexually transmitted diseases, "so that they here with their own eyes can become convinced of the frequent consequences of sexual excess. Such a visit through long, stinking sickrooms, where one picture of human misery after the other is unrolled for view, says more about the seamy and dark sides of vice than any moral sermon, no matter how good or well intentioned."[21] Waxen models can trump the in-person visit in a crucial way, the program continues, however, by making striking visual impressions of disease more widely and permanently available under more sanitary conditions. The writer states, "An anatomical-pathological museum is on the other hand more pleasant [*hyggeligere*] than a hospital"—the implication being that wax "recordings" allow access to diseased bodies without actually being exposed to them. A similar point is made in Haviland and Parish's historical account of wax modeling in medicine, where an eighteenth-century visitor to a Parisian anatomical museum is reported to have exclaimed, "Mademoiselle, there is nothing lacking except the stench!"[22]

In later cinematic treatments of the wax museum, traces of these previous historical connections between effigy and corpse resurface in the service of horror. In the two most famous Hollywood wax-museum films, *Mystery of the Wax Museum* (1933) and its later remake, *House of Wax* (1953), the sinister secret at the heart of the waxworks is that all of the wax figures are in fact real corpses coated with a thin layer of wax: each of the effigies is in fact an urban murder victim and literal missing person. The figures are paradoxically perceived as "lifelike" by visitors because they are real dead people. Apart from the macabre pun on the phrase "taken from life" that this plot device allows (and which both films exploit with tongue-in-cheek humor), this narrative element leads us to perceive a macabre kind of recording in which what is supposed to be an impression or trace of the body is actually not a part at all, but the whole thing—dead, but preserved in the last moment of life. Both films depict a representational game gone sour, in which the playful effigy substitution is at once too literal and too complete.

Claës Lundin's short story about accountant Andersson at the Swedish Panoptikon, introduced earlier, points similarly to the paradoxical nature of effigy-as-corpse. In one section, Lundin imagines the crowd's reactions to various displays on opening day. At the display of the deathbed of Wilhelm I, where according to the catalogue the German kaiser has just breathed his last (fig. 3.2), Lundin has his fictional spectators enthuse

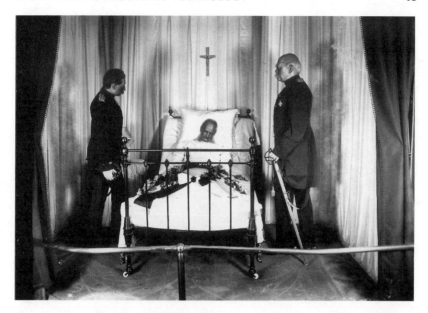

FIGURE 3.2. "Kaiser Wilhelm's Deathbed" at the Swedish Panoptikon, after 1889. Photo courtesy of the Stockholm City Museum.

about the tableau's realistic effect with the usual wax-museum response, "It's as if he were alive!"[23] Lundin's joke, of course, is that the central effigy in this deathbed scene is not supposed to seem so real as to be alive, but so real as to be convincingly dead. The paradoxical nature of embalming—its ability to make real live dead people—emerges in such instances as fundamental to the logic of the panoptikon. It is a logic that extends to its smallest details, such as the leaves on the plants in the Copenhagen panoptikon's hall of mirrors, which the catalogue tells us "are natural, but are coated with a substance that gives them an imperishable life in both form and color."[24]

Close by the metaphor of embalming at the panoptikon was that of resurrection. It was common for traveling wax cabinets striving for respectability to turn to religious subject matter, focusing on the life of Jesus and Palestine in much the same way as did the educational-religious stereoscope series, magic-lantern travel lectures, and eventually, the various passion plays of early film.[25] Such a waxen Bible visited Christiania (Norway's capital) in 1889, featuring these four sections: the Twelve Apostles; the Mount of Olives; Jesus' Grave, Resurrection and Ascension; and Mary Magdalene.[26] The life, death, and Resurrection of Christ could gain an added resonance when presented in a display medium that had itself accrued a certain association with life after death.

The secular version of the resurrection idea at the wax museum had more to do with media and the idea of celebrity, however. When famous people died abruptly, the wax museum could seemingly bring them back just as quickly. Early in the history of Madame Tussaud's museum, she discovered the profitability of the hurried production and display of effigies representing recently deceased celebrities. When she displayed a popular young opera singer's wax likeness immediately after the performer's unexpected death during a music festival in 1836, crowds rushed to see the diva restored to view at Madame Tussaud's.[27] The public response was almost certainly motivated in part by the way the display of the recently deceased could make good the loss, especially when the loss was collectively felt.

If a sensational death occurred in public before a wide audience, all the better, since the display of the effigy could attract equally impressive crowds when it brought the figure back from the dead. The proprietors of the Swedish Panoptikon learned this marketing lesson soon after the opening in Stockholm as well, when they mounted a display of a twenty-two-year-old Swedish aeronaut named Rolla. The handsome captain had plunged to his death during a public hot-air balloon exhibition on May 29, 1890, just off the Swedish coast. His body was found the next day by fishermen. The tragedy was made all the more poignant by the fact that the death could have been averted had Rolla's parachute not fallen overboard soon after liftoff. His spectacular death in full view captured the public's imagination; Captain Rolla, "upon whose grave so many women scattered so many flowers," was described as a "martyr for aeronautical science."[28]

The Swedish Panoptikon seized the opportunity to trade in his sudden, tragic fame. A mere twelve days after Rolla's accidental death, his effigy stood ready in the panoptikon, "displayed in the original aeronaut costume *in which he died* and with his original parachute, whose premature fall from the balloon was the cause of his death" (emphasis in original).[29] The macabre pathos involved in showing the actual objects from the death scene is counterbalanced by the fact that Rolla's effigy was displayed as if it were alive, not dead. The wax display seemingly rolls back the tape, so to speak, to the moment just prior to the scene of death and restores the figure to life—not "life after death" but "life before death." For the panoptikon's audience, of course, the depicted moment was full of premonition, since they would have known all too well the events following the depicted scene. The structure of the practice is irresistibly fetishistic, as if the return to (and energetic investment in) the last moment of presence before death could ward off the real absence of the dead body.

Effigy as Index

In the inaugural catalogue for the Scandinavian Panoptikon, Bernhard Olsen writes, "This energetic work of getting as close to reality as possible has been expanded to the smallest details."[30] At the wax museum, this meant first and foremost asserting a privileged connection to the represented body, the kind of connection that only a recording could claim. But a recording's effect of hyperpresence at the turn of the century was maintained in delicate balance with the crucial representational absences that allowed it to circulate freely; without such absences, it would be no more mobile or portable than the original bodies themselves. To create the particular blend of intense realism and widespread accessibility that typifies modern media and their representational systems, recorded traces had to be able to circulate widely *and* provide assurance of a secure path back to a genuine source. Phonography and photography had that kind of currency. If a voice recording existed, it was seen as a guarantee that the body had at one time been in the presence of the machine; if a photograph existed, then the body had stood before a camera. But just as these media's reputation for incontrovertible, indexical truth waned as their production processes became more generally familiar (and thus subject to manipulation), confidence in the wax effigy's absolute proximity to its source eroded gradually throughout the nineteenth century.

The wax figure has always relied on a combination of iconicity (its powers of resemblance) and indexicality (its physical connection to a source) for its realistic effect, as did true forms of recording. The balance between the two tendencies was in constant flux throughout the history of the wax museum. At the height of the French Revolution, indexicality was the primary attraction of the wax figure, due to the grisly historical convergence of wax modeling and Madame Tussaud's experiences with the death masks of guillotine victims.[31] Both before and after that important founding moment for the modern wax museum, however, wax modeling usually employed rather traditional sculpting procedures and sittings with live models.[32] The wax faces made from death masks were a different matter, however—they could be said to have touched the faces of the sources, even if only in relay. The most famous example is without question when the revolutionary council enlisted Marie to fashion a death mask of the assassinated Marat immediately after his murder, his dead body still warm in his tub. The plaster mask in turn served as the mold for Marat's wax effigy at her wax museum in London.[33]

Philippe Curtius had special access to severed heads from Sanson the executioner even before the Revolution, from which he modeled many of

his subjects at the "criminal" branch of his museum, the Caverne des Grands Voleurs.[34] During the Reign of Terror, when both Curtius and Marie Tussaud were officially commissioned to make plaster death masks of guillotine victims, the usual process involved taking a clay squeeze from the mask, and from there a mold would be fashioned into which the hot wax could be poured for the final effigy figure.[35] One particularly gruesome, possibly apocryphal, account has Curtius making a direct wax impression of a guillotine victim right at the Madeleine Cemetery. Warner summarizes this account by saying, "He then poured a layer of wax straight onto the turf at the side of the grave, and rolled the severed head in it to take an impression of her features."[36] A more striking and insistent relationship between body and effigy could hardly be imagined than pushing the actual face into hot wax on the ground itself (even if it is unclear in this case how the wax negative would then be sculpted into a positive). Just as evocative is the fact that the most direct form of representation in wax also involves most spectacularly the literal death of the subject, since only a severed head could be modeled directly in hot, molten wax. The death implicit in all representational practice, the sacrifice of life for the sake of display, finds in this early account a most macabre realization.

If, for our purposes, the face pushed into the wax on the ground can stand in as an emblem for the height of indexicality, even if only imagined, the subsequent wax modeling tradition can be seen as apologizing for less secure physical ties to the bodies represented.[37] Chapman points out that when Madame Tussaud began traveling through England, she could not depend on being physically present at all the important executions, as she had been in Paris, where the executions were centralized and the corpses brought to the Madeleine Cemetery.[38] As long as she used either plaster death masks as a source (or life masks, in the case of more respectable celebrities who were willing to undergo that procedure), she would at some time have to be in the actual presence of the person being modeled. This enhanced the appeal of the effigy that had "touched" the original. It presented practical difficulties for the modeler, however, especially since Madame Tussaud insisted on strict standards of accuracy during her lifetime, excluding all "imaginary" or "undocumented" representations. Those standards could only be maintained through the authenticating presence of the modeler at the source. As long as indexical modeling remained the dominant practice, the *modeler's* body had to circulate to gather in the traces that made the effigies genuine.

Richard Altick documents an early hint of retreat from a purely indexical standard in this catalogue description from Tussaud's traveling show in 1802: "All the figures have been taken from life, from masks molded on the persons themselves, or from the best original paintings . . . the body and limbs being molded on persons as nearly as possible of the shape and

size of the originals."[39] The statement obligingly reveals a kind of semiotic hierarchy, in which the iconicity of painting serves as a backup for indexicality, and similarly sized individuals serve as models for limbs when the actual people are not available. Further slippage can be seen in an incident from 1829, when the Tussaud exhibit included effigies of Burke and Hare, England's most infamous grave-robber killers. (The two criminals had not just stolen bodies but also had enterprisingly provided medical anatomists with victims of their own making.) Soon after Burke was executed, his effigy appeared in Tussaud's display along with this notice: "It represents him as he appeared at his trial and the greatest attention has been paid to give as good an idea as possible of his personal *appearance*" (emphasis in original).[40] This effigy began not with the physical cast of a face mask but in sketches and notes from the trial.

Burke's partner in crime escaped prosecution by turning government's evidence, so Hare's effigy was even harder to track down. With no trial or execution, there was no chance for either careful observation or a death-mask impression. Since Hare was unlikely to cooperate for a live sitting, Madame Tussaud had one of her sons play detective by going to Edinburgh "to procure a good likeness of him," as she put it in a subsequent advertisement for her museum, which resulted in a wax figure of Hare that was promoted as "fully indicative of his character."[41] At the same time, Chapman reports, it was discovered that a death mask had been made of Burke after all. Instead of making a new figure from the casting, Tussaud simply added it to the display as a supplementary, indexical relic next to what were by now purely iconic effigies. As odd as this solution might seem, and as ridiculous a picture as this modeling scenario might call up (the younger Tussaud tailing his "mark," all the while making furious sketches), it demonstrates the obligation wax modelers felt to maintain a physical connection to a source body.

As portrait photography became more common later in the century, it became possible to rely more and more on the new medium's own representational authority and let the photographs do the circulating. John Theodore Tussaud, the great-grandson of Marie who assumed directorship of the museum in 1885 (and thus was the contemporary of Grévin, Olsen, and the others), was an avid photographer. Whereas Curtius had used his connections to the executioner to gain special access to the heads themselves a century before, John Theodore used his influence to get good seating in court. According to family lore, he used his prime vantage point not only to make copious sketches but also to take secret photographs of the criminals on trial with a detective camera hidden in his hat.[42] With the introduction of photographs as sources, it became less necessary for the modeler to have been personally in the presence of the source, since one could now be confident that the photographer had been. One conse-

quence of this new partnership with photography in the modeling process was that even wax museums especially concerned with accuracy, like Tussaud's, could turn increasingly to international subjects the modelers had never met personally (such as Hitler in the 1930s).

The Scandinavian wax museums were founded midway through this general shift, at a time when the modeling process rarely involved even the intermediate step of plaster masks made on the face itself.[43] Instead, the likeness during this period was almost always "taken from life," that is to say, from a live model in a traditional sitting arrangement in a sculptor's studio. The plaster mold into which the hot wax was poured was now formed over a traditionally sculpted clay bust, not the face itself. The face of the source body thus no longer left any directly morbid traces on the wax effigy at the late nineteenth-century panoptikon, unless one thinks of the trace as being historical in nature, a kind of vestigial shudder tied to earlier practices.[44]

The effigy's reputation for indexicality, however, could be used as a kind of backup in a case where the likeness was weak. All wax-museum discourse is notoriously hyperbolic in its promotion of "astounding likeness," but there are a few hints in the Scandinavian material that the iconic powers of the effigy may not always have been so overwhelming, such as this one conveyed by Zakarias Nielsen nine months after the Copenhagen museum's opening. His account describes spectator reactions to an exhibit featuring effigies of Nordic politicians, "whose heads are all modeled from Nature, yet without succeeding in getting the likeness right in every case. 'Hmm, is that supposed to be Berg?' asks one viewer and shakes his head. 'Yeah, and Høgsbro there at the table and Professor Matzen to the side!' answers another and scratches himself skeptically on the neck."[45] This rare glimpse of two unconvinced spectators is important to keep in mind, especially for the historian tempted to take the hyperbole of the wax museum's iconic claims at face value. This is not quite P. T. Barnum's humbug; the wax museum's self-promotional claims were not a matter of hoaxing and its exposure, the dynamic Neil Harris has called the "operational aesthetic."[46] The icon makes a different claim than the freak of nature, encouraging a game of likeness appraisal and amateur connoisseurship rather than a knowing sort of authenticity assessment.

The gradual loosening of the previously indexical link between body and wax effigy went largely unadvertised, a fact that may help to explain the continued display of death masks in many of the wax museums. At Madame Tussaud's museum, the death masks of Robespierre, Marat, and other revolutionary celebrities remained on display throughout the nineteenth century. One might argue that this is simply further evidence of that museum's continuing, obsessive relationship to the violent events of the French Revolution.[47] But what would account for Bernhard Olsen's

decision to introduce a similar variety of death masks alongside the wax effigies at the Scandinavian Panoptikon soon after its founding in the 1880s? His museum was not marked by any such founding historical trauma, yet death masks were nevertheless apparently thought to be the obvious neighbors of the wax tableaux. Perhaps the death masks served the same function as the recording technology devices placed in the same vicinity: to impute to the adjacent wax figures a shared indexical status. As vestigial reminders of the previous historical connection between mask and effigy in the sculpting process, death masks could serve as backup for the effigy. The recent addition of death masks to the royalty exhibit at today's Tussaud affiliate wax museum in Copenhagen seems an even more calculated gesture; the haphazard subject matter of the masks there (silent-film director Eric von Stroheim's mask next to that of Danish king Christian VII?) indicates that the primary reason for their inclusion is to create a general semiotic atmosphere of contiguity to source.[48]

Similarly, a visitor to Olsen's "Pantheon" display at the Copenhagen panoptikon in 1890 could see, in addition to the wax tableaux, "a collection of masks, formed over renowned men's and women's heads," along with "castings made over their hands."[49] A letter from Olsen to a Swedish colleague in 1888 inquires about sources for good portraits and death masks to use as models, not only for his mannequin modeling but for his own separate death-mask collection as well. He asks Georg Karlin in Lund,

> Do Tegnér's and Carl XV's death masks exist? Since Tegnér died in Lund and King Carl in Malmö, it should be possible that they might be found at those places. Do you know of other death masks of leading Swedish men and women? I have Carl XII's, but that is all. I have started a collection of historical masks, which has its own great interest, but I would like to have as many as possible from Nordic countries.[50]

The collection eventually expanded to include masks taken from such renowned international cultural luminaries as Schiller, Goethe, Dante, Beethoven, Maria Stuart, Cromwell, Martin Luther, Thackeray, and Napoleon, none of whom are depicted as separate wax figures at Olsen's museum.

Without diminishing Olsen's achievement in acquiring such a variety of famous artifacts, one should realize that fully ten of the thirty subjects for the death masks on display in Copenhagen in 1890 could also be viewed the same year in Stockholm in versions available at the Swedish Panoptikon.[51] In other words, the Swedish masks and Olsen's masks, both of which claimed to be "formed over renowned men's and women's heads," were perhaps not always unique originals but conceivably second-generation impressions or simulations (even though it is of course possible that more than one original death mask was made). At this point, it is easy

to imagine a death-mask industry providing the proliferating European panoptika with multiple copies of famous faces, all jostling for position near the authenticating touch of the source. The familiar problem of relic authentication reemerges here: if the masks exist in multiple copies, impressions taken of impressions, does that diminish the visual power of the unique object and its relationship to the original body? How many relay steps were too many?

Neither of the 1890 catalogues from the Scandinavian panoptika raises the problem of originality in relation to their death-mask copies. Instead, the masks simply play their supporting role as a comparatively more grounded form of representation helping to buttress the by-then vaguely indexical effect of the wax figures themselves. Evidence from Tussaud's museum is more explicit on this point. In John Theodore Tussaud's history of the museum, he mentions that paintings or sculptures of historical personages often look too contemporary to us because modern models have been used for the faces. Not so with the wax figures, Tussaud assures the reader: "The revolutionary figures sometimes look odd to us precisely because their real aspect has been so vividly preserved. The hand that modeled Marat was a hand of Marat's age. It touched the flesh of the dead man. The eyes that received the conception reproduced by the hands, gazed upon Marat himself as he lay back dead."[52]

Still, it worried the panoptikon that the creation of a wax bust in the late nineteenth century was fundamentally an artistic intervention, with all the usual representational distances and absences that entails. Concern about the actual weakness of the wax effigy's indexical claims might be registered in an article that prepares the way for the Swedish Panoptikon's opening in Stockholm by detailing the various stages of the wax modeling process for readers. One of the several sketches included there is especially interesting, since it may be compensating in a subtle fashion for the nonindexical status of the wax bust (fig. 3.3). The drawing shows King Oscar II of Sweden sitting as a model for the wax effigy that would eventually be included in the Swedish Panoptikon's royal family tableau. An artist figure to the right is in the process of forming the preliminary clay bust. Between the model and the sculptor, a third figure offers up for the king's appreciation a head modeled in wax.

The identity of the wax head depicted hovering in the air between model and bust is difficult to ascertain from the picture; it may represent one of the princes in the royal family, modeled at a previous sitting, since the display under preparation in this illustration was likely the Swedish royal family tableau that included them all. But it is the visual composition of the sketch that is more intriguing, with its indirect and perhaps unintentional depiction of a representational hierarchy. The modeling situation here is a traditional one (note the aestheticizing posture of the artist and

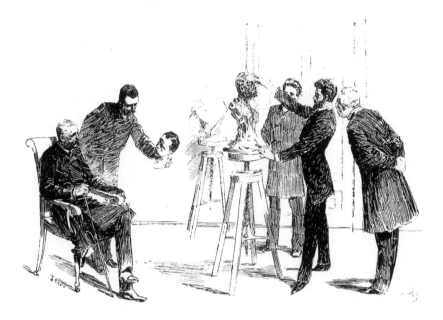

FIGURE 3.3. King Oscar II of Sweden getting modeled at the studio of the Swedish Panoptikon. *Ny Illustrerad Tidning* (15 December 1888).

the physical distance from the source). The wax head, by contrast, inserted into the illustration at the halfway point from the model, trumps the clay bust with an implied claim of physical proximity. The privileged position given to the wax head diverts attention from the fact that it, too, began as a clay sculpture, just like the bust at right. The role of the king in giving official royal approval of the likeness further grants the wax modeling process an overdetermined authority.

The wax effigy's indexical aspirations were still more precarious when live models were unavailable and other representational models had to be used as sources. Paintings were common choices, but they could not guarantee the indexical relationship in the public mind the way photographs or a death mask could. Their suitability as likenesses thus had to be buttressed more carefully with supplementary written material. As mentioned, Olsen was always on the lookout for "good portraits," and the panoptikon's printed catalogue generally provides assurances along with the completed effigy that the source painting was the best likeness available. When the Scandinavian Panoptikon staged its wax-tableau imitations of paintings from Hogarth's "Marriage à la Mode" series, the program narrative emphasized not just that the wax museum's imitation of the painting was a secure mimetic transaction but that the original paint-

ings themselves were exact representations of real life. Hogarth's memory was said to be "without equal," and he was described as the first English artist to paint "what he experienced and saw."[53]

The problematic status of paintings as display sources was apparently even more keenly felt at the Tussaud museum in London, where paintings of Napoleon were displayed alongside his wax effigy in the 1870s for comparison purposes. The paintings were accompanied by remarkably strange printed testimonials in the guidebooks, which guaranteed with signatures that the paintings, like the effigy itself, were perfect likenesses.[54] Interestingly, the testimonials came from people who either had known the emperor personally or were present when he sat for the painting—eyewitnesses who had been near the real body before it became representational, and who could serve as a relay point for the claims to authenticity. Altick suggests that the Tussauds' obsession with authenticity and certifiable likeness was intended to distinguish their museum from the cheaper waxworks, in which an effigy likeness was at times so imperfect that it could be used to represent several different personages by changing costumes as the displays were updated.[55] But the location of that authority in the discourse rather than the object may also be taken as evidence of the effigy's drift from source body.

The better backup model was thought to be a photograph—not surprisingly, given its reputation for a high degree of both indexicality and iconicity. In his inaugural catalogue for the Scandinavian Panoptikon, Bernhard Olsen writes that the wax heads were "modeled from Nature, or, where this has been impossible due to the absence of the person portrayed, from photographs executed especially for this purpose."[56] The visual authority accrued by enlisting the photograph as backup is potentially counterbalanced, however, by the image's deficiencies. The obvious limitations of the photograph as a modeling source for wax figures were its lack of three-dimensionality and color, both essential characteristics of the eventual effigy on display.

John Theodore Tussaud tells a story about Pope Leo XIII that underscores the tenuous nature of the photograph's authority. Immediately after the new pontiff's election, at a time when photographs of him were extremely scarce, an effigy was made for the museum. Some photographers, pressed to produce images of the new pope for the public, decided to use the new Tussaud effigy as their source and simply passed off the mannequin in the photograph as the real thing. According to Mr. Tussaud, "So lifelike was the picture that when it was placed upon the market beholders concluded that the Pope had sat for it." The punch line of Tussaud's anecdote is a predictable one: when another photography studio actually obtained an official sitting and made a photograph of the pope himself, "very grave doubt was raised as to whether the new portrait was really a good

likeness, and many persons questioned its genuineness, much to the chagrin of the photographers who produced it."[57] This is of course an old story in Western thought—the simulation that satisfies realist aesthetic criteria better than the thing itself—but the point here is that the effigy's rivalry with the photograph was due to their mutual juxtaposition within the wax museum in the first place.

The aspects of photographs that made them mobile, and thus available to the wax-museum modelers when the real person was not, were also the aspects that potentially undermined the exclusive proprietary relationship to the source body. Walter Benjamin's discussion of the loss of aura attending the age of mechanical reproducibility is especially pertinent here. Tussaud again provides the exemplum with his mention of surreptitious snapshots that visitors would sometimes take at Madame Tussaud's museum: "The result has been that the photographs thus secured—all subject to copyright fees never collected—have been made use of for all kinds of purposes; they have turned up as blocks in newspapers and magazines, illustrations in books, and portrait postcards, besides being treasured in albums and framed as pictures." Tussaud again flatters his own institution by mentioning that these effigy images, smuggled secretly out of the museum and put on display outside the museum's control, would at times circulate back to their origin as supposed traces of real bodies: "It has so happened that we have had sometimes to send a member of our staff in quest of all the latest photographs of a favorite celebrity whose figure we have desired to remodel and bring up to date. Not infrequently has he brought back with him 'photographs' purporting to have been taken from life, but which have been instantly recognized as reproductions of figures in the Exhibition."[58]

The ability of the effigy photograph to circulate easily from hand to hand, to simply turn up anywhere, takes the already existing corporeal juxtapositions of panoptikon effigies to a more radical extreme. The difference, of course, is that the unauthorized snapshots circulated centripetally instead of centrifugally, as did the wax mannequins when they were originally gathered under a single roof. And in spite of Tussaud's reassurance that the museum staff could always tell "instantly" when the photograph depicted one of their effigies instead of the real body, a photograph of an effigy raises some thorny epistemological problems. When the body images lifted photographically from the wax display entered unauthorized paths of circulation, they threatened an already precarious sense of origin. A representational *mise-en-abîme* begins to open at the point when the wax figure begins to function as the original in Tussaud's anecdote.

A further photographic example can illustrate the potentially radical unmooring of effigy from body. A vexing problem for the historian working with this kind of archival material is determining the ontological status

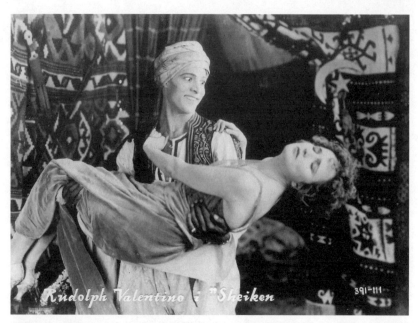

FIGURE 3.4. Rudolph Valentino—the "real" Valentino—in a scene from *The Sheik* (1921). Photo courtesy of the Stockholm City Museum.

of a photographed figure: How can one be sure from a photograph whether a figure is real or stuffed? Is the assumed link to the real body "direct" or accomplished in relay through a wax figure? A particularly suggestive example is an image of Rudolph Valentino in *The Sheik*, which was included among the archival photographs from the Swedish Panopti-kon at the Stockholm City Museum (fig. 3.4). When I first showed this photograph in lectures and presentations of this material to film scholars, there was general agreement that there must be some mistake, that this must be a publicity still or frame enlargement from the film rather than a wax-museum photograph. The realistic flesh of the female figure's bare arms and neck, the convincing impression of weight, Valentino's natural posture—all the visual clues seem to indicate that the photograph has cap-tured the image of real bodies, not of mannequins.

That in fact turns out to be the case, but the misclassification in the archivization process involves an interesting kind of perceptual error. A large number of photographs was donated to the City Museum in 1950 and 1951 from a Swedish publishing house that had just issued a book on the history of Stockholm entertainment life.[59] Included in the collection were many photographs of wax tableaux from the panoptikon, and when

they were sorted for the archive, this Valentino photograph was assumed to be a wax-figure display and was catalogued in the Swedish Panoptikon folder. When I in turn requested photos from the panoptikon for my research, who should turn up in the batch but Rudolph Valentino, in what was assumed to be a wax display reproducing a scene from *The Sheik*. For a time I, too, wondered about the photograph, marveling at the extraordinarily lifelike qualities of these "mannequins." Not until later, when I cross-checked the archive accession records with Tjerneld's original book, did the misclassification of the photo become clear (it had originally been used in his next chapter on cinema and popular Stockholm culture in the 1920s, not in the chapter on the panoptikon).

The interesting theoretical point is that the ontology of the body and that of the mannequin are mutually implicated in this kind of photograph. The idea is not that an actual viewing of a waxen scene from *The Sheik* would be so illusionistic that it could not be distinguished from the real thing, in spite of how much a wax-museum catalogue might like to make that claim. Instead, it is that a *photograph* of the wax tableau might be mistaken for a *film still* of Valentino's real body. In the idea of recording, the frozen image of the wax tableau and the frozen frame of the film converge, and one loses track of a clear conceptual path back to the body. The archivist's classificatory dilemma when faced with a photograph like this is in one sense another version of the game played with decoy figures in the museum. Is a body a mannequin just because it is not moving?

The photographed mannequin, which since the late nineteenth century has been used as a common promotional joke at wax museums (usually featuring model and effigy together), actually articulates in the convergence of material and recorded forms of display a crucial juncture of the visual culture of modernity. The photograph of the mannequin embeds the material practice within the recording technology, and the historical precedent within its successor. Interestingly, such photographs have done the bulk of promotional work for the wax museums, circulating much farther afield than the mannequins themselves could ever do, even as they make an implicit argument for the mannequin's clumsy obsolescence as a form of effigy. But the point of joke photos, like the one promoted for sale to all visitors at the entrance to the present-day Movieland Wax Museum— a photograph of oneself alongside a mannequin of George Burns—is that the status of bodies begins to converge in the photograph, the great leveler of the living and the dead.

The many-layered absences of the photographed wax tableau take us far from the severed head pushed into molten wax on the ground of the Madeleine Cemetery. The distance traversed can be measured by a final example, a scene from Vincent's Price's *House of Wax*. As mentioned ear-

lier, the mad waxwork proprietor Jarrod is obsessed with re-creating his former masterpiece, an effigy of Marie Antoinette that was destroyed in the same fire that caused his own horrible disfigurement and insanity. The snoopy, intuition-driven heroine Sue, who is on the verge of discovering the museum's macabre secret (that "the whole place is a morgue!"), is said to be the spitting image of the lost Marie Antoinette. At one point, Jarrod confronts her with a model of her own head in wax that had originally been sculpted in clay by her boyfriend, Mark Andrews:

> JARROD: Your Mr. Andrews permitted us to make a cast of the head he did of you. Leon has just finished it in wax. Do you like it?
>
> SUE: It's sort of a shock to see your head detached that way. I guess it's a very good likeness.
>
> JARROD: Yes and no. Andrews is clever, but like all modern sculptors he has too much imagination—he would improve on Nature. What I need for my Marie Antoinette is you—the real you. Nothing less will satisfy me.[60]

The invitation leads predictably to the film's final showdown, in which Jarrod traps Sue inside the museum at night and tries to cover her live body in molten wax to give her the same "eternal life" that he had given the others. The horror effect of the scene derives on one level from the substitution of the literal body for the figurative, but the historical resonance is still more clever. Jarrod's grotesquely indexical scheme, that is, also shows a desperate attempt to recover a lost form of the wax museum, for which Marie Antoinette stands as the most appropriate and evocative historical emblem. Jarrod's is actually the museum of the Revolution's decapitated head and indexical death mask, not the museum where "modern sculptors" offer up approximate ("artistic") likenesses that improve on nature instead of reproducing it exactly. Therein lies an extra horror effect, that of the historically uncanny vestige returning to reclaim the wax museum from what the Swedish Panotikon materials called its "evolutionary" progress.

If this general outline of the nineteenth-century wax museum is correct, the practice of wax-effigy display at the end of the century starts to look like an elaborate rescue operation: the farther the effigies stray from the source, the more crucial becomes the lifeline leading back to an originary body. In this sense, the longed-for original body is in part a vestigial historical trace, the body of greater proximity left over from earlier wax modeling processes. But the later practice still needs that body, perhaps even more than did the death-mask effigy, because proliferating layers of representation make the connection more tenuous. As the guarantees that the face of an effigy had touched its source began to weaken, wax-museum proprietors needed help in forming a metonymic process of relay and authentication.

Persuasive Relics

Providing discursive assurances that sources and modeling processes were indexically secure was one way of managing the potential shortcomings of wax as a recording medium; supplementing a wax bust with traces of the body itself, such as real human hair, was quite another. There were grotesque historical precedents for the use of real body parts in earlier forms of religious effigy, such as wax figures supplied with the fingernails and hair of Inquisition victims, or a Christ effigy in Spain that apparently consisted of tanned human skin and gory wax wounds.[61] In comparison, the practice of using real hair for effigies in the nineteenth-century panoptika seems quite tame. Nevertheless, the hair implanted in the wax busts was often donated by the person depicted, as was the case with the hair given as a gesture of support by "royal persons" when the panoptikon opened in Copenhagen.[62] Few period articles about the wax museums failed to mention that facial hair, eyebrows, eyelashes, and hair on the scalp were planted in the wax busts strand by strand, as demonstrated in an illustration of the Swedish Panoptikon's studio (fig. 3.5). Although this later practice does not seem quite so grotesque as its historical precedents, the vestigial trace of an earlier talismanic practice allows the wax effigy to cross over from representation to the real thing in the spectator's imagination, or at least to suggest that possibility. And, in fact, the traces of the real incorporated into the display may have had a more persuasive hold on viewers than the general issue of likeness, since they encouraged an imaginary completion of the authentic body implied just beyond the trace. A detail like the hair, or a casting taken over the hands, could evoke the body in a way that likeness could not.

Original articles of clothing could create a similar effect. They, too, had often been in contact with the source body, since many of the costumes had been worn by the people in question and donated to the panoptikon specifically for use with their wax effigies. The importance of this detail for the display's perceived authenticity is attested by the extremes to which this effort was taken. In cases where clothing and accessories were not donated by original owners, the panoptikon would buy them from "the businesses where the person usually shopped."[63] Olsen's correspondence contains a request for a clothing donation from the Danish writer Erik Skram for his wax effigy, which concludes, "or if that is not convenient for you, then give me the address of your tailor."[64] A tailor, of course, might simply be an inside source for the real body's measurements, but an example from a wax display put on at the Malmö industrial exhibition in 1896 hints at the higher stakes of a thoroughgoing aesthetic of adjacency. Lacking original clothing for the renowned Swedish aeronaut Salomon August

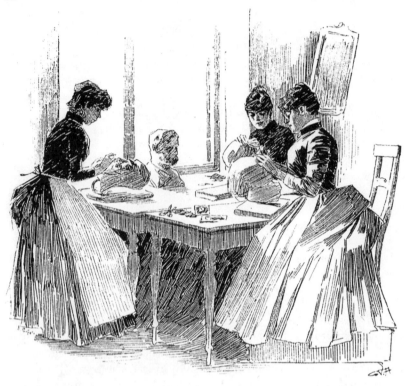

FIGURE 3.5. Implanting hair at the Swedish Panoptikon's modeling studio. *Ny Illustrerad Tidning* (15 December 1888).

Andrée, the Swedish Panoptikon affiliate at the exhibition solicited the services of Andrée's tailor, not just to make an exactly sized replica but to take the display's clothing "from the same piece of cloth as the ones they are actually wearing on their adventure-filled voyage of discovery."[65]

A similarly obsessive fascination with contiguity extended to the props in a display. One itinerant museum traveling through Sweden in 1894 put on display a tableau scene depicting a famous anarchist and mass murderer, William King Thomas, who set off a bomb on a ship in the Bremen harbor in 1875. There was an obvious problem, however, with the attempt to provide genuine relics from the event, since "the original timer surely blew up into thousands of atoms in the catastrophe." Nevertheless, the museum guide hurries to assure the viewer, "This timer is a thorough copy of the original, built and precisely imitated by the above-mentioned I. I. Fuchs in Bernburg (who built the original)."[66] Just as using the same tailor could help retrace the steps back to an original body, turning to the same watchmaker here could guarantee more than a mere copy of the missing origi-

nal; this was a copy that had touched an "original" body—if not the body of the criminal on display, then the body that made the object that had been in its proximity.

So one display had the cloth that earlier had been adjacent to the cloth that was now touching the real body; another had the timer that had been created by the same watchmaker's hand. The metonymic chain of authentication in each case led back to the genuine touch of an acceptable source. That touch seems crucial to writers of the accompanying printed material for the 1894 Stockholm display of an earlier Andrée voyage: "The daring balloonist stands in his gondola, which is not a reproduction [*af-bildning*] but is exactly the same in which the chief engineer S. Andrée made his hazardous air journey over the Gulf of Bothnia in the late autumn of 1893."[67] Here, too, the clothing was said to be authentic from the trip, as were the ropes and instruments. Most important, next to the display one could see a navigational map with Andrée's handwritten notes—an indisputable trace of his actual hand. In short, when the wax effigy was put in the proximity of "genuine," "exact," and "authentic" relics (as they were described), it achieved a greater equivalence with its human referent through a subtle substitution of bodies.

The idea of identifying characteristic objects was foregrounded as an inherent element of the depicted fictional scene in the Scandinavian Panoptikon's morgue tableau. At a morgue, of course, objects are key to the identification of the anonymous corpse, so the choice of this display subject makes the more general reciprocity between objects and wax effigies more conspicuous. Olsen writes in his catalogue description of the morgue display: "In 'La Morgue' they always take the most minute and precise care that the objects found on or near the dead person are preserved, since it has happened from time to time that bagatelles have led to a positive identification."[68] Olsen's tableau re-created that practice, with props hung on the wall next to the (waxen) corpses. For one of Olsen's corpse effigies, which depicted a woman said to have committed suicide by shooting herself after a fancy-dress ball, that meant hanging up "the revolver, with which she killed herself, her elegant cape, her gloves and fan"—interestingly, objects that would all have been literally in hand had the effigy been an actual corpse. In the Paris Morgue, the objects would of course have been real traces and clues; Olsen's display items were instead simulations of clues, leading nowhere. As such, they referred not to a real identity but instead to the process of signification itself, the process of connecting object to body.

Events at the closing auction of the Swedish Panoptikon in 1924 suggest a fetishistic component to this extraordinary investment in the real body's adjacent objects. It was the moment when the intricate verification system of relics became most visible, when the sum effect was reduced to

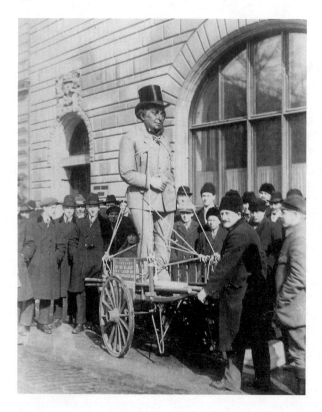

FIGURE 3.6. Effigy of Schinké, the American giant, being sold off at the closing auction of the Swedish Panoptikon in 1924. Photo courtesy of the Stockholm City Museum.

its parts as the wax effigies, their clothing, and various accessories were put up for sale. Some of the effigies ended up in store windows, others as scarecrows, others in the hands of eccentrics who reportedly later placed them in their living rooms to surprise guests,. The wax figure of Schinké, the "American giant," attracted some attention at the auction (at least that of a photographer), probably due to his unusual size (fig. 3.6).

But of far more interest than the wax effigies themselves to potential buyers were the objects. A newspaper article written fifteen years after the auction describes the surprisingly weak interest in the mannequins at the auction and claims, "Weapons, furniture and props were more sought after."[69] Although the figures and accessories were often sold as a package, the actual bids turn out to have had more to do with the clothing than with the relative popularity of the person depicted. Clothing that was modern in style and in new condition generally drove up the price of the corresponding effigy. The well-dressed male members of the royal family, for example, went for a significantly higher price than the female royalty, suggests historian Hans Lepp, because of the latter's "unmodern clothing" (because women's fashion changed more quickly).[70] This suggests

that the clothing at the auction recovered its use value after what turned out to have been a brief hiatus on display, entering back into economic circulation.

This commonsense explanation for the outcome of the auction still leaves room, however, for the observation that the clothing was more clearly indexical than the effigy itself. In fact, it is interesting to see how the bidding sorted out the panoptikon's authentic goods from the merely representational; "likeness" did not sell as well as the "real." Effigies in original costumes attracted higher bids than those in copies, and accessory objects reported to have touched the original hand or body of a celebrity gave the respective effigy a value out of all proportion with what one would expect. Kaiser Wilhelm II's wax figure, which was dressed in an original helmet, drew a bid of 27.50 Kronor, and his sword sold for 31 by itself, while Bismarck's effigy with all its accessories, which were not identified as authentic, sold for a paltry 3.75.[71]

What we see staged in dramatic fashion at the auction is the collapse of the discursive supports for the body on display. Once the elaborate persuasive context of the panoptikon fell away (its promotional descriptions, its program guides, its complex juxtaposition of recording technologies, death masks, wax figures, and their accessories), the wax body at the core of the display was worth little in comparison with its things. Unlike the wax figure, the display objects that had both use value *and* relic value outside the museum context could circulate in other systems of exchange. The auction at the Swedish Panoptikon makes plain just how much the wax body depended on these accompanying objects, and how little its corporeal effects were due to qualities inherent in the figure itself.[72]

The one exception to this pattern was the Swedish case just mentioned, where the original body of the polar explorer Andrée held an unusual fascination for the spectators—undoubtedly because its owner remained a literal missing person for so many years, never having returned from his ill-fated balloon voyage of 1897.[73] At the time of the auction, his remains had still not been recovered from the Arctic ice, although notes and pieces of his equipment had been found adrift at sea (having themselves become macabre, displaced traces). The bodies of the crew would not be found until 1931, seven years after the Swedish Panoptikon's closing auction. Viewer fascination with the panoptikon display's visual traces of Andrée's absent body simply made more explicit the underlying logic of panoptikon display techniques in general. The same kinds of pieces, traces, and vestiges allowed all of the wax figures to evoke their source bodies, even when the persons were less poignantly missing. Granted, Andrée's effigy also had special value for its ultimate purchaser at the auction, a Stockholm rope shop (where the famous balloonist's effigy could be displayed surrounded by the store's ropes and pulleys), but an additional attraction was likely

the way the Andrée effigy, relics, and clothing could conjure up his return from oblivion, from what the catalogue calls "the great deathly silence" surrounding his disappearance, and make good a collectively felt loss.[74] The combination of factors garnered the top bid of the auction, with Andrée's effigy selling for one hundred kronor.

During the panoptikon's years of operation, this kind of thinking turned its proprietors into eager collectors of relics. The obsession with accessory objects might seem a strange activity for a museum supposedly preoccupied with the body, but in the context of the discourse of recording, it makes perfect sense. Any trace of the originary touch of the body, even if relayed through objects, could help shore up the ways in which the wax effigy fell short of "recorded" status and smooth the substitution of the wax body for the real. With the actual physical objects, the effigy could even surpass the reality effect of the photograph. Convinced by the authentic objects piled up hyperbolically around the body, the panoptikon visitor could be distracted from the representational aspect of the effigy itself, especially the weakened indexicality of the late nineteenth-century mannequin and its sometimes inadequate iconic powers.

At Tussaud's, the logic of relic collecting reached manic proportions in the highly successful Napoleon room, which Altick characterizes as a "Napoleon shrine" because of its "collection of 150 personal relics, including Napoleon's camp bed, repeating watch, toothbrush, and table knife, an extracted tooth and the instrument his dentist used to extract it, and the clothing he wore in exile."[75] Notably, for the present discussion, a preponderance of the relics listed here and in the Tussaud catalogue of 1873 are objects that could have been taken right from Napoleon's hand or that enjoyed an unusual proximity with his body. At Castan's Panoptikum in Berlin, interest in the objects themselves (like Goethe's favorite cup) threatened to overshadow the coherence of the display.[76] The extension of the collecting activity to all objects that had been in the proximity of interesting bodies of course made the project endless, which in part accounts for museums like Castan's overflowing their space and establishing affiliates in other cities.

The accessory object's relic function makes more obvious the essentially discursive nature of the wax effigy's recording effect. Relics, that is, are usually not defined by strikingly unique visual characteristics, but on the contrary can be quite ordinary in appearance. The only way to verify a relic object's unique status is through an accompanying discursive stream of testimonials, certifications, and written assertions. In the wax display of Andrée's balloon, for instance, a gondola was simply a gondola until the catalogue assured visitors that it was the *exact* one used by Andrée, a characteristic that would of course be visually unverifiable for the average spectator. Likewise, the handwriting on the map next to the gondola

would remain unremarkable if it were not identified in the catalogue as coming from Andrée's hand. It is only at the moment of identification that it becomes a potentially awe-inspiring trace of his body. The authenticity of the relic stands or falls on the strength of discursive assertion alone.

Note the pains taken by this Scandinavian Panoptikon catalogue description to enhance the value of the scenic props in this 1903 tableau depicting a shipwreck rescue off the west coast of Jutland at Harboøre: "The entire interior is correct. In the very costumes used here, the people concerned have taken on a hard job during countless shipwrecks and all of the pieces of clothing have been procured from the Harboøre fishermen by the Panoptikon. Yes—even the sand that forms the dunes has been dug up from the beach at Harboøre!"[77] Without this supplementary prose, nothing would seem more ordinary than this sand. It would scarcely attract the notice of spectators. The added information from the written program, however, turns an apparently unremarkable element of the tableau scenery into an authentic physical connection to the real bodies of the fishermen and the place of the scene—this particular sand, we are meant to marvel, may have been touched by the feet of the *actual fishermen*!

The dependence of display objects on textual authentication opened up the wax museums to the same potential problems as churches competing for religious relics. Many of the wax museums in the late nineteenth century, if not competing directly with each other for the same visitors (except in the crossover visits made possible by a newly expanding tourism industry), could potentially come into conflict when they sought to display the same internationally important events or personalities. For any one event, there were of course only so many authentic objects that might be procured. When foreign scenes like the Dreyfus trial or the assassination of French president Carnot showed up in the tableaux at the Stockholm wax museum, the Swedes were put in competition for relics with wax museums closer to the event's original location. British serial killer Frederick Deeming, for example, who hid the corpses of his victims under his kitchen floor, inspired John Theodore Tussaud to move the actual kitchen and floor piece by piece to his wax museum in order to surround his Deeming effigy with authentic effects.[78] At the same time, however, the Swedish Panoptikon had its own Deeming display (fig. 3.7), reimagined in a cellar setting, presumably because of the unavailability of the authentic traces of the actual kitchen. One can easily imagine wax museums all over Europe competing for the same authentic clothing, murder weapons, silverware, shaving cups, and blood-stained shirts from the same events. (Even within Sweden, one can find competing displays of Captain Rolla at the Swedish

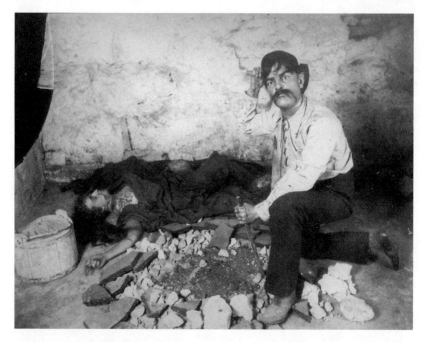

FIGURE 3.7. The Swedish Panoptikon's effigy of serial killer Frederick Deeming, shown in his cellar, not his kitchen—that was on display in London. Photo courtesy of the Stockholm City Museum.

Panoptikon in Stockholm and in a traveling show in Wimmerby in 1894. Both claimed to have the original, unlucky parachute on display.)[79]

There is an obvious limit to the possible number of wax bodies depicting the same event when outfitted with authentic clothing and objects—an event as a whole was, in other words, not infinitely reproducible in the fully staged wax tableau display as long as authenticity had priority over simulation. The stubborn physicality of the relic-like accessories, which the wax figure needed in order to shore up the indexical relationship to the body, was paradoxically thus something of an obstacle to the effigy's aspirations to the status of recording. The wax effigy might be mechanically reproduced in the Benjaminian sense through multiple castings (as was done after the fire at the Tussaud museum in 1925 destroyed many of the most famous effigies, but not the original molds).[80] The relics, however, could not, since their most central claim was their original and unique existence in time and space (and, in fact, the array of famous Napoleon relics was lost irretrievably in the same fire). Photographs of relics, on the other hand, might circulate freely, just as copies of the same film

might play simultaneously in Stockholm and Paris, or just as the photo of the Valentino display got unhooked from its moorings. But if wax displays depicting the same event at the Swedish Panoptikon and the Musée Grévin both claimed to have the same shirt, then one of them was guilty of a hoax.

Despite some similarities with premodern practices of religious relic collection, the wax museum's acquisition of authentic objects seems to have been more panicked. The piling up of trace objects around the effigy was an obsessive project of mise-en-scène with no logical end in sight. Perhaps, as Tom Gunning has suggested, modernity's fascination with the representational real derives from a "loss of shared reality" in modern experience around the turn of the century.[81] In that context, the wax museum's relic collecting emerges as more compensatory than sacred. By mimicking the relic objects of premodernity, the effigy accessories remind one of earlier notions of unique objects in circulation even as they bear witness to the loss of the real.

The use of relic accessories also underscores the limits of the wax figure's aspirations to the status of a recording technology. The more frenetic the claim that surrounding objects had touched the real body, or the more adamant the assertion that the hair was real, the more one recognizes a certain disquiet about the representational distance of the wax effigy from the real body. The wax effigy could clearly not stand alone, stripped of clothing and objects, and make the same claims of privileged proximity to its source. If it approximated the effects of recording, it did so through an awkward combination of the representational (the wax figure) and the real (the accessories). The photographic trace, by comparison, offered a more elegant, imperceptible combination of presence and absence, of the real and the image, which film would exploit to much greater advantage.

The faux recording status of wax display is best expressed in a final, suggestive example. Returning to the display of Andrée at the Malmö exhibition of 1896, mentioned previously, we find upon close examination of the program text that the carefully authenticated event on display "recorded" a moment that never actually happened. The panoptikon that was set up for the summer in Malmö depicts the balloon launching as if it had already taken place. This was a bit of faulty prophecy, it turned out—the 1896 expedition was actually aborted and postponed until the next summer, a year after the Malmö exhibition. One of the figures depicted there, N. G. Ekholm, did not even make the eventual journey, withdrawing at the last minute because of doubts about the safety of the trip (well-founded, it turns out, since none of the other explorers survived). With strategically placed quotation marks, the catalogue prose betrays its hesitation about displaying an event that has not yet occurred:

We imagine the "historic" moment when the weak little gas bubble casts anchor, to float between heaven and unsurveyable ice fields on paths never before trodden. A perceptible, but soon diminishing cry of hurrah from the thick, teeming crowd present for the launch, a last greeting from the civilized world—and the great deathly silence, the great loneliness that swallows the three of them.[82]

The planned launch was a natural choice for panoptikon depiction, and the publicity surrounding the event probably made it irresistible for the proprietors at the 1896 exhibition to jump the gun. But only the last part of this recording/prophecy turns out to be accurate, and then only ironically—the great silence did in fact turn out to be "deathly" for the crew.

This attempt to record an event in advance is perhaps the best indication of the rhetorical nature of the wax effigy's claims of proximity. Even if promoted as a privileged form of corporeal representation with a special (even macabre) relationship to the source body, the wax mannequin falls inevitably short of recorded status under closer scrutiny. Yet there is a virtue in this failure: in the wax museum's clumsy orchestration of models, in its detective work of procuring likenesses in person, in the hyperbole of its material guarantees of proximity, it is much easier to see the real stakes of turn-of-the-century mobility. The photograph of the mannequin, in other words, elides too much by covering over the physical aspects of collection and circulation. The wax museum is in this way the "back room" of recording technology—the place where one can find fully visible the physical preconditions that make the illusion possible.

FIGURE AND TABLEAU

> One can of course see from the ethereal beauty
> that rests over the female faces that it is a collec-
> tion of wax figures one is facing; but there is
> something so deceptive [*skuffende*] in the arrange-
> ment of the figures, their clothing, their poses
> and their smiles, as well as in the entire decor of
> the room, that one really believes oneself to have
> been transported to a women's coffee party in the
> capital city of Holberg's time.
> —ZAKARIAS NIELSEN, *writing about the Scandi-
> navian Panoptikon* (1886)

THE PRECEDING DISCUSSION has empha-
sized that many of the mannequin's presence effects depended on acces-
sory objects, which in turn depended for their authentic effect on accom-
panying narrative material. Real corporeal traces like donated hair
contributed to an unusually hyperbolic revivification project that helped
deflect awareness away from the essential lifelessness of the mannequin
itself. But the collection and straightforward display of relic-like objects
gathered around a mannequin were only initial steps in a more general
implementation of a tableau technique. Although the real hair, the blood-
stained shirt, or the actual balloon gondola could help buttress the reality
effect by the simple fact of their display next to a mannequin, they could
do more by being integrated as theatrical props into a fully staged wax
tableau. Displays like the Napoleon Room at the Tussaud museum stopped
short of this, simply surrounding the wax figure with a miscellaneous array
of interesting relics claimed to have been in the emperor's hand at one
time. The fully implemented tableau technique, by contrast, would take
those same relics and seemingly return them to use; the blood-stained
shirt of Henry IV would be taken from the separate case where it was
displayed at Tussaud's and put back on an effigy depicted at the very mo-
ment of assassination.

The Scandinavian wax museums were unusually devoted to the idea of self-consistent fictional scenes. The preface to a catalogue in Stockholm claims the tableau to be the pinnacle of wax-effigy display:

> In the wax cabinet, the kind we still remember from the middle of this century, the figures were usually placed in long rows along the walls, crowned head and criminals next to each other in not exactly the most beautiful harmony. But the evolutionary drive was in ferment here as elsewhere and gave vent to more or less artistic attempts to take the figures out of their isolated positions and compose them in living groups with reciprocal dramatic rapport between the individual figures.[1]

The principle of miscellaneous juxtaposition that is rejected here, however, was not as much eliminated as it was deferred to a higher level. Within each scene, the panoptikon obsessed about the consistency of the depicted fictional world and the effigy's convincing placement within it, but the number of different fictional worlds presented side by side could not help but create a more general effect of miscellany and juxtaposition. The combination of immersion on the individual scenic level and the sense of ever-shifting location in different parts of the museum is one of the interesting paradoxes of late-century wax-museum display that made it a form of virtual mobility.

What also emerged from this thoroughgoing contextualization of bodies-in-effigy was a fundamental shift in the relationship between figures and objects. If a driving principle of the wax cabinet was the miscellany of the potentially endless series of "touched" objects, the tableau technique introduced a principle of selection—editing, if you will. Relic objects that may have been acquired, but that were not appropriate for the logic of the particular scene in which the wax figure now appeared, were now relegated to storage. In fact, the transition from a single, sprawling curiosity collection to individually coherent, theatrically staged tableaux is what created the storage room as a conceptually separate and necessary space in the first place; before this development, storage and display were essentially synonymous. One sacrificed the scope of the objects one could potentially display for the principle of consistency within each scenic world itself. When the significant object appeared in a tableau, it turned from relic into prop; when the mannequin entered the same scene, it turned from display object into dramatic subject, a character in interaction with other characters. The claim was that the wax figure could look and not simply stare. It was now imagined to be exchanging glances with other mannequins.

The Scandinavian panoptika provide a particularly useful context for understanding this waxen mise-en-scène. The monumental contextualization efforts there help illuminate both a particular phase in the history

of wax-figure display and more general spectating trends in turn-of-the-century modern life. Especially when seen in the light of that other influential continuity system, the developing narrative technique of early film, the increasingly contextualized wax mannequin display demonstrates the existence of a somewhat wider, intermedia investment in the idea of diegesis; that is, in the construction of convincingly consistent fictional space. When one realizes that the project of creating continuity systems of representation out of bits, pieces, and fragments was common to several adjacent institutions of the visible, one comes to suspect that the idea of contextualization might carry a special cultural charge at this time and place. In part compensatory for a perceived unmooring of bodies and objects in the daily life of modernity, in part exploitative of that same unmooring for effects of visual mobility, continuity systems like that of the wax museum played a crucial role in defining the possibilities of both virtual travel and contextualization at the turn of the last century.

Showing Stories

The terms "spectacle" and "narrative" seem especially relevant here, since the contrast between them has been a fruitful point of departure for discussions of early film's transition to narrative cinema in the early 1900s. The most influential model in that field of research, Tom Gunning's "cinema of attractions," observes that early cinema's "exhibitionist" and relatively direct relations with the film audience gave way in film's first decade to the more obliquely positioned and absorbed spectatorship of narrative cinema.[2] Early cinema in general had announced its specularity with an open invitation to spectators to look their fill. When cinema went in for storytelling more seriously after its initial decade by developing character-based plots, more sophisticated cause-and-effect trajectories, and a more continuous linear temporality, it also lost some of its more overt exhibitionism. Films turned laterally in on themselves by establishing absorbed acting codes. Directors began to discourage direct address to the camera and started conducting business as if nobody were watching. As a result, spectators were offered an oblique vantage point that encouraged the now-common voyeuristic fantasy of watching a scene unobserved. Paradoxically, the rigorously observed formal distance between film and spectator made possible a greater degree of identification with both story and character on-screen.

Although the cinema-of-attractions model does not scan neatly onto the developmental trajectory of the wax museum, it is suggestive to see the dominant interests of traveling wax displays—the downstairs tradition associated with the body in pieces—as a tradition with strong "attraction"

affinities, a display form that actively solicited the spectator's curious look or fascinated gape. In early cinema's trick and transformation films, this effect was similarly often accomplished by testing corporeal integrity in a seemingly unending parade of magnification, decapitation, petrifaction, dismembering explosion, morphing, disappearance, and caricature. Most of these scenes were played for comic effect, in part to test and showcase the qualities of the new filmic medium and explore the continuity or discontinuity of the cinematic body image. As a static medium, the wax display could not of course replicate all these effects, but the body's dissections, decapitations, torture, wounding, and diseased dissolution in the disreputable traveling shows contributed to the same general project of making an attraction of the body in pieces.

Even when the wax body was not pressured in these ways, the customary frontal pose of individual wax figures created an impression of direct address. A typical example of a presentational display comes from a traveling show in Copenhagen in 1867, in which an automaton figure solicited viewer attention like a stage magician.[3] Another can be found in a show that visited Copenhagen a decade later, which gave one figure the title "A Jolly Farmer from Stuttgart Offers the Spectator a Fresh Pinch of Snuff."[4] The display of mannequins on pedestals, arranged singly in frontal pose, was actually the default position for much of the nineteenth century, including the early years of the Tussaud museum in London. It persists today as well, as a visit to almost any modern wax museum will confirm.

The self-sufficient world of the carefully staged wax-figure tableau, with the absorbed and reciprocal posing of wax figures within an extended theatrical scene, is by contrast the exceptional modality in the tradition. Although it reached the height of popularity in the late nineteenth century, it was not invented then—even London's Mrs. Salmon is reported to have displayed some wax tableaux in the early eighteenth century.[5] But the tableau's requirement of stable and predictable display space and the considerably higher costs of a thoroughgoing theatrical staging made it more suited to the larger budgets and permanent, elegant locales of late nineteenth-century wax museums like the Musée Grévin and the Scandinavian panoptika. The history of the wax tableau should not be seen, however, as a simple trajectory from single-figure display to ever-more-complex scenes at the turn of the twentieth century. It would be more accurate to say that tableau scenes have come and gone throughout the history of wax display, depending on the financial resources of each proprietor. The prestigious late nineteenth-century wax museums made a specialty of wax tableaux in part because they could afford them. At no other period (before or after) was the tableau principle so consistently observed in preparing wax displays as in the 1880s and 1890s.

Even museums with an officially proclaimed affinity for tableau display, like the Scandinavian panoptika at their openings, did not banish attraction-based viewing any more than did the cinema after its first decade, but rather incorporated it into the context of a complex scene and attached it to a story through accompanying narrative guides. One is reminded of the "ape in the human" idea mentioned earlier, as well as Gunning's emphasis on the vestigial "attraction" modalities that occasionally resurface, more codified and contained, in later forms of narrative cinema.[6] In practice this meant that a wax figure that before might have served as an anonymous model (or even body fragment) in an anatomy show might now conceivably appear in an autopsy scene surrounded by surgeons, observers, and a diorama of the entire clinic, with a supplementary prose narrative in the catalogue extrapolating information about the life story of the patient before and after the depicted scene takes place. Likewise, a torture instrument applied to a specific body fragment in the anatomy shows might now be shown as part of an elaborated historical scene from the Inquisition, as was the case at the Swedish Panoptikon (fig. 4.1). In many of the more carefully staged wax tableaux, in fact, one can isolate an element of spectacle that might conceivably have been featured as a solo display in less thoroughly contextualized display practices.

The evident parallels between the narrativization of cinema and the development of wax tableaux suggest that the assimilation of spectacle may simply be a necessary component of a more general process of middle-class institution formation, at least in the given historical conditions of the later nineteenth century. In both cases, the consolidation and apparent subjugation of the body on display to the laws of consistent time and space made possible a fuller psychological notion of character, the detailed construction of a convincing diegetic effect, and the erection of the invisible fourth wall between display and audience that enabled a more complex mode of invisible spectating. Once figures (both waxen and filmic) stopped confronting the audience, they could provide evocative vacancies in the image that eased the process of imaginary identification, inscription, and access into a scene for spectators.

Even so, the wax medium lacked one essential characteristic of film's narrative effect, namely, motion. The wax tableau, like the *tableau vivant* and the emotional high points depicted on the nineteenth-century melodramatic stage, specialized in "frozen moments."[7] This is not to say that the wax museum lacked motion entirely; the automaton tradition of the traveling wax cabinets had incorporated mechanical movement into wax displays, a tradition that continued as surprise comic-relief counterpoint to the more serious wax tableaux even in some of the more respectable wax museums after the turn of the century. Hans Lepp describes one of these in this way: "A little scene that opened in 1902 at the Panoptikon

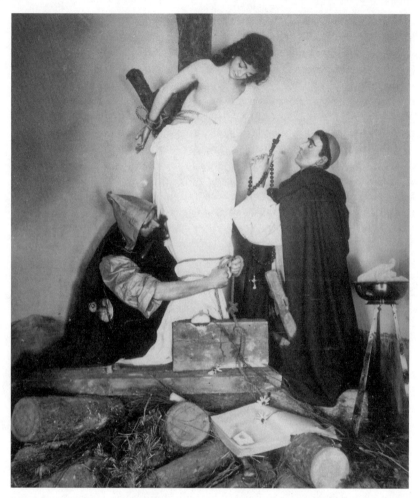

FIGURE 4.1. "A Victim of the Inquisition" at the Swedish Panoptikon, mid-1890s. Photo courtesy of the Stockholm City Museum.

belonged to a category not present before. The intention was to make the visitor surprised, maybe embarrassed. If one opened a door, one got to see a 'mechanical' Dalecarlian woman get up from a chamber-pot, and the action repeated itself each time someone opened the door."[8]

The nonmechanized tableaux could, moreover, *imply* movement by displaying moments of chaotic dramatic action, in which a built-in compositional tension might anticipate a resolution and carry the scene into an imaginary future. One such display in Stockholm had the Swedish king Gustav Wasa rallying his drunken soldiers from a pub in 1521 by smashing

wine barrels. The catalogue picture of the tableau shows the wine in the process of splashing onto the floor.[9] Vanessa Schwartz has, moreover, shown how some tableau displays at the Musée Grévin may have depended on the spectator's own movement past the display to create a sense of motion.[10]

Such attempts to overcome the inherent inertia of the wax figure and the necessarily frozen moment of the display were ingenious, but they serve mostly as test cases that underscore the inherent temporal limits of the medium. Closer to a narrative effect per se were the tableau series inspired by the Musée Grévin's "L'histoire d'un crime," with their consecutively linked scenes. The Scandinavian Panoptikon in Copenhagen became especially devoted to the series idea, perhaps not surprisingly given that institution's stated aversion to the spectacle tradition of wax display associated with the chamber of horrors. Between 1893 and 1910, the Copenhagen museum mounted nine different elaborate series, with the largest of them, "The Life of Napoleon" (1895), made up of ten scenes from this most famous of lives.[11] Other displays there took their cue from the painter Hogarth ("Marriage à la Mode," 1897), historical incidents ("Pizzaro's Treasure," 1901), or the ever-popular morality-tale series in the spirit of "L'histoire d'un crime" ("The Evil Paths," 1893; its sequel, "The Evil Paths, the Story of a Copenhagen Magdalene," 1906; and "From Fall to Salvation," 1903).[12] The degree of investment in sequentially linked tableaux at the Copenhagen museum can be assessed from the fact that in 1903, four large series were running simultaneously and together accounted for over half the total number of individual scenes at the panoptikon.[13]

One example at the Copenhagen wax museum, the tableau series "From Fall to Salvation" (figs. 4.2–4.8), reveals clearly how the integrated tableau sequence might be enlisted for the specific class interests of the middle class. When I first encountered the photos that made up this series in the archive, they were in no particular order, and I had not yet found an accompanying catalogue narrative. I assumed that the images were to be arranged into the usual cautionary sequence of the Grévin series and its imitators elsewhere, ending inexorably with the prison and execution scenes. But the jail scene here, which I took initially to be the final tableau, actually turned out to be tableau 3, as I discovered when I finally found a contemporary catalogue description of the series. Unlike most of the other series, that is, this is a success story. Relying on a kind of *Bildungstableau* logic, if we may call it that, this series begins in a squalid lower-class home and witnesses a poor youth's turn to crime and his subsequent arrest. At this point, however, the trajectory turns back upward. The program text relates: "A worthy man, a well-established old master carpenter who has just become acquainted with his case, speaks good words to the young

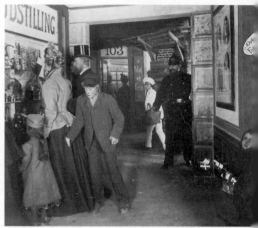
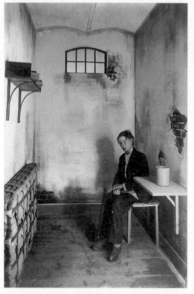
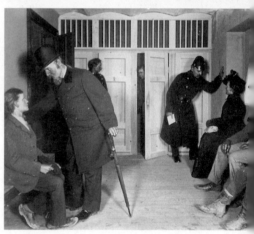

FIGURE 4.2. (*top left*) "The Childhood Home," the first tableau of the series "From Fa—
Salvation" at the Scandinavian Panoptikon, ca. 1903. Photo Peter Elfelt, courtesy of the
tional Museum of Denmark (Brede).

FIGURE 4.3. (*top right*) "The Theft," the second tableau of "From Fall to Salvation." Pl
Peter Elfelt, courtesy of the National Museum of Denmark (Brede).

FIGURE 4.4. (*bottom left*) "In Custody," the third tableau of the series. Photo Peter E
courtesy of the National Museum of Denmark (Brede).

FIGURE 4.5. (*bottom right*) "On the Criminals' Bench," the fourth tableau of the series. P
Peter Elfelt, courtesy of the National Museum of Denmark (Brede).

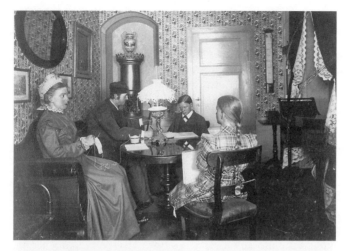

FIGURE 4.6. "A Happy Home," the fifth in the series. Photo Peter Elfelt, courtesy of the National Museum of Denmark (Brede).

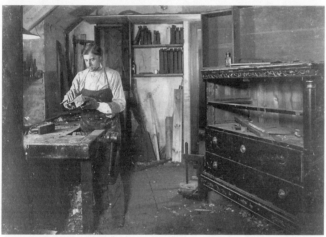

FIGURE 4.7. "At the Workplace," the sixth in the series. Photo Peter Elfelt, courtesy of the National Museum of Denmark (Brede).

FIGURE 4.8. "The Journeyman Celebration," the final scene in the series. Photo Peter Elfelt, courtesy of the National Museum of Denmark (Brede).

heart. And the boy's mind is softened and tears come to his eyes. The master offers to take him into his own house, to teach him the trade and take care of him."[14] Remarkable in this account is not only the interior emotion attributed to the mannequin by the prose narrative (complete with tears claimed to be *in the process* of welling up in the mannequin's eyes) but also the way in which the story is redirected to the happy ending of integration into the bourgeois home and workplace. The narrative trajectory of this display series can in fact serve as a tidy analogy for the wax museum's development in Scandinavia: like the wayward juvenile, the disreputable wax cabinet is rescued (by the respectable Bernhard Olsen?) from its lower-class origins and "criminal" subject matter and assimilated into the middle class. The possible end points for a tableau series thus include both downstairs and upstairs outcomes.

Olsen made explicit the moralizing stakes of his narratives in another of his comparisons to foreign trends:

> At the Musée Grévin in Paris, they have displayed something they call "The Story of a Crime," but without realizing that they should have called attention to another side of the issue, namely, the reasons that contributed to the commission of the crime; they thereby have created a picture of Nemesis knocking every step away from the paths of reason and morality. Only in the account of the causes [of the crime] can one defend the bloody scenes that are placed before the spectator's eyes.[15]

Crime and punishment alone do not justify inclusion of the spectacle kernel in these displays—the "bloody scenes" have to be more elaborately justified by identifying cause and effect, thereby adding one of the central preconditions for traditional narrativity. If the panoptikon was to retain its new reputation as something "finer" than a wax cabinet, it had to guide the spectators to proper conclusions about shocking sights, which ostensibly would be presented only as necessary parts of a moral lesson. The argument works the other way as well, though, and in this sense to the panoptikon's marketing advantage—that nearly any scene can be excused as long as it is accompanied by a moralizing narrative frame. The Swedish Panoptikon's "Crime and Punishment" series, for example, improves on the showpiece scene from the Grévin series, the murderer's eventual forced confrontation with the corpse, by changing the gender to female and exposing her naked breast not only to the criminal but of course to the spectators as well (fig. 4.9). Now, however, the corpse appears in the cause of justice—in the catalogue's supplementary story, it is the sight of the dead body that produces a confession of guilt from the criminal.

The tension between the attraction of a single moment (such as the provocative display of the nude corpse) and the implied moralizing trajectory (the punishment of crime) is basic to the wax museum, and the writ-

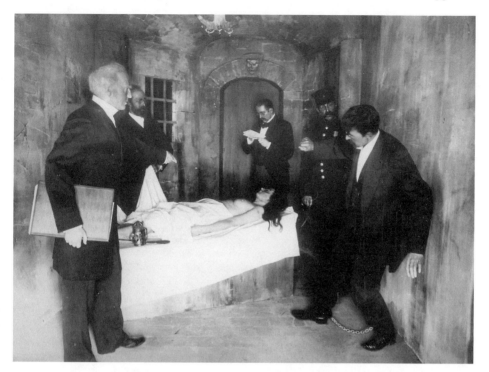

FIGURE 4.9. The third of five tableau scenes that constituted the series "Crime and Punishment" at the Swedish Panoptikon, 1897. Photo courtesy of the Stockholm City Museum.

ten guide often mediates between the two. The visual narration implied in the sequencing of tableaux provides only a partial sense of story; the ubiquitous written guide might not only fill in gaps but also redirect visual impressions in more acceptable directions. The realization that the pictures from the "Fall to Salvation" series, if reshuffled, could easily create the opposite narrative trajectory highlights the arbitrariness of the moralizing narrative effect, or rather, the degree to which the ultimate meaning remained external to the displays themselves. To be sure, the physical layout of the series at the museum itself created a fixed order of interpretation in a way that a pile of unmoored archival photographs does not. Even when arranged properly, however, the sequential images need the prose narrative of the catalogues to close the deal.

Although the catalogue's gap-filling narrative role is perhaps most conspicuous in the role it plays in these series, the same could be said of its relationship to all of the tableaux. As the wax museums increased in institutional prestige, the catalogues grew more elaborate in design, but more

crucially also shifted the voice in which they were written. Tussaud's cata-
logue throughout the nineteenth century, for instance, remained mostly
a source of third-person historical and biographical background informa-
tion about the figures on display. At the two tableau-dominated wax muse-
ums in Scandinavia, by contrast, the catalogue prose reflected the increas-
ing theatricality of the waxen scenes by adopting a more deictic language,
situating the viewer/reader "here" as opposed to "there," and "now" as
opposed to "then." The prose was engaged with the depicted scene itself
at the moment of its presentation to the viewer, as is evident in this text
accompanying a Fritjof Nansen exhibit:

> The daring polar traveler has for a moment sat down to rest during the
> reconnaissance outing he has undertaken from the steamer *Fram* in order
> to choose the course for the rest of the trip. He sits on a piece of ice, with
> his skis next to him; in one hand he holds a ski pole, in the other his field
> glasses. In the distance behind him can be glimpsed the steamship, the only
> sign of life in this environment of nothing but snow and ice.[16]

The prose here creates a fuller sense of the depicted moment by informing
the viewer of past and future action, by identifying parts of the scene in
decreasing proximity to the figure, and by establishing an atmosphere of
tension that may not be apparent from visual cues alone. Taking this logic
to extremes, one display from 1890 even goes so far as to claim that the
mannequins on display are speaking another language as we watch them.[17]

The increasing immediacy of the supplementary prose was supported
by a switch in its name as well—at the Swedish Panoptikon, the former
"catalogue" became a "guide" in the mid-1890s (the *katalog* became a
vägvisare). That latter term captures the way a conversational language of
place had become an important characteristic of the accompanying prose.
The narrative voice of these guides quite literally led visitors through the
display, told them where and when to look, and what they should be sure
to notice, most often referring to the scenes as real places and events,
instead of the mannequin tableaux that were in fact in front of the viewers.
It provided a running commentary, evident even down to the syntactical
level—the printed guide in Stockholm tied the tableaux together by break-
ing off commentary in midsentence at the end of one scene and picking
up where it left off at the next. The resulting impression of oral presenta-
tion may be due in part to the fact that there was a minor tradition of live
narration in some nineteenth-century wax museums, as was also common
in early cinema exhibition.[18] The written material could, in other words,
be seen as a trace version of an implied live narrator who could link dispa-
rate scenes together.

The suggestive imaginative power of the accompanying narrative was
especially apparent in the nondocumentary scenes that increasingly made

their way into the wax museums of the late nineteenth century. As should be apparent from the discussion in the preceding chapter, the turn to fictional subject matter at the wax museum was fraught with questions about the nature of the medium itself; an effigy without a real referent called into question the indexical tie to a source that had been so much the logic of the wax museum in the early part of the century. In what sense could an effigy of a *fictional* subject be considered authentic, for example? How could its powers of "likeness" possibly be evaluated? The Tussauds remained quite strict on this point; for many years they even refused to depict Jack the Ripper in the Chamber of Horrors, despite the obvious public interest in his figure, simply because he was never caught, and a likeness could therefore not be verified.[19] For the Tussauds the turn to fiction meant giving up their wax museum's best claim to fame, namely, the effigy's combination of proximity and likeness to its original source in the historical context of the French Revolution. This attitude also explains why Tussaud's museum resisted the "History of a Crime" series idea until after other museums had adopted it so successfully—the story of a typical criminal's downward spiral was based not on the existence of a real-person referent but on a social type.[20]

Interestingly, the increasing adoption of tableau display techniques at turn-of-the-century wax museums and the resulting appeal to the imaginative involvement of a spectator in a scene made fictional subjects more acceptable. Although a good number of the tableaux took their material from historical incidents and their compositional structure from history paintings, the fictional incident was seen as increasingly appropriate as long as it was vivid and realistic in effect, even if not in fact. At the Copenhagen museum, then, one could find a seven-part series in 1906 that took visitors on a tour through "Slaraffenland," the mythical land of culinary excess, returning them only at the end back to the "ground of reality" in the rest of the museum.[21] Other fictional subjects in the two panoptika included Aladdin, Cinderella, Snow White, the Little Match Girl, scenes from plays, and various "genre" scenes taken from well-known paintings. At first, the discourse registers nervousness about these nonindexical scenes by emphasizing the connection to a particular painting or in some other way tying the waxen scene to a representational precedent. Fictionality eventually came to be seen as less and less of a problem, though, especially in the later years before the closing when the Scandinavian panoptika were competing with feature films for an audience share.

The general picture that emerges from the wax museum at the turn-of-the-century shows attempts on several fronts to exceed the tableau's inherently limited narrative potential. The extranarrative prose, the linked scenes, and the other supplementary strategies that were necessary to create a fuller sense of story suggest that temporal narrative might not have

been the late nineteenth-century wax museum's real strength. If the tableau came up short in its ability to generate narrative effects and plot, though, it truly excelled in its ability to create the convincing impression of a self-existent fictional world.

The Living Tableau

There were technical preconditions to the tableau turn at the wax museum near the end of the century. Most practical among them was the need for a consistent display space. In the traveling shows, the unpredictability of display conditions from town to town did not make it worthwhile to invest great care or expense in settings for the mannequins. Once established in a permanent locale, however, the wax museum could afford to spend time and money on a more elaborate mise-en-scène. If the owner knew that the king's effigy would be in the same room both this week and next, then it was worth the effort to surround it with carefully orchestrated sets, lighting, and props. Recognizing this, the increasing dominance of tableaux over single-figure displays at the Scandinavian panoptika in the 1880s and 1890s seems a natural outgrowth of having a predictable space (although the lack of similar developments at Castan's in Berlin reminds us that this outcome should not be seen as inevitable). The more elaborate displays also required significantly more capital investment than did the wax cabinet's isolated figures. For the Scandinavian Panoptikon, the start-up sum reportedly amounted to 250,000 Danish kroner.[22] The Swedish Panoptikon likewise sold stock to raise between 100,000 and 150,000 Swedish kronor.[23] This put the panoptikon in a significantly different economic class than the traveling show. Operating expenses came not only from admission profits but also from the local sponsors who placed ads all through the exhibition catalogues (and who themselves were more likely to advertise if the wax museum were a permanent fixture in the cultural landscape of their city).

Technical advancements in the mannequins themselves were also required before one could create successful dramatic interaction and reciprocity between figures. The most important of these was the creation of a flexible, poseable torso. As one Swedish account states dryly, "But a person is, as is well known, made up of more than a head. He must for the sake of completeness have a body."[24] It is a testament to the illusory powers of wax-museum display techniques that one often assumes mannequins to be waxen through and through, at least as substantial as a modern department store mannequin. Descriptions of the modeling processes used at the Scandinavian panoptika, however, reveal that the wax figure was usually a composite object, with the hollow wax head and pair of hands joined to

a stuffed skeletal torso of wood or metal. When covered neck to toe by clothing in the concealing fashion of the late nineteenth century, the torso could give the impression of continuity with the waxen body parts.

Since the hidden torsos were part of the invisible supporting cast, so to speak, they could be made of sturdier but cheaper materials than wax castings. Bernhard Olsen had first tried to model the torsos with a process involving clay, plaster, and then *carton-pierre* (a type of papier-mâché used to imitate stonework), but was unsatisfied because, as he put it, "the resulting figure is quite uncooperative and does not let itself be modified in position and attitude, a matter that is of great importance in combined groups where there is dramatic rapport between the individual figures."[25] The more flexible the torso, the more convincing and nuanced the individual pose and its function in the overall scene, he argued. Olsen elected instead to use a skeletal combination of iron and wood, which could be given "the pose that is both characteristic of the person portrayed and that fits the situation."[26]

A description of the modeling process at the Stockholm museum includes the detail that the poseable torso skeletons were covered with linen stuffed with seaweed, reportedly since it combined an appearance of substance with flexibility (fig. 4.10).[27] The Swedes agreed that reciprocity in the tableau display could be better achieved if each mannequin's face was modeled specifically with its intended dramatic role in mind: "At no other panoptikon have they gone about it in this manner, but experience has clearly shown that the busts turn out better and more naturally when the artist can create them for a specific situation."[28] This notion that it would make a difference if a mannequin was prepared from the start for a particular dramatic context creates a kind of Stanislavskian school for mannequins, who like their live-actor counterparts in the realistic theater could become more convincing in their roles when they lived themselves into a particular situation.

It is quite easy to lose track of this seaweed body underneath all the imposed illusionistic layering. Some of the more risqué or bloody scenes, of course, would show more flesh (that is to say, wax) than the displays depicting "proper" figures. For example, the potentially prurient attractions of the Inquisition scene discussed earlier (see fig. 4.1) are clear, but it is not always easy to remember that the lack of clothing in such "fleshy" scenes made them more expensive, not less. It was not just a matter of stripping the mannequin, because there would be nothing to show underneath the normal mannequin's clothing but the machinery of the poseable torso. Instead, any degree of mannequin nudity involved creating extra wax flesh for the parts exposed, the skin in effect adding another representational layer mediating between the clothing and the truth of the metal torso beneath. Given the extra effort and expense of that process, one can

FIGURE 4.10. A behind-the-scenes look at torso construction at the Swedish Pa-
noptikon's studio. *Ny Illustrerad Tidning* (15 December 1888).

see why nude figures would involve both economic and institutional risks.
The wax museums had to strike the right balance by presenting a view
that was piquant enough to draw crowds, and thus recoup the extra invest-
ment, but not so risqué as to offend and put the growing middle-class
standing of the institution in jeopardy.

Even the implication that real flesh could be found beneath all the
clothing was not enough to guarantee the effect of realistic presence by
itself, however. The Scandinavian panoptika adopted ever-more-elaborate
strategies to distract from the fact that even "revivified" mannequins had
more in common with staring corpses than living persons. As crucial to
the effect of presence as the reciprocal posing of the figures was the implied

relationship of the tableau (and, further, of the figure) to the world beyond the display. A comparison with developments in the late-century realist theater is instructive, since it also frequently invoked the "slice-of-life" model for its mise-en-scène. Theater historian Freddie Rokem identifies this as an essentially metonymic dramaturgical principle, a stage practice that finds its fullest expression in the plays of Ibsen, Strindberg, and Chekhov.[29] Unlike the stage of most later twentieth-century theater (which Rokem calls metaphoric), the naturalist stage implied both physical contiguity and continuity between onstage and offstage space. The implication throughout is that the world is always larger than the frame, and that the presented "slice" is one of many possible views.

Bernhard Olsen's prior experience as a set designer for the theater seems to have made him especially sensitive to such spatial issues of mise-en-scène. The wax tableaux at his museum went to great lengths to give the same impression of an extended world. Doorways were created on the right and left of a scene, backgrounds added, and figures frequently posed directing their looks "offstage." The catalogues often called attention to threshold figures entering from what would be the wings of a stage set.[30] The activation of threshold space, underscored by catalogue language in the present progressive tense (at the Sleeping Beauty display, "the Prince is in the process of entering the room"), gives the impression that in many of the displays, visitors from the outside world are possible at any moment, a principle exploited consistently in the realistic theater as well.

A similar connection between the "here" of the display space and the "there" outside it could be suggested by the poses of the mannequins themselves. In 1890, for example, the Arctic explorer Erik Nordenskiöld was shown in conversation with the captain of the *Vega* during their then-recent expedition to the North Pole (fig. 4.11). A catalogue description supplies this missing action: "They are discussing here the question of to what degree the stretch of land which had been observed this day and in which direction Baron Nordenskiöld is expressly pointing will turn out to be the same which Captain Palander of the *Vega*, according to his own calculations, thinks he is able to distinguish on the sea map lying in front of him."[31] There are two obvious deictic indications of the existence of an off-scene world here, namely, Nordenskiöld's gesture toward the space outside the cabin, and the map that verifies the existence of the same. The effect is further underscored by the tableau positioned immediately adjacent to the Nordenskiöld exhibit in the panoptikon, in which the financier of their expedition is depicted "overseeing" the voyage from his safe vantage point back home.

Another of the tableau's common revivification strategies involved creating ontological hierarchies within the display, a structuralist game of relational oppositions that could help give the wax figure a comparatively

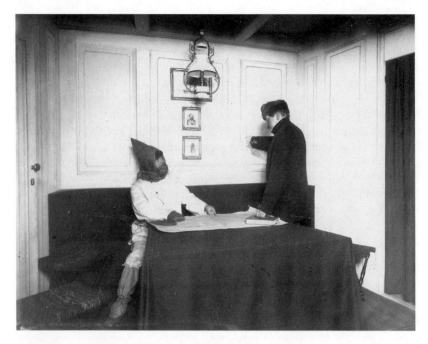

FIGURE 4.11. Effigies of Captain Palander and the explorer Nordenskiöld in the simulated cabin of the *Vega* at the Swedish Panoptikon, 1890. Photo courtesy of the Stockholm City Museum.

strong effect of presence, as if by default. This would explain the profusion of other kinds of sculpted human figures that accompanied the wax effigy in the tableau settings. In the various displays one could find effigies represented in salt, a petrified man, marble statues, optical illusions of Pygmalion and Galatea, mirror images—what seems to be a thorough inventory of Western civilization's fascination with the status of the representational body. A 1918 display in Copenhagen, for example, depicted two miners trapped by a cave-in. In their desperation, they pray to the patron saint of the mine, "whose marble image hangs in the rural church at home." Judging from the program description of the display (the only remaining trace), as the two figures "pray" and we watch, a vision of the saint manifests itself: "A weak illumination appears and more and more clearly the saint's head of stone emerges from the darkness of the mine. And suddenly the image changes to flesh and blood, only to become veiled by a mystical darkness, in which it finally disappears."[32] It is not clear from the description how the display actually accomplished this transformational illusion for the visitors—it may have been a series of magic-lantern projections— but the narrative description prods the viewer to consider a wide gamut

of representational possibilities for the saint's figure, including a marble image, an image hovering in the air, a head of stone, and flesh and blood. As the image of the saint performs these ontological permutations, one quite loses track of the fact that the miners experiencing the vision are themselves wax mannequins.

Complex representational layers could similarly be found in the most straightforward scenes. The Copenhagen museum's gesture to the Swedish royal family in 1885 seized on the crown princess's sculpting hobby and depicted her in the process of sculpting a bust of her husband, while another sculptor-mannequin in the background shows the queen a sketch. A Sarah Bernhardt display there the same year highlights her sculpting talent as well, displaying her wax effigy in an artist's studio "in the process of taking the cover off Victor Hugo's bust." The repeated return in these displays to the scene of the sculpting studio, where all of the panoptikon's mannequins themselves had their source, flirts with the potential deconstruction of the wax display. It seems worth the risk, however, since if successful it has quite the opposite effect. After all, there is little that could distract more from the mannequin status of the figures than letting them make another effigy or be depicted in the process of its artistic appraisal. Other displays that put a toy doll in a mannequin's lap, or marble busts in the background decor, or photograph portraits in a mannequin's hands accomplished much the same effect.

Another effect of having mannequins produce other mannequins or works of art is, of course, that the active figures are depicted as "absorbed," in Michael Fried's sense of the term.[33] In the art criticism of Diderot, Fried argues, the depiction of figures involved in "absorptive" tasks or situations requiring concentration turns them inward on the depicted world; their apparent obliviousness of the painting's beholder in turn frees up that observing position for a voyeuristic appreciation of the scene. Although the force of Fried's claims concerns painting (with an implied nod to later stage practice due to Diderot's influence on naturalist theatrical aesthetic), the model he outlines is strikingly appropriate to describe the techniques of the wax museum's tableau turn as well.

Tableaux depicting distinct layers of consciousness were ubiquitous in turn-of-the-century wax museums. A display at the Danish panoptikon's opening in 1885 is a good example (fig. 4.12). The scene depicts the Danish king Christian II with his dying mistress, Dyveke, who has been poisoned by a rival. A reporter's prose interpolates the following into the scene: "In despair he leans over Dyveke's corpse and squeezes her white hand to feel if the pulse is still beating after all, listening for an invigorating breath from her silent breast. But the little dove is dead."[34] There is a crucial relational logic to this scene; the only sense in which King Christian (the mannequin) is alive is in comparison to the dying Dyveke (the manne-

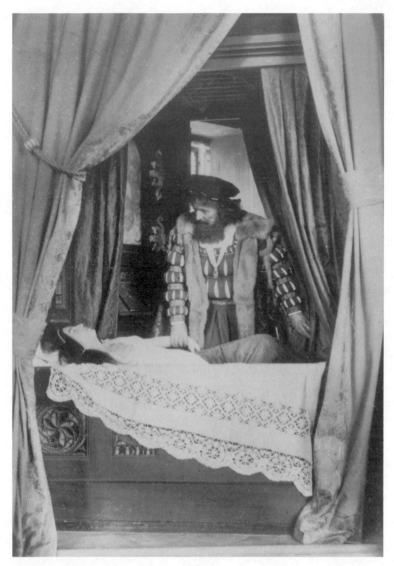

FIGURE 4.12. Mannequin first aid: King Christian II and Dyveke on her deathbed at the Scandinavian Panoptikon, ca. 1885. Photo courtesy of the Royal Library (Copenhagen).

quin) at his side, who gives her life that he might live, so to speak. The same could be said of the Sleeping Beauty display at Olsen's museum the same year, where a reporter's narrative once again "fleshes out" the dynamic of the scene: "We see depicted here the moment of the Sleeping Beauty fairy tale when the Prince enters the hall and is dismayed to see all of the people absorbed in petrified sleep under the magic spell."[35] The mannequin prince acquires agency, even an impression of motion, by stumbling onto a scene in which all the other wax figures are said to be sleeping.

The widespread predilection for death scenes at wax museums more generally is sometimes explained by the suitability of wax in color and substance for portraying deathly pallor. Wax figures do in fact make excellent corpses; Olsen's re-creation of the Paris Morgue attests to that fact. Beyond that commonsensical explanation, however, there is also an element of strategy for the display as a whole in assigning a different ontological status to one wax figure in the tableau's fictional scene, because it both provides a logical explanation for the silent and motionless condition of the mannequins more generally and distracts from the fact that all mannequins in truth share the same status. Hence the stabbed figure in the well-known Norwegian genre painting *Killing at the Wedding Feast*, when portrayed in a wax tableau, is said to be "still alive, but death rests in his eyes." His in-between state could describe quite nicely the present-but-absent quality of all the mannequins in this genre tableau, but this visitor reaction shows how easily one reserves that observation for the mannequin stretched out on the floor, whose death in effect brings all the other mannequins back to life: "One shudders when one casts a look into the 'genuine' Norwegian farmhouse and sees the pale, deceased figure lying spread out on the bench with bare chest stabbed through, surrounded by terrified, despairing relatives."[36]

The same could be said of the "Red Terror" display years later, which "animated" the figures of Lenin and Trotsky by depicting a girl "lying unconscious on the floor."[37] There is only the slightest fictional pretext for the fainting in this case (it is a denouncement scene), but given all the possible ways one might depict the leaders of the Russian Revolution, the choice to include a fainted girl starts to make the device of the unconscious mannequin quite conspicuous. And, in fact, one begins to notice that many display choices of subject matter seem to have been guided by similar concerns. When the wax museum turned to fairy tales, Sleeping Beauty was a natural choice, as mentioned earlier, but so was Snow White, who could be portrayed dead-but-alive in her glass coffin, surrounded by "grieving" dwarf-mannequins, as she was in Copenhagen in 1923. From the potential scenes from contemporary politics, there was an advantage in depicting the deathbed of Kaiser Wilhelm I with the corpse flanked by

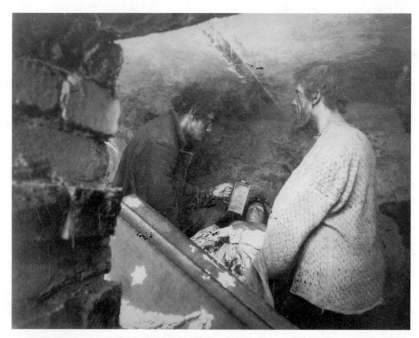

FIGURE 4.13. The grave-robber display at the Swedish Panoptikon, 1890s. Photo courtesy of the Stockholm City Museum.

the "living" Bismarck and Wilhelm II (see fig. 3.2). The grave-robber exhibit in the Stockholm panoptikon's short-lived chamber of horrors could similarly create an implicit hierarchy between the "active" mannequins and the passive corpse, at the same time as it exploited what was unusually sensational subject matter for that museum (fig. 4.13).

When turning to dramatic literature for source material, the panoptikon chose scenarios that were already about the confusion between life and death, such as the death scene from *Romeo and Juliet*, taken "from the chapel where the seemingly dead Juliet awakens from her deathly sleep to find Romeo, who followed her here."[38] This display provokes a double, perhaps even triple perceptual error—true to the play, Romeo has killed himself when he mistakes Juliet for dead, although she is actually only asleep, and Juliet finds him dead when she awakens. In its waxen version, the dramatic scene takes on a further complexity, since we as spectators of the scene might mistake both mannequins for alive, only to find from catalogue prose that the Romeo mannequin at the particular moment depicted is supposed to be dead, not asleep (which fact would of course otherwise be visually unverifiable). Add another bit of information from the catalogue (that both mannequins are modeled after two well-known

Stockholm singers who had recently played Romeo and Juliet in the opera), and the layers proliferate at a dizzying pace: the mannequins actually are meant to resemble an actor and actress who for the operatic version of the play are playing the roles of, respectively, Romeo, who seems to be asleep but is dead, and Juliet, who was thought to be dead but was only sleeping and is now awake. As awake as mannequins get, that is.

In a sense, all wax mannequins share the status of a female sleepwalker depicted at another of the Swedish Panoptikon's displays. As she performs her perilous night walk along the top of a wall, the catalogue prose warns us, "One false step and the young, unhappy girl is lost! But she walks forth more safely with eyes closed than she would be able to do in a waking condition."[39] The balancing act between presence and absence enacted here by the effigy of a young girl in a trance is similar to the precarious representational game managed by all wax figures. Unsupplemented, all wax effigies are "dead," but they can acquire an impression of life through the display's relational structures (dead/alive, sleeping/waking, unconscious/conscious).

The wax museum's game of structuralist oppositions may be inherent in the very idea of tableau, if Jay Caplan's analysis of Diderot is correct. In his treatment of Diderot's tableaux as written narratives, Caplan pursues the paradox of spectator participation and exclusion by emphasizing a structuring loss at the core of tableau display. Taking as his most expressive example an oft-cited scene in the second discussion from Diderot's *Conversations on The Natural Son* (1757), Caplan points out that the loss of a family member is at the real center of the scene, creating a kind of vacancy in the otherwise perfectly composed and complete scene that invites the imaginative participation of the reader. The reader assumes the position of the missing dead person and through his unifying act of perception re-creates the wholeness of the family in the same way that his act of looking creates the "whole" tableau. Caplan theorizes it in this way: "A desire for wholeness never alters the fact that the tableau is always incomplete. The tableau is always minus one." The structuring of a tableau around a central loss creates what Caplan calls "the aesthetics of sacrifice."[40]

Caplan's observation holds for many of the wax tableaux at the panoptikon as well. If one finds a partial explanation for the accumulation of corpses at the late nineteenth-century wax museum in the historical connections to embalming or the violence of the French Revolution, one can also find a theoretical motivation in the tableau's need for a structuring loss around which to organize the elevated, suspended moment. The dead, sleeping, or unconscious body could carry the burden of absence that allowed the rest of the tableau to seem full. It made possible a representational shell game that focused attention on the utter lack of one mannequin figure in order to slip the others past the careful scrutiny of the

viewer.[41] In addition, the absence built into the wax tableau by the dead or unconscious figure made available an inconspicuous position from which the spectator could both assess the scene and participate in its imaginative completion. Where the direct address of the frontal display rebuffed the viewer, offering only confrontational presence, the tableau offered instead the evocative, oblique absence of "minus one," as Caplan suggests, that allowed the viewer to fill the scene with his or her own subjectivity.

A final technique intended to distract viewers from the actual status of display figures was to impute to them the power to look. Much of this effect depended on the elaborate catalogue descriptions, which mentioned constantly where the figures were directing their interest and what they were imagined to be perceiving, thinking, and feeling at the depicted moment. But in some cases, the arrangement of the figures and details of the set went even further in representing mannequin vision. One of the popular early displays at the Swedish Panoptikon depicted the well-known Stockholm *flâneur* Soto Major. Until his death in 1894, this Portuguese diplomat was a fixture in Stockholm's cultural life, frequently promenading near his home in the Kungsträdgården district, coincidentally quite near the Swedish Panoptikon. Major was immortalized as an aesthete in the panoptikon's display, surrounded by art treasures and elegant decor (fig. 4.14). The ontological games outlined previously appear full force here (the mural, the statue, the mirror image of the statue), with the added effect of turning Major's figure laterally so that he is looking at the other objects. A written guide from 1897 encourages the spectator to "look closely then at the mural, which the gallant vice-consul is here examining."[42] When one does, one's look passes imperceptibly through the wax figure to the surrounding aesthetic objects. The mannequin, which is implied to look as we look, becomes a subject like us in comparison to the surrounding objects, which are there to be looked at and not through.

A still more compelling example approximates quite strikingly the iris effect of a cinematic point-of-view shot, that crucial element of classical cinema that inscribes the spectator's gaze within the filmic narrative world. The display subject in question here is taken from the H. C. Andersen story "The Little Match Girl," a narrative that would have been quite familiar to Scandinavian audiences by this time. (Both of the panoptika introduced a little match girl in wax around 1890.) The fairy tale describes the poor match girl who, alone and freezing on a step outside in the snow, strikes her last remaining matches to try to keep warm. As the Swedish Panoptikon's catalogue puts it,

> As each newly lit match burns down, one tableau [*taflan*] after the other appears to the poor frozen girl's inner vision [*inre syn*]: first the warm stove,

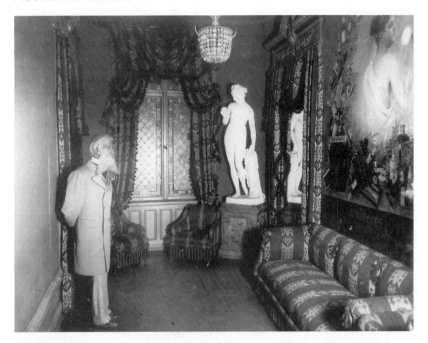

FIGURE 4.14. The Soto Major mannequin casts an appreciative eye over its art treasures at the Swedish Panoptikon, 1890s. Photo courtesy of the Stockholm City Museum.

which must be inside in the great, stylish house, then the lovely roasted goose, whose fragrance penetrates through the stone wall, and after that the wonderful, beautiful Christmas tree she just saw in a store during the Christmas recently passed, and finally the friendly, long-dead grandmother.[43]

The subjective status of these visions might seem unrepresentable in wax, but both of the panoptikon displays attempt to get inside the match girl's subjective experience by using an opposing wall as a screen upon which to project the object of her gaze. As was the case with the Soto Major tableau, the spectator's look in the Danish display (fig. 4.15) is passed along unobtrusively through the laterally positioned wax figure to some other sight, object, or view—in this case, a strikingly subjective sight that normally would remain unverifiable to outside spectators. The preceding Swedish narrative hints at a sequence of alternating visions that were likely not actually represented, although one could conceivably have used lantern slides for the changing scenes. Film would eventually improve on the depiction of subjective "visions" by isolating the vision as a separate point-of-view insert shot and by showing several in succession, effects that were

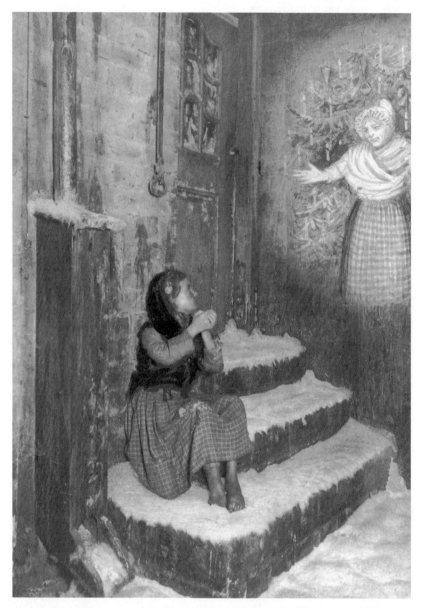

FIGURE 4.15. "The Little Match Girl" display with point-of-view iris at the Scandinavian Panoptikon, 1890s. Photo courtesy of the National Museum of Denmark (Brede).

obviously beyond the material limits of the static tableau. The panopti-kon's precocious iris shot, however, demonstrates that the general interest across media in endowing images with subjectivity resulted in similar strategies.

Toeing the Line

With the tableau technique in place, the wax museum became a school for voyeurs. All of the necessary elements were there: the careful establish-ment of a supposedly inviolate line between spectator and display, "oblivi-ous" figures within the display absorbed in reciprocal interaction, a hyper-realistic medium (the wax castings, relic props, and diorama sets), and the complex techniques that distracted from the representational status of the illusion. The viewer who stumbled onto this slice-of-life scene, which was inviting yet sealed off at the same time, could seemingly gain direct access to a realistically convincing scene without actually participating. The pri-vate could be made public without compromising its status as an intimate scene, as long as the fiction of the one-way mirror between spectator and display was maintained. The great appeal of this kind of viewing experi-ence was *not* that it was "just like" being present at a scene, despite the frequency of that inflated claim in the wax-museum discourse. Actually being there could conceivably entail danger, embarrassment, discomfort, or other risk to one's body, depending on the nature of the scene or person depicted. Instead, the wax museum offered visual access to the scene with-out subjecting spectator bodies to any of its possible physical effects. It was a position of mastery, not unlike that enjoyed by the viewer of photo-graphs or stereographs, one that depended on simultaneous access to and protection from the content of the display. Voyeurism, that is, was a form of virtual travel.

The paradoxes inherent in the voyeuristic model of viewing gave the wax museum of the 1880s and 1890s rich material for visual play. The goal was to make mannequins appear as lifelike as possible, to seem as if they *might* return one's look, but not so alive as to threaten the viewer's com-mand of the scene. Similarly, scenes would be arranged for maximum visi-bility, yet with the pretense that nobody was watching at all. This was a delicate balance, one that brought the voyeuristic experience forward in the consciousness of museum proprietors and visitors alike. The catalogues pitched displays with that in mind, and the frequency of voyeuristic meta-phors in the interpretive newspaper discourse clearly indicates that visitors understood a trip to the new kind of wax museum as an opportunity to peek unobserved. The composition and framing of the displays themselves made that recognition unavoidable, especially when scenes included voy-

eur wax figures peeking within the display itself. The wax museum, that is, did not simply enact a voyeuristic paradigm of vision—it *tested* it.

The following discussion will lay the groundwork for this book's larger claim that a voyeuristic mode of spectating, while certainly not unique to the turn-of-the century period, nevertheless became especially charged and expressive of the experience of modernity, and that this in turn forced the issue of the material conditions of display. The late nineteenth-century wax museum's ostensible product was a now-familiar brand of voyeurism, couched as a comprehensive program of spectator pedagogy that taught skills in urban surveillance and discreet observation. Its by-product, however, was a map of the physical world's impediments to pure visual mobility. The next chapter will examine more closely the specific ways that metropolitan experience was projected onto the Scandinavian wax museums of the 1880s and 1890s, but here it will suffice to say that the wax museum's perceptual games, on the one hand, encouraged visitors to become inconspicuous observers and learn a revised, urban relationship to their bodies and, on the other, inevitably reminded them of the physical bodies through which they experienced what in the final analysis was always an insistently material display.

The first aspect of the voyeuristic tableau display that deserves attention here is the frame itself. Its status remained inconspicuously given in many of the displays, but with unusual regularity, one could also find the tableau idea being folded into the display itself in either structural or thematic ways. The wax tableaux, that is, often performed their own deconstruction. Several of the displays, for example, were visually accessible only through peepholes. Claës Lundin's short story about the Swedish Panoptikon, generally reliable in its descriptive detail, mentions "a young lady who was peeking through the window hole" at the grave-robber exhibit, a trace of which can be seen along the frame (see fig. 4.13).[44] Another wax tableau there designed as a look through a window, called "Fritjof and Ingeborg in Balder's Garden," took its subject matter from the Norse *Fritjofssaga* (fig. 4.16). The position here is unexpected, however: one finds oneself looking *out* onto the love scene in the garden. The most straightforward way to display an open-air scene would simply have been to provide the spectator an unobstructed outdoor view, so the inclusion of this window frame within the larger display frame makes the Balder's Garden tableau as insistently about secret watching as about Norse sagas.

This tableau becomes even more interesting, however, when one considers the cultural resonance of the subject matter, connotations that would have been familiar to Swedish audiences through a more recent reworking of the Fritjof material by the renowned Swedish poet Esaias Tegnér in 1825. Balder's Garden, it turns out, was a pagan temple site. In Tegnér's *Fritjofssaga*, Ingeborg has been placed there by her brothers for

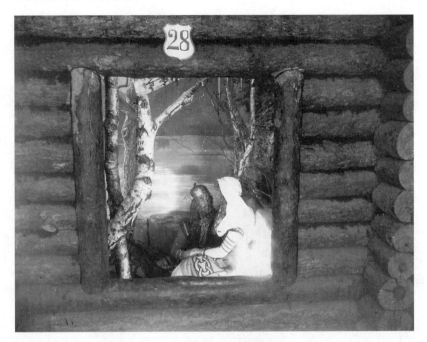

FIGURE 4.16. "Fritjof and Ingeborg in Balder's Garden" at the Swedish Panopti-kon, after 1894. Photo courtesy of the Stockholm City Museum.

safekeeping from Fritjof when they go off to battle, because the sanctuary laws forbade men and women to come together there.[45] In the saga, of course, it is inevitable that her suitor, nicknamed Fritjof the Bold, will dare to do so when he comes to court her. This "idyllic" scene from Norse romance, made available in tableau form at the Swedish Panoptikon, is thus actually about an interloper, a daring transgressor of boundaries.

Read as an allegory of tableau spectatorship, this display-through-the-window, which so insistently foregrounds the conditions of voyeuristic spectating, provides interesting metacommentary on the tableau turn at the wax museum. The display space is identified with an inviolate "sanctu-ary" and the spectator as a potential intruder. But two kinds of spectators are implied by the scene: those who, like Fritjof the Bold, might transgress the boundary between display space and spectator space, and those of the Swedish Panoptikon's public who remain in place beyond the frame, watching inconspicuously from behind the window. Given that the consis-tent deployment of tableau display techniques was a relatively recent devel-opment in the wax museums, the implicit comparison here between bold and discreet spectators can be seen as an attempt to coach spectators to adopt a more consistently oblique relationship to the display space.

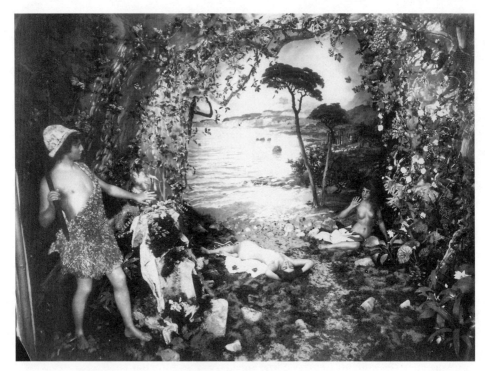

FIGURE 4.17. "Interrupted Idyll" with naughty shepherd mannequin, Swedish
Panoptikon, 1894. Photo courtesy of the Stockholm City Museum.

The written guide calls the Balder display an example of an "uninter-
rupted idyll," emphasizing the buffer the window provides for the voyeur-
spectator's viewing activity.[46] The phrase is a play on the title of a display
encountered earlier at the same museum, "Interrupted Idyll" (fig. 4.17).
Here, too, the voyeur issue is quite near the surface, judging from the
catalogue description: "It is in ancient Greece. Several young shepherd-
esses have just finished bathing, and one of them stretches out indolently
on the beach. But unfortunately they are not left undisturbed."[47] A later
reminiscence of a trip to the panoptikon in 1904 recalls one spectator's
reaction to this particular display: "Oh my, a really shameless shepherd
takes a peek at them through the bushy lianas of jasmine and honeysuckle.
One understands of course that the girl shoos him away with her little
hand. When we have seen our fill, there remains another little peephole
for us to peek into."[48]

The voyeurism depicted here is the classic variety; one can in fact easily
imagine endless clichéd soft-porn versions of this same scenario. This par-
ticular naughty shepherd figure, however, is in several ways relevant to the

wax tableau technique under consideration here. First, since he has been "discovered" by the female mannequins and the display's actual spectators have not, they come off as the more discreet of the scene's many voyeurs. The "idyll" that the shepherd interrupts, that is, is not only the narcissistic self-absorption of the shepherdesses at bath, but the pleasurable contemplation of that scene by the better-behaved voyeurs. The shepherd figure interrupts both by crossing the invisible line and "disturbing" the display, but his diversionary tactic frees up the actual spectators for voyeurism of a different order at the same time that he provides a negative example of spectating. Interestingly, his position vis-à-vis the object of vision is almost identical to the placement of the wax figure in the Soto Major display discussed earlier (see fig. 4.14). Turned laterally on the edge of the scenic frame, both the shepherd and Soto Major create an inconspicuous relay point for the spectator's gaze to enter the scene while still toeing the line between display and spectator.

The importance of a particular relay of looks for the voyeuristic effect becomes even more evident when one compares the wax display "Interrupted Idyll" with what was likely one of its visual precedents, namely, a celebrated painting by the Swede Julius Kronberg, entitled *Hunting Nymph and Fauns* (1875; fig. 4.18). This monumental painting caused a scandal when it was initially shown in Sweden, initiating a furious debate about the "lewdness" of the female figure, with notables like August Strindberg rushing to the painting's defense.[49] More shocking today is the insistent verticality of the composition—at almost nine feet tall, the painting places the fauns in the upper-left-hand corner, looming over nymph and viewers alike.[50] These, the truly lewd characters in the painting, passed mostly without comment in the contemporary discussion, although their conspicuous confrontational pose could certainly contribute to a sense of unease about taking voyeuristic pleasure in the female nude figure.

If in fact the local notoriety of the Kronberg painting served as a visual precedent for the "Interrupted Idyll" display at the Panoptikon, it is interesting that the wax tableau relocates the peeper, having him enter the scene from the side instead of the top and back of the composition. The panoptikon's version, more in line with the typical arrangement of figures in the wax tableau, includes the theatrical threshold effect of having a mannequin entering from the "wings" and provides the spectator with an oblique position from which to sneak into the composition, much as later cinema spectators could sneak into the world of a film. The lateral relay of looks allows the spectator to be both present and absent from the "exposed" position of voyeurism. At the same time that one might take up provisional residence in the shepherd's point of view, one also comes off as more discreet and inconspicuous than the rude "interrupter."

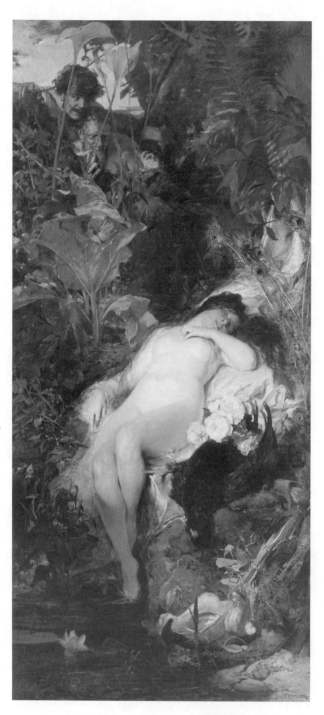

FIGURE 4.18. Julius
Kronberg, *Jaktnymf och
fauner* (Hunting Nymph
and Fauns) (1875). 269 ×
130 cm. Oil on canvas.
Photo courtesy of
the National Museum
(Stockholm)

Another tableau at the Scandinavian Panoptikon encouraged spectators to keep their distance, namely, a seductive display depicting two bathing beauties from 1899, entitled "Young Girls Prepare Themselves for a Swim from an Open Beach." The investment in extra wax necessary for these completely nude figures was apparently expected to pay off by attracting more visitors, and the more sensational tone of the subject matter is probably an indication of growing trouble at the box office for this otherwise self-consciously upstanding museum. The figures are arranged in a frank, presentational pose, which given the subject matter might make the tableau's invisible line of demarcation relatively precarious. But this display apparently had a surprise tactic in reserve to protect the boundaries of display; we learn from the catalogue that any viewer responding too literally to the siren call of these mannequins was in for a shock: "The spectator has surprised the young girls just as they have completed their undressing. But the spectator ought to exercise a reasonable discretion. If he ventures too far forward along the bridge, one of the young girls opens her umbrella and hides both herself and her girlfriend from curious gazes."[51] The lesson is, of course, that the discreet look will be rewarded as long as it keeps its distance, and that a viewer who "acts out" by trying to cross over from vision to participation will be punished with the removal of the pleasurable scene from view. The spectator was clearly expected to hover around the boundary of the display, participating imaginatively in the scene while remaining physically aloof. Joke displays like this one helped teach spectators the appropriate limits of watching.

One of the tableau diagrams for the Hogarth series in Copenhagen actually maps out this in-between spectator position (fig. 4.19). (When printed catalogues did not include actual photographs of displays, they would sometimes provide this kind of schematic diagram identifying figures in the scene.) The scene in question takes place just after the count discovers the countess's adulterous tryst and is fatally wounded in the ensuing scuffle. The diagram, reproduced here from the Scandinavian Panoptikon's 1897 catalogue, is typical in that it maps the positions of the various wax figures but is quite unusual in that it identifies a single spot (b) for the spectator to stand, seemingly inside the display space. The catalogue narrative explains the addition in this way:

> The shadow of the fire tongs on the floor is an ingenious way of making clear that the scene is taking place in the glow of the fireplace light and that the spectator must imagine himself standing to the right of the large upper structure of the fireplace, which in this old house has been placed in the corner to the left and protrudes in front of the fourth wall of the room, which for the sake of the view [*Indblikket*] has been removed.[52]

_FIGURE 4.19. From the Scandinavian Panoptikon's Hogarth series, "Marriage à la Mode," 1897. Translation and reproduction of original catalogue display diagram.

The main reason for putting the spectator in an exact spot seems motivated by perspectival concerns (to make the fireplace shadow appear natural), and the catalogue further attributes this spectator position to Hogarth's original composition from the "Marriage à la Mode" series (1745–46).

The position of the figures in the wax tableau does in fact mimic their placement in the painting, but there is of course no mention of a literally inscribed spectator position there, in part because vantage point is already constrained in that medium (as it would be in film as well). The wax museum—all forms of museum spectatorship, really—is more like the theater in this regard, since there is a variety of possible sight lines, depending on where one is sitting or standing. As intriguing as the attempt to control that position in the panoptikon's accompanying diagram, however, is the way the wax-tableau spectator is conceptualized both inside and outside the scene, as both participating along with the figures in the display and observing them in the light of the fire at the same time. The wax museum's assignment of a spectator vantage point right along the plane of the invisible fourth wall makes explicit the wax museum's special investment in a

FIGURE 4.20. The royal family display at the Swedish Panoptikon, one of the original tableaux at the opening in 1889. Photo courtesy of the Stockholm City Museum.

consistently deployed system of voyeurism and makes literal the travel metaphor of being both here and there.

A similar example involves one of the most popular displays at the Swedish Panoptikon, that of the royal family. The royals' keen interest in modern forms of entertainment had led them to supply the panoptikon with the samples and likenesses necessary for a convincingly realistic display, and the interior scene of the royal family at home was a crowd favorite that was continually updated throughout the life span of the museum (fig. 4.20). The catalogue prose helped draw one's attention to important details in the display and, as a final parting comment, encouraged visitors to turn around and take a look into the mirrored wall behind them, vis-à-vis the display: "When you have seen enough and turn around, look at the royal family for a moment in the mirror situated opposite the display as well. The mirror image is just as worth seeing as the original."[53] The desired effect, of course, was to see one's own mirror image reflected among those of the royal family, to erase the difference between the famous and

the common by flattering the spectator right into the tableau, so to speak. (The mirror thus works like the joke photographs that juxtaposed live body and effigy in order to turn both into an image.) A side effect, though, is that the mirrored spectator is left in an intriguingly in-between threshold space. Hovering inside and outside the display simultaneously, the viewer inhabits a conceptual space that in filmic terms would be the space of the edit, the space between two halves of a shot and reverse shot.

The encouragement for spectators to think of themselves as hovering between presence and absence in a scene was enhanced when decoy figures were placed in the spectating space. The surprise of finding them there depended, interestingly enough, on an initially clear demarcation of display space from viewing space. The general setup created an expectation that figures would be found within a clearly composed scene, and that spectators would stay on the other side of the invisible fourth wall. Only then could the mannequins be truly *dis*placed and surprise visitors by turning up on the wrong side of the line. Today, of course, the decoy wax figure has become one of the wax museum's most predictable jokes, with waxen ticket takers, waxen guides, or waxen fellow spectators positioned at unexpected points along one's path through a museum. Not all of the wax museums have been equally playful in this regard, but it seems to be the rare museum that does not exploit the wax effigy's striking mimetic effects in this way at least once. Recent tricks at the modern Louis Tussaud museum in Copenhagen, for example, include a waxen tourist figure taking a flash photograph of a display, a waxen bag lady resting on a bench, and a waxen guard supervising one of the display rooms.

Both of the turn-of-the-century Scandinavian panoptika had decoy figures peppered throughout the spectator space or in other unexpected corners. The old-woman effigy rising from the chamber pot has already been mentioned; others included two "regulars" (*Stamgæster*) seated at an eternally reserved table in the Scandinavian Panoptikon's restaurant; a pretty Dalecarlian woman at the Stockholm museum looking down a spiral staircase, "curiously observing those who are climbing up the stairs"; or a valet effigy, of whom it is said at the opening of the museum there, "He smiles and waves with his hand. But you shouldn't give him your ticket or try to get him to take your cane. He won't accommodate you, but will keep on smiling just as he, ever since he came here, has been smiling to the carpenters and painters bustling around him."[54]

The appearance of such a decoy effigy outside the display space proper can create a moment of delicious uncertainty about the ontological status of one's neighbor; the figure one takes to be real turns out instead to be a missing person. Zakarias Nielsen's rich account of his trip to the Scandinavian Panoptikon again helps out by providing a perfectly typical

sample of the decoy discourse at the wax museum. His description of the various displays includes reference to this overheard (or perhaps imaginary?) commentary from other visitors:

> Over there by the balustrade on the right stands a traveler, apparently an English tourist, staring through his lorgnette down at the crowd in the main hall. He must have discovered something especially remarkable down there—he is as if petrified with surprise, he doesn't move a limb. "Could the gentleman please tell me the way to the Slumbering Grove?" asks a stout bourgeois woman politely. He doesn't move from the spot. "Oh goodness, it's nothing but a wax man!" she exclaims upon closer inspection. And half-dead from laughter she turns to her female companion—likely her daughter—who likewise has a priceless laugh at the mistake.[55]

The "half-dead from laughter" is a nice match for the "half-alive" mannequin, whose unusual absorption in the act of spectating is first partially excused by the fact that he seems to be a foreigner. Just how foreign is only apparent after the fact, of course, when the two women discover that he is not just from another country but from another ontological category.

They find this to be a good joke, but it also plants a seed of doubt that reaches fruition at a later point in their visit:

> But there we have the missus and young girl from before. They stand there poking each other with their elbows, looking askance at an old woman sitting quietly on a chair reading a newspaper. "Do you think she's alive?" the missus asks, peeking ahead. "I don't know, but we can go over and take a look at her." "No, don't be crazy, child, let's just wait a bit and see if she moves." They stand for a moment staring at her with tense facial muscles and staring gazes. Then the old newspaper reader begins to sneeze with all her might. . . . That gave the missus a start. "Oh God bless her soul—there's still life in her yet!" And with mutual relief that they didn't go over and "stare right in her face," they usher themselves off to take a look at the foyer's collection of authors and actors.[56]

Their experience with the earlier decoy figure apparently set in motion an uncertainty about the status of everyone in the museum, a reticence that is fostered as yet another facet of the panoptikon's pedagogical project. These two have learned the intended lesson of skepticism; fooled once, the women don't want to be fooled again, and they hold back until they can be sure whether the old woman is alive or dead.

The fact that a similar pair of decoy jokes can be found in the early reporting on the Swedish Panoptikon confirms the suspicion that we are dealing with a set piece typical of wax-museum discourse in general. There a Swedish journalist writes:

> Whereupon my young Stockholm lady begins to investigate the difference between people of wax and straw and people of flesh and blood. She excuses herself courteously when she happens to shove Boulanger, who in response neither greets her nor looks like he will require revenge, and she says of a curious, gaping young man who is standing in a corner and looking chic, that he is "remarkably alive," which assessment curiously enough does not seem to flatter him.[57]

These anecdotal accounts of spectators stumbling their way through the wax museum's games of life and death are in one sense an extension of the ontological layering within the displays themselves. The investigation of "the difference between people of wax and straw and people of flesh and blood" might in fact be seen as the central project of the wax museum.

A crucial kind of decoy was the rube spectator, a wax figure standing in for viewers who had not yet assimilated the new visual habits successfully. Not surprisingly, given the then-recent influx of citizens from the Scandinavian countryside, depiction of the unschooled spectator often relied on rural stereotypes. If the mark of skilled urban dwellers was the ability to look discreetly and unobtrusively, that of rural visitors was the tendency to stare and gape, and the difference between the two kinds of spectators was made the main point of one of the longest-running joke displays at the Swedish Panoptikon, entitled "Practice in Patience." A later spectator reminiscence tells what it was like to encounter this display:

> Down here there are also some peep-holes in the wall that one should not pass by without casting a glance inside. There are three holes, and in two of them we can peek, but at the third stands an old farmer [*en bondgubbe*] staring, and he never seems to get enough. There must be something really interesting to see there! He shades his eyes and stares hard. We wait a moment—surely he'll leave soon!—I mean, really!—Excuse me, but would it be possible to take a peek? He's deaf too. Excuse me!— — — The exhibit is called "Practice in Patience" and is made of wax and straw. That old man has felt a blow tremble in the air many a time. He could drive a person crazy and get one's curiosity up to the boiling point.[58]

The decision to dress the staring mannequin as "an old farmer" creates two implicit categories of viewers: the urbane spectator who can peek quickly and move on to the next view, and the rube viewer who stares and "can't get enough," making a conspicuous show of his viewing activity.

Claës Lundin's "The Path to Immortality" makes the premise of the "Practice in Patience" display the centerpiece of the short story about the accountant Andersson's attempt to get portrayed in wax at the new panoptikon. After this Stockholm Everyman has searched the entire wax museum in vain on opening day to see where his likeness has ended up, he

approaches a panoptikon official and is led upstairs to a display similar to "Practice in Patience":

> "Look into that peephole there!" he exhorted the accountant.
>
> "I've tried that several times already," explained the accountant, "but that gentleman seems like he will never leave."
>
> The Panoptikon official laughed:
>
> "That gentleman is you, of course. Don't you recognize your own clothes?
>
> It really was the accountant's coat and pants. The man at the windowpane was a panoptikon figure and not a living being. And that was supposed to depict Andersson from Government Services? The accountant found that to be a bad joke. The one standing there with back turned to the entire public and whose face one couldn't even see was supposed to make the name Andersson famous for all time! Who could guess that would be the way the accountant would find the path to immortality?[59]

The pitiable accountant, immortalized in his position at the window, becomes the butt of one of the panoptikon's most pervasive pedagogical jokes. Although the accountant is not a rural rube, he is the naive object of satirical humor, the anonymous city dweller with an unreasonable desire for fame. His fault as a spectator is that he does not want to remain an invisible voyeur-spectator but wants to be conspicuous (famous) instead. This story, published by Lundin the same year the Stockholm panoptikon opened, plays the usual role of supporting discourse in helping to establish the ground rules for spectating. At the new panoptikon, this meant helping visitors to understand that staring was now out of fashion, having been replaced by the discreet viewing of invisible and savvy spectators.

Parallel examples from early cinema demonstrate that a quite similar process of spectator pedagogy was also at work in that institution's formative early period. The film that has received the most recent attention in this regard from film historians is Edwin S. Porter's *Uncle Josh at the Moving Picture Show* (1902), which depicts the inappropriately histrionic response of a rural rube to his first encounter with the moving image. Miriam Hansen has quite perceptively identified the comic effect of this early film in the disparity between the depicted response of the rube and what was assumed to be the more sophisticated reaction of the actual audience of the film, which already in 1902 was unlikely to act out any astonishment at seeing a moving picture. As she puts it, "The 'proper' relations among viewer, projector, and screen, the peculiar dimensions of cinematic space, were part of a cultural practice that had to be learned," and Uncle Josh provided the real film spectators with an object of ridicule that demonstrated how not to behave in the new space of the cinema, or reminded them of how they themselves might recently have behaved before assimilating the rules of the new cultural practice.[60]

If we see this early Edison film as a primer in cinematic spectatorship, one has to acknowledge quickly that it represents just the tip of the iceberg when it comes to rube portraits in turn-of-the-century films. *Uncle Josh* itself was a remake of the Englishman Robert W. Paul's *The Countryman and the Cinematograph* (1901), and many other early films took up the same theme, if not with such interesting filmic self-reference. The rube figure, as Hansen points out, could be found everywhere from vaudeville to comic strips at the turn of the century. Its deployment in each of those contexts surely taught slightly different lessons about viewing; the wax museum's decoy rube mannequin glued to the windowpane makes an equivalence between spectator body and mannequin that is different from what Uncle Josh's arm-waving hysteria says about the cinematic medium and modern shock, a point developed in detail by Lynne Kirby.[61] But the cultural pervasiveness of the figure shows that it was not just the conventions of cinematic spectatorship that were to be learned from such anecdotes but a more general form of impassive viewing from an invisible spectating position. It is not just a cinematic model of vision but a cultural one. The voyeurism that enables the "classical" model of cinema spectatorship, that is, may also be the sociohistorically determined mode of vision more generally activated in the period we call modernity.

Entrapment Scenarios

The claim just developed is that the wax museum's school for spectators developed voyeuristic competencies in its graduates by portraying intrusions on a composed scene as primitive, rude, or unschooled. The successfully trained spectator entered a scene in fantasy alone, through acts of identification or imagination that did not require physical presence within the display but rather a subtler substitution of spectator for the bodies in the scene. The well-trained voyeur was in this sense both inside and outside the display. Conceptualized right at the invisible border of the diegetic world, the spectator was ideally positioned to move either in or out with a single step, as the diagram of the Hogarth tableau expressed so schematically. The promise of extraordinary access to a realistic scene was only attractive, though, when the spectator had equally satisfactory assurances of continued mobility back out of and away from the scene—the modernity of this mobile subjectivity lay precisely in this guarantee. (Correspondingly, many popular-culture time-travel fantasies, from television shows to movies like *Westworld* and *Jurassic Park*, tout the exhilaration of real access to another time and place only to raise the fear that one will be permanently trapped in the scene with no return possible.) The feeling of "transportation" to Ludvig Holberg's eighteenth-century Copenhagen,

to return to this chapter's opening example, is only thrilling as long as there is an implicit understanding that one will, of course, return home afterward. It is not surprising, then, to find that the nightmare versions of modern circulation depict a kind of access so extraordinary that no return is possible.

Nervousness about engulfment shadows the celebration of voyeurism in several displays. A tableau at the Danish wax museum, for example, depicted the devastating fire that had broken out at the Christiansborg royal palace in 1884, not even a year before the panoptikon's opening. The scene appeared in full diorama style but put spectators behind a window pane looking in on an upper room of the palace while "flames flash and crackle through openings in walls and doors, burning beams and pieces of wood stick out everywhere," and the wax figures work either to rescue victims or to escape the flames. The summary account of the display by Zakarias Nielsen reads, "The whole thing is masterfully depicted; at no other place in the wax cabinet [*kabinettet*(!)] is the illusion more lifelike. It is as if one is actually in the midst of the sea of flame; the fear rushes through one's body, and one spontaneously turns one's head to the side to make sure that the hall one is standing in isn't filled with smoke and flames."[62] In order to experience purely visual risk, that hallmark attraction of voyeuristic viewing, the spectator needs both unusual access to and protection from the scene on display. Here, the windowpane provides the buffer that makes it pleasurable to imagine oneself engulfed by the flames, that provides a safe feeling of fear.

Cinema, of course, does this one better; its screen-window combines a heightened illusionism with the recording medium's more absolute guarantees of displacement. Unlike tableau space, screen space is never really shared by the spectator. These differences make it instructive to examine how filmed depictions of museum-going imagine entrapment. Two particularly rich cinematic texts, one a silent comedy and one a recent low-budget horror film, seem relevant here. The first is a Danish silent film from 1910, *Christian Schrøder in the Panoptikon*. Although not presently available in complete form, this short comedy (five to six minutes) did leave behind archival traces in the form of several still photographs and a plot description.[63] The plot involves a rural visitor to Copenhagen who has unwisely tried to see too much in one day and falls asleep in the panoptikon at closing time (fig. 4.21). Finding himself alone and locked in, Schrøder apparently begins to investigate the various wax tableaux by feeling the shapely leg of one mannequin (fig. 4.22). Such violations of museum protocol, however, cannot go unpunished, and he gets his comeuppance in the form of a cannon shot from an adjacent display (fig. 4.23). The original sequence of these last two scenes is unknown, since the existing plot description does not mention them specifically. It is logical,

FIGURE 4.21. The rural visitor to the wax museum falls asleep and gets locked in overnight. *Christian Schrøder at the Panoptikon* (Christian Schrøder på Panoptikon, Nordisk Films Co., 1910). Photo courtesy of Nordisk Film.

though, to see them together as a causal pair, with the rube's sexualized advance on the female mannequin eliciting an equally sexualized, but punitive, response from the phallic cannon pushing the interloper back out of the scene.

According to the plot description, the chastened rube is quite ready to be disgorged by the panoptikon in the morning: "When the confused Mr. Schrøder is found by the guard in the morning and in a slightly rough way is ushered out of the premises, he is not sure if the night's remarkable events should be attributed to dream or reality, so strangely alive the whole thing has seemed—but he can never quite bear to talk about it."[64] Here again is the durable wax museum trope: if one could see the mannequins at midnight, one would find that they come alive, as if their waking time were our sleeping time, and vice versa.[65] Added to that idea here is that the midnight viewing allows expression of behaviors repressed at the museum during waking hours by the conventions of voyeuristic viewing. In this little allegory of illicit midnight spectating, the rube figure crosses the invisible display lines only to discover that the barrier keeping him out

FIGURE 4.22. Testing the boundaries of the tableau display. *Christian Schrøder at the Panoptikon* (Nordisk Film Co., 1910). Photo courtesy of Nordisk Film.

was also a protection keeping the display contained within. That is, if disregarding the barrier makes possible a more participatory pleasure (feeling the leg), it also makes possible the punishment by return fire from the uniformed figures supervising the display boundaries.

Christian Schrøder played the entrapment scenario for comedy, but its horror potential is equally evident, judging from the many films that have played the uncanny aspects of the wax figure for chills instead of laughs. Beginning with Paul Leni's German expressionist *Das Wachsfigurenkabinett* (1923), the series of wax-museum horror films includes *Mystery of the Wax Museum* (1933) and its more famous 3-D remake, Vincent Price's *House of Wax* (1953), *Midnight at Madame Tussaud's* (1936), *Charlie Chan at the Wax Museum* (1940), and several more recent low-budget offerings, like *Nightmare in Wax* (1969) and *Terror in the Wax Museum* (1973). Also in this latter category, coming at the tail end of the tradition, are two films by Anthony Hickox, *Waxwork* (1988) and its sequel, *Waxwork II: Lost in Time* (1992). All of the wax-museum horror films exploit for terror effects the wax museum's tenuous boundaries between corpses, mannequins, and spectator bodies. At the same time, they explore the

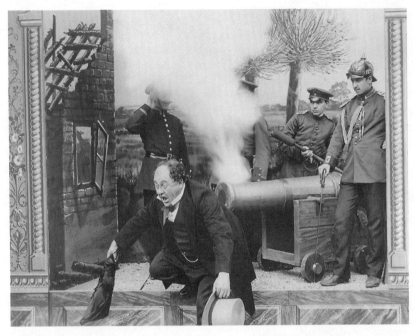

FIGURE 4.23. The revenge of the tableau. *Christian Schrøder at the Panoptikon* (Nordisk Film Co., 1910). Photo courtesy of Nordisk Film.

relationship between film, still photography, and wax, playing with differences in dimensionality and motion to create surprises, morbid jokes, and shock effects along the way.

The horror film's long-standing interest in enclosed spaces makes the prospect of engulfment in the wax tableau an attractive set piece for these films. Following Carol Clover's observation about the high degree of self-reflexivity in low-budget horror films (especially of the 1970s and 1980s), one might expect the relationship between cinema and the wax museum to be closer to the surface in the low-end wax-museum films.[66] *Waxwork*, Hickox's "trendy monster gorefest" (as one reviewer has called it), does not disappoint in this regard, articulating in late-moment, campy style the most important principles of wax-museum spectatorship and their relationship to the cinema.[67] The film is especially insightful in its identification of the entire wax tableau, not the mannequin itself, as the source of the wax museum's power over the spectator. But in this nightmare, "downstairs" version of the wax museum, the tableau's power of illusion is no longer marvelous but sinister, something that must be resisted at all costs.

Waxwork's plot centers around the main character, Mark, and a group of his teenage friends, all of whom are specially invited to a private midnight showing at a disturbing new wax museum that has appeared suddenly and unaccountably in a wealthy, modern suburban neighborhood ("Strange, I've never seen *that* before!" "Yeah, weird place for a waxwork"). The waxwork is the chamber-of-horrors variety, with eighteen fully staged tableaux depicting various monsters and evildoers. The tableaux fascinate the teenagers, two of whom just cannot help but walk into the space of displays that have particularly attracted them. Predictably, both of them become entrapped in the display's imaginary world and are forced to play out the depicted scene until they become that monster's victim, at which point they themselves turn into gory wax mannequins. Permanently embalmed in the victim position, the overly curious spectators literally fill up the structural absence in the display with their own bodies, completing the tableau permanently and irreversibly by becoming stuck in the scene.

The unaccountable disappearance of the two friends spurs Mark and his friend Sarah to investigate. Their research leads them to the discovery that the waxwork proprietor, Mr. Lincoln, has sold his soul to the devil in order to bring to life "eighteen of the most evil souls who have ever been" by sculpting them as lifelike wax effigies and providing them with new, living victims in the form of wax-museum visitors enticed into crossing the thresholds of the tableaux. As Mark's godfather relates in the film's obligatory explanation-of-the-occult scene, the key to the wax tableau's power to attract new victims lies in its convincing theatricality. Each effigy is displayed together with a magical talisman, an object once belonging to the evil person, and not that alone, but also "a small piece from the dwelling" of each one, which Mr. Lincoln has used as the metonymic cornerstones of his diabolical mise-en-scène. "What Lincoln has done," the old man continues in crescendo, "is to re-create a whole scene from each character's life, which becomes like a small time vessel. The whole display is the ghost, not just the figures. He doesn't need to kill anyone, sacrifice, or use spells—he just sits back while the display does it for him." The suspense of the film revolves around filling up the last six empty spaces in the tableaux with "believing victims," at which point will come—try to take this seriously—the dreaded "voodoo end of the world, when the dead shall rise and consume everything," a cataclysm that, interestingly enough, can only be prevented by destroying the entire display, not just the figure in question.

What Lincoln has also done, it should be apparent from the discussion in this chapter and the last, is to replicate the key tableau techniques from the turn-of-the-century wax museum. The relic objects, the authentic sets that were collected, transported, and reassembled in the wax museums, the

role of the spectator in activating the scene, the tableau's implicit sacrificial logic, the risks of violating voyeur protocol—all of these have much more to do with the late nineteenth-century panoptikon than they do voodoo. Tellingly, Lincoln's deal with the devil has prevented him from aging, leaving him and his waxworks permanently frozen in time around the turn of the century (thus the anachronism of a gothic waxworks appearing suddenly on a tree-lined suburban street). This waxworks is a foreign body, an uncomfortable vestige that preserves both the setting and the tableau techniques of the turn-of-the-century wax museum in a late twentieth-century world (where one kid's suggestion of visiting a waxworks gets shot down with, "Nah, waxworks are out of date. This is the video age"). "The whole display" is indeed the ghost, an uncanny trace of a previous historical practice.

The tableau's potential for horror is further exploited by foregrounding its implicit sacrificial logic. Caplan's observation that the tableau is always "minus one" here gets a macabre twist that makes all too literal the idea that a scene only comes to life when the spectator stands in for a dead person in the display. Significantly, the spectator who enters the scene must be willing and believing, pulled by his or her desire into the scene, in order for the scene to "fill." Conversely, the heroic spectator in this film is the one who can defend himself with skepticism, as Mark does success-fully after being pushed into a tableau resembling *Night of the Living Dead* ("This isn't real! None of this is real. I was forced into this! If I don't believe in you, then you don't exist.") The exit back through the invisible fourth wall of the tableau, represented in the film as a kind of funky blue electric force field, is barred only to the *believing* spectator-victims, and once Mark realizes this, he not only manages to get out of his own display/trap but also can rescue Sarah from hers. As he puts it when he leads her back to the boundary, "This is the barrier. If you don't believe in all of this, then the barrier, it can't stop you."

Sarah's situation deserves separate comment because, unlike the wax-work's male victims, most of whom enter the displays to retrieve interest-ing objects (a fetish-driven violation of the boundaries), Sarah is attracted into her scene by the promise of a date with the Marquis de Sade. Given that the other female victim enters the Dracula display for the same reasons ("What are you supposed to be doin', handsome?" she says seductively to the mannequin), and that she, too, becomes her monster's lover-victim, it starts to look as if *Waxwork* replicates in caricatured fashion the dominant gender economy of Hollywood spectatorship (fetishistic or voyeuristic po-sitions for males, masochistic positions for females).[68] Sarah, who gets so sexually aroused once inside her display that she prefers a beating to a rescue, must be saved by Mark's demonstration that when he does not believe in the display, his body becomes immaterial (more like a cinematic

body?); bullets or whips pass right through him. His body, that is, does not have the substance that might put it at risk within the display as long as he does not believe in its reality—in effect, as long as he remains outside the display in his mind, safely anchored in the spectator's seat. His is a *threshold* body; only Sarah's naive belief and uncontrolled spectatorial desire make her own body tangibly vulnerable within the fantasy.

The film thus turns out to be an intricate excursus on the principles of tableau spectatorship. The entire plot revolves around the discovery and nullification of those laws, the attempt to prevent the vivification effect the wax tableau was originally designed to achieve. One might say that *Waxwork* ends up defending filmic distance and the immateriality of the filmic body from the horrific implications of the wax museum's earlier, obscenely material shared space of corporeal display. The historical positioning of the wax museum vis-à-vis film (the "out-of-date" waxworks versus the video age) highlights the one characteristic of the wax tableau that made it vulnerable to competition with film—the limits imposed by the mannequin's intractable physicality. Wax-museum spectatorship could never be as mobile and versatile as film spectatorship because of the inertia and resistance of the wax body. Too "present," too stiffly immobile, too *tactile*, the wax mannequin could only approximate the more complex spectatorship of moving-picture body images. The elaborate tableau techniques of the turn-of-the-century wax museum attempted (but were not able) to overcome the materiality of the medium.

It is perhaps not surprising, then, that the wax museum's nightmare scenario of entrapment should find its most consistent deployment in *films* about wax museums. In other words, there is perhaps a later layer of spectator pedagogy at work here as well. If the wax *tableau* promised spectators a more immaterial, indirect relationship to a realistic scene than they had had in the wax *cabinet*, cinema trumped that offer with a return to indexicality (the photographed status of the bodies) and a corporeal image both more present (in its motion and perfect likeness) and more absent (in its irretrievability as a recording of a past moment). The wax-museum films show the "horrors" of voyeuristic spectating that are possible when the visual object is more material than in film; cinema spectators know they will always return to their seats because the characteristics of the medium guarantee that the experience will be imaginary in the Metzian sense.[69]

The after-hours testing of the "proper" wax museum's display barriers takes one of the basic elements of voyeuristic viewing—the *imaginary* participation of viewer in a scene from a distance—and gives it an exaggerated literalism. If the encouraged form of spectating at the turn of the century is to take an unobtrusive visual sample and move on, voyeurism-gone-awry allows the immersion but not the easy return. This is modernity's background anxiety, that the increased mobility and access to distant

sights and scenes might leave one stranded far from home. It is the oscilla-
tion between "there" and "here," between "then" and "now," between
"you" and "I" that is the attraction of the wax museum and other institu-
tions of the visible at the turn of the century; when the easy movement
from one to the other failed, however, modern mobility turned from
promise to threat. The tableau technique is at the very heart of this precari-
ous balance, with its simultaneous invitation to be transported, immersed
in a scene over "there" while being assured by the formal barrier of the
fourth wall's one-way mirror that the scene could be mastered at the same
time.

CHAPTER **FIVE** PANOPTIKON, METROPOLIS,

AND THE URBAN UNCANNY

> ... it was Blom, who stopped in front of Berg
> and Lange in the middle of the crowd and half-
> kneeled while waving his outstretched hand, "So
> do we know how to do it, we Copenhageners?"
>
> "Damn, is there *atmosphere* here, or what?"
> Blom laughed, so that one saw all of his white
> teeth.
>
> "Yeah," said Lange nodding, "there's a
> 'commotion'—that can't be denied."
> —*Conversation in the crowded Copenhagen*
> *entertainment district in Herman Bang's novel*
> Stuk (1887)

THE WAX MUSEUM of the late nineteenth cen-
tury, like many of its contemporary institutions of the visible, fused two
competing modes of visual display in its pitch to the middle classes: ab-
sorption was the main course, variety the spice. The preceding discussion
has presented the techniques that made a sense of vicarious immersion
and imaginary transportation possible; what remains to account for is the
effect of shifting scenes, the panoptic aspect of the panoptikon. The view-
ing moment of any particular scene, that is, may well have had the effect
of grounding individual figures in a convincing context, but the back-to-
back juxtaposition of many such scenes could create an effect of unusual
visual mobility. In fact, the tableau's superior ability to involve spectators
in each illusory scene may have intensified the experience of spatial and
temporal contradiction in the overall display space. When spectators had
the experience of "really being there" in any number of far-flung scenes,
the accelerated rhythm of departure and return had the potential for con-
fusion as well as absorption.

The experiences of disorientation, of course, along with shock and dis-
traction, are the ones cultural historians have come to associate most
readily with the turn-of-the-century metropolis, following the lead of

Simmel, Kracauer, and Benjamin in their theorization of urban experience
in Paris and Berlin. Acceleration of traffic through the streets, new circuits
of media circulation, and the attendant onslaught of visual stimuli make
it easy to think of the late-century metropolis as the setting in which all
sense of coherence and place was rapidly disintegrating into fragments.
Using this model of the modern city, the aspect of the wax museum that
seems most metropolitan is precisely the constant shifting of scenes, as
Schwartz has emphasized with the Musée Grévin, and not the meticulous
care devoted to the coherent illusion and realistic materiality of each scene
in and of itself.

But modernity is also about an oscillation between depth and surface,
between the grounded and the ungrounded, between the "here" and the
"there." Jonathan Crary's recent work on the historical production of
attentiveness in the late nineteenth century has been extremely helpful in
pointing out various systems of counterpoint to the fragmentation and
dispersal of sensory experience. He writes that "attention and distraction
cannot be thought outside of a continuum in which the two ceaselessly
flow into one another, as part of a social field in which the same imperatives
and forces incite one and the other."[1] Crary's work makes possible a recov-
ered awareness of modern culture's compensatory moves, its struggles to
work toward structures of attention that could function in the place of the
social coherence perceived to have been lost in the transition to modernity.
Urban experience breaks down cultural coherence in part by making avail-
able potent new experiences of distant cultures that have been recorded,
captured, or simulated convincingly and made available to city dwellers.
But the genius of modern cultural logic, according to this critique, is the
next step in which urban dwellers are then told that they can live at home
and abroad, in traditional and modern worlds simultaneously—that the
modern world is powerful enough to retain coherence and offer dispersal
at the same time. (This is once again the cheerful version of "access," the
one that sees new forms of experience in touristic terms.)

The modernity of the late-century wax museum lies precisely in this
important double movement between scenic coherence and unending vi-
sual variety, and the discourse generated by the Scandinavian panoptika
(catalogues, promotional literature, journalistic accounts, memoirs) is as
likely to register enthusiasm for an overwhelming sense of immersion in
distant scenes as it is to testify of a dazzling whir of sensations (immersion
being the rough equivalent of Crary's attention, especially in the way that
it captures not just a visual relationship between spectator and scene but
a somatic one as well). For example, the same Danish visitor who praised
the gripping illusionism of the fire scene that made one feel as if "one
were right in the middle of the sea of flames" described the overall effect
of his visit as an experience that leaves "the contents of one's head shaken

loose, so that everything in there is just strewn about."[2] To put it in other terms, this is once again Anne Friedberg's idea of the virtual *and* mobile gaze; the viewer is immersed in a hyperrealistic, convincing scene, but after experiencing several such scenes in succession, one could also experience a cumulative disorientation, not an overall sense of grounding.[3]

The following will explore the contradictions of this intensified experience of both "here" and "there" at the Scandinavian panoptika. If the preceding discussion has been more comparative and general in scope, the specific cultural currency of the wax museums in the late nineteenth-century Scandinavian capitals will now be the central focus. Although the Scandinavian panoptika, like the Parisian Musée Grévin, were without question seen as quintessentially "metropolitan" when they were founded, it is important to sort out how that idea may have been understood differently in Scandinavia than in Paris, Berlin, London, or any of the leading metropolises of Europe. The experience of modernity as an import product to the geographic periphery of Europe infused the idea with a paradoxical combination of reality and fantastic projection. In addition to the uncanny effects of wax figures themselves, that is, I would claim a kind of "urban uncanny" for the panoptika and their relationship to the city.[4]

Small Big Cities

The founding of the panoptika in Copenhagen and Stockholm carried surprising cultural currency. In the minds of the public, the panoptikon was seen not only as a more refined site for the viewing of wax figures but also as proof that their capital cities had reached a certain metropolitan stature. This was a problematic claim for the Scandinavian cities. At mid-century, the capitals were, to be sure, all regional centers of commerce and culture but hardly "metropolitan" by European standards; the significant industrialization, the influx of a rural population displaced by agricultural modernization, the rapid architectural expansion, and the transportation revolution that had already begun to usher in modernity elsewhere were still a few decades distant for these countries on the northern outskirts of Europe.

In 1850, Copenhagen was the largest of the three Scandinavian capitals (population 129,000).[5] Although that population total was small by European standards, its confinement within the unusually narrow confines of Copenhagen's traditional city walls did perhaps give the impression of a more populous city, as Danish cultural historian Martin Zerlang has pointed out.[6] Copenhagen also had relatively closer economic and cultural ties to the European mainland, and often considered itself the cultural center for all of Scandinavia, or at least to be its intermediary with the

Continent.[7] Stockholm, geographically more remote from Europe than Copenhagen, had a more difficult time claiming cosmopolitan stature; as Zerlang sums it up, "Copenhagen was terribly provincial compared to London, but was a cosmopolitan city compared to Stockholm."[8] The Swedish capital had only 93,000 inhabitants in 1850, although it, too, could exert a claim of influence in the North due to its dominant role in the union with Norway, which lasted from 1814 until 1905.[9] Christiania, as Oslo was known at the time, was far smaller than either of the other two capitals in 1850, with a mere 28,000 citizens.

If the modest size of these cities in 1850 made them unlikely candidates for metropolitan status then, their explosive growth during the last half of the century makes clear why Scandinavian urban dwellers might nevertheless have begun to think along those lines. Due to a strong influx of rural citizens in the 1870s and 1880s, Copenhagen had grown to 401,000 at the turn of the century, while Stockholm's population had grown to 301,000 and Christiania's to 228,000. This relatively rapid urban expansion is all the more remarkable because it came about in spite of widespread emigration to the United States from Scandinavia during the same period.[10] Together, urban in-migration and emigration created a dramatic redistribution of population in Scandinavia. Thus the capital cities of the North, if not exactly teeming with inhabitants by European standards, had nevertheless experienced an exponential growth that fostered fanciful comparisons with London, Paris, and Berlin.

The population shift to the cities entailed sometimes hectic construction activity that attempted to remake the cities in the model of existing European metropolises. Paris exerted the most direct influence, in part because of its own recent transformation at the hands of Baron Hausmann in the 1850s and 1860s.[11] In Copenhagen, cafés and buildings with mansard roofs and stucco decor sprang up along Vesterbrogade throughout the 1880s, including the new Panoptikon building (see fig. 1.5). Such architectural details, comments Copenhagen city historian Caspar Jørgensen, were meant "to remind of Paris, which stood as the symbol of a modern metropolis." He further characterizes Vesterbrogade itself as "the city's only congested boulevard in the best Parisian style."[12] In Stockholm, urban planners modeled their own *esplanadesystem* of urban renewal even more directly on the Hausmann model, widening and redesigning streets to accommodate increased traffic flow and urban growth.[13] From the 1870s to the mid-1880s, the regulation, renaming, and remodeling of streets were guided by the motto "air and light" (*luft och ljus*), which in addition to its social-hygienic overtones, was also meant to remind of Paris, the model "city of light."

Carl Muusmann, noted Danish journalist and *flâneur* of late nineteenth-century Copenhagen, describes in his memoirs the fascination

Paris held for Copenhageners, especially in the late 1880s, when both cities hosted industrial exhibitions. Copenhagen's 1888 exhibition had attracted more than a million foreign visitors and was perceived to have showcased successfully the rapidly developing Nordic "metropolis." Muusmann remarks that when he returned from the Parisian international exhibition the next summer, he saw people on the streets of Copenhagen whom he had just greeted weeks earlier on the boulevards of Paris: "There was an echo of Paris over Copenhagen, just as there had been an echo of Copenhagen over Paris during that [previous] summer, and I truly felt as if I had never been away, or rather as if these two cities, which for me have remained the most precious, had been taken up in a greater unity."[14] Muusmann overestimates the reciprocity of the relationship here, but his perception of Copenhagen's new international importance is interesting in its own right.[15]

The new panoptikon in Copenhagen was seen by Danes as proof that such metropolitan aspirations were not misplaced. When it opened its doors in early August 1885 to an eager Copenhagen public, it was welcomed as "an especially happy addition" to the urban sights (*Seværdighederne*) in the Danish capital.[16] The enthusiastic local press had in fact discussed the new wax museum far in advance of its opening. As one reporter put it on opening day, "When the word Panoptikon was first mentioned a couple of years ago and it was rumored that Copenhagen would be blessed with one, everyone got interested and wanted news about it. And the papers competed in indiscretion. They told far and wide of the anticipated splendors."[17] Muusmann remembers the sentiment in this way: "The idea gradually came about that Copenhagen, which was on the verge of entering into the league of the European metropolises, also ought to have a genuine panoptikon, like Castan's in Berlin, Grévin's in Paris, and Madame Tussaud's in London."[18] The location of the first large nineteenth-century wax museums in the three most populous cities in Europe seems to have created an irresistible logic for pretenders to the title of "metropolis," as if having a panoptikon were a kind of necessary prerequisite, as important an element of urban mise-en-scène as the crowds, electric lights, telephones, industry, or new systems of transportation.[19]

In Stockholm, some journalists perceived the arrival of their new panoptikon in 1889 even more clearly as certification of a successfully completed urbanization project. Its location in the Kungsträdgården district likewise placed it in a recognizable constellation of bourgeois entertainment.[20] The large rectangular park at the center of the district had been an upper-class promenade area in the early 1800s (and before that a royal parade ground), but it was rapidly attracting more middle-class visitors who took pride in the new "cosmopolitan" developments. As one reporter put it in 1888:

> Through newspaper articles our readers have likely already become familiar
> with the fact that during the first half of next year, our capital city, among
> its many other metropolitan-like [*storstadsaktiga*] institutions that have
> arisen in recent times, will be able to count a panoptikon, in which images
> from all times and various countries' histories will be reproduced with the
> greatest exactitude, and famous personalities from near and far will be repre-
> sented.[21]

Since wax effigies had been available to Stockholmers at the traveling wax
cabinets for decades, the attraction here was clearly the added develop-
ment of having in native form the sort of richly furnished, respectable wax
museum that one used to have to travel to Paris or London to see.

 In the relatively remote Swedish capital the possession of a wax museum
was seen as evidence of increased contact with Europe as well, proof of
that city's inclusion on the circuit of international cultural circulation.
Here is another reporter's heady response to the Swedish Panoptikon's
opening in Stockholm:

> Isn't it a metropolis [*storstad*] we live in now, you might ask? A city at the
> height of European culture? We have electric lighting and spiked helmets.
> We have public meetings and election campaigns. We have conferences of
> Orientalists with the whole world's most learned men and women in coats,
> not less learned. We have a winter circus—which is closed, to be sure, but
> which exists nevertheless. Now we have gotten a Panoptikon, and before we
> will have managed to see our fill of that, we will get a giant panorama. If
> the metropolis is not completed then, then it won't be until the year 1892
> comes along with its huge exposition, its thousands of visitors from all the
> countries of the world and its millions rolling into the pockets of Stock-
> holmers.[22]

The wonder expressed here is that cozy Stockholm could have the power
to attract everything from an international scholarly conference (sched-
uled to take place a month later in September 1889), European political
trends (democratic liberalization), a permanent circus, and an interna-
tional exposition. This eclectic list of "proofs" is followed by a detailed
description of the new wax museum in the body of the article, which ends
with the line "But everyone is convinced that their city is a metropolis."

 The opening line of the preceding quote actually turns out to be a stan-
dard introduction in the period's illustrated weeklies for articles dealing
with any new development on the city's visual cultural front. Another
article about the Swedish Panoptikon takes the same tack ("Stockholm
is beginning more and more to be a metropolis [*storstad*]"[23]), and one
detailing the opening of a new department store sounds almost identical
in tone:

The past few years have shown that Stockholm in more than one sense increasingly deserves the name metropolis, not only due to the steadily increasing stream of tourists, the newly arranged Orientalist Congress, the telephone company's well-nigh unprecedented development, elevators, railway connections, and streetcar systems and the like, but that we also in the area of taste and fashion could compete favorably with more than one of the cosmopolitan cities.[24]

The new store itself was so elegant, the article continues, that one could "believe oneself to have been transported to the city of the Seine," demonstrating that the very idea of cosmopolitan institutions could create effects of virtual mobility.[25]

When Stockholm's international exhibition finally took place in 1897 (not in 1892, as anticipated in the earlier quote), the Swedish Panoptikon took advantage of this showcase of Swedish industry, technology, commodities, and urbanity to promote itself as a necessary stop on the tourist itinerary. A special catalogue from 1897 proposes a five-day tourist itinerary for the exhibition, with the Swedish Panoptikon scheduled on the first morning. More interesting than this bit of self-promotion, though, are the other urban attractions the Swedish Panoptikon included in its suggested tour of modern Stockholm: the National Museum (an art museum), the natural history museum, the Nordic Museum (the indoor folk museum), the royal palace, churches, theaters, Skansen (the open-air folk museum), Stockholm's Tivoli, and the exhibition itself.[26] As a veritable map of Stockholm's institutions of the visible, the itinerary gives a good sense of the cultural constellation to which the panoptikon was perceived as belonging. Copenhagen's panoptikon had published a similar map of the city for its exhibition visitors in 1888, with special emphasis placed on the wax museum's position adjacent to the exhibition site.[27]

The most obvious aspect of the panoptikon that linked it with the metropolitan in the popular mind was its visual variety. At the panoptikon one could see many of the same miscellaneous sights that characterized the city, such as displays of a familiar corner newspaperman, or of the Stockholm *flâneur* Soto Major, or of the Opera Café, the original models for which could all be found literally right out on the street in front of the Swedish Panoptikon in Kungsträdgården. In this sense, the Scandinavian panoptika followed the Musée Grévin's lead in documenting urban sights in a journalistic fashion. Bernhard Olsen writes in his first panoptikon catalogue: "People have called the modern Panoptikon a plastic newspaper, a companion to the graphic illustrated newspapers. The word is well chosen, because one finds here all of the journalistic rubrics: life at court, in politics, in the theater world, in literature and art, modern life, and the day's history-making events."[28] The panoptikon's shifting scenes and

juxtaposition of effigies, its seemingly unlimited virtual access to the world, and the international currency of many of its celebrity subjects evoked not only the idea of the newspaper but also that of a newly minted metropolis in the modern, Parisian sense. By gathering in such a wide variety of sights and celebrities, the panoptikon could claim to do what all great metropolises do: it could serve as a magnet for the rest of the world, past and present, and lay it all at its citizens' feet. The collection of effigies at the panoptikon not only flattered the spectators, who received the various celebrities into their presence, but also complimented the museum and the city more generally, by imputing to them the power to attract so many famous figures from distant lands.

A spectator's progress through the panoptikon also mimicked the flow of city traffic. One Swedish reporter used precisely that sort of language when he described the experience of visiting the new museum on opening day: "You go up the steps to the second floor and find yourself suddenly face to face with the President of the French Republic"; "Just a few more steps and you stand before his majesty and the entire royal family"; "In a little anteroom you run into a person well known to all Stockholmers"; "A few steps from there and you stand suddenly before the dashing General Boulanger"; and "Right next to that, one runs into a man with a high hat on his head."[29] The logic of the street is reflected in these narrative transitions, with their sense of surprise and haphazard flow—as on the street, one never knows who one will meet in a scene at the panoptikon.

In Copenhagen, the Scandinavian Panoptikon's location on the new quarter's most emblematic boulevard gave it added currency as a symbolic center of the imagined metropolis. One journalist even devoted an entire article to the view from the Panoptikon's roof, which he chose as the prime vantage point for taking in the panorama of the new city in 1885:

> Copenhagen looks different from here than when seen from the Round Tower. The Copenhagen we see from the Round Tower—assuming we see anything at all—is the old hazy Copenhagen with its narrow, twisting streets and cramped, dark courtyards. The Copenhagen we see from up here on the Panoptikon's roof is the new Copenhagen, the Copenhagen that has shot up out of the ground during the last decade, still growing rapidly with wide, orderly streets, showy buildings, and lots of spires, towers, and ornamentation.[30]

The rhetorical contrast here between the Panoptikon and the Round Tower, the vantage points of the new and old cities, shows how closely tied Copenhagen's new wax museum was to Vesterbro and the modern metropolis that Copenhagen was on the verge of becoming. Everything about the new building positioned it at the nexus of metropolitan thinking and fantasies.

These connections between the panoptikon and the new modern city were especially insistent in Scandinavia, since the founding of the wax museums in the 1880s and the main push of urbanization there were very nearly concurrent. To be sure, modernity and the wax museum went hand in hand in Paris as well, as Vanessa Schwartz has shown, but without the compressed time line or the anxious sense of the city needing to prove itself as a metropolis, as was the case in Scandinavia. The Parisian model was experienced differently, that is, when it was imported to the northern European capitals; the panoptikon became a screen for a particular kind of urban experience, borrowed conceptually from abroad but experienced locally under conditions that sometimes fell short of the international model. The city images projected onto the Scandinavian panoptika were thus still home movies in important respects.

"*Isn't* it a metropolis we live in now?" The Swedish journalist's question remains hanging in the air, perhaps leaving more room than intended for doubt. Amid all the boosterism of the metropolitan discourse outlined here, one can find tiny moments of uncertainty, cracks in the smooth facade of proclaimed urban progress. Claës Lundin's ironic story of accountant Andersson at the Swedish Panoptikon's opening has given some indication of possible slippage in the confident metropolitan fantasies of fame and immortality. Another of his journalistic sketches in the same collection, "From the Throne of the Mälar Queen," goes further in taking up the negative sides of the modern city.[31] This little morality tale follows the fate of a naive rural couple arriving in Stockholm so the husband can find work in his chosen field of journalism. At first the members of the family are entranced by the glitter of Stockholm's shop windows and late-summer café life (the Parisian facade), but they soon begin a free fall into grinding poverty. The only available job turns out to be not reporting but late-night clerking and copyediting. After months of hunger and disillusionment, the family finally bails out of city life altogether and with a palpable sense of relief returns to the country. As the narrator puts it at one point, "The big city was for the Petrén family a huge, terrifying grave" (124). The metropolis is not always able to absorb everything and everyone; here and there one finds a stubborn provincial trace that remains unassailable.

Taken together, the anecdotes of Stockholm's urban life in *Stockholmstyper förr och nu* are in fact full of this kind of double movement. On the one hand, Lundin seems to appreciate the coziness of Stockholm's cultural scale. In the introduction to the collection, he writes: "Stockholm is a large city, but even so people seem to know each other quite well there. At least that is how it seems out in Strömparterren, at Berns [café], at Operakällaren. One nods to the right and the left, calls each other by name, is 'brother' to the whole world, so it seems. This is Stockholmian

[*Dette är stockholmskt*]" (9). This same intimacy, however, shows up elsewhere in the story collection as an incurable provinciality—the city seen from the perspective of the Parisian looking in from the outside. Lundin himself had spent the years 1859–66 as a journalist in Paris and retained close contact with the French press after he returned to Stockholm. His own acquired Parisian gaze gives his writing about Stockholm life a kind of double consciousness, assessing the culture from both within and without simultaneously. The same could be said of much of Scandinavia's cultural elite in the 1880s and 1890s, a remarkable proportion of which had spent time as writers, artists, and *flâneurs* in Paris. Henrik Ibsen's well-known contrast between the Parisian "joy of life" and Norwegian provinciality in *Ghosts* is but one example of this more general view.

Carl Muusmann could in many ways be considered Claës Lundin's Danish double—both were Francophile journalists who described with great interest the metropolitan project of the Scandinavian capital cities in the 1880s and 1890s. Muusmann was perhaps less self-aware of his Paris envy, to use a clinical pun, but he provides an appropriate term for the in-between status of the Scandinavian cities in one passage from his memoirs. Explaining that new districts were annexed in Copenhagen after 1890 largely to increase population and to bolster the metropolitan claim, he writes, "But since it secretly gnawed at us to reach 500,000 so that we could be counted among the small metropolises [*smaa Storstæder*], we annexed Frederiksberg, Sundbyerne og Utterslev and reached a total of 375,719."[32] The oxymoronic status of the term "smaa Storstæder" is more apparent when the compound is taken apart for English translation, producing the awkward phrase "small big cities." In the suspended contradiction of that term one can read both a recognition of the limits of the metropolitan aspirations and the palimpsestic map of Paris underneath the newly conceptualized Scandinavian capitals.

Urbanity and Orientalism

The doubleness of the Scandinavian metropolis is also the point of Martin Zerlang's recent research on Orientalism at Copenhagen's Tivoli amusement park. The Orientalist decor and architecture that pervaded the park from the very beginning have been seen by most as romantic escapism pure and simple, but Zerlang argues convincingly for the modernity of its effects. The crowds, the mingling of classes, and the encounters with the unfamiliar, Zerlang claims, allowed visitors to Tivoli to perform a metropolitan role-play, to practice in a safe setting the skills of modern life. Here one could "experiment in visual interaction" and practice urban crowd behavior at the same time as one performed a kind of cultural masquer-

ade.[33] Tivoli was "a little model city, a city-within-the-city, a city which like the old Copenhagen was surrounded by ramparts and moats, but which at the same time, like the Copenhagen of the future, strove for openness and wide perspectives."[34] In this sense, he argues, Tivoli paved the way for modernity's arrival in Copenhagen: "Here, in modern and commercial conditions, you got a palliative for the modern, commercial lifestyle."[35] One got a controlled dose of Danish-mediated exoticism, an experience marked by both a piquant spice of otherness and reassuring familiarity. In corporeal terms, one could say that Tivoli was a foreign growth on the city body that was nevertheless nourished and sustained by its host.

The idea of role-play is especially important to Zerlang's reading of Tivoli, since implicit in that notion is not only the theatricality of the spectator's part but also the recognition that a "real identity" is always lurking underneath. It allows the player to have one foot in both worlds, to experience both a "here" and a "there." The theme-park aspect of Tivoli, that is, allows a convincing transportation to another space and time while retaining enough awareness of home to make the travel unthreatening. Thus, although the exotic seems to be the most important aspect of Tivoli's Orientalism, Zerlang is quite right to emphasize the important things this role-play reveals about the Danishness just beneath the surface. As he puts it succinctly, "Here you could experiment without putting your existence at risk. Mentally disguised as a Sheik or a pasha or an odalisque the Copenhagener could enjoy modernity in quotation marks."[36]

Claës Lundin mines some of the same conceptual field in another sketch from *Stockholmstyper*, this one entitled "Den sagolika paschaen" (The Fabulous Pasha). The setting is Stockholm's Orientalist Congress of September 1889, which, as mentioned previously, served many Stockholmers as an emblem of modernity's arrival to their city. The congress participants included foreign scholars and dignitaries from the Middle and Far East, whose visible presence in Stockholm caused quite a stir. Lundin begins his story by detailing the currency that various kinds of foreigners had in Stockholm. Southern Europeans, he writes, used to be sufficiently foreign for Stockholmers a few decades earlier and would attract public attention merely by walking down the street (one is reminded of the popularity of the Portuguese diplomat Soto Major, whose effigy was displayed at the Swedish Panoptikon). By 1889, however,

> one is not surprised at seeing an Italian or a Spaniard in the market square, and other Europeans are noticed no more than a person from Gothenburg, and certainly much less than a real mill owner. Now a foreigner must be a non-European, and that doesn't even help if he comes from America and goes around dressed like the Stockholmers themselves. If on the other hand he comes from Asia or Africa, is yellow or brown in the face, has a turban

or at the very least a fez, wears skirts . . . and speaks some language that nobody but professor Herman Almkvist understands—then he can be sure to attract attention.[37]

Lundin's ironic account of Stockholm's inflationary scale of "foreignness" as the city becomes more connected with the world emphasizes the importance of surface signs like skin color and unusual dress, which in a culturally homogeneous culture like Sweden would seem to be secure indications of foreign origin.

Lundin's pasha story describes a typical Stockholmer who is trapped in this premise, a hotelkeeper named Fru Holm who finds her establishment honored by the arrival of one of the congress's participants. Like other Stockholmers, she reacts to this development with "the most sublime mixture of ghastly fear and wild rapture for the remarkable thing that had come to the city" (183). Based on the appearance of the striking red fez worn by her guest, "an indisputable sign of oriental origin and participation in the congress" (169), Fru Holm decides that a real pasha has come to stay at her hotel. She waits in vain as the week progresses for the mountains of luggage and the cortege of slaves and harem girls that she assumes must be soon to follow her pasha to the hotel. The pasha never speaks to her, increasing the level of mystery to the point that the hotelkeeper begins shadowing him throughout Stockholm. What she eventually discovers is that her "fabulous pasha" is in truth a Swedish tobacco salesman from Alingsås, who had come to Stockholm to capitalize on the Orientalist fever. The registration signature that she had read as "Abba's Pascha" was actually "Albert Paulson"; the fez she had taken as an "indisputable sign" was part of a masquerade costume he had worn years earlier. The salesman had been suffering from a bad case of laryngitis upon arrival to Stockholm but now speaks to Fru Holm in Swedish with a perfectly native accent.

Like the readers of the story, "Pasha" Paulson is amused at Fru Holm's misunderstanding and tells her: " 'Pasha! Ha, ha, ha! . . . To be sure! I am a participant in the Oriental Congress, and everyone there is a pasha. There I have met Pasha Bergström and Pasha Strömberg and Pasha Andersson and many others of the same type" (191). The joke of Lundin's entire story is that almost everyone and everything that had appeared to be intoxicatingly oriental was actually someone native in costume. The culminating dinner party of the exotic Oriental Congress, meant to be a "brotherhood feast for East and West," actually turns out to be "a genuinely patriotic [fosterländsk] ceremony with a few decorative Oriental figures," Lundin remarks wryly (196). His amusing story unveils the Orientalist fantasy as the provincial in disguise, using the commonsense logic that behind the theatrical facade one can find the real, in this case the small-scale capital city caught up in delusions of internationalist grandeur. The story talks

sense into the metropolitan role-player by showing the inexorable return of the real, but it still gives a token nod to the power of the fantasy with the final sentence: "Then he [Paulson] went back home to his country, but at Fru Holm's hotel and in the entire neighborhood, people still talk about the fabulous pasha."

Zerlang's take on the Orientalist role-play at Tivoli is that it provided a release valve, a "palliative" for the experience of modernity that gave both instruction in modern life and relief from it at the same time:

> The invitation to stop and linger was actually the commodity most in de-
> mand with a public who had an increasing need to balance the stress of
> urban life, "neurasthenia" as it was termed in 1869 by an American patholo-
> gist, with the temporary relaxation provided by amusement parks, variety
> theaters, wax cabinets, illustrated magazines, and other parts of the emerg-
> ing "show business."[38]

As his argument develops, the "palliative" metaphor yields to one of inoc-
ulation. In Tivoli's Orientalism, he argues, "One experienced what was almost an inundation of the senses, whilst also drugging oneself against the swarming streets, the noise of the factory and the other threatening aspects of the new reality." This would certainly be more likely at the Tivoli of the 1880s than in the 1840s; at this earlier stage such urban pressures were still more imagined than real in Copenhagen. But what of the "wax cabinet" Zerlang includes in this same general vaccination program? Did visitors to that institution find protection from modern stimulus by receiving a controlled dose of the same?

To get at this question, it is striking to note that the wax museums in Scandinavia adopted some of the same Orientalist strategies as did Tivoli. The Swedish Panoptikon in Stockholm, for instance, soon acquired a smaller rival in the form of the Oriental Maze Salon, Eden Salon, and New Panoptikon (*Orientaliska Irrgångs-salon, Eden-Salong, og Nya Panopti-kon*), located at Hamngatan 18B adjacent to the Sveasalen variety theater. This new attraction, founded by the sculptor R. Sundell, opened in Janu-ary 1890, just five months after the Swedish Panoptikon opened across the way in Kungsträdgården. The main attraction here was initially a laby-rinth in which visitors made their way through a series of forty different floor-to-ceiling mirrors put at various angles to each other (more on this in the following). Later the same year Sundell added the Eden Salon, which was a combination mirror hall and greenhouse, with six hundred mirrors and exotic plants, fountains, and lighting.[39] A year later, visitors could also enjoy a tropical garden room and a series of wax tableaux de-picting harems (fig. 5.1) and allegorical scenes, such as the one called "Dawn" (*Morgonrödnad*; fig. 5.2).

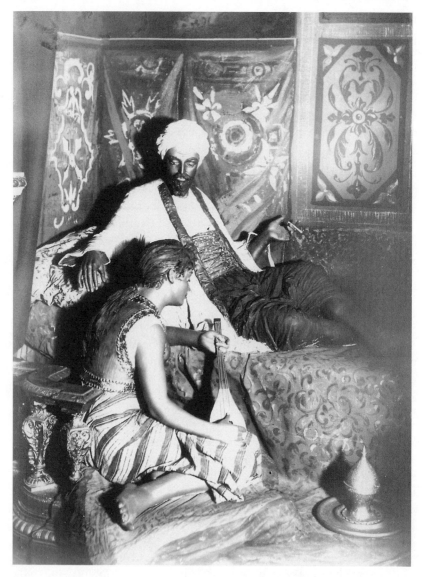

FIGURE 5.1. One of the harem tableaux at the Oriental Maze Salon in Stockholm, 1892. Photo courtesy of the Stockholm City Museum.

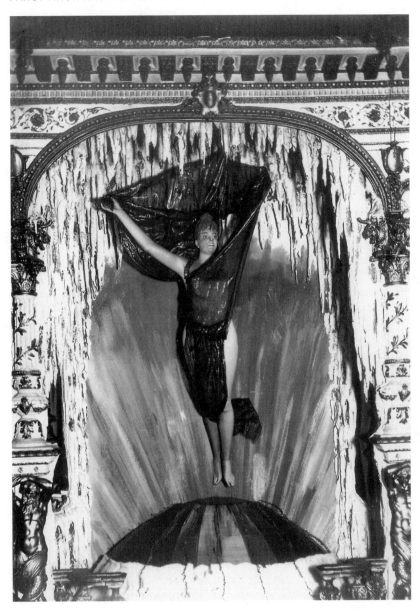

FIGURE 5.2. "Morgonrödnad" (Dawn) at the Oriental Maze Salon in Stockholm, 1892. Photo courtesy of the Stockholm City Museum.

Unlike the Swedish Panoptikon, this attraction devoted itself almost exclusively to Orientalist fantasy, and visitors enthused about the effect of being transported to such exotic spaces. There were tropical plants growing in the middle of winter, there were fountains, colored lights, and warm breezes. In one account, a reporter emphasizes the stark contrast of the experience when in late November he stumbled snow-covered into this "paradise" in the middle of Stockholm. Another describes his exit back onto the Stockholm street as a return to the Western world.[40] The return of Orientalism at Stockholm's second panoptikon suggests that a modern logic of recording may have given earlier forms of romanticist Orientalism new life. "Theme" experience was not new to the turn of the century, but stronger claims could be made about the virtuality of the space when it was surrounded by recording devices and other hyperrealistic modes of representation. The availability of a space like a garden oasis in the midst of the dark Stockholm winter, when linked to the indexical connotations of the mannequin and its backup accessories, created fertile new possibilities for imagining the gathering in of distant scenes.

The domestication of the exotic foreign was also, as I have been arguing, an essential part of the metropolitan thinking in the Scandinavian capitals. Zakarias Nielsen's account of his visit to the Scandinavian Panoptikon in 1886 slips in a useful metaphor for thinking about the dynamic of home and abroad in the "small big cities":

> One's head reels and gets tired from all this splendor and glowing color, this eternal shifting of scenes and episodes [*denne evige Vexlen af Scener og Optrin*]; one has the impression of having traveled around the world and had the contents of one's head shaken loose, so that everything in there is just strewn about [*saa det ligger hulter til pulter derinne*], awaiting repose to sort it out. But one feels that many an impression will stay firmly in place, and that at home in the corner of one's living room [*hjemme i Stuens Krog*] one will time and again pull faces and groups out of memory's hiding places and lose oneself again in the throng of sights from this interesting museum.[41]

The disorientation described here is both marvelous and overwhelming, and seems to have left Nielsen feeling a bit too exposed to nervous stimulation. Tellingly, his reaction to the disorientation of his "world travel" is to retreat to the domestic sphere; only there does he anticipate being able to order the experience through an act of reflection. The corner armchair provides a superior vantage point from which to get "lost" in the museum, a more attractive form of mobility. If the actual experience of visiting the panoptikon was like that of walking on a crowded city street, that is, the later reflection upon the experience was more like browsing through a memory photo album in one's own living room. At home and abroad at

once, the domestic urbanite manages an increasingly complex and poten-
tially unnerving metropolitan experience with a kind of photographic
control.

The tension between city and home plays itself out in the Swedish Pa-
noptikon's discourse as well. Two of the initial newspaper reports at the
opening compare the new Swedish wax museum with its already renowned
Danish neighbor, and in doing so emphasize the local feel of their emphat-
ically *Swedish* Panoptikon. One states: "You won't find any exaggerated
luxury here, but everything is nice and comfortable, giving almost the
impression of something homey [*hemtrefligt*], with soft carpets, inviting
divans and a pleasant, subdued lighting."[42] Another uses the same term:
"It is quite homey [*hemtrefligt*], our panoptikon. The rooms are not as
splendid or impressive, here there is not the magnificence or variety which
distinguishes the corresponding establishment in Copenhagen."[43] The lat-
ter observation, interestingly enough, comes in the same article as the
most enthusiastic welcoming of the metropolis ("isn't it a metropolis we
live in now?"). The recurring term in both accounts, *hemtrefligt* (homey,
cozy, comfortable), indicates that Swedish visitors to the new wax museum
conceptualized it as somewhere between home and metropolis—local
enough to seem familiar and expansive enough to seem cosmopolitan.

The importance of the domestic for the panoptikon's metropolitan
role-play is similar to the combination Anthony Vidler points to in his
fascinating collection of essays on the "architectural uncanny." Vidler's
contribution to the literature on the uncanny is to move the idea beyond
its usual gothic frame of reference and into a modern one. For Vidler, the
"unhomely home" is the essential spatial expression of modernity—a
home made strange, a home recently put in quotation marks. Vidler lo-
cates the architectural uncanny on two fronts: in the haunted house, with
its mixture of domestic comfort and secret horror, and in the modern city,
"where what was once walled and intimate, the confirmation of commu-
nity—one thinks of Rousseau's Geneva—has been rendered strange by the
spatial incursions of modernity."[44] In this estrangement from both home
and city, Vidler finds the evocative juncture that typifies the experience of
modernity.

Copenhagen of the 1850s works as well as Rousseau's Geneva as an
example of lost community, since it, too, was "rendered strange" by the
removal of its city walls. Zerlang quotes a Danish source from 1873 that
highlights the lost sense of home from the Copenhagen of thirty years
before: "One can characterize the difference between now and then in
these few words, that at that time one felt at home [*hjemme*], both in one's
own house and that of one's friends, and that now one is always abroad
[*ude*], both with respect to one's circle of friends and to oneself!"[45] Copen-
hagen poet Hans Vilhelm Kaalund seems similarly adrift in his poem

"When They Tore Down the Ramparts" from 1877.[46] In that text, the poet tries out an initially cheerful greeting of modernity's arrival ("Everything will now disappear for the New / we need space for the crowds"), but he conveys increasingly both a barely concealed apprehension about the city's new exposure to "current and wind" and a twinge of nostalgia for what has been lost ("For me it is like a melancholy dream, / when I look back / from the wild, bubbling current of the present / on those old days").[47] In Kaalund's poem, the new, unprotected city body is on the one hand liberated from its "tight armor" when the walls come down, but on the other is stripped of its beautiful "green garland" (the tops of the embankments that had become parks and promenade areas).[48] The removal of the walls represents both progress and loss in the poem, and Kaalund's indecisive stance is typical of the reactions to a city space made "unhomely."

The complex of issues gets a further twist when one considers anecdotes about the fate of the wax figures of both panoptika after their closing auctions. In both cases, figures are reported to have ended up at the remote homes of eccentric collectors. In Denmark, some of the unhoused mannequins ended up on a farm in North Sjælland, where they were "procured by their owner for the express purpose of brightening up his rooms. At various places in chairs and on sofas sat princes, refined and famous people, statesmen and renowned politicians with stiff wax faces and staring eyes. Until the man's death, they made up his main social interaction."[49] In Sweden, reports circulate that some of the auctioned figures ended up in summer cottages and shop windows, but "the Royal Family was apparently gradually collected by a well-known squire in Nordland and has now and again been sitting at table when the doors were opened for eagerly waiting guests!"[50] Even if both stories have only anecdotal currency, that in itself suggests that it grabs the imagination to picture such cosmopolitan celebrities ending up stranded in a rural domestic setting. The uncanny appeal of this scenario comes from the return of the mannequins from a museum to an oddly familiar setting. Like celebrities whose fame has faded, they live out their old age in obscurity at "home."

It was the Scandinavian experience of the "small big city" that gave special resonance to this idea of being left stranded between home and abroad. When we recognize that the Scandinavian capitals did not experience precisely the same kind of modernity and urbanization that was felt elsewhere, we become more aware of the discrepancy that resulted when the smaller-scale material conditions intruded on fantasies of metropolitan expansion. Helpful in this regard is an idea like Marshall Berman's "modernism of underdevelopment," which he develops in his cultural analysis of St. Petersburg. Berman is interested in the modernity that developed

late and off-center, away from the major Western cities, because in that context modernity's contradictions are more apparent and its articulation more pointed. Although Berman's St. Petersburg surely represents one of the more extreme cases of disparity between the real and the imaginary, the idea is useful for the Scandinavian cities as well because they, too, found themselves initially watching modernity's development from abroad. Most interesting is the formulation Berman provides: the modernism of underdevelopment "is forced to build on fantasies and dreams of modernity, to nourish itself on an intimacy and a struggle with mirages and ghosts."[51] The fact that such fantasies should be played out at the wax museum, I will argue in what follows, has everything to do with its status as a corporeality show where the "struggle with mirages and ghosts"—in the form of effigies and reflected mirror images—was given center stage.

The City in the Mirror

Wax museums today make liberal use of mirror effects as visitors make their way through the museum space. Turn a corner, and you see a body; a second later, you realize it is not an effigy but a reflection of one in a mirror-lined wall, or perhaps it is your own image where you expected to see an effigy. Such optical tricks reinforce the wax museum's ongoing investigation of corporeality by encouraging the visitor to be on guard, not to make assumptions about the substance of the bodies encountered there. Like the decoys, such mirror games only became possible in the regularized space of a permanent locale, where they could serve as counterpoint surprise to the gathered space of the tableau.

Mirror games could be found throughout the Scandinavian panoptika as well. Some could be found within the displays themselves, contributing to the hierarchy of images within the scene, as was the case with the mirrored statue in the Soto Major display (see fig. 4.14) or the mirrored body of the visitor interpolated into the Royal Family display discussed earlier. Others were distorting mirrors of the fun-house variety, in which the spectator was encouraged by the catalogue to take a peek for a bit of comic relief:

> After you have seen enough of Rolla, step back a few steps and observe your own image in the long mirror to the left; if you are unhappy with your small size, then you can easily enough find yourself to be long enough. If you are further unhappy with being too tall, then go right up next to the mirror across from Rolla, and you will suddenly find your size shrunken to the degree that you feel satisfied. And finally if you are vexed by your corpulence,

then place yourself in front of the heating stove next to the figure "Enjoyment" (modeled by Agnes Kjellberg) and look at yourself in the third of the fun-house mirrors, then you find that you look smart enough.[52]

The fun-house mirror (*fixérspejl*) described here is, of course, now a standard feature of amusement parks and carnivals. In the context of the panoptikon, however, its games of corporeal distortion resonated with the more general activity of assessing bodies and effigies. Here, too, is a kind of joke logic when the viewer, who has been encouraged throughout the panoptikon to evaluate figures for degrees of likeness, finds in the mirror not his or her mimetic image but a distorted one.

One might say that the metropolitan fantasies outlined earlier are also the product of a distorting mirror. When the real leaves something to be desired, the projected image can compensate for the shortcomings. The connection becomes even more apparent at the panoptika after 1890, when sophisticated mirror labyrinths opened in both Stockholm and Copenhagen, reportedly following the lead of the wax museum in Berlin.[53] Like the panoptika themselves, the mirror mazes in the northern capitals were relatively luxurious affairs pitched at an ascendant middle-class audience. The first of them made its debut in Stockholm at the Oriental Maze Salon (fig. 5.3). In the photograph shown here, one can see the lion heads and arabesques of the decor multiplied infinitely to create deceptively long passageways in the locale.

The success of the Oriental Maze Salon in Stockholm led Bernhard Olsen to see the potential of the idea, and he opened his own mirror maze in the Scandinavian Panoptikon soon afterward.[54] Like his Swedish colleague, Olsen emphasized the exotic by installing a maze (which he called the "Spejlkabinet") and a luxuriant "Palm House" with mirrors (fig. 5.4). He also had a room called the "Kaleidoscope," which seems to have been a triangular space with winding iron staircases in each of two corners. The walls, floor, and ceiling were all lined with mirrors. At the top of the staircase was a platform, joined to the other descending staircase, from which the viewer could look up, down, and across, seemingly into infinity in all directions. The promotional material for Olsen's mirror rooms boasts of the twenty-five hundred square feet of Belgian glass used in the rooms and the intricate craftsmanship of the design. (If the high display standards at Olsen's Danish Folk Museum are any indication, this was likely not an inflated claim.) One reporter writes somewhat chauvinistically after the opening, "The result that is achieved here in a relatively small space is truly amazing, and just as our domestic Panoptikon is superior overall to Grévin's and Castan's, the workmanship at the cabinet of mirrors is so thorough and striking that there is hardly any equal to it in all of Europe."[55]

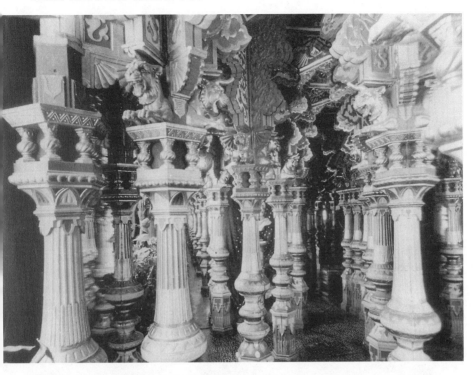

FIGURE 5.3. The Oriental Maze Salon mirror labyrinth at Hamngatan 18B, 1890.
Photo courtesy of the Stockholm City Museum.

One of the strongest resonances of the mirror maze with the discourse
of modern metropolitanism was in fact the way it could convert a small
space into a grand expanse. The more general metropolitan project of the
Scandinavian cities, which itself was a kind of magic trick that would make
the small seem large and the provincial cosmopolitan, can be read against
one of the most common visitor reactions to the mirror halls: a fascination
with the seeming expansion of small spaces into infinity. Nearly every press
description of the mirror halls, for example, takes pains to give the actual
square footage of the locale and contrasts it with the much larger perceived
space—one report invoking the domestic-foreign comparison by charac-
terizing the actual space as "no bigger than a common dining room
[*spisestue*]."[56] When Bernhard Olsen further emphasizes the mirror's
"enormous liberating ability, its power to tear down walls, to break open
ceilings, to make short distances long and narrow rooms infinite,"[57] we
find ourselves right back in the discourse surrounding Copenhagen's own
recent wall razing and urban "liberation."

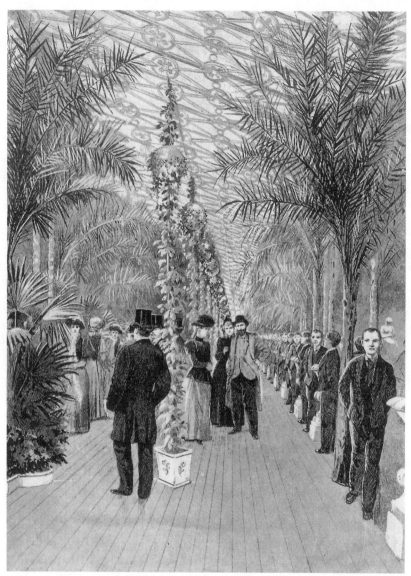

FIGURE 5.4. The "Palm House" hall of mirrors at the Scandinavian Panoptikon, 1890. Illustration from *Illustreret Tidende* (16 November 1890). Photo courtesy of the Royal Library (Copenhagen).

Not only could the small space be made big at the hall of mirrors, but its endless proliferation of single images could turn the individual into a crowd. The importance that might be attached to this becomes clear when one thinks about the population disparity between the real urban conditions and the Parisian-sized mental map of the city. In spite of the fever pitch of the crowds that Herman Bang describes in *Stuk*, his novelistic picture of the financial speculator's Copenhagen of the 1880s, a good number of archival photographs of the Vesterbro area at that time show the new boulevard in place, but with almost deserted streets. To be sure, photographers may have tried to avoid the crowded times of day, since relatively long exposure times tended to create ghosts out of moving subjects. But it is precisely the difference between a photograph of the city street and a drawing (or novelistic description) that is worth considering, since the hand-drawn illustrations of Vesterbrogade (like the one shown earlier as fig. 1.2) might easily exaggerate the size of the crowds in a way that a photograph could not. Unconstrained by the photograph's indexicality, an illustration could populate the depicted urban space at will. The hall of mirrors, like an illustration, could play a suggestive role in helping visitors to imagine the metropolis that might not quite be there in actuality outside, but which they expect and hope will be there soon. The Parisian-sized crowds that might be missing on the streets, that is, could be found inside through the hall of mirror's optical illusions.

Many visitors did in fact describe the experience of a visit there as a sudden population explosion. A reporter for Copenhagen's *Dagbladet* described his impressions this way: "One finds oneself in a space of seemingly infinite expanse. Here a small number of people become myriads; it is as if one were standing in the middle of the large hall at the Hamburg stock exchange when it is tightly packed with people. There seem to be no limits in height or depth either."[58] A journalist for *Politiken* similarly describes a mirrored host of bodies so large that "even the asphalt could not make space."[59] Olsen adds in his introduction to the "kaleidoscope" room, "A single person in this room turns into a crowd; several to an unsurveyable multitude that looks like thousands." He remarks that the mirror-image bodies on the ceiling seemed to possess the "acrobatic abilities of flies," and that the spiral staircases together with the mirrors created the effect of "a building made of story upon story, all teeming with people. Two people standing at this balustrade become an entire throng,"[60] a description that sounds for all the world like that of a proto-skyscraper filled with people.

With the mirror maze's powers of expansion and multiplication came a challenge to accustomed perceptual boundaries. As reporters describe the experience of entering the labyrinth, they invariably document how their usually confident navigational skills gave way to confusing hesitation, usu-

ally after their first abrupt collision with a mirrored wall. If the wax decoy figures described in the previous chapter used embarrassment to teach caution in approaching strangers, the mirror maze used a bump on the forehead. Appropriately chastened, the reporters proceed more carefully through the maze. Now feeling their way hesitantly forward, they describe how the mirror maze has managed a seemingly complete transformation of space. Nearly all accounts include a twinge of panic at this point, even if only in jest. The Danish reporter from *Social-Demokraten*, for example, writes with nervous humor, "Yesterday I stopped in at the Panoptikon's newly opened Hall of Mirrors—luckily I made it back out again with my skin, but I have never before experienced something so confusing [*sinds-forvirrende*]."[61] A Swedish counterpart expresses relief at the "Ariadne-hand" of the custodian leading him to the exit, and a reporter for *Stockholms Dagblad* says, "One walks and walks and finds no exit, until a merciful guide leads one out of the magical palace."[62]

The balance between access and escape seems once again to have produced an entrapment scenario, as it did with the tableau viewing elsewhere at the panoptikon. Here, however, it seems more accurate to say that the visitors are lost in traffic, unable to negotiate the crowds suddenly surrounding them in the mirror maze. Allan Pred's research on Stockholm's turn-of-the-century cultural geography suggests a productive social subtext. In the 1885 *gaturegulering* program of urban renewal, Stockholm's streets were not only redesigned but extensively renamed. Pred documents how working-class urban dwellers resisted the newly imposed nomenclature with their own "language of resistance," a popular folk geography that retained its own colorful slang for city streets and landmarks, but he also emphasizes the disorientation that would likely have attended such extensive revision of the official city map.[63] Coming only five years after this upheaval in Stockholm's urban geography, Mr. Sundell's mirror maze may have resonated with recent experiences of losing one's way on city streets that had been renamed and transformed.

The mirror's ability to transform space and throw images across the room made it difficult for spectators to judge the status and position of the bodies they would meet in their path. Olsen puts it succinctly: "It is the mirror's power to suspend actual spatial relationships that has especially surprised people." In Stockholm, one journalist wrote, "The people we were politely allowing to go ahead of us were actually to be found at the other end of the hall. And the ones we had discussed aloud and made fun of from a distance, we found nose to nose with us when we came around a pillar."[64] In other words, the mirror's play with distance disrupted normal assessments of public and private space as well. Once initiated into the game, the visitor realizes that nothing is where it seems to be, or, as a Copenhagen reporter put it: "Then one comes across a beauti-

ful statue with a sunset-red background. It stands of course in an entirely different place from where one sees it."[65] Another amusing account reminds one of the earlier "investigation" of wax and straw among the mannequins: "And a young lady, whom I poked with a (forbidden, but smuggled-in) cane, turned out to be *a perfectly real young lady* [*en alldeles riktig fröken*]. First she jumped back and thought I was crazy. But I explained to her that I was only momentarily mirror-dizzy [*spegelvimmelkantig*]" (emphasis in original).[66]

If the decoy technique elsewhere in the wax museum involved a simple reciprocal substitution of wax for flesh, the mirror maze complicated the tricks still further. Take, for example, the reporter in the Copenhagen mirror maze who catches a glimpse of one of the wax effigies from the main display while walking through the labyrinth: "At various points widely varying perspectives open up—now a garden view from both near and far, now a statue, or a rose arbor, or a salon with a glass-mosaic window, etc. Even the [wax] figure of the Pope outside the maze is caught in one of the Labyrinth's mirrors and makes for further disorientation."[67] Another visitor there tries to start up a conversation with just such a mirror body, repeating the joke of the mistaken decoy: " 'This is wonderful, this here,' I continued. 'Don't you agree?' He still didn't answer, and I began to suspect that he actually wasn't present, and that it was only his mirror image that I stood conversing with. A careful grope ahead with my hand convinced me; it was in reality only air I had before me."[68] Here is the literalization of Marx's phrase, popularized by Marshall Berman: "All that is solid melts into air." Everything that seemed substantial was made unreal by endless multiplication in the mirror, leaving one uncertain of the reflected image's position, size, origin, and status.

The disorientation games could spill over into the urban experience of the streets. One Swedish newspaperman, signed "Jörgen," described his visit to the hall of mirrors in Stockholm as a confrontation with his double, whom he initially views as a strange gentleman who will not move out of his way, as if he had met a rude stranger on a city sidewalk who refused to let him pass. He finally recognizes the image as his own, but as he takes each new step, the mirror system begins proliferating his "double" exponentially. Eventually he sees "at least 20–30 Jörgens," then 48, then 52. When he staggers out of the hall, he reports, "Out in Kungsträdgården I stopped at every tree and thought I saw editor Jörgen come striding out from behind it, with his stick in hand and looking cross. And when I came to the premiere at Dramaten, I found it flat-out ridiculous that Mrs. Hartman and Mr. Hartman and Mr. Palme and the director Fredriksson did not appear onstage *in dupplo in infinito*."[69] A similar reaction comes from a visitor to the Copenhagen mirrors: "When I finally came out onto the street and passed by Vesterbro, I caught myself several times in the

fancy that the people I met were my own mirror image, and I involuntarily held out my hand so as not to bump against the mirrors! It is enough to go insane over—in case one isn't already."[70]

These accounts, like many other newspaper reports covering amusement attractions, exaggerate effects with a tongue-in-cheek tone, to be sure. Nevertheless, they provide a provocative commentary on the connection between new forms of visual entertainment and the transformation of perceptual habits. What we see here is a kind of dilated moment just after the new experience, when the transformation of space and the testing of corporeal models left visitors open to a new perceptual register. The effect was temporary, to be sure, and the claim is not that these visitors' vision had been permanently transformed by the panoptikon but simply that the experience had denaturalized certain habits of perception and had created a mental space for fantasies of a transformed cityscape.

In sum, the hall of mirrors provided the impetus to imagine many of the conditions of a larger metropolis. As the *Dagbladet* journalist puts it, "One never feels lonely in these infinite halls!"[71] Or provincial, we might add? If so, the fantasy was always short-lived because in the hall of mirrors the recognition that the populous crowd was made up of one's own single self was never far behind perception of the illusion; it seems in fact to have been the main point of that venue's joke logic and is staged rhetorically as a punch line in every one of the journalistic accounts. First comes the description of being surrounded by the urban crowd and of running into obstinate strangers who will not move aside, and then the moment of recognition when the foreign illusion is found to be only the familiar, provincial self after all. One Copenhagen reporter says of the Kaleidoscope room, "Already on the bottom step the mirrors perform their deceptive effects, in that by casting one's eye downward one discovers a huge complex of staircases and sees these stairs populated by crowds of people who all have an unmistakable likeness with one's own person."[72] A Swedish reporter likewise describes the process of picking the familiar self out of the "oriental" crowd:

> The Eden Salon, like the Oriental Maze Salon, is a masterpiece of mirrors, which makes the visitor believe himself to be transported to an infinite paradise with tasteful flower garlands, illuminated by light from many sources and teeming with people. Meanwhile, upon closer inspection it will be discovered that the people are merely composed of a multiplication of the visitor's own self through the mirrors.[73]

Another Danish account relates, "The first person I saw in there was an elegant gentleman, who upon further inspection turned out to be myself, and after taking another step into the sanctuary I observed with satisfaction at least fifty gentlemen, just as elegant, who were also all myself."[74]

When these mirror images are recognized as doubles of the self—"relatives," as another source puts it[75]—the moment is mostly played for amusement in the discourse, although some accounts betray a slightly nervous, joking anxiety about the doubling:

> Thereupon we flee, flee from our alter ego. . . . Everywhere we see ourselves in full, half and three-quarters profile, from the front and back, the classical nose, the blond hair, the proud swayed back, the little mustache. We go to the left and we come across our double [*Doppeltgænger*]; we go to the right and see him promenading toward us; we fasten our gaze upon his heel and at the same time on his stomach, and we pray to the Lord to preserve our sanity.[76]

The connotations that attach themselves to this mirror "alter ego," this multiplied self, are twofold. On the one hand, the mirrored image is the metropolitan body, whose powers of proliferation offer the viewer simultaneous and mutually exclusive perspectives. Seen from the front, back, profile, and three-quarters views all at once, this "cubist" mirror body in fact anticipates in remarkable ways later artistic approaches to the human figure in modernist painting.

On the other hand, since the fragmented and multiplied body of the reflected image is always eventually reclaimed by the viewer as the same body that he or she brought into the hall, the mirror body also represents that which only *seems* foreign and modern, but which in reality is still familiar and prosaic—the equivalent of Lundin's "pasha." Note the constant deflation of illusion in the following account from Stockholm: "When I opened my eyes, I was—in paradise, I was about to say along with Holberg's Jeppe. I stood in the midst of an enormous garden of Eden, full of flowers and sweet leaves in wonderful light. My face was caressed by the mildest breezes, presumably balsamic, but due to a cold I couldn't really tell."[77] The literary reference to Ludvig Holberg's eighteenth-century stage comedy *Jeppe paa Bjerget* is important, because there is not a more prototypically provincial character in the Scandinavian literary canon. (Jeppe, a colorful rural drunk, is fooled into thinking he is king when he wakes up from a drunken stupor and finds himself similarly in an opulent "paradise.") In that play, as at the hall of mirrors, reality eventually trumps fantasy, with Jeppe's true nature proving too obstinate for the royal role-play. The fact that the sniffling, snow-covered reporter at the hall of mirrors invokes Jeppe at the moment he steps into his "paradise" is perhaps the clearest indication of the role the provincial played in this "oriental" modernity. The body that seemed to travel to the Hamburg stock exchange or to Alhambra was, in other words, always still the one that was in Copenhagen or Stockholm the entire time. The visitor's body

was only temporarily modern, just as the Nordic city at this point could only claim to be a kind of rented metropolis.

The uncanny doubling, perspectival distortions, and entrapment scenarios played out in the Scandinavian hall of mirrors were obviously not experiences unique to modernity any more than the hall of mirrors itself was an invention of the turn of the century. One can imagine similar effects being created in the mirrored rooms of earlier historical settings as well, even if directed to other ends.[78] The point here is that when placed within the particular institution and discourse of the Scandinavian panoptika, the mirror's illusions resonated with the metropolitan project and its uncanny return of the self in the form of a stubborn provincial residue. In other words, the spatial and perceptual transformations of the hall of mirrors invoked both the nascent urban experiences in the Scandinavian cities *and* the imagined ones more rightfully characteristic of the larger European metropolises.

The complex reactions to the reflected bodies in the Stockholm and Copenhagen halls of mirrors could certainly be characterized as a tussle with phantoms, to return to Berman's phrase. Or, as another of the reporters put it, in the hall of mirrors one found "a field where fantasy and reality meet each other in a completely surprising way."[79] There is a crucial difference, however, between Berman's "modernism of underdevelopment" and the experience at the hall of mirrors in Scandinavia. In Berman's St. Petersburg, and especially in the Third World countries he sees grappling still with Western ideas of modernity, the "image" perceived in the mirror is a tortured metropolitan fantasy, and the discrepancy with the real is often tragic. At the hall of mirrors, it was, by contrast, a cheerful tussle with ghosts—an experience of vicarious modernity played for laughs. The mirror reflections all shared the same punch line: what appears to be foreign turns out to be domestic, familiar, bourgeois, and ultimately reassuring. The visitors could dabble in modernity because the museum's disorientation effects needed only to be sorted out in the corner of one's living room—or in one's home culture, since in Scandinavia there was still at this time a clear conceptual path of retreat to more grounded social forms. The second half of this study will take up the ways that many of the same corporeality issues get played out in the "institution of the visible" most concerned with that sense of "grounding," namely, the Scandinavian folk museum. Kissing cousin to the panoptikon, the folk museum played many of the same games with spectators, but much more earnestly and with much more at stake—not the assumed identity of the metropolitan body but the native body of folk culture.

CHAPTER SIX VANISHING CULTURE

> When the real is no longer what it used to be, nostalgia assumes its full meaning. There is a proliferation of myths of origin and signs of reality; of second-hand truth, objectivity and authenticity. There is an escalation of the true, of the lived experience; a resurrection of the figurative where the object and substance have disappeared. And there is a panic-stricken production of the real and the referential, above and parallel to the panic of material production.
> —JEAN BAUDRILLARD, *Simulations* (1983)

IT HAS BECOME customary when looking for examples of late nineteenth-century spectatorship to focus on city streets, arcades, boulevards, and promenade areas, following the lead of Walter Benjamin's *Passagen-werk* and similar cultural-historical projects. The hybrid space of the arcade, with its shared qualities of exterior and interior space, has been a fruitful site of visual-cultural archaeology, especially in developing theories of consumption and *flânerie*, as Anne Friedberg has done in *Window Shopping*. Since many of the visual attractions of modernity cluster around the arcade, theories of spectatorship have consequently incorporated the flow of the city street into assessments of early cinema, variety theater, panoramas, department stores, amusement locales, and, as in the preceding chapters, the wax museum. The combined sense of unusual access and hyperreality in these urban spaces allowed spectators to experience an "as-if" modern body that hovered between inside and outside, that could experience the "there" while remaining "here." New technologies of displacement and juxtaposition (accelerating commodity circulation, expanded transportation networks, the proliferation of images) gave spectators the range, while realistic display techniques (fueled by the idea of recording) provided them with the necessary guarantees of authenticity.

In the several chapters that follow, it remains to examine the other visual-cultural practice that could be found at Vesterbrogade 3 and several other urban locations throughout Scandinavia: the display of folk costumes, antique furniture, obsolete tools, and handcrafted objects at the folk museum. The extended, programmatic development of *rural* theme space at this institution of the visible put the wax museum in quite different company than was the case in Paris, London, or even Berlin. For Scandinavia, the wax museum was largely a borrowed form; the folk museum, by contrast, was a peculiarly Scandinavian project. The fact that both were intertwined from the start there gives a quite different pitch to that region's experience of visual mobility.

The link between the wax and folk museums does not spring readily to mind; many would in fact follow the lead of one early commentator from 1885, who took pains to distinguish the mission of the folk museum from its contemporary visual-cultural context: "It probably goes without saying that just because the museum is housed in the same building as the Panoptikon, that doesn't mean that they have anything to do with each other. They are two different institutions, each with its unique purpose."[1] Some would even see the placement of the folk museum in Vesterbro to be a kind of stubborn protest against the hectic urbanization symbolized by the wax museum downstairs and its other neighbors on the boulevard.[2] This view has persisted in historical treatments of the folk museum, which most often see it as a straightforwardly national-romantic project of preservation, a reaction against (and not a participant in) the very social transformations that created the late nineteenth-century city. From these perspectives, the early folk museum seems distinctly out of place in the urban landscape of the 1880s and 1890s, an island of rural culture holding out against the rising urban tide.

Here I develop a contrasting view by taking the insistent geographic juxtaposition of folk and wax museum as meaningful rather than coincidental or unfortunate. The task is to explore what role this apparent monument to the premodern might have played in modern modes of spectatorship in the late nineteenth century, thereby theorizing the degree to which the rural can be accommodated in a cultural study of modernity and its spectating practices. Posing the question in this way turns out to be crucial, since many of the apparent distinctions between the folk museum and its neighboring urban attractions melt away once one adopts spectatorship (rather than display content) as the relevant term of analysis. A detailed examination of the rich record of early visitor reactions to the folk museum, that is, reveals patterns of discourse familiar from the panoptikon: the appeal of convincing access to virtual worlds, the repeated testing of corporeal substance, the play with display boundaries, and the emphasis on visual availability. The folk museum also participated in the

shared mannequin culture of modernity first by experimenting with folk-life tableau figures, rural cousins of the wax effigies so to speak, and then by moving increasingly toward the missing-person effects of spatial effigy.

In my earlier discussion of the wax museum's accessory objects, I argued that the material status of the supplementary relics as unique objects hindered any aspirations the display might have had to be a truly mobile form of recording. Much the same could be said of objects at the folk museum, with the caveat that since collected objects there were linked to anonymous rural dwellers rather than to famous celebrities, the relic effect of any particular object was correspondingly weaker. Nevertheless, the authenticity of the material culture remnant was quite important to the folk museum, even more basic to the overall display strategy than was the case at the wax museum. By collecting authentic traditional objects in ever-expanding concentric circles of contextualization, leading out to the collection of buildings and samples of their natural landscapes, the folk museum could eventually remove the human effigy from the display and let the objects and buildings assume primacy as an attraction.

The folk museum thus provides an interesting addition to any theorization of late nineteenth-century media history because it accomplishes effects of visual mobility with the most insistently material means. Links to serious museum practice added an expectation of verifiability and authenticity that was only peripherally relevant to the wax museum, since that institution was based more on principles of likeness than preservation. And unlike the circulation made possible by the photograph or other forms of recording (including film), the "travel" experience at the folk museum (especially the open-air variety) used real space, made available by a literal and painstaking dislocation of interiors, even as it smoothed over such disruptions by creating a compensatory continuity system of representation. For those interested in film's own early grappling with visual effects of continuity and discontinuity, this parallel medium of corporeal display, with its much more visible sociocultural stakes and material basis, provides an intriguing counterpoint.[3]

Generalizing from the suggestive situation in Copenhagen, then, I will explore how the various folk museums throughout Scandinavia formed an influential museological paradigm that could accommodate and incorporate rural culture as one of the scenic options available to modern spectators. Olsen's new institution, that is, was just one of several, and not even the first, that would fall under the general category "folk museum" in Scandinavia during the last decades of the nineteenth century. Since the conceptual discussion in the following chapters will require frequent shuttling back and forth between the various museum and national contexts, it will first be helpful to include a brief historical overview of the relevant folk museums.

The folk-museum movement grew out of the great international exhibitions of the 1860s and 1870s, to which the participating Scandinavian countries contributed displays of mannequins posed in colorful folk costumes and supplemented with other artifacts representing their traditional rural cultures.[4] As Bjarne Stoklund has demonstrated, the contextualized ethnographic display of costumes, mannequins, and interiors was quite general among the participants of the Paris Exhibition in 1867, but the international acclaim afforded the Scandinavian displays in particular provided the impetus for a longer-range and fuller exploration of these display principles, beginning with the establishment of permanent venues for folk-cultural display back in the Scandinavian capitals. The Swede Artur Hazelius is usually credited with the "invention" of the first "folk museum" per se, an account Stoklund characterizes as the "Hazelius Myth" due to the widespread international precedents at the 1867 exhibition unrelated to Hazelius's initiatives.[5] This point should not, however, deter one from recognizing the influence his particular extension of the display idea had throughout Europe. His Scandinavian-Ethnographic Collection (*Skandinavisk-etnografiska samlingen*) in Stockholm was founded in 1873 and established a highly influential paradigm; his Norwegian folk-museum colleague Anders Sandvig would later state, "With his work he has lit the torch that shines not only over the North, but over all of Europe."[6] Located in the midst of the city on Drottninggatan, Hazelius's museum was, like Olsen's later museum in Copenhagen, easily available to both urbanites and tourists. As this photograph of the museum's display window suggests (fig. 6.1), the interface with the street was not so different from that of the wax museum over in Kungsträdgården (see fig. 2.2). In 1880, the name was changed to the Nordic Museum (Nordiska Museet), the appellation by which the still-existing institution is currently known. Problems of space at the original location were finally solved in 1907 by the opening of the museum's huge building in Northern Renaissance style in the Djurgården area, still quite near the Stockholm harbor and city center.

It was on this same conveniently located peninsula, traditionally an urban retreat and promenade area, that Hazelius would at the same time develop Skansen, the open-air museum offshoot of his ethnographic collection. It opened to the public in 1891 and is the institution most frequently associated with the open-air museum idea today, to the point that the term "skansen" has even become a generic loanword for this type of museum in many foreign languages.[7] Djurgården was also the chosen site of the 1897 Stockholm Exhibition, that influential nexus of technology, commodified display, and nation-building where projected film would also make its Stockholm debut.[8] The confluence of old and new there, as in the building at Vesterbrogade 3, underscores once more the emphatic

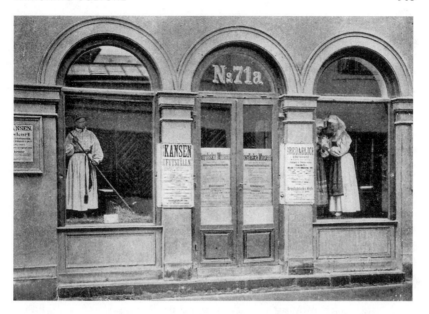

FIGURE 6.1. The display window of the Scandinavian-Ethnographic Collection/ Nordic Museum in its location at Drottninggatan 71. Photo from 1890s, courtesy of the Nordic Museum (Stockholm).

hybridity of Scandinavian modernity (a point that will get a fuller treatment in chapter 9).

The folk museum's developmental trajectory in Stockholm from the ethnographic or cultural-historical collection to the open-air museum provided a blueprint for other similar collections. In the southwestern Swedish city of Lund, just across the sound from Denmark, students began gathering in folkloric clothing and objects for cultural-historical plays and tableaux in the late 1870s.[9] In the spring of 1882, the Scanian Dialect Society began its own more systematic collection of artifacts from southern Sweden, and by that summer was able to invite the public to see the Cultural-Historical Museum in Lund, set up in temporary quarters in a parsonage. The collection was subsequently housed at the University of Lund until 1886, then at a private residence in Lund. Finally, in 1890, the Cultural-Historical Society for Southern Sweden made plans to buy old farmhouses to use as the display setting for a new open-air museum. Georg Karlin, the driving force behind this effort, opened the new museum as Kulturen i Lund in 1892.[10] In the mid-1880s, the museum had begun using many of the same display techniques that Hazelius had developed in Stockholm: diorama interiors with life-size mannequins and display objects placed in scenic re-creations of folk life. Karlin was always

insistent that he beat both Hazelius and Bernhard Olsen to the open-air museum concept, getting it down on paper in 1890 as the "pavilion system," although his own outdoor museum did not actually open until one year after Skansen's debut.[11]

Norway's claim on the open-air museum idea rests on two small relocated building parks from the early 1880s, as Tonte Hegard has described in detail.[12] One set of rural buildings, purchased by the king of the Swedish-Norwegian Union, Oscar II, was relocated to the Bygdøy peninsula just outside the capital-city center, an area that was developed during the nineteenth century as "a nature-park for the capital city," an intentional imitation of Stockholm's Djurgården.[13] "King Oscar's Collection," as it came to be known, included a stave church and several farm buildings moved from rural Norway to the capital and was opened to the public in 1882. Hegard sees a second precursor to Skansen in Thomas Heftye's set of buildings at Frognerseteren, an elevated area on a forested ridge overlooking the capital city. His project had an interesting trajectory, beginning with new structures built to simulate old buildings in national-romantic style (with designs taken from photographs from rural districts) and ending with moving the actual buildings themselves (after 1884). Heftye was not as interested in preservation, Hegard claims, as he was in helping making potent experiences of rural culture available to recreating city dwellers, a goal that corresponded nicely to his work as the first director of the Norwegian Tourist Association, established in 1868.[14]

The best-known folk museum in Norway, however, began not with relocated buildings but with the same kind of rescued rural objects that were being collected simultaneously in Stockholm and Lund. The visionary collector in this case was Hans Aall, and the institution to which he devoted his life was the Norwegian Folk Museum (Norsk Folkemuseum).[15] As was the case with the Hazelian "ethnographic" collection, the objects Aall gathered in were first displayed in a central city location, although not until over twenty years after the early Nordic Museum opened in Stockholm. Although technically founded in 1894, Aall's Norwegian Folk Museum was made available to the public for the first time in 1896. Its location on Kristian IVs gate placed it in the center of town near the university and other existing museums.[16] Eventually it, too, evolved into the open-air format it exhibits today after moving out to Bygdøy and adding to the buildings of King Oscar's Collection more relocated buildings of its own.

North of the Norwegian capital, in the tiny town of Lillehammer, hardly a city even by Norwegian standards, was the founding site for the last of the folk museums that will receive attention in this book, the regional museum called Maihaugen.[17] This collection of rural material culture from Gudbrandsdalen, the long interior valley running north-south

between Oslo and Trondheim, began as the personal project of dentist Anders Sandvig in the late 1880s. On his work-related travels to outlying districts, he began purchasing old artifacts that interested him; in 1894, he bought his first old house and had it moved to his garden in Lilleham-mer, where it could serve as a convenient display space for his growing collection of objects. He quickly acquired several other old houses, making necessary a new, larger location. In 1901, Sandvig officially sold his collec-tion to the city of Lillehammer, although he stayed on as its director for many years. In 1904, the museum reopened on a hill outside of town, where it still is located today.

Returning to the Danish Folk Museum, it remains to add to my earlier description that Bernhard Olsen's display ideas there also developed into an open-air museum project, although somewhat farther removed from the city center than in Stockholm and Christiania. The new museum re-mained institutionally separate from the Danish Folk Museum, which was later assimilated instead into the existing National Museum, but many of the display ideas at what was called simply the Open-Air Museum (Frilands-museet) grew out of Olsen's experiments with whole-room interiors at the original urban location. Olsen began buying buildings in 1897, and in 1901 his open-air museum opened to the public out in Sorgenfri, a pasto-ral setting north of Copenhagen.[18]

It is worth a reminder that the three Scandinavian countries were on culturally intimate terms at this time; the historical political alliances and the relatively small scale of each nation's population and infrastructure put the cultural elites in close contact. Many of these museum founders had close interactions across national borders, visiting each other's muse-ums and corresponding throughout the years. That fact is not as interest-ing for what it might imply about models of invention and influence as for what it says about how shared social conditions gave rise to a collaborative museological paradigm.

One interesting quality the folk museums all shared was their accessibil-ity to urban audiences. Several of the museums began in urban locations as ethnographic collections, as the full name of Hazelius's first museum makes clear: the Scandinavian-Ethnographic Collection in the Capital City. Even after this and other collections made the transition to open-air museums, where the collections were naturalized in more bucolic settings, there remained something quite urban and modern about the access they offered. The eventual locations at Djurgården and Bygdøy, for example, were situated just enough apart from Stockholm and Oslo that they could seem a world away but were accessible enough that they were within easy reach of the city center. These were threshold spaces, which like touristic spaces, offered the twin experiences of immersion and mobility. The mu-

seum visitor's retreat was temporary, and folk culture was thus experienced at most as a brief respite, perhaps even as one of several alternative modes of urban experience. Even in tiny Lillehammer, the development of Sandvig's collection coincided quite nearly with the opening of the train line from Oslo in 1894, making it convenient for tourists day-tripping from the capital. As one account put it in 1901, "One can use the waiting time between trains to inspect the 'Gudbrandsdalen Museum' and the six old buildings."[19] Another concurs: "The railroad rushes by—one hears the noise from the power plant—sees a colorful crowd of tourists and vacationers—what could be more unexpected than the sight of an old cottage [*Ramloftstue*] complete with traditional maiden's bower?"[20]

The folk museum may have been an island of rural material culture, then, but that island's location within a context of urban attractions made any experience of the rural in museum form a mixed experience. The public discourse generated by each museum underscores this effect whenever it describes making preserved "pictures" of folk culture available to the public.[21] The great advantage of the folk museum, according to much promotional material and many early visitor accounts, was that it could take folk culture and "render it watchable" (*åskådliggöra*, and equivalents in Danish and Norwegian). This "watchability" needs to be theorized in connection with other living-picture media and late nineteenth-century forms of recording, since the circulation of these museum pictures, with their insistent and hyperbolic material scope, demanded more resources and effort than did the movement of photographs and images through the culture. Even so, by gathering in these material remnants and making them available all at once to spectators, the folk museum followed the logic of late nineteenth-century recording technologies, which also promised to make a wide variety of authentic visual experiences available to spectators expending a minimum of effort. In this way, the folk museum offered a version of armchair tourism like that of the wax museum, the cinema, and the city itself.

When one approaches the folk museum from this angle, surprising affinities emerge with other institutions that on the surface might seem as unrelated as, say, the Oriental Maze Salon in Stockholm in 1890. Few would link these two institutions as parts of the same cultural project, but in terms of a visitor's experience of space and time, in some important sense it made little difference whether the depicted scene was a harem or a farmhouse. In both cases, one "found oneself" elsewhere. And, in fact, a careful examination of the way viewers articulated their experience shows that many visitors probably made sense of the folk museum in *series* with the other visual attractions of the city; at the folk museum, too, spectators played with display boundaries, speculated on the ontological substance of bodies and effigies, and described feeling "transported" to a de-

picted scene. The panoptikon and the folk museum, no matter how different their stated missions and cultural status, contributed reciprocally to shape composite habits of a distinctly modern visual mobility and a fascination with convincing (but temporary) displacement.

Cultural Juxtaposition

A visit to the folk museum was not the only available way to take up the position at the threshold, to shuttle back and forth between modern and traditional cultures. The late onset of industrialization in the Scandinavian countries—a process "more compressed than in many other European countries," according to the cultural ethnographers Jonas Frykman and Orvar Löfgren[22]—for a time made it possible to experience such juxtaposition firsthand, outside the museum context. The rationale for creating a folk museum was, of course, that it was becoming increasingly difficult to find "potent" pockets of traditional culture in situ as the century wore on, but the uneven economic development in the nineteenth century temporarily made possible striking cultural contrasts, especially in the period just after midcentury. The realities of Scandinavian geography, with its stark physical barriers and remote northern regions, had worked to delay contact between local cultural forms (agricultural tools and methods, design of household objects, building and dress styles, etc.) and the forces of modernity elsewhere in Europe (expanded transportation and communication networks, the accelerating circulation of people and goods, the transition to a uniform monetary economy). Those forces, when they finally did make themselves felt, created what was perceived as sudden access to formerly remote areas and at the same time, through that same access, threatened the stability and potency of the found cultural forms.

Much of the extraordinary amount of collecting that went on in Scandinavia at the time was in fact due to a paradox: thanks to modernization, "untouched" cultural practices had never been so widely available (in print media's visual reproduction or as a tourist experience), but the same processes that gave access to that culture also threatened to destroy its most prized qualities of cultural alterity and distinctiveness. The experience of folk culture as a "scene" or "living picture" was thus always tinged by a sense of its precarious position, since folk culture at its most visible was also tradition at its most threatened. Modernity simultaneously created the urgent need to collect before it was too late and, by providing the technological means to do so, ensured that folk culture would be experienced—as a collection—by ever-widening audiences.

What sets the folk museum project apart from other scholarly nineteenth-century collection projects was that the founders were not content

to leave the marks of collection visible in their display practices. There were professional differences of opinion among the various Scandinavian curators about how far one should go in naturalizing the presentation of folk material to the public, but the folk museum generally attempted to resuscitate collected material by placing it in a "living picture" context resembling that in which the collector found it (or imagined to have found it). The folk-museum spectator was given the illusion of stumbling upon a scene that was both extraordinarily accessible and convincingly real at the same time.

It should be emphasized that none of these premodern rural cultures should be thought of as absolutely static or isolated from outside contact before modernization; Scandinavia has long had sailors and fishermen, trade routes and market days, as well as other forms of long-distance social circulation. At issue, rather, was the rate of change and the scope of exposure, an acceleration that was profound enough to take on absolute and irreversible qualities in the minds of those experiencing it, as was the case for Swedish professor J. A. Lundell, writing for the Swedish Tourist Association in 1900:

> Remember this: with regards to the life of the masses (and for that matter certain aspects of human culture in general), a historical dividing line falls in our century, a separation of old and new, more thorough and pervasive than the difference between the Middle Ages and more modern times. To me it is not even clear that Christianity—as it has existed to this point—was the cause of such upheavals as our age sees.[23]

Not all commentators would go this far, but it is interesting that someone with an interest in promoting tourism found it advantageous to play up the transformative powers of modernity, as if to say, "Catch traditional culture while you can."

The perception of stark boundaries between old and new was especially the case in Norway, the Scandinavian country with the least modern development at midcentury. Although cities and other centers of commerce were in contact with some modernizing impulses from abroad, the majority of that country's traditional rural areas remained geographically and culturally remote, as Stephen J. Walton has emphasized in his biography of Ivar Aasen (Norway's best-known nineteenth-century linguist and collector of native dialect samples). Walton calls Norway's economy at midcentury "dualistic," marked by a "nonsynchronicity" (*usamtidigheit*) that for a time allowed traditional barter and modern monetary economies to exist side by side, especially in the outlying districts. In the first half of the century, he claims, the ruling elite had little contact with the rural districts, with predictable results: "Those towns that lay the farthest away in the most economically underdeveloped areas could without difficulty

appear exotic."[24] The widespread collecting of Norwegian folklore and dialect samples in the 1840s and 1850s was driven by this disparity between access and the myth of untouched culture.

By the 1870s, improved transportation possibilities throughout Scandinavia (longer railroad lines, increased steamship travel, new highways) and communication networks (such as the telegraph and a dramatically expanded postal system) made possible a relatively sudden increase in social mobility between the formerly isolated rural districts themselves, between country and city, between home and abroad. The increased circulation of people and goods sometimes created possibilities for striking contrasts; as one historian has put it, in remote areas of Sweden the situation was such that "from a train window or the deck of a steamship a traveler could catch a glimpse of a living folk culture with archaic features."[25] The first official tourist associations in each Scandinavian country were also founded during this general period,[26] evidence of the growing accessibility of the rural districts for city dwellers, the main targets of Scandinavian tourism's first organized phase, but eventually for foreign tourists as well.

The same transportation networks that made the interior valleys more easily accessible also facilitated the accelerating flow of surplus farm labor to the cities. Modernizing transformations in modes of agricultural labor displaced large numbers of rural workers through emigration and urban in-migration in the closing decades of the century. The exponential population growth in the Scandinavian capital cities within a couple of decades meant that there was a significant rural presence in the new "small big cities." A close look back at figure 2.2 reveals that one can see on the street outside the Swedish Panoptikon both a woman dressed in folk costume on the left and a promenader with a parasol on the right, making concrete the social juxtaposition of rural and urban in the city. Orvar Löfgren claims that in Sweden, "the new industrial class was taken straight from the plow,"[27] and in Norway the situation was similar. As a consequence, when Hans Aall needed to find "authentic" rural tour guides for the Norwegian Folk Museum in 1902, he needed to look no further than Christiania itself, according to one journalist: "One might assume that it was rather difficult to find people to take this on. But the director of the open-air museum, the curator Mr. Aall, says that this hasn't been his greatest difficulty. There are so many people from the countryside here in the city now that one can sometimes find among them people who can recite over 200 *stev* [stanzas of folk verse and song]."[28]

It is easy to see how this kind of cultural overlap might seem precariously short-lived. The train traveler, one would assume, would suspect that the presence of the train in the countryside was destined to change the untouched picture of apparently timeless traditional culture that was available through the window frame, and the collector turning to the city

for rural informants must likewise have realized that the powerful assimila-
tionist forces of the city would make this displaced vestige of rural culture
increasingly less available as time went on. The moment of collecting in
late nineteenth-century Scandinavia was a period when the cultural juxta-
position between the traditional and the modern could give the impres-
sion of a very narrow window of opportunity that might slam shut at any
moment.

The collecting activity already in process at midcentury expanded its
scope as a result, taking a decidedly material turn. To the language sam-
ples, songs, genre-painting scenes, and folklore gathered in the first wave
of national romanticism the 1840s and 1850s, collectors in the 1870s and
1880s added folk costumes, tools, furniture, and crafts, as well as build-
ings, flora, and fauna from rural districts. The scope of the activity and
the fixation on objects provide evidence of a certain cultural panic. Löf-
gren again states it well: "As peasant culture was threatened by industrial
development, the interest in the natural, indigenous people increased.
Scholars and folklore collectors saw themselves as a rescue team picking
their way through a landscape of cultural ruins, where scraps and survivals
of traditional life-styles could still be found."[29]

This is also the rhetoric one finds everywhere in the contemporary
sources, such as this statement made by Norwegian folklorist and professor
Moltke Moe at the inauguration of the open-air location of the Norwe-
gian Folk Museum in 1902:

> But this monument must be erected *soon*. It is high time. The old legends
> and songs are disappearing more and more with each old woman who is
> buried. And the *visible* reminders of the older culture have not fared better:
> every railway and every new highway that flattens the path into our closed
> valleys, in fact just about every tourist who visits our country, carries out
> with them one piece after the other of our disappearing culture."[30]

It is striking here how culture threatens to disappear body by body, object
by object as time goes by, with the threat of an impending cultural void
hovering over the account. Everything distinctive (that is, visible) will be
lost through the "flattening" of the cultural landscape into an internation-
ally homogenized modern culture. The urgency conveyed here ("this
monument must be erected *soon*") echoed throughout this discourse of
collecting; another Norwegian journalist asked, "Can we really afford to
do this—to let some of the best of our educational material for our na-
tional development leave the country and be scattered to the four
winds?"[31] The eventual destruction of rural material culture seemed a
given unless collection efforts intervened to preserve and record the ves-
tiges that remained.

Artur Hazelius laid the foundation for such reactions after a visit to the rural Swedish district of Dalarna in 1872, a trip that could be seen as the originary impetus for his collecting activity. He starts his own 1899 history of the Nordic Museum by describing this scenario:

> When I traveled in Dalarna in the summer of 1872, I experienced a vivid impression of the force with which the peculiarities of folk customs were being leveled out [*utjämnas*], even in those villages where, more than in our other landscapes, we have traditionally loved to see rural dwellers preserve the customs of their ancestors. It became clear to me that one had to step in soon if one wanted to take advantage of the research possibilities that still presented themselves in the form of these old dwelling-places, which were being torn down, or of these household goods, which were disdained, and of these costumes, which were being abandoned.[32]

Here, too, we see panic in the face of leveling forces that seem bent on replacing all distinctive cultural traces with a homogeneous, modern way of life. The fact that the Dalarna region, which before this time had not actually been seen as typically Swedish, could be imagined as a geographically protected interior "pocket" of Swedish culture due to its hilly landscape only strengthened the rhetorical force of this threatened "leveling." (As Gustaf Nässtrom has suggested, Dalarna actually owes its reputation as the heart of Sweden to the 1890s' national-romantic movement and, in particular, with a kind of reverse logic, to Skansen's popularization of that region's cultural artifacts.)[33]

In that same year of 1872, writing to encourage the preservation of regional folk costumes, Claës Lundin (the journalist referred to in earlier chapters in connection with his writings about Stockholm life) gives another picture of the perceived precariousness of folk culture:

> We don't complain that the times are moving toward new forms, because that happens out of an inner necessity. But we must deplore that one has not already taken care of that which not too long ago was most characteristic of the people living in our various districts. There is even greater reason now in this time of railways and easy transportation to take charge of what there is remaining. In Vingåker, for example, there is no longer any shame in appearing "without clothing," as they call it, and the number of "*slimsklädda*" (those who have put aside the old regional costumes) in Dalarna is growing all the time. A powerful hand needs to intervene in order to save from oblivion what can still be saved. (emphasis and gloss in original)[34]

The need for immediate action was perceived as even greater in Denmark in the 1880s, since Bernhard Olsen and others feared that it might already be too late for successful collection efforts there. Olsen wrote in 1878 that the secondhand dealers and antique collectors had already taken

their toll: "Thanks to this activity this country, once so rich in mementos of the past, has now been almost emptied out."[35] Denmark's smaller geographic area, its closer contact with the European continent, and its relatively more accessible topography had put its rural districts on an earlier collecting timetable, since with fewer protective pockets and "closed valleys," to use Moe's phrase, the Danish folk-cultural landscape had always been imagined as more vulnerable. As one reporter put it at the opening of the Danish Folk Museum, "The country had already been plowed through for many years, mostly by foreign collectors and buyers, and much that would have been desirable to preserve was already long gone; often the best pieces had been taken, and the less valuable left behind."[36] Again, the "plowing" action shows how modern forms of social and economic circulation were seen as flattening the naturally found features and protective barriers of a folk-cultural landscape, with the difference being that the process in Denmark was seen as almost complete. After the turn of the century, the perceived availability of traditional material-cultural traces in Denmark had decreased to the point that the situation there could be used as a fund-raising argument for the Norwegian Folk Museum's own collection efforts; according to historian Tonte Hegard, "The scare-scenario was taken from Denmark, where it was no longer possible to carry on with collecting because everything had disappeared."[37]

The perceived scarcity of Danish folk life made it more difficult to imagine oneself stumbling onto "intact" scenes of originary culture. Surprisingly, one exception could be found in the immediate vicinity of the capital city, on the large island of Amager right across from Copenhagen harbor. The island had been the site of a Dutch settlement in the 1500s and remained a conservative cultural enclave—interestingly, of *Dutch* cultural forms—up through the late nineteenth century, as Adrian de Jong and Mette Skougaard have pointed out in their article on the cross-influence of Dutch and Danish folk-museum display.[38] Here is what Olsen writes about Amager in 1878, demonstrating his interest in the conveniently accessible, intact cultural scenes in Copenhagen's immediate vicinity:

> The rather common opinion that large cities, as centers of modern civilization, pose a threat to inherited folk characteristics, and that here in our country, the spirit that emanates from Copenhagen . . . is to blame for the almost-completed leveling out of different ways of life, which shows up externally in the arrangement of the house, etc., must have received a blow from the little section of the newly opened Exhibition of Art and Industry that consists of objects from rural life. The idea that just a few miles outside the city walls one can find a piece of the past preserved like this one, which until recently was located on Jan Wibrant's farm in the northern part of Magleby [on Amager], and which one still can find in several places in the

surrounding district, and that on the exhibition's opening day one could meet women in their beautifully embroidered clothing, pleated skirts and aprons, and even men in old costumes, cannot be imagined in any other district in Denmark.[39]

Two things interest me about Olsen's description here. First off is that he indirectly defends Copenhagen and its influence against sole blame in the destruction process. He seems intrigued by the remarkable (but, as even he would admit, probably short-lived) juxtaposition of the urban and the rural. Second, and perhaps more interesting, is his perception that Denmark's strongest remaining bit of cultural coherence is to be found in a transplanted Dutch community, suggesting what one might have suspected all along, namely, that the perception of cultural integrity and homogeneity increases in direct proportion to cultural difference.

There is reason to prod this rhetoric of disappearance a bit, however, if only to foreground the peculiarity of this idea that culture is the sort of thing that can vanish. Even if the idea had unusual currency in late nineteenth-century Scandinavia, it should not be taken as obvious; it is only one of many possible ways to conceptualize cultural change. In contrast to these images of cultural "dilution," "dispersal," and "extinction," alternative metaphors of change are possible, such as "translation," "hybridization," "transplantation," or "cross-fertilization." The particular metaphor that dominates the discourse in a particular time and place thus keys into some very fundamental assumptions about the way culture is perceived. James Clifford locates one aspect of the "disappearing culture" idea in a certain Western conception of time: "Collecting—at least in the West, where time is generally thought to be linear and irreversible—implies a rescue of phenomena from inevitable historical decay or loss. The collection contains what 'deserves' to be kept, remembered, and treasured. Artifacts and customs are saved out of time."[40] I would only add that perhaps the linearity of loss held special sway in the late nineteenth century, when post-Darwinian thought helped conceptualize the competition between cultural forms, especially between the old and the new, as a struggle for survival in which only one outcome was likely. It was seen as a given that modernity, as the evolved and "fit" cultural form most adapted to changing conditions, would overwhelm the forms of traditional culture it encountered. Driven to extinction, traditional culture would then vanish, as unrecoverable as a lost genetic strain.

I would also argue that the social conditions outlined here gave the more general Western attitudes toward collecting an inflection of place as well as time. Straddling sometimes stark contrasts between "untouched" rural life and accelerating urbanization, it was easy for Scandinavians at the turn of the century to foresee an impending irrevocable loss of traditional

culture unless some massive rescue effort were to intervene. The best that one could hope for, given these assumptions, was to salvage the pieces and traces of traditional material culture that still retained their potency and preserve them in a compensatory representational form. Those forms gradually came to replace the sense of originary culture, becoming prior to it in a Baudrillardian sense, such as when a Swedish tourist in 1890 who had poked his head into an actual Norwegian farm building, still in its original location, writes, "If one peeks into the main room, . . . one can for a second think that one has walked into a museum."[41]

My analysis to this point should not give the impression that I assume these effects of vanishing culture to have been only rhetorical and discursive—there were real material changes in rural and urban life in the late nineteenth century. But it is also clear that those changes were not absolute. Despite the turnover in rural population through emigration, which represented a true population shift, the rural districts were not literally emptied out. People went on living there—even as late as 1920, there was still a slight majority of the Swedish population in the rural districts, for instance.[42] Our tendency to equate modernization with the rapid expansion of cities, that is, makes it is easy to lose sight of the subsequent history of rural culture in the twentieth century. Traditional forms of cultural practice, even if subjected to unusual transformative pressures during the last decades of the nineteenth century, eventually adapted to the forces of modernization without complete destruction.

It is helpful to be reminded, in other words, that this idea of vanishing subjects and objects, despite its partial material basis, is also an interested rhetoric. Maihaugen scholars Tord Buggeland and Jakob Ågotnes get at this idea by pointing out what would have been the pragmatic advantages of staging the folk museum as a salvage project:

> In his memoirs, in newspaper interviews, and on other occasions, Anders Sandvig himself and others have depicted the work of collection as a rescue of national cultural treasures, almost as if it were at the last possible moment that they managed to pull the objects out of the burning fire. But then we should remember that Anders Sandvig has for the most part written his own history as he perceived it and as he thought it should be told. For some objects, it may have been something like a rescue operation, but not in the general sense, even though Sandvig perhaps experienced his work in that way. Today, 100 years after Sandvig started his collecting activity, there are far more old houses and objects left in Gudbrandsdalen than that which has ended up at the museum. It can thus not have been the vestiges of our material culture they rescued from oblivion, but instead a part of it.[43]

Walton has also drawn attention to the ironies of this situation—that Norway at the time probably had *more* traces of traditional vernacular culture

left intact than many countries in Europe, and that after collection, the traces of Norwegian folk life were unusually voluminous, in part due to precisely the panic reaction of collectors.[44]

This discourse of vanishing objects and people has nevertheless proved to be a favorite of museum founders, spectators, and historians alike, perhaps because the evocative absence of the traditional rural body has made possible rich forms of both spectatorial and historical imagination. It has created an absence, like the "minus one" Jay Caplan sees in the tableau, that has allowed and continues to allow entry into the scene of rural life.[45] By conceiving of rural inhabitants as missing persons, and folk culture as a recently vacated scene, we are able to step in and enliven it with our own modern presence.

Tableaux for Tourists

After accepting the premise that folk culture was destined to die, one was left with continued access to it only through the mediation of display and representation. If they had thought it possible, most folk-museum collectors would have preferred to keep traditional culture rooted authentically to place, but there is a seductive aspect to the logic of collection and display as well, in which one begins to prefer the advantages of the representational form—its peculiar combination of portability, malleability, and durability. For the museum founders, the activity of collection afforded a kind of control over what they perceived to be a rapidly changing object; for museum visitors, display gave them easier access to a visually powerful experience than that which they might find by seeking out original rural contexts themselves. Musealized versions of folk culture enjoyed the advantages of representation while at the same time implying a special claim to authenticity.

The analysis immediately following here will cluster around a particularly evocative scene of rural display that was the subject of paintings, illustrations, and travel accounts throughout the nineteenth century: the church boats arriving at Leksand church in Sweden's rural district of Dalarna. This weekly display of cultural plenitude, which at its height could involve thousands of folk-costumed rural dwellers rowing across the large expanse of Lake Siljan from outlying districts in order to attend church, was a scene in all senses of the word. Painters sought it out for its epic scope and striking visuality, and those circulated images in turn inspired tourists to duplicate the experience in their travels by seeking out the place themselves. Their published travel accounts further established the scene as a stop on the standard tourist itinerary.

The importance of this living folk tableau for the present discussion is that Artur Hazelius, founder of the Nordic Museum, was one of the string of observers who took up the vantage point overlooking the scene at the Leksand church during the trip to Dalarna that inspired his initial collection efforts and the founding of the influential Scandinavian-Ethnographic Collection. Histories of Hazelius's museum describe this as a moment of "calling" that spurred him on to rescue the remnants of folk culture. In fact, however, his viewing of the scene was just one of many. The various descriptions of the church boats at Leksand trace a trajectory measuring the perceived availability of folk culture as a powerful visual display. Taken together, they also show how the folk museum preserved an observational situation as much as it did material objects.

We might take as the first link in the chain a travel description by one of Scandinavia's most famous travelers, Hans Christian Andersen, who visited Dalarna in the summer of 1849 and worked a description of the church boats at Leksand into his travel account *In Sweden*.[46] His description emphasizes the volume of the crowd, the striking colors of the folk costumes, and, at several points, the ubiquitous nursing mothers and infants; he calls one such pair in a corner of the church "a living, beautiful picture [*et levende, deiligt Billede*] of the Madonna herself."[47] He repeats the impressions from memory as well in his later autobiography, *Mit Livs Eventyr*.

> They were tying wreaths on the may-poles for Midsummer Eve when I approached Leksand, where Lake Siljan, spread out and great, shone before me . . . all of the life and commotion, the painterly costumes, the summer heat—everything was so different from what I had expected up here in the still, cold North; and now such liveliness at the Midsummer festival! Boats in great numbers came overflowing with dressed-up churchgoers, old and young, even small nursing infants, it was a painting so vivid, so wonderful, I can reproduce it only poorly with words.[48]

Where Andersen had been expecting death (the "still, cold North"), he instead found life, such a living picture (*et Malerie saa levende*) that it quite takes his breath away. The return mention of the small nursing infants makes especially clear that Andersen imagined himself to be in a scene of unbroken cultural continuity and fullness.

At the end of this memoir description, Andersen includes the offhand mention that the Danish painter Wilhelm Marstrand (1810–73) was so impressed by what Andersen had said and written about Dalarna that he decided to make a painting of the scene. Traveling there on his honeymoon in the summer of 1850, Marstrand made countless sketches of Swedish folk life and was also particularly captivated by the church boat scene, which he chose as the subject of a painting with one of those long,

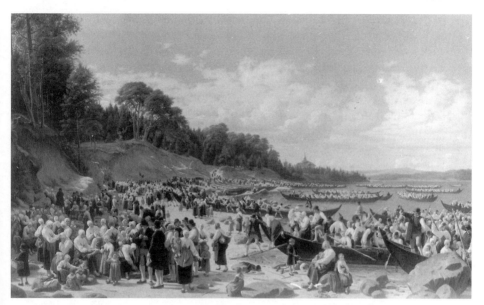

FIGURE 6.2. Wilhelm Marstrand, *People Coming to Sunday Services at Leksand Church in Dalarna in Their Great Church-Boats over Lake Siljan* (1853). 130.5 × 215 cm. Oil on canvas. Photo courtesy of Statens Museum for Kunst (Copenhagen).

narrative nineteenth-century titles, *People Coming to Sunday Services at Leksand Church in Dalarna in Their Great Church-Boats over Lake Siljan* (1853; fig. 6.2). The ritual aspects of this weekly journey in full rural splendor made it hard to resist, and the fundamental components of Marstrand's scene—the costumed masses, the boats, the arrival on shore, the central placement of the path leading from the shore to the church service—all pick up on details from Andersen's account that would be also repeated in almost every later written version of the scene.[49] The Leksand church, through its power to attract such overt display of folk-cultural vitality, can also serve as a benchmark to measure the fate of folk culture as it was played out in the transition to modernity.

Marstrand's version of this scene stresses its fullness, with subsections of the canvas packed with his characteristically conscientious detail. Small, anecdotal miniature scenes play themselves out in all corners of the composition: the mothers nursing their babies, boys drinking from the lake, people disembarking precariously from the boats, children playing, women and men adjusting their clothing. An impression of cultural continuity arises not only from the many small interactions between parents and children in the scene that demonstrate intergenerational ties but also

in the seemingly inexhaustible supply of boats, both off in the distance and entering from the right edge of the canvas, all laden to overflowing with folk reinforcements. There is no shortage of bodies here; this is no endangered species. The scene is also tied together compositionally by the way the upward curve of each boat keel echoes the line of the path leading up the hill to the church in the distance, the goal of the journey and the organizing force behind this continuous procession of folk bodies.

Four years later, English traveler Charles Loring Brace witnessed the same scene and included a description in his travel diary, commenting that the sight of the Dalarna church boats was "one of the most impressive I ever saw." He described the boats "flashing and ploughing through the water," the red and white costumes glistening in the sunlight. He, too, emphasized the inexhaustible numbers in the crowd (estimating it at seven thousand), the strong unison voice of the peasants during the church service—"surges of sound which rolled up from the vast assembly"—and also made sure to mention the most important evidence of the culture's vitality and future continuity, the ubiquitous nursing mothers and the constant cries of the children in the background.[50]

Hazelius's turn at the same scenic overlook in 1872 is described by his wife, Sofi, in her travel diary. Her account is worth quoting at length:

> But how our hearts beat more strongly when behind the point we caught sight of one boat after the other approaching with swift oar-stroke, the red and white attire shining against the sun. The Dalecarlian women sitting around the sides of the boat and forming a wreath of strong colors. Grandpa can be seen solemnly in the stern, at the rudder. Ten pairs of oars put some speed in the big, long and narrow boat, which seats more than fifty people. Imagine between thirty and forty such boats almost simultaneously advancing on the sunlit surface of the water! What a sight, magnificent and indescribably captivating at the same time! It was impossible to observe this singular drama without shedding tears [*Det var omöjligt att utan tårar betrakta detta sällsamma skådespel*].

As Sofi Hazelius revels in the painterly and theatrical qualities of the scene, the boats arrive at shore and are unloaded. Sofi continues by describing the scene on the beach:

> Now one can see the women adjusting their attire, tying the cap on better, passing out bread or such to the older children and nursing the little ones. The old women adjust the neckerchiefs on the old men and help them into the thickly lined homespun coat, which on Sundays must, even in the most oppressive heat, be placed on top of the usual undercoat, itself quite thick. Add to that a buttoned long vest and a sturdy woolen scarf around the throat, and they probably won't have to freeze on a hot summer's day!

> But then one group after the other gradually disappears in the trees up on the hill, and we hurry after them so as to keep following them with our eyes, there where they all, old and young together with the small children, are walking toward the church. It is intercession day, so there is morning prayer. Not all of them go into the church. Many seat themselves here or there in the shady churchyard. What a beautiful sight![51]

Sofi's prose conveys a keen compositional sense. With color, lighting, and dynamism, her description has all the elements of a painting—Marstrand's painting, perhaps? Each part of her description could, in fact, be taken as a detailed, close-up view of the scene Marstrand depicted. Now it is possible that the scenic elements were so ritually constant that any depiction of the church boats could not help but repeat earlier observations, but it is also possible that Sofi Hazelius was influenced by the prior circulation of Marstrand's image, or perhaps the travel descriptions that preceded her own. What is clear is that Sofi finds the scene strikingly convincing because of its representational qualities, to invoke the counterintuitive logic of tourism. That is, like the tourist who finds an experience to be authentic because it corresponds to prior visual expectations, Sofi Hazelius responds to the scene as if it were a "drama" (*skådespel*).

But Sofi Hazelius adds immediacy to the Marstrand painting with her description. In his Dala-scene, Marstrand has given us an overview picture from a distance (*et Anskuelsesbillede*), as one of his critics calls it.[52] Sofi Hazelius, however, wants the folklife closer at hand. She is thrilled at the arrival of the boats and revels in the colorful scene on the beach, but paired with this insistent visual presence of the peasants is the anxiety that enters her description when they stream out of view up the path to the church. She hurries after them so as to keep following them with her eyes, as if she finds it distressing not to keep them in view. Sofi's written account is worried by the possibility of losing sight of the participants in rural culture, the very figures that are the object of her fascination and riveted attention. Given the church boat scene's central position in the journey that convinces Arthur Hazelius to begin his massive collecting project, it is easy to read the anxiety about vanishing folk bodies as the prime motivation for their reconstitution in display form at the Nordic Museum and Skansen. It seems that for some, even a mannequin body or a role-playing folk body was better than an invisible folk body.

The contrast between Marstrand's distant overview and Sofi Hazelius's enticement into the scene also reminds one strongly of the fundamental tension between voyeurism and immersion that governed the scenic sensibility at the wax museum. My earlier argument was that the wax-museum visitor was intended to hover at the threshold, to develop a sense of toeing the line. The tug of the scene at Lake Siljan on Sofi Hazelius reveals the

slightly different stakes of the folk-cultural scenario, stakes that carried over into displays at the folk museums as well. Again and again, we will find spectators of folk displays unable to hold back in a purely visual relationship to the material. Sofi's desire to keep the folk body in view, that is, causes her to violate in this tourist scenario what would be the equivalent of the invisible fourth wall of a museum tableau.

By the turn of the century, trips by Swedes to their own remote rural districts, like the one undertaken by Hazelius and his wife, were becoming more common, thanks to the expansion of the railroad's northern line in 1882 and the efforts of the recently established Swedish Tourist Association (1885), which originally had as its stated goal the promotion of native tourism for Swedes.[53] When one reads through the various articles in that association's annual publication, it becomes clear that what was only an anxious subtext of Sofi Hazelius's travel account has later in the century become more overt. J. A. Lundell, cited earlier, conveys that sensibility while trying to explain why tourists almost universally seemed to favor landscapes over people. If tourists could think of themselves as ethnographers instead of naturalists, he argues, they would be able to catch sight of a way of life that, like that of Sofi's Dala-folk disappearing up the hill, was on the verge of vanishing:

> Bustling systems of transportation mix people together like peas in a pot. It obliterates [*utplånar*] all local differences in housing, dress, and customs. . . . *An entire cultural epoch*, whose existence can be calculated to the thousands of years, *is disappearing in front of our eyes*, is being destroyed by steam, electricity, and the rotary press. . . . For the person with just a bit of historical inclination, surely it could be interesting to observe this fleeing culture [*flyende kultur*] while it still remains—broken and mixed [*bruten och blandad*], to be sure—but still with the old features here and there in remote villages. Right?
>
> Because just as the giant—as folk belief would have it—cannot stand to hear the church bells, old customs and modes of thought flee in the face of the steam whistle and the telegraph code. (emphasis in original)[54]

The clincher of Lundell's argument here, that the traditional scenes of folk culture are disappearing "in front of our eyes," is an idea that circulates through much of this tourist literature, which proposes as a countermeasure the creation of as many tourist-eyewitnesses as possible. Gunnar Andersson, writing for the Swedish Tourist Association yearbook in 1910, had seen a powerful expansion of the modern tourist industry in the twenty-five years of the organization's existence, and he depicts travel "for the sake of seeing" as an almost ethical imperative: "Modern tourism's greatest and most important work is that it allows thousands upon thousands to see and observe, to compare and inspect; it makes them form an

idea, even if only a superficial one, of what the books have told and of that which their own eyes tell them now in their simple, clear language."[55]

Tourism's own contribution to the "breaking and mixing" of rural culture with modern forms remains mostly undiscussed in this kind of writing, engaged as it is with promoting contact with the rural districts. Glimpses of those kind of effects can be seen, however, in a travel account to the same Leksand church, from a trip taken the year after Lundell wrote his article. Here is how the Sunday morning scene at Lake Siljan looks to an American viewer just after the turn of the century:

> Of late years a little steamer has been introduced by some enterprising citizen, which picks up passengers all along the shore on Sunday morning, lands them at Rättvik in time for church and takes them home in the late afternoon. This custom and the introduction of bicycles has caused the church boat to be abandoned in many places, and we saw only one instead of a dozen that formerly came each Sunday.

He goes on to describe the bicycles stacked up against the fence during the church service, mentioning offhand that "the Dalarna costume looks queer on a bicycle and is scarcely appropriate."[56]

Taken together, these various Leksand scenes imply a tempting trajectory leading straight to the conclusion that Sofi and Artur Hazelius were right to be worried; the cultural plenitude available to H. C. Andersen and Wilhelm Marstrand at midcentury, and still fleetingly to the Hazelius couple in 1872, does in fact seem to have waned by the turn of the century, leaving only "broken and mixed" forms. But the very terms "broken" and "mixed" require acceptance of retrospective whole-cultural models, and are thus worth leaving in quotation marks. If one does not accept the model of culture-before-the-fall, the last account from 1903 might instead provide evidence of folk culture's ongoing adaptability, not its demise. After all, even if the bicycle riders seem too "mixed" to qualify as true folk bodies, these are still real rural dwellers attending church, even if they do so more conveniently. What has disappeared is the convincing theatricality of the scene *for the spectator*, not the people themselves.

A better lesson to draw from a trajectory of this sort is that the "living picture" of folk life was both at its apex and at its most precarious in the 1870s when Sofi and Artur Hazelius experienced it, since the cultural context still seemed grounded enough that it could provide a strong affective experience of an unbroken scene, while the rapid retreat of the "fleeing" culture beckoned the spectator into the scene in order to keep the object in full view. Held in suspension between striking presence and threatened absence at any moment, the folk body was at its most desirable at this foundational moment of collection. The folk museum's stated mission was to capture folk culture and preserve it for the future, but what it

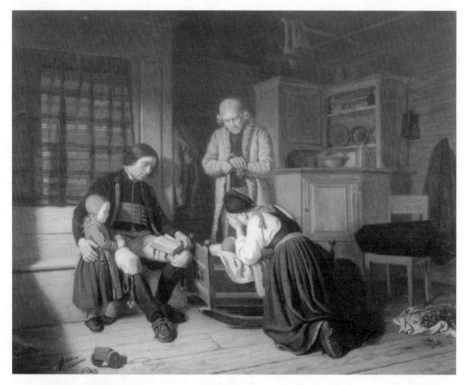

FIGURE 6.3. Amalia Lindegren, *The Little Girl's Last Bed* (1858). 77 × 98 cm. Oil on canvas. Photo courtesy of the Nordic Museum (Stockholm).

ended up capturing more accurately in these "living pictures" was the dynamic of cultural juxtaposition and the positioning of the traveler-observer at the threshold of the traditional and the modern. The folk museum thus became a monument to the tension *between* living and representational forms of culture; both "original" scenes *and* the tourist's access to them were in this way preserved in perpetuity.

Cradle or Grave?

I turn now to a second painting that played a crucial role in defining the folk museum's technique of interior display, and again the overt connection is with Artur Hazelius and his early Nordic Museum. This piece, too, stands in for a series of paintings and museum displays that wrestle with the paradoxes of putting living culture on display. The work in question was painted by Amalia Lindegren (1814–91), one of the most popular Swedish genre painters, and dates from 1858 (fig. 6.3). Entitled *The Little*

Girl's Last Bed (Lillans sista bädd), it shows a family gathered around a dead infant in a cradle, the mother absorbed in grief and the father reading words of comfort. On the chair to the right of the grouped figures is the ominous object that will be the little girl's truly final bed, the tiny black coffin brought by a figure I take to be the town carpenter (dressed in the light-colored coat). This painting circulated widely in reproduction, in everything from illustrated journals to calendars, making its iconography quite familiar in late nineteenth-century Sweden.[57]

The genre-painting content of the work is easily apprehended. Marianne Zenius, in her study of Danish genre painting, summarizes several previous art historical definitions and arrives at these general criteria: a genre painting takes a scene from everyday life, depicts human figures anonymously as types, is set in contemporary times, and depicts actions that are repeatable from one human life to the next.[58] Lindegren's painting fulfills many of these conditions: hers is a figurative painting with strongly narrative content, depicting anonymous social types from Dalarna in a situation designed to elicit a strong and immediate emotional reaction from the viewer. Its title, like those of other genre paintings, provides the crucial empathetic clue or bit of information that sets up the response in the viewer. Although the idea of a genre painting commonly conjures up amusing or sentimental scenes, often with small children, there is room in the definition for paintings with more serious content, as long as the situation remains firmly within the range of the typical rather than the exceptional (or, to put it another way, the situation can be sorrowful or moving but not tragic in the technical sense of that term).

It is the question of continuity that most attracts me to these genre paintings. By emphasizing typical space, action, and characters, the genre painting implies an unbroken world. Potentially repeatable action aims for a universal viewer response, since any scene is to be understood as neither the first nor the last of its kind. One of the most paradigmatic Danish genre paintings of the 1850s can serve as the example here, a work by Julius Exner (1825–1910) entitled *The Visit to Grandfather* (1853; fig. 6.4). The painting's longer narrative title, under which it was originally exhibited, highlights the easily accessible emotional content of the scene: *A Little Boy, Who Together with an Older Sister Is Visiting His Grandfather in Order to Be Seen in His New Clothes.*[59] (A similarly narrative title from a later Exner painting [1867] gives a similar sense of intergenerational connection: *Grandmother Brings the First Greetings to the Little Girl Who Has Gotten up from Her Sickbed.*)[60]

Zenius opens her source-critical study of Danish genre painting with a discussion of Exner's 1853 piece in order to point out that in real rural houses, there would never be an entryway in the same room as a heating source; Exner simply needed the open door to convey the idea of a visit,

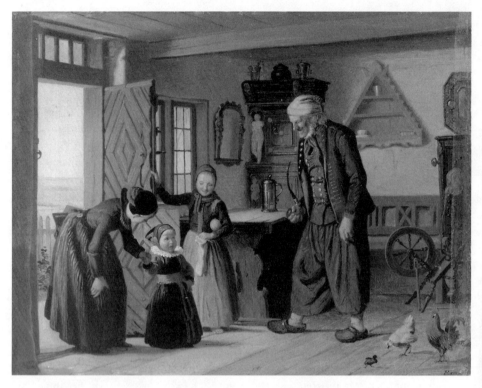

FIGURE 6.4. Julius Exner, *The Visit to Grandfather* (1853). 27.4 × 35.3 cm. Oil on paper. Photo Hans Petersen, courtesy of the Hirschsprung Collection (Copenhagen).

so he probably added it to an existing home that had served as his model. I am not as interested in questions of accurate referentiality here as I am in the potential connotations of the open threshold that Exner adds to his model, since it introduces the possibility for continuity effects similar to those deployed in the wax-museum tableaux. There as here, the open door with figures positioned at a threshold activates the space outside the frame, showing its continuity with the depicted space of the interior. The world inside is implied to be of a piece with the world outside.

At the wax museum, that technique simply seemed part of the project of hyperreality, of making the depicted world seem "*so* real" by embedding it in an extended world offstage. Depictions of folk life that employ the same logic give more of a clue to why this "panicked production of the real," to use Baudrillard's phrase, should be so pervasive in turn-of-the-century Scandinavia: there is clearly much at stake in the existence of this particular off-frame world, given growing nineteenth-century anxieties

about vanishing cultural forms. No matter how "full" any individual de-picted scene might seem, that is, no matter how filled with beautifully handcrafted objects and naive rural dwellers in strikingly colorful cos-tumes, the question increasingly arises of how far the depicted world ex-tends. Is what we see merely a vestigial pocket of concentrated cultural potency—perhaps the only one left—or can the scene still be regarded as typical? Exner's own career as a genre painter shows the pertinence of this question, since his search for untouched rural settings led him to locations increasingly distant from Copenhagen in order to find places where interi-ors could still be found embedded in a surrounding "authentic" milieu.[61]

It is in this respect that the off-frame exterior space is crucial in scenes like *The Visit to Grandfather*. The anecdotal content of the situation em-phasizes the intergenerational aspect of that space: the off-frame world, where the little boy presumably lives with his family, is close enough that he can visit grandfather with the help of an older sibling. The implied contiguity of space finds an echo in the child's clothing, the narrative focus of the scene, which seems to be taken from the same cloth, so to speak, as the grandfather's. In the small child we see the naive replication of a way of life that seems to ensure its continued viability, at the same time that Exner himself in reality had increasing difficulty finding un-touched, self-replicating milieus to use as settings for his folk interiors. The "visit" idea thus carries with it an entire complex of ideas about gener-ational continuity that gives the anecdote its timeless quality.

The motif of Lindegren's painting becomes in comparison much more interesting, precisely because the anecdotal content of the scene—the pre-mature death of an infant—implies just the opposite. The cradle, a key object in the cultural imaginary (think of the currency of the term "cradle of culture"), can serve as a test site for imagining cultural regeneration and the continued viability of one's way of life. Depicted in *The Little Girl's Last Bed* is the wrenching paradox of a cradle filled with a tiny dead body, depicted at the moment just before it is moved to its final resting place in the waiting coffin. At once both full and empty, this cradle of culture is marked with presence and absence.

While flirting with the idea of folk culture's possible nonregeneration, the painting nevertheless provides compensatory evidence to the contrary: in the composition there is another older child in reserve, the mother and father both wear the emblematic traditional dress, and the carpenter's presence gives evidence of an extended community beyond the individual family. It is possible, then, that the scene here is taking advantage of the same kind of "sacrificial logic" that we saw in the tableau display at the wax museum. There, the dead and dying created evocative vacancies that emphasized the comparative presence of the other figures and allowed the composition to "give way" and allow for the viewer's imaginative partici-

FIGURE 6.5. Christian Dalsgaard, *The Village Carpenter Brings a Coffin for the Dead Child* (1857). 73.5 × 104.5 cm. Oil on canvas. Photo Hans Petersen, courtesy of Statens Museum for Kunst (Copenhagen).

pation in the scene. Here, the girl in the cradle, soon to be in the coffin, creates a vacancy at the center of the composition, allowing the remaining folk bodies to appear at their fullest potential.

The possible meanings that cluster around Lindegren's painting start to order themselves a bit when one realizes that the dead-baby motif had a wider circulation in art of the time. The Danish genre painter Christian Dalsgaard (1824–1907), had in fact painted a remarkably similar scenario just a year before Lindegren's painting: *The Village Carpenter Brings the Coffin for the Dead Child* (1857); fig. 6.5). Here, too, the weeping mother's face is absorbed in grief and hidden from the audience, and the arrival of the carpenter with the coffin similarly depicts the last moment before the dead baby is removed from its cradle.

There are important differences, however. Dalsgaard's composition is much more concerned with realistic texture in everything from faces to furniture. Here the coffin is placed under the carpenter's arm, geometrically flattened into an understated but evocative hexagonal shape with the end showing face-on. The cradle that presumably contains the dead child

of the painting's title is squeezed almost out of the composition entirely in the extreme right foreground, positioned for the most part in a liminal off-frame space where one might even overlook its presence. The emotional content of the scene is also presented without much compensation; the costuming is less folkloristic, there is no sign of other children, and figures are not grouped as tightly as in Lindegren's painting, suggested a somewhat starker and less cathartic emotional landscape.

The fact that this painting preceded Lindegren's by a year raises the question of whether she may have deliberately reworked Dalsgaard's theme. The motif may, on the other hand, simply have been in cultural circulation, and in fact these two compositions were not alone in exploring the theme of the dead infant. Several other Scandinavian paintings exploit the same theme, even if not with rural settings or genre-painting style.[62] While it is tempting to argue that this flurry of tiny coffins and empty cradles rests on a correspondence to social experience, infant mortality rates in Scandinavia were in fact among the lowest in Europe at this time. They were actually steadily decreasing throughout the mid–nineteenth century and, interestingly, were lower in the country than the city.[63] Perhaps these dead-baby paintings are best understood not as reflections of social conditions but as a motif that allows painters to grapple with the models of cultural loss and replication that the "fleeing" traditions made so pressing. These compositions, that is, entertain the prospect that rural culture might not have offspring, that the cradle (and the originary cultural context it evokes) might be vacated prematurely. By so doing, they convey the sense of precarious fullness that the living-picture idea implies more generally.

The Scandinavian folk museum's debt to the genre painting tradition in general, and to Lindegren's painting in particular, gives these issues an added importance for late nineteenth-century museology. When curators searched for ideas about how to display rural rooms and figure groupings, genre painting offered them handy visual precedents that proved highly influential. For example, several of the more prominent genre painters, especially in Denmark, had shown a keen interest in painting interiors devoid of figures as well. A work of this kind by Exner from 1853, the same year as *The Visit to Grandfather*, gives some indication both of the painter's interest in interiors for their own sake and of the evocative effect of space and objects in conjuring up missing bodies (fig. 6.6). With its depopulated interior, this painting may seem intent on conveying the opposite of the intergenerational visit, but a careful look around the space shows clear signs of habitation. Both the wooden clogs on the floor and their placement near the empty chair invite an imaginative completion of the missing person in the viewer's mind, as does the open win-

FIGURE 6.6. Julius Exner, *Interior, Sitting Room of a Farmhouse at Amager* (1853). 46.3 × 61.9 cm. Oil on canvas. Photo Hans Petersen, courtesy of the Hirschsprung Collection (Copenhagen).

dow, the hat hanging on the rafter, and the key dangling from the upper dresser drawer.

The visual influence of Exner's interiors on the Danish Folk Museum is apparent from a comparison with one of the whole-room interiors displayed there on Vesterbrogade (fig. 6.7). The sitting room from Samsø shows similar interest in the object's power to conjure up missing persons, with the open Bible and the knife on the table, together with the empty chair positioned at the movable tile heater, all hinting at the momentary return of the room's inhabitants. The familiar impression was not lost on one journalist from the museum's opening in 1885, who saw the connection in this way: "It goes without saying that the rooms themselves are not completely correct, since they are all ideally and copiously filled [with objects], somewhat like the interiors Exner paints. Actually, Exner has in his pictures gathered together a folk museum before folk museums were invented."[64] Zenius's painstaking source criticism of Danish genre painting confirms Exner's tendency to elaborate imaginatively on models, and several accounts from 1885 mention the same about the folk museum's interiors, but the more important connection is the way that work by genre painters was as invested in a pleasurable sort of melancholy as it was

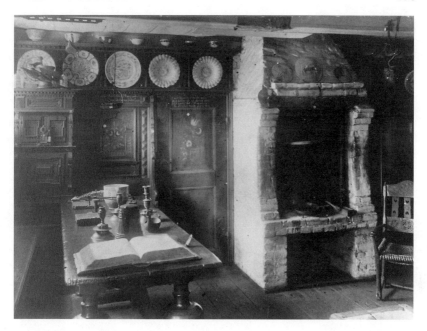

FIGURE 6.7. Sitting room from Samsø, one of the first interiors on display at the Danish Folk Museum in its Vesterbrogade location, n.d. Photo courtesy of the Copenhagen City Museum.

in depicting the fullness of folk life. Like the folk museum displays, these genre paintings were produced by the cultural tensions between the presence and absence of folk life, and reflect both of those possibilities in the range of subjects chosen. Zenius even adjusts her definition of genre painting in this direction, adding that genre painters "had a predilection for depicting that which was on the verge of disappearing."[65]

Still, the more obvious link between the folk museums and genre painting emerges when figures are actually depicted. Genre painting provided not only ideas for the grouping of figures in strongly anecdotal, narrative situations but in some cases provided the literal model for folk-museum scenes. The trend began at the 1867 exhibition in Paris, where the Nordic folk mannequins were first exhibited internationally, although not so thoroughly contextualized in theatrical settings as they later would be.[66] Nevertheless, this Danish journalist clearly understood the 1867 figures in terms of their genre-painting precedents: "The implementation is so illusionistic that many visitors mistake these figures for living; not only are the costumes exquisitely beautiful, but they are also worn by actual folk-types, whose grouping, faces, and hands make the whole thing into a collection of genre-sculptures rather than dressed-up mannequins."[67] The

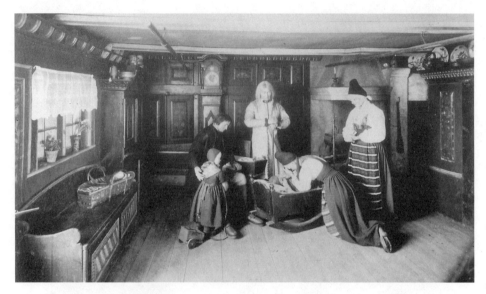

FIGURE 6.8. The mannequin tableau from the Nordic Museum, based on Linde-gren's *The Little Girl's Last Bed*. This arrangement was one of several; others in-cluded temporary displays at world exhibitions in Philadelphia in 1876, Paris in 1878, and Chicago in 1893. Photo Axel Lindahl, n.d., courtesy of the Nordic Museum (Stockholm).

implicit connection informing this neologism of "genre-sculptures" be-came more strongly associated with the museum display of folk culture when Hazelius's new ethnographic museum incorporated similar tech-niques after its opening in 1873. Mannequin figures displayed in striking narrative scenes became the hallmark display principle for which his early museum was best known internationally, a reputation that was strength-ened by Hazelius's own participation in the international exhibitions that followed the founding of his museum.

One of Hazelius's early experiments with such a scene took its composi-tional model directly from Lindegren's sorrowful painting. As can be seen in the version of *The Little Girl's Last Bed* that appeared in mannequin tableau at the Nordic Museum (fig. 6.8), another standing female figure has been added to Lindegren's composition, but other details, such as the interactive pose of the four main figures around the cradle, the clothing, and even the toy on the floor, have been preserved. I hasten to add that interpretation of a mannequin tableau must be seen as more provisional, since unlike a painting, it has movable parts. In the traveling versions of this tableau sent to the international exhibitions, for example, the objects and figures were sometimes arranged in slightly different ways.[68]

One intriguing feature of the permanent exhibit, however, seems crucial here, namely, that the coffin has been moved to the center of the composition, immediately adjacent to the cradle, just above the visible head of the dead infant. In the Dalsgaard painting, the extreme foregrounding of the cradle gives it the impression of straining for the edge of the composition, as if it were reluctant to give up its contents; the spatial organization of the scene thus helps underscore the emotional difficulty of giving over the dead child. Even in the Lindegren painting, which centers the cradle and includes the carpenter in the family circle, the coffin remains to the side of the main composition, although contemporary observers still caught the double meaning of the title's "last bed." Only in the Nordic Museum's tableau, though, are the two objects so insistently adjacent, an arrangement that insists on the slippage in the actual referent of the title. This version of *The Little Girl's Last Bed* acquires still more weight when one realizes that this arrangement was kept on display for years at the Nordic Museum and was chosen as the commemorative tableau display in the 1951 restaging that marked the fifty-year anniversary of Hazelius's death.

This version of the dead-infant motif, then, the one that has acquired a kind of authoritative status for the museum's historical identity, also emphasizes the ambiguity of Lindegren's title most strongly with its visual pun. Was it a conscious strategy? It may not matter—as a foundational tableau, it still provides an evocative site for conceptualizing issues raised by the new folk-museum paradigm. In fact, it is hard to think of a more paradigmatic tableau for this kind of museum; the museological implications ripple outward from this conflation of cradle and coffin. Are the mannequins themselves alive or dead? Is the clothing they wear in use or on display? Do the collected objects add up to a real home or a museum tableau? Will the folk museum itself be the cradle or grave of rural artifacts—a living representation or cultural mausoleum? Finally, do the advantages of representational folk culture (portability, durability, selectability) compensate for the perceived lost connection to a living context?

DEAD BONES RISE

One, perhaps even the most important, of the eth-
nographic cultural-historical open-air museum's
tasks is precisely to popularize. But in order to
speak to the people in an intimate and winning
way, science (or in this case, the museum) must
be induced to step down from the pedestal that
has been raised by academic aristocrats, in order
to comply as much as is allowable with the de-
mands of the masses. And the broader public re-
quires watchability and liveliness [*åskådlighet och
lifaktighet*]; it wants to see the breath of life in
the dead bones; it wants to hear the old instru-
ments play with full sound.
—EDVARD HAMMARSTEDT, *museum assistant at
the Nordic Museum* (1898)

THE ELABORATE gathering operation set in
motion by the Scandinavian folk-museum collectors seems most obviously
to have been devoted to the rescue of objects—the tools, furniture, cos-
tumes, and dwellings that were once part of the fabric of rural daily life
but were on the verge of falling out of use. As far as the objects themselves
were concerned, the folk museum differed from museological predecessors
like the archaeological museums or curiosity cabinets only in its extension
of collectibility to a new range of rural objects previously considered too
recent or ordinary to deserve display in a museum. In spite of the claims
of scarcity that drove the collection efforts, the inclusion of this newly
worthy class of objects resulted in a flood of potential display material—
tens of thousands of closely related objects.[1] A principle of selection was
clearly necessary.

Given the acute anxieties about vanishing rural bodies described in the
previous chapter, it is perhaps not surprising that the folk museums would
organize displays around the idea of compensatory effigy. Many commen-
tators have pointed to the folk museum's early borrowing of mannequin

techniques from the wax museum, but the relationship to objects was somewhat different there. As one Copenhagen city historian has summarized it, "In the Panoptikon, the main emphasis was on the *figures*, while in the Folk Museum it was on the *objects*, be they furniture pieces or tools (emphasis in original)."[2] The wax museum's objects were celebrity relics, meant as backup for the wax figure; the folk museums, by contrast, began with the object as their basic unit of collection. The mannequin's inherently supplementary role there is clear from the fact that early experiments with carefully posed plaster figures were eventually abandoned in favor of living guides, historical role players, or no one at all. I argue in this and the following chapter, however, that the idea of effigy was extended at this stage more than it was abandoned. All of the various display strategies continued to encourage viewers to imagine objects back into the hands of their former owners, to understand objects as if in use (that is, still in relationship to a body) instead of as collected objects on display.

The present chapter will trace the first part of the folk object's trajectory from dusty rural attic to contextualized scene by showing how it ended up as an object-in-hand in the half-room mannequin tableau. The next chapter will then outline the decisions that led to the abandonment of mannequin display and show how the space of the tableau was opened up for "inhabitation" by visitors. The goal of both chapters is to plumb the metaphor of resurrection in order to understand better the essential logic of the folk museum and its brand of living pictures, but the present chapter will deal more directly with strategies that employed literal effigies.

Museologist Susan M. Pearce makes the connection between museum display and resurrection, grouping a brief discussion of heritage museums (with the Scandinavian folk museums leading the way) under the heading "The Resurrection of the Body," presumably due to the tendency of all such museums to flesh out and resuscitate contexts for individual objects.[3] The idea goes much further than putting an object back into relation to an individual body; the folk museums aimed to bring back to life an entire milieu, surrounding the folk object with so many circles of contextualization that its status as an accident of the collection process would be forgotten, and the line between display and real life momentarily suppressed. The idea of effigy, especially in the open-air museum versions of the folk museum, thus extended far beyond the individual figures needed to populate the simulated folk space of the museum. Each scene was in some sense an effigy of a place and a practice, every collection of buildings an architectural effigy of an original milieu. But everywhere one turned, the metaphor of museum-as-body dominated—the parts assembled themselves into a seamless whole through a logic of corporeal restoration.[4]

Pearce quite rightly points to the historical boundaries of this enterprise:

For a time, as we have seen, in the nineteenth century, such resurrection was believed to be within our grasp, provided only that an adequate quality and quantity of material could be arranged with the benefit of sufficiently ample scholarship. But now we have lost our faith in simple certainties, and recognize that what we thought was re-creation is only simulation. The artifacts do not re-create but are reassembled, the original authors are absent, and the voyeuristic viewers take their places in the queue.[5]

Back when people believed museological resurrection was within their grasp— that could be a fitting conceptualization of the historical moment and intellectual project of the turn-of-the-century folk museum. But as should be clear from what follows, I do not ascribe to Pearce's implied historical-critical model of progression from initial faith to eventual skepticism; evidence from early spectator accounts suggests instead that the pleasures of the folk museum—even at the height of the resurrection project—were enjoyed somewhat more self-consciously than Pearce's account would allow. Those viewers did not, it turns out, experience the living pictures of folk culture naively but instead as visual connoisseurs trained in viewing habits both inside and outside the folk museum, to borrow a helpful model from studies of early-cinema spectatorship.[6]

Most useful in this regard will be an examination of the resurrection idea not as one of those back-projected, postmodern metaphorizations of cultural-historical material but instead as it was put into play by the founders and contemporaries of the early folk museums themselves. The prominent Finnish-Swedish writer Zachris Topelius tackles the idea head-on, borrowing his resurrection metaphor from the vision of the scattered and dry bones in chapter 37 of Ezekiel. In the biblical scene, the pieces are brought to life through Ezekiel's act of prophecy—bone joined to bone, sinews and flesh upon them, skin covering it all, and finally the breath of life bringing the restored figures to their feet, an army ready to reclaim the land of Israel. In his extension of the metaphor, Topelius equates the bones with ethnographic objects:

> The visual objects of a museum resemble the scattered bones on the battlefield of Ezekiel's vision. Pour a living, coherent idea into these soulless, often anonymous objects; sort them, order them, group them around their centers; . . . in this way let the meaningless receive its meaning, let the apparently worthless find an ingenious use, and the scattered bones will arrange themselves into figures; ethnographic objects in their unsurveyable mass will gather themselves into types, and the visitor will leave the collection with a total impression of a people now living and breathing in the provinces, in the fatherland, in the Scandinavian North. It is true that the life of these types must be sought in the visitor himself; he is the one who recognizes and loves them. The foreigner, by contrast, does not sense the way their

> bosoms rise with each heartbeat nor the warmth of life turning to a glow
> on their cheeks. But even for him human traits appear with an infinitely
> more lively truth than in the stiff wax cabinet.[7]

In their uncollected form, ethnographic objects are like the dry bones
jumbled together, unsurveyable traces of the bodies to which they pre-
viously belonged. The act of collection assembles them into recognizable
figures, shapes, and types—taking them as far as a traditional museum
might do with its classificatory systems and display paradigms. The addi-
tion of mannequins takes the scene a step further, but Topelius seems to
recognize along with Ezekiel (v. 8: "but there was no breath in them")
that the last piece of the puzzle, what Topelius calls the "glow on their
cheeks," must be added by an agent outside the scene, in this case the
museum visitor's imaginative participation.

Georg Karlin, founder of the folk museum in Lund, was also aware of
the corporeal logic of this new museology. When faced with sharp criticism
for moving buildings from original locations, his written response mo-
mentarily concedes one point: "The monument's connection to the place
where it was erected makes it an offense to historical sensibility to dislodge
it: what one moves is no longer the same as it was before the move; the
spirit is gone, and what remains is only an uninteresting dead body."[8] His
counterargument to such claims, though, was simply that in modern times
the "death" of many traditional buildings was inevitable in one form or
another: one could only choose whether to let it happen in place through
razing or neglect, or through the displacement involved in its rescue by
collectors. In the latter case, at least, there was still hope for a kind of
resurrection of the "dead body" with the help of living-picture display
techniques.

The resurrection of objects required a production of effigies in some
form or another. In the earliest phases of folk-cultural display at the inter-
national exhibitions and the first ethnographic museums, that process in-
volved production of literal figures, painted plaster mannequins posed in
interactive tableau settings.[9] In order to convey the impression of life-
before-one's-eyes, the folk tableau availed itself of many of the same mise-
en-scène techniques of reality production as did the wax museums. (Since
the mannequin displays at the exhibitions and at Hazelius's earliest mu-
seum predate the founding of the Scandinavian wax museums, they are
best seen not as derivative of the other tradition but as independent evi-
dence of a shared mannequin culture.)

In professional museum circles in turn-of-the-century Scandinavia, this
display technique came to be known as the "interior principle," that is,
the strategy of placing objects back in relation to bodies, and both back
into domestic interiors by staging a scene imagined to be taking place

before the viewer's eyes. This was the first solution the folk museum developed to deal with the challenge posed by the objects' real status as dislodged, collected fragments: how to help spectators "see the breath of life in the dead bones," or to "hear the old instruments play with full sound," as Edvard Hammarstedt puts it in this chapter's epigraph.[10] It was this desire to meet the public on familiar terms that turned traditional museum display into the living-picture medium of the folk museums.

Homeless Objects

The presence of an object in a museum is always evidence of some previous moment of travel and collection, of a prior displacement that creates the visual availability to which the museum owes its identity and purpose. This is true of museums both early and late in Western culture. In royal collections, the simultaneous presence of disparate objects might be evidence of the monarch's conquering range; in a curiosity cabinet, such juxtaposition might testify to the powerfully eccentric personality of the collector; in a naturalist or botanical museum, to the commanding classificatory overview possessed by the scientist. All of these early museum forms attest to the portability of objects. Pearce makes this feature a key component of her definition of museum objects as "selected lumps of the physical world to which cultural value has been ascribed," and further as "discrete lumps capable of being moved from one place to another."[11] To be a museum object, the collectible must have a connection to an originary context *and* be extractable. When moved, all such objects lose something of their original value, and in exchange gain display value in the new context of the collection.

Even if all museum objects have been moved, however, not all are understood as being equally "out of place" in their new context. That is to say, an object is felt to be *dis-placed* only to the degree that one has a strong sense of an originary context as a true and proper one. That sense will, of course, vary according to object and collecting situation. Although Pearce's definition of the museum object helps remind us that modernity did not invent the circulation of objects, it is also clear that the late nineteenth-century investment in the idea of lost origin cannot help but inflect the possible meanings of a moved object. Given the particular before-and-after logic of modernity in Scandinavia, it is not surprising that the increasing portability of objects there was viewed with some alarm (cf. Moltke Moe's anxiety about culture being carried off "piece by piece" by foreign tourists). Moved objects, according to this logic, were homeless objects.

Georg Karlin, the founder of Kulturen in Lund, uses exactly that metaphor in a 1918 guidebook to his open-air museum. He begins by theorizing that the fitting response to the perceived universal destruction of traditional material culture is nothing short of a *universal* collecting project—a tall order, Karlin admits when he writes that practical concerns should nevertheless focus attention on cultural forms close at hand. He adds that one should not purposefully dislodge objects for the sake of collection alone: "The limits [to the universal collecting project] lie in part in the idea, applicable here, that a museum should be a rescue institution for homeless things, for the sort of thing that has already slipped out of its milieu, and should not be a robber's den that piles up loot without regard to the object's right to live out its own life for its own purposes."[12] It is clear from the metaphors at play here that the object's relation to original milieu is seen as an organic one. Any talk of objects being allowed to "live out their natural life spans" at home makes the act of collection a particularly delicate operation—it reminds one of the way a collector for a zoo might talk about gathering in animals and putting them on display. When the folk-museum collector "robs" instead of "rescues," he risks "killing" the object by extracting it either too soon or too violently from an original context that is perceived to be rooted and whole.

Not all museum objects lend themselves equally to this kind of metaphorization, but one particular category does: what Barbara Kirshenblatt-Gimblett has called "ethnographic objects." This subset class of possible museum objects can be distinguished by the special dilemmas they present to the collector:

> The artfulness of the ethnographic object is an art of excision, of detachment, an art of the excerpt. Where does the object begin, and where does it end? This I see as an essentially surgical issue. Shall we exhibit the cup with the saucer, the tea, the cream and sugar, the spoon, the napkin and placemat, the table and chair, the rug? Where do we make the cut?
>
> Perhaps we should speak not of the ethnographic object but of the ethnographic fragment. Like the ruin, the ethnographic fragment is informed by a poetics of detachment.[13]

Ethnographic objects bear the marks of having been carried off; they are objects that so clearly *have belonged* elsewhere that they continue to evoke that distant context when put on display. That is both their attraction and their essential paradox: they are both here and there at the same time.

The "poetics of detachment" described here helps cast light on the folk-museum project precisely because of these collectors' hesitancy to make the cut themselves; hence Karlin's stated preference for gathering in already-detached objects. Even given that restriction, there were still plenty of eligible objects that had already "slipped out of their milieu" due to

rapid changes in rural culture. Capitalist market forces, expanded trans-
portation networks, and the modernization of agricultural techniques al-
lowed tools, clothing, and consumer goods new forms of mobility. Many
of the traditional objects of rural life they replaced were already ending
up in the storage lofts of rural farms, disregarded to the point that when
the early folk collectors first began asking for them, the owners themselves
did not see any value in them at all. After Hazelius's first museum had
opened, one anecdote has members of his family circle joking that "the
many milk buckets, harness pins and collars, and other such items actually
belonged mostly at home in real sitting rooms, stalls, and cowshed pens,"
to which Hazelius reportedly countered that his intention was to put them
back into exactly those kinds of spaces, but in museum form.[14]

The folk-museum movement created a new kind of market for everyday
items, a new economy of objects based on display value instead of use
value. As the collection activity expanded, it sometimes overlapped, such
as when Hazelius traveled to Norway to find items for his pan-Scandina-
vian Nordic Museum, or when the nationally conceived Norwegian Folk
Museum competed with regional museums like Maihaugen for the rights
to local materials, or when the museums in Stockholm, Lund, and Copen-
hagen all were actively collecting material from southern Sweden at the
same time.[15] Donors who previously would simply have handed over old
objects began to understand that they might want to hold out for the
highest bidder. When an interviewer asked Sandvig in 1903 if it was easy
to acquire objects for his collection in Lillehammer, he replied: "Oh no,
at any rate not any more. On the contrary, people are inclined to believe
that everything like that has quite enormous value. So for the most part
it has all turned into a question of money. But there are always some people
who have a lively interest in the collections and understand the old objects'
worth, above and beyond the money they can bring in."[16]

Another of Pearce's observations helps to put this object inflation in
perspective. She uses the idea of "rites of passage" to talk about the way
objects acquire different values when moving between contexts: "If entry
into a collection is an object's first rite of passage, then entry into a mu-
seum is its second—a passage which marks its translation into the class of
heritage material, of sacred durables."[17] At the point when it becomes
twice collected, it acquires new and different value, a process that contin-
ues throughout the life of the object. In an earlier chapter, we saw the
other end of the musealization process, when the celebrity relics at the
panoptikon fell out of their museum contexts at the closing auctions,
becoming relics of the newly defunct institution, or metonyms of the ce-
lebrities themselves, or even objects with a returning use value in their
own right.

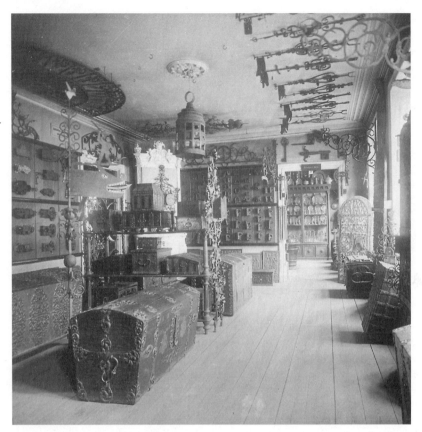

FIGURE 7.1. The Iron Room at the Nordic Museum around the turn of the century. Photographer unknown, photo courtesy of the Nordic Museum (Stockholm).

Pearce's idea of an object's "passage" between contexts can help explain the folk museum's motivation for finding new modes of display as well. Before this time, museums in Scandinavia, as elsewhere in Europe, had been founded on principles of royal power, wondrous miscellany, or scientific classification.[18] None of these museological paradigms found the dislocation of the object to be particularly troubling; in fact, the object's inclusion in a display was far more likely to be seen as enhancing its prestige, since it could appear more magnificently, interestingly, or orderly with other objects than it could in its original use context.

Folk museums like Hazelius's first ethnographic collection relied in part on these older display models, as can be seen in the so-called Iron Room of the Nordic Museum (fig. 7.1). With objects hanging from the ceiling

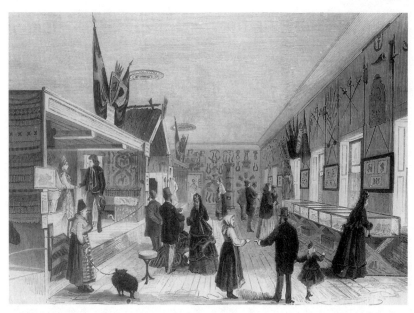

FIGURE 7.2. Interior view of Hazelius's Scandinavian-Ethnographic Collection/ Nordic Museum in its location at Drottninggatan 71 in Stockholm. The manne- quin tableaux can be seen on the left vis-à-vis the more traditional display cases to the right. Illustration by R. Haglund, n.d., photo courtesy of the Nordic Museum (Stockholm).

and crowding the floor space, the room testifies to the scope of this col- lecting activity and shows an affinity to the curiosity cabinet in the impres- sion of overwhelming overflow. From the archaeological museum, the Iron Room similarly borrows principles of taxonomy and classification. The room is full not of miscellaneous items but of objects exhibiting the interdependent structuralist relations of membership in a paradigm: here, all kinds of things made of iron. Even in the room containing some of Hazelius's famous mannequin tableaux, one could also find tradi- tional display cases, as shown in this frequently reproduced image from the early days of the Scandinavian-Ethnographic Collection (fig. 7.2). Captured here is the coexistence of different display philosophies: on the left side, one could experience folk culture as a scene; on the right, as a series of objects.

A similar situation existed at Bernhard Olsen's Danish Folk Museum, where in addition to the main attraction of the nine reconstructed whole- room interiors, one could find in two larger halls overflow rooms that were intended for display of "all the riches that have not fit in or which couldn't find space in the different interiors,"[19] according to an early ac-

count. Here were "great collections and series of individual objects illumi-
nating the different aspects of life and customs in the past," rooms that
still existed at the twenty-five-year anniversary mark.[20] These two urban
folk museums, in other words, never became completely "coherent";
throughout their existence, there were reminders of an older logic of the
series display.

Historian Staffan Carlén emphasizes a practical explanation for such
rooms at the early folk museums: a desperate lack of storage space.[21] At his
museum's initial location, that is, Hazelius of necessity showed everything
he had gathered in simply because he had nowhere else to put the things.
The situation was similar for Olsen in Copenhagen. Part of the reason, in
fact, that the folk museums moved beyond these urban locations, and on
to the expanded quarters of the open-air museum, was to gain the space
necessary to move more objects out of the series and storage and into
contextualized displays. But even at open-air museums, Georg Karlin em-
phasizes, the two modes of display were not seen as mutually exclusive: "I
have already emphasized sufficiently that there is no implied requirement
in the new system for the incorporation of the scientific series into gath-
ered pictures of place and time, that these pictures are only meant as one
side of popular-scientific museum work in which the museum goes from
being the scientist's domain alone to being the property of the entire
culture-seeking public."[22] So even though the emphasis was placed in-
creasingly on "gathered pictures," the series paradigm remained a part of
all the folk museum projects.

The favor shown to the contextualization model, however, may have
come in part from the troubling structural similarity between the scien-
tific series and the series created by processes of modern production. One
of the prime motivations for the initial collection of folk artifacts, that is,
had been the ascendancy of commodified objects in nineteenth-century
economic and social life. The introduction of factory-made goods created
the possibility of identical objects in a potentially infinite series of "leveled-
out" production, to return to the scare word often used by the collectors
themselves. It was exactly this kind of series that provided a dramatic con-
trast to the folk exhibits at the industrial exhibitions. Skansen historian
Bo Grandien notes, "At the first world exhibition in London in 1851, it
had turned out that industrial products were so remarkably similar, no
matter which land they came from. It seemed to be the same goods that
were being made everywhere. A consequence of this was a striving by
the exhibitors to create a national distinctiveness, and that was what the
organizers encouraged as well."[23] An intriguing tension emerges between
understanding the international exhibitions as promoters of the interna-
tional mass production of goods, on the one hand, and as showplaces of
national distinctiveness, on the other.[24]

When Bernhard Olsen visited the 1878 exhibition in Paris, his encounter with the Hazelian displays proved to be a defining moment for his conceptualization of the folk collection, and again the industrial object provided the counterpoint. As he wrote later in 1885, explaining the inspiration for the Danish Folk Museum:

> He [Hazelius] filled the corner pavilions of the Trocadero Palace with interiors from Lapland and Sweden, with numerous figures in folk costume and with lots of objects of everyday use. The impression was particularly unusual and stood out sharply and clearly from that of the rest of the exposition, with its heaps of industrial-artistic wonders and useless objects, fabricated for the day and worthless when it was over.[25]

The enduring value perceived in the everyday rural objects (the same objects that most rural dwellers might well have regarded as old junk at this time) emerges in part from the contrast with the infinitely reproducible commodities available elsewhere at the exhibitions. As Camillus Nyrop writes in the conclusion of his guide to the 1879 exhibition in Copenhagen, "The general public has at the exhibition become aware of the meaning and interest that can become attached to many objects they previously regarded as trivial. A great many things will now undoubtedly be preserved that would have perished if not for the exhibition. The proper kind of collecting activity has been supported."[26]

The rural object was imagined to retain a relationship to the hand of an individual maker and to bear the traces of a unique moment of production. Paradoxically, that made the completion of the series of rural objects all the more difficult. If objects of industrial production were identical, there was little point in even starting in on collecting the series, since it was potentially endless. But the individuality of handcrafted objects, taken together with their perceived rapid disappearance, made the collection of all available objects both meaningful and conceivable. This proved to be a snare precisely because the folk objects kept on *not* running out, and the museums were soon filled to overflowing with seemingly endless variations of everyday objects. This made the collecting pursuits at the folk museums the target of critique on occasion. One newspaper contribution in 1895 calls Skansen an "antiquarian orgy," a kind of collecting mania that should be brought under control before using up any more valuable public resources. On the one hand, the writer criticized Hazelius's extension of collecting to areas outside Swedish national boundaries: "This desire to scrape together anything he comes across from all corners of the world, which is common in children, ravens, lunatics, magpies, and kleptomaniacs, but ridiculous in a wise old respectable man, threatens of late to destroy exactly that highest and best aspect of the museum, its *national*

characteristic."[27] He further criticized what he perceived to be the collection's endless repetition, mirroring in his prose the piling up of objects in the museum series:

> I will not speak ill of the bell towers or farmer's houses at Skansen, I would only request that they not be so *completely alike*. This is, however, a completely fruitless wish when it comes to beer tankards, officials' desk drawers, beaters, harness-heads and -pins, harness hooks, whetstones, bread knives, swingles, chests, rolling pins, old apothecary jars, tiles, clay pots, copper kettles, pewter kettles, tankards, plates, and candlesticks. Of these objects and hundreds of others, from articles of clothing to seal imprints, one can find between fifty and a hundred that are *completely identical*, among them often a whole score from the same district. In some of the museum's sections this uncontrollable heaping up of completely identical, in many cases hardly remarkable, objects has made it so that the visitor completely loses the feeling of being in a collection of antiquities, and feels instead that he has landed in a third-class clothing shop or at best at the auction of an eccentric old rural dweller in some forgotten or ancient village. (emphasis in original)[28]

This critique claimed that the social benefits of the folk museum could no longer be balanced against other social needs seen as more pressing than the continual refinement of a collecting paradigm. For this viewer, who most emphatically is not intrigued by the endless small variations of handmade objects, nor overly concerned with reconstituting the missing persons of rural tradition, the scope of the collection has begun to approach a kind of mania that needs reining in. As he puts it pointedly, "I must ask, have we have done enough for our *living* neighbor that we can with good conscience contribute three million [kronor] for the protection of the old household utensils of *the dead*?" (emphasis in original).

Other folk-museum collectors also fell victim to the grip of the series, just as Hazelius seems to have done. The perceived urgency of their shared rescue mission made it imperative to save everything, not just the most typical or most valuable samples. Both Anders Sandvig and Georg Karlin were eventually relieved of their purchasing rights by the board of directors of Maihaugen and Kulturen, respectively, because they could not stop collecting still more variants of already collected objects, buying more than the museums could really afford to pay for new acquisitions.[29] It is clear that in spite of their more famous recontextualization techniques, the folk-museum founders also struggled with the logic of the object in series, in which there was always one more item.

Chapter 2's historical overview of the wax museum posited two main historical trends in wax modeling as a display medium. The first, and in many senses the logically prior of the practices, was the display of the

body in pieces, which contrasted with the attempts later in the century to present consolidated, contextualized, and "transparent" wax bodies in convincing tableau scenes. My discussion of the folk museum so far suggests certain parallels leading from the miscellany of the curiosity cabinet to the scenic sensibility of the early ethnographic collections. The jumbled bones of the ethnographic objects before they are collected are another kind of "body in pieces," awaiting the resurrecting impulse of more consolidated display forms.

Before moving on to detail the complex resurrection project of the folk museums, I would like to dwell briefly on the moment of collection, when it is the collector's body rather than a folk effigy that gives the objects their corporeal logic. Situated conceptually in between the dry bones and the living figures, the ethnographic objects at this intermediate stage are linked not by the touch of an original hand but by that of the collector. It is the collector's body that can both vouch for the original authenticity of the object in situ and preside over its role in the series collection. (Madame Tussaud, one will remember, had performed a similar function at her wax museum as well, as eyewitness to the Revolution and guarantor of her relics' authenticity.) Because the folk museums began as *personal* collections, that is, the founders could serve this important role of giving objects, even in this first stage of collection, a corporeal logic.

A well-known painting of Anders Sandvig from 1904 expresses the complex relationship of collector's body to object (fig. 7.3). The painting, by Eyolf Soot, shows Sandvig posed inside one of the old buildings at Maihaugen, holding one of his treasured objects in hand while surrounded by other collectibles on the table. As Buggeland and Ågotnes point out, the obvious point of the composition is to show the way Sandvig the collector "brought the treasures of the past out into the light," mediating between the darkness on the left side of the painting and the light of day streaming through the window to the right.[30]

There is more to add to this observation, though. The objects shown here inside the room have no clear relationship to each other; here we do not stumble upon a coherent scene from rural life but instead simply catch the collector with his objects (which, it should be remembered, include in this case the building in which he is shown standing). The depicted moment is precisely that of the object's rite of passage. It is the touch of the collector's hand that mediates the transition from storage chest to display case. The logic here is not yet that of the cultural effigy; that would require placing the object instead in the hand of a mannequin, or a role-player, or some other implied body that could simulate its use. The moment depicted here captures the moment logically just prior to recontextualization. Since the painting was done in 1904, there is an added resonance hinting in that direction, since what is shown here is in fact the

FIGURE 7.3. Eyolf Soot's 1904 portrait of Anders Sandvig, posed in one of his relocated buildings at Maihaugen surrounded by various museum artifacts. Photo courtesy of Maihaugen—De Sandvigske Samlinger (Lillehammer, Norway).

historical moment just before Sandvig's objects became twice collected. The year 1904, that is, when the Sandvigian Collections were turned over to the city of Lillehammer and became the public open-air museum at Maihaugen. If we were to imagine a sequel to this painting, that is, it would necessarily depict the object back in the hand of an "original" inhabitant. It is that crucial step that will now be the focus of discussion.

Props

The series display, as useful as it was for showing the entire scope of the collection, perhaps conceded too much to modernity's displacements. When an object was positioned in a display case or arranged in a group on a wall, its dislodged status remained all too clear. No matter how convinc-

ingly full the classificatory paradigm might become, it was seen by some
as a poor substitute for the living context that was perceived to have been
lost. When a culture on the verge of extinction needed rescuing, the token
enthronement of objects in existing museological forms seemed an inade-
quate response to the severity of modernity's challenge; only a new mu-
seum form could make the objects once again seem whole. As Gustaf
Upmark put it at Skansen's twenty-five-year anniversary, "This principle
of display for objects in a cultural-historical museum, this animation [*lef-
vandegörande*] of museum material that has been gathered for scientific
reasons and purposes is undoubtedly Artur Hazelius's great and original
contribution to the area of museum technique."[31]

It is worth a quick reminder that the folk museum's "discovery" of
living, contextual display principles was thoroughly imbricated in museo-
logical developments across the board (and, as I will discuss in chapter 10,
in more general visual-cultural trends as well). We have seen in earlier
chapters that the wax museum showed evidence of a similar tendency to-
ward mise-en-scène in its movement from wax cabinet to museum, in its
own "evolutionary drive" that encouraged arrangers "to take the figures
out of their isolated positions and compose them in living groups with
reciprocal dramatic rapport between the individual figures."[32] A retrospec-
tive article on the Danish Folk Museum's first twenty-five years describes
the historical trajectory of the folk museum in nearly identical terms, as a
progression from pieces to pictures:

> Museums in the old days were storerooms of sorts. Originally one heaped
> together all kinds of rare and curious things—art and stuffed birds, seashells
> and swords, armor and rare beetles. Eventually these curiosity cabinets
> were divided up, each section according to its purpose, but the packing
> together of rarities, piled up remarkably and in great numbers in display
> cases, long remained the principle. We still notice it today. But even so,
> common sense has won out. In art as well as ethnography, it is the living,
> impression-creating *picture* [*det Indtryks-levende og Indtryks-skabende
> Billede*] that is emphasized. At the folk museum it is the necessary precondi-
> tion. (emphasis in original)[33]

Just as the wax museum had grown out of its own curiosity-cabinet/anat-
omy show tradition, and had boasted at the end of the century of its pro-
gression to interactive, "living" tableaux, the folk museum turned increas-
ingly to the gathered picture in the display room.

As an aside, it is also interesting to observe a similar trend in turn-of-
the-century natural history museums as well. There, of course, the resur-
rection project is even more pronounced, since the collection material
used to be literally (not just metaphorically) alive. The decision to give the
"dry bones" flesh is acted out most spectacularly with reassembled dino-

saur bones and later simulated models. In fact, the tension between pre-
serving the scientific fragment and the popularizing historical reconstruc-
tion of dinosaurs raises issues that are remarkably similar to the corporeal
turn at the folk museums.[34] The same might be said of taxidermy in gen-
eral, which interestingly enough underwent a similar trend toward con-
textualized display during the first decade of the twentieth century, when
illusionistic nature dioramas called "habitat groups" became common at
natural history museums. There, too, spectators were encouraged to imag-
ine themselves stumbling onto animals caught "unaware" in a scene, as
Donna Haraway has shown.[35]

At the folk museums, the ever-increasing number of objects in the ex-
panding collections presented the biggest challenge to a project of recon-
textualization. If the collected object was to be understood not as an indi-
vidual entity but as a subordinate part of a picture, then it needed to be
displayed as an object in use. But the more objects there were, the more
problematic contextual display became, because the new technique could
quite simply not accommodate as many basically similar objects as the
older series paradigm. As one of the folk museum's most outspoken critics
quite rightfully pointed out in 1897:

> All in all only a meager amount of material could be accommodated in origi-
> nal use relationships and contexts. Say there were only 20 mangle boards
> and a similar number of scent-boxes in the museum: it would require the
> same number of rooms or figures. Say one had several hundred antique clay
> pots; in order to display them in interiors one would need a good many
> pottery workshops, even if each of these was plentifully equipped. Several
> hundred bronze swords would require raising a small army.[36]

To recontextualize an entire collection of thousands of objects was clearly
out of the question, and to do so partially struck this critic as too mixed
a curatorial philosophy for a responsible museum to adopt.

Scientific display standards were of little concern to a prominent and
very enthusiastic visitor to the Sandvig collections in Lillehammer, Nor-
wegian impressionist painter and author Christian Krohg. On the con-
trary, he shudders to think what would have happened had Sandvig's col-
lection fallen into the hands of a professional museum man:

> If a scientist, a fantastically learned man had gotten hold of this collection,
> a so-called conservator who wanted to be pretentious about his learning and
> his unerring geographic and historical knowledge, the result would have
> been horrible.
>
> Everything would be furnished with a number and an inscription re-
> minding that "The objects must not be touched." Nothing would have been
> allowed to be placed where it appeared, but would have been forced into

the places where academic journals could justify placing it. Entire rooms would have to stand empty, due to the lack of historical evidence that the exact furniture one had come to acquire was already in use at that time. Other rooms would be overloaded; they would have become storerooms, because one had too many of the objects that belonged in exactly that room. It would become an excellent source of study material for three or four existing specialists, but without a trace of meaning for the public.[37]

The tension between these two viewpoints shows that scientific accuracy does have to give way to some degree if one wants to create the impression of a whole room in use. One cannot show everything one has managed to collect, since the collecting process does not take place in picture-sized units. The need to limit the objects shown introduces a kind of editing effect, since behind every object that is chosen for a scene are many others that end up out of sight. This was one of the prices one had to pay for turning objects into props.

The object-in-use nevertheless became the preferred display modality of the folk museum. Georg Karlin formulates the goal of the new museum movement in this way: "The museum man who arranges such a gathered picture of time or place, must set up as the norm for his arrangements that if the people who lived at the place or time represented in the interior could wake up and see his work, they would feel themselves completely at home and not begin walking around in order to get a look at the many remarkable things."[38] If everything is arranged as it should be, Karlin indicates, one could imagine the dead rising again, immediately setting about to use their objects once more, unaware that they had awakened to a museum display space instead of the real world. By emphatically conceptualizing the body of the revived user as a nonspectator, Karlin implies that the model of use upon which the display of objects should be based should appear to be entirely unselfconscious. At the risk of putting too fine a spin on this, one might say that the goal of a fully contextualized display is not "use," but *use*.

This is an impossible concept, of course; display is shot through with theatricality from the start. Interestingly, this was literally the case for the first objects in Karlin's museum, initially collected by the Lund Student Association not for museum display but for amateur folklife performances: "One after another they [the students] brought back from their home villages an old article of clothing, a household utensil, or found out where such things could be found, in order to give new life and visibility [*åskåd-lighet*] to the dying folk worldview, customs and way of life."[39] The tie between the "new life" and the "watchability" of objects underscores the representational basis of any "living" relation between bodies and objects

at the museum. The phrase Karlin uses for the initial core of the Lund museum's materials—"a collection of props" (*en rekvisitasamling*)—simply underscores the hazy line between real use and stage use in all museum settings.

Thinking of an object as a prop makes unavoidable the idea of a body to use it. As mentioned earlier, in the act of folk collection the body of the original user has given way to that of the collector, but for the contextualized display, that body in turn yields to that of the folk effigy. "Sleight of hand" is the perfect phrase for describing the substitution that must occur, since the spectator had to be encouraged to forget the role of the curator's hand in the display and to imagine instead the depicted or implied hand of the display to be the original rural hand arranging the furniture just so, or opening the Bible on the table to exactly that page, or watering the plants on the windowsill, or tending the garden or the animals that might be seen wandering around in an open-air display. That substitution is a kind of magic trick, or maybe more to the point here, it is a theatrical gesture invoking a willing suspension of disbelief.

In the early folk tableau, the new hand was identified as that of the mannequin. Two evocative photographs from the Nordic Museum show this strategy in its most basic form. I should emphasize that I include these pictures not to prove a chronological transition from typological display to a full-blown interior technique. Both photos are actually taken from a temporary exhibit of folk costumes in 1902, long after the first mannequin tableaux were created in the 1870s, and ten years after the opening of Skansen as well. Instead, these two images simply capture the distinction in display styles most economically by laying bare a fundamental choice facing the curators. The first image (fig. 7.4) shows two mannequins dressed in folk costumes, sitting in front of a wall of display cases containing traditionally arranged object paradigms. The pose of the mannequins, turned forty-five degrees from the viewer, is halfway between a purely interactive display and a frontal pose. As my discussion of the wax-museum material emphasized, this simple move represents one of the most basic shifts in spectatorial dynamics, since a display's turn inward on itself implies a scene that is living a life independent of spectator perception. There is only the barest hint of a "scene" here, of course, but these folk mannequins clearly belong together.

The second photo shows another display from the same exhibit that takes the process of narrativization a step further by introducing an object into the scene (fig. 7.5). The nature of the object is unclear from the photograph, but what is most interesting is the way its position in hand transforms it into a prop, in stark contrast to the status of the background objects. (This is the same Iron Room, incidentally, as the one shown in

FIGURE 7.4. Mannequins posed interactively in the Nordic Museum in a temporary folk costume display, 1902. Photo Anton Blomberg, courtesy of the Nordic Museum (Stockholm).

figure 7.1, with this backdrop visible at a farther distance in that photograph.) If the objects on the wall here—iron locks of every size and shape—have made themselves at home in a classificatory paradigm, the object in the male mannequin's hand has seemingly come back to its prior home in the hand of an original user. The effect is strengthened by the purposeful, interactive sight lines (the man showing the object while looking at the woman, the woman reacting by looking at the object). These mannequins have obviously received the same "Stanislavskian" training as did the figures at the Swedish Panoptikon, who likewise were sculpted with a specific situation in mind. A subtle result of depicting this simple interaction, with the insistent "look-here" of the mannequin's deictic gesture, is not only that the object in hand seems uncollected but that it in turn distracts attention away from the collected status of the folk costumes worn by the mannequins themselves. There is an intriguing ontological hierarchy at work in this scene, however accidental the juxtaposition of

FIGURE 7.5. Mannequins from temporary exhibit in the Iron Room of the Nordic Museum, 1902. Photo Anton Blomberg, courtesy of the Nordic Museum (Stockholm).

display styles, considering that all the visible objects could very well have been collected on the same trip to the rural districts—locks, object-in-hand, and costumes alike.

The object has to become a prop in order to recover a measure of the life it was thought to have lost when it "slid out of its milieu" in the first place. By putting it in relation to a mannequin body, the representational game takes on a fundamental circularity, especially keeping in mind the elaborate measures that had to be taken to shore up the presence effects of the mannequins themselves at the wax museum—including precisely the reliance on supplementary objects. If the folk-museum object is invested with a heightened realism and "life" by virtue of its proximity to a human effigy, one must also recognize that the body on display in turn achieves its lifelike appearance by being given objects to use. Without props available to activate the viewer's imagination, the mannequin remains a dummy (as can be intuited in the difference between figures 7.4 and 7.5); with props, the figure can more easily simulate agency and consciousness.

The earliest tableaux at Hazelius's Scandinavian-Ethnographic Collection were already more thoroughly theatricalized than these mannequin couples from 1902, but even back then they needed backup support to become a living picture of folk life. Techniques familiar from the wax museums appear in the composition of some of them. For instance, the most famous of the Hazelian tableaux, *The Little Girl's Last Bed* (see fig. 6.8), shows aspects of both the "aesthetics of sacrifice" and Fried's idea of "absorption," as discussed earlier in connection with the wax tableau. One finds the same in the depiction of an older couple from Halland in the Bålastuga interior (fig. 7.6), in which the one figure reading aloud and the other lost in thought at the table seem perfectly oblivious to the display situation. Threshold effects as well, similar to those of the open doorways in the wax tableaux, showed up in the interior from Delsbo parish in Helsingland, in which one mannequin figure is seen crossing the threshold at the left, "bursting" onto the scene and surprising the inhabitants (fig. 7.7). The moment of surprise creates yet another scenario of absorption that contains the scene entirely within its space on the other side of the invisible fourth wall, and helps motivate the frozen posture of the inhabitants as well.

There is a difference, however. Wax museums tried to capture famous events and celebrities, relying on the iconic powers of the mannequins and tableau strategies to help spectators recall an already famous figure or scene. The point of the deictic prose was to flesh out character motivation, establish cause-and-effect relationships, and infuse the space with a sense of "here" and "there, thereby anchoring the scene to a specific event. Hazelius's folk museum, by contrast, had to rely instead on the typical

FIGURE 7.6. Interior display of a cottage in Halland. Photo Axel Lindahl, courtesy of the Nordic Museum (Stockholm).

instead of the extraordinary, since his overall project obligated him to depict the timeless, constant aspects of rural culture, not the dramatic, onetime event. The narrative aspect of these tableaux would be closer to that of the genre painting than of the wax tableau.

The Nordic Museum's printed guide from 1892 (interestingly, published around the same time as the Swedish Panoptikon's first written guides) can provide a specific example. When the catalogue took to presenting Hazelius's prized tableau scenes, the strategy was first to give each scene's artifacts a responsibly scientific discussion and then to cap off each description with a gathering narrative that imagines the scene as taking place at the moment of both watching and writing. From the visual clues of the Delsbo interior alone, to take one example, one gets nothing close to the sense of story that is laid out here in the guidebook:

> Concerning the situation in which the people depicted in the picture [*tafla*] find themselves, one notices immediately that the entering man elicits from the room's inhabitants a less than pleasant surprise. He has clearly had a dispute with the man of the house and believes that with the help of the document he is holding in his hand he can ensnare his adversary. The one daughter sits barefoot and in everyday clothes. The mother and the other

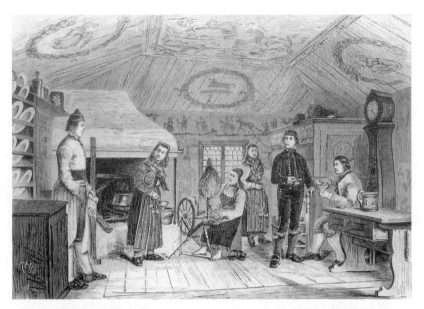

FIGURE 7.7. The cottage interior from Delsbo parish in Helsingland, one of the early mannequin scenes at the Nordic Museum. Illustration by R. Haglund, from *Ny Illustrerad Tidning* (13 March 1875).

> daughter have just come home from a feast and have brought along the young man, who is welcomed by the father with a drink of whiskey from the heirloom silver cup. This is done with a spoon, which according to ancient custom can be used by the guest to partake of the cup's contents three times in a row without repeated invitation. The young girl is the only one who is not worried by the entrance of the visitor, absorbed as she is in her thoughts about the guest of the house, the Delsbo boy standing in front of her.[40]

That is quite a story to be carried by a single mannequin tableau. It has everything: a surprise entrance, a pending lawsuit, budding romance, and a short lesson in drinking customs. By suggesting various subplots and story trajectories, the written narration not only attempts to motivate each character's presence in the scene by extending the time and space of the depicted moment (telling where characters have just been in moments prior, for instance) but also turns objects into props and collected clothing into theatrical costumes. With the help of the printed narrative, an unremarkable piece of paper in hand becomes a crucial piece of evidence, just as the museum objects proper—the spinning wheel, the silver heirloom cup, the spoon, the dishes on the wall, the six complete costume sets, and the table—are grasped for their part in the story carried by the scene. It

is worth remembering that each of these collected objects could conceivably have been displayed in series with twenty similar objects; instead, the scene contains only as many objects as the room and the story can plausibly bear (even as is, the coherence of the scene is stretched to the limit in the accompanying prose).

Such a paragraph embodies in narrative form the tension between coherence and miscellany. All objects are accounted for by some narrative hint, and the scene does its best to convince of its immediacy and authenticity, but the combination of story threads never quite blends to a seamless whole. In spite of reports of strongly emotive spectator responses to the tableaux ("all the mothers" were said to weep at the sight of *The Little Girl's Last Bed* at the Paris Exhibition, for example),[41] or journalists' frequent claims of having been fooled by the mannequins (as at the wax museum), the mannequin group still shows ample evidence of posing and collection. One might say that the tableau interior took the object and put it onstage but did not give it a home. The quest for an authentic representation of folk culture seemed to require more than a prop in a mannequin's hand.

INSIDERS

This is something quite different than going
around peeking into display cases and cabinets,
as at the usual exhibitions.
*—Comment by an unnamed visitor to Skansen
immediately after its opening* (1891)

THE HALF-ROOM interior populated with
mannequins was the closest the folk museum got to the actual display
practices of the wax museum. The visual regime of that presentation strat-
egy was clearly voyeuristic, and contemporary spectators understood it to
be of a piece with the practices of detached viewing that were developing
concurrently in other forms of visual display. One obvious parallel to the
arrangement of viewing space at both the wax museum and the folk tab-
leau was the serious theater, which itself was establishing its own increas-
ingly disciplined barrier between stage and audience. This was especially
true in Scandinavia, where leading-edge theater practice and new plays by
Ibsen and Strindberg embraced the naturalist performance style and even
helped formulate that aesthetic system. A strictly separated stage space, it
should be remembered, was a nineteenth-century development as well,
made possible by advances in lighting (which finally allowed for a darken-
ing of the hall) and new experimental stage spaces (like the Théâtre Libre
in Paris, whose intimate scale reduced the need for declamatory style and
grand, legible gestures directed overtly at large audiences).[1] Theater
actors, too, were increasingly encouraged to adopt an absorbed, interactive
acting style turned inward on the action and away from the audience.
With these preconditions in place, theater spectators positioned on the
other side of the one-way mirror could watch a scene with the increasingly
secure expectation of not being watched in return.

Or, at least, that was the fiction promulgated by the naturalist theater
aesthetic. Since the theater actually trades in live bodies on both sides of
the invisible fourth wall, the possibility of an accidental interactive ex-
change with the audience hovers in the background of even the most disci-
plined naturalist performance situation. It took the addition of recording

media to the mix to maximize the voyeuristic potential of such performance situations. Only then could the barrier separating actor and audience take on the character of an ontological divide, stretched out across a gulf of both space and time. This effect, of course, goes to the very heart of recording—to phonography and photography as well as film. But it is in film that the effect is most noticeable, since the addition of motion to an image (and eventually synchronized sound and color as well) heightened the presence effect of bodies on-screen while maintaining the absolute assurance that they could never engage the audience in a fully reciprocal look.

The mannequin thus finds itself somewhere in between stage and screen bodies. As shown earlier, the effigy at the wax museum aspires to the status of recording with its own play of presence and absence, driven by similar assurances that the mannequin can never look back. No matter how propped up by realistic display techniques, the wax figure remains fundamentally absent, on the other side of the obstinate ontological gulf separating the live bodies from the dummies. It is only the ultimate materiality of the mannequin that makes it fall short of the cinematic signifier's imaginary status, to use Metz's term once again. But that same physical presence also means that mannequins are deployed in three-dimensional space, as in the theater, and not on the flat surface of a screen. It is not *impossible*, that is, for the viewer to enter the space of a mannequin display. It is real space, after all, separated from the viewer only by conventional spectating protocol.

The connotations of origin that attached themselves to the folk museum's display space made the scene on the other side of the barrier particularly inviting (think back to the tug of the folklife scene on Sofi Hazelius). While visitors at the wax museums may have been curious about the kinds of display space offered to them there—the private space of celebrities, that of famous events of the past, or of distant lands that the viewer could never hope to see in person—the space of the folk museum was charged with connotations of source not only for cultural insiders but potentially for foreigners as well. That aspect of "folk space" was already in play at the international exhibition in 1867, where the Swedish folk mannequins served as a kind of blank screen to receive the imaginative projection of one journalist: "Yes, these must be the worthy Dalecarlian peasants over there, simple, sincere, without any affectation, and not at all spoiled by an all-too-frequent contact with our so-called modern civilization. It is a pleasure to see them naively occupied with their own affairs, not worrying themselves about the noise and agitation around them."[2] Like many of the joke narratives from the wax museums, in which a narrator feigns being duped by the reality effect of the mannequins, this viewer claims to be taken in by the mannequins, imagining them at first to be real "worthy

peasants" from rural Sweden. Here, too, the point of the joke is that the narrator eventually discovers that they are naive and oblivious because they are mannequins, not because they are premodern. The mannequin display made cultural voyeurs out of viewers, since the figures would not—and could not—return the look.

A similar reaction was evident in Paris at the follow-up exhibition in 1878, where Hazelius's cradle tableau elicited this response:

> Even I stood transfixed there, strongly interested, soon quite touched, espe-
> cially when in passing by the scene I had in front of my eyes, my thought
> penetrated into the customs of this life of by-gone days; because, alas, it
> appears that the vertiginous evolution of modern progress is making itself
> felt even up to those frigid regions where the good old days seemed intent
> on lasting forever, demolishing in hurried strokes the ancient edifice of cos-
> tumes and practices, as well as ideas.[3]

Seen through Continental eyes with no particular relationship to Swedish culture, the frozen moment of folklife could be imagined as a generic one just prior to modernity's widespread changes. It could stand in for what everyone—not just Swedes—imagined themselves to have been and to have lost.

An interesting contrast to this distant view of the frozen North is pro-vided by a Swedish account from the same exposition, in which a journalist was apparently given special permission to walk into the display space for a closer look, perhaps because he was one of Hazelius's fellow countrymen. This reporter's description of viewing several mannequins grouped in an outdoor scene, as well as the "Last Bed" tableau adjacent to it, is worth quoting at length:

> Look at this landscape from the Mora district! Walk in among these good
> men of the valley and their wives, if like me you obtain permission to do so,
> and you will think yourself transported to the "beautiful shores of Siljan."
> Way down there is the magnificent lake—not even the church boats are miss-
> ing. What a view!
>
> And these groups are "artificial" (yes, really!), and the view can be
> found—just a few steps away from you!
>
> There, just to the left, is a cottage. If you aren't permitted to "peek in
> through the windowpane," climb down among the crowd, move yourself a
> little to the left, and you will have an unobstructed view of what is happen-
> ing in this humble dwelling. . . . The poor people in there! They take no
> notice of what is outside. The poor mother! With what sentiments do you
> lie there, bent over your little loved-one's useless cradle? Yes, it is a heavy
> burden after all your waiting, after all your agony, now to lift your little one
> and place her in the black coffin, her last bed.

To the degree that the spectators comprehend the significance of this scene they have in front of their eyes, their voices are lowered and they walk silently away.[4]

As this reporter moves into the space of the mannequin display, he enters a particularly charged cultural landscape—actually, the very scene by Lake Siljan where Hazelius is said to have received his collector's calling six years earlier, and where so many other viewers imagined catching a glimpse of Swedish culture just before it disappeared.[5] His exclamation ("What a view!") resonates with those other accounts; this tableau, in short, captures the very viewpoint that had previously been the goal of so much tourist travel to Dalarna and transports it to the world exhibition in Paris instead. What this Swedish account makes clear, however, is that what for the international viewers was just a generic northern landscape instead resonated with special cultural significance for native Swedes.

For this reason, it is interesting to see the way the narrator toys with both immersion and voyeurism. He has been allowed to mingle with the mannequins and be in the space, yet even within the display, he falls back on the voyeur's position by peeking through the side window at the adjacent exhibit's mannequins, the figures in the "Last Bed" display. He then goes back out among the general audience to get an unobstructed "fourth-wall" overview of those same figures, which, as he notes, proceed about their "business," oblivious of the watching crowd. The implication seems to be that the culturally familiar viewer, unlike the foreigner, knows this scene literally inside and out and can move easily between positions of identificatory immersion and distant appreciation and aestheticization. (One is reminded of Claës Lundin's double view of Stockholm simultaneously from within and without, as discussed in Chapter 5.) This viewer's mobility contrasts with the apparently fixed position of the exhibition's general crowd, which remains on the other side of the barrier in its appreciation of what for it remains a distant scene and a single perspective. Perhaps this is what Zachris Topelius hinted at with his comment that "the foreigner, by contrast, does not sense the way their bosoms rise with each heartbeat nor the warmth of life turning to a glow on their cheeks."

As permanent exhibits at Hazelius's museum back in Stockholm, these same folklife tableaux had far more opportunity to work these effects on a public of cultural insiders. Although access to the mannequin groups there was initially of the voyeuristic variety, it did not take long for that to yield to a more immersive experience, as will be shown later. For now, though, the Hazelian folk tableaux are worth a closer look. The illustration shown earlier (see fig. 7.2) gives some indication of how the tableaux were presented to the public early on at the Scandinavian-Ethnographic Collection. On the left-hand side of that drawing, one can see the interior

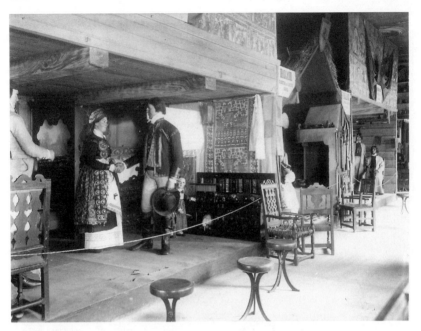

Figure 8.1. The Ingelstad cottage interior at the Nordic Museum, seen from an oblique angle. Photo Axel Malmström, 1904. Courtesy of the Nordic Museum (Stockholm).

scenes raised above floor level, like a theatrical stage, with a rope draped along the crucial fourth wall. Both details reinforce the staginess of the presentation, an effect echoed in the stool for seated spectators placed in front of the first interior.

Another look at the same display, taken from a later photograph, gives an even clearer picture of how the visitors were meant to engage with the displays in this museum space (fig. 8.1). One surmises that the museum visitors taking up the seats arranged along the display boundary were intended to contemplate each scene carefully, both for its detail (aided by the scholarly portion of Hazelius's guidebook) and for the narrative and emotional content of the scene (as suggested by the fictional scenarios that close the guidebook's description of each display). Another view of the Halland interior (the older couple with the cat, introduced earlier as fig. 7.6) seen from a slight remove shows a similar seating arrangement on this side of the barrier rope, in which spectators might linger in cultural-historical conversation or read their printed guidebooks (fig. 8.2).

The folk tableau, then, initially encouraged a model of spectatorship very much like that of the wax museums. Viewers of the half-room manne-quin interior were invited to toe the line and hold back in their observa-

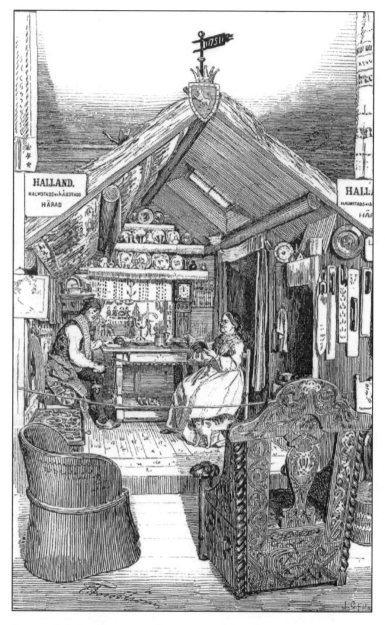

FIGURE 8.2. Another, more distant view of the cottage in Halland (cf. fig. 7.6) as displayed at the Nordic Museum. Photo courtesy of the Nordic Museum (Stockholm).

tion of a scene, receiving in return the implicit assurance that they would have imaginary access to something undisturbed in the scene. The problem, of course, was that given the stakes of the displays' subject matter, such lines of demarcation seemed to concede too much separation between the urban viewer and the rural scene. Many viewers did not want the scene from Siljan to have the same distant status as a wax tableau of Stanley in the Congo, or Nansen on skis in Greenland; it should be felt to be a natural extension of the spot from which they viewed the scene. They wanted their culture of origin to remain powerfully present to them, fully available in their own space, not on the other side of a cultural and spatial divide. It was this desire that led to the experiments with surround-style, whole-room interiors.

Cohabitation

The mannequin tableau's use of real, three-dimensional space as a basic unit of representational exchange conceivably put the depicted space of folk culture within reach of the spectator. The first to pursue the implications of this fact in Scandinavia was Bernhard Olsen of the Danish Folk Museum. Olsen had been influenced in many ways by Hazelius's collection project and his groundbreaking folk tableaux. He himself identified Hazelius as the creator of the folk-museum paradigm and credited his visit to the Hazelian displays in Paris in 1878 with showing him how folk material might grip the public's imagination with a powerful sense of scenic composition. At the same exhibition, however, Olsen received another quite different inspiration that would take his Danish Folk Museum in an important new direction. Here is how he described it seven years later:

> The Dutch had, either through their own invention or instructed by Hazelius's participation in earlier international exhibitions, set up their own little folk museum that contrasted with the Swedish and Finnish ones. Whereas those depicted interiors in smaller rooms whose fourth wall is open to the public, in other words as it is done in the wax museums, the Dutch here had a complete room which one could walk into. Every single thing had been taken out of old houses and stood in its proper place. In contrast to the Swedish manner, the effect was stirring, and from the moment I walked into this old room, which was like being in another world, far in time and space from the teeming, modern exposition, it became clear to me that this was the way a folk museum should be arranged.[6]

The whole-room interior of the Dutch display, in contrast to Hazelius's half-room tableaux, allowed all visitors the opportunity to occupy the space of the display in a literal fashion and to surround themselves with

the interior milieu of folk culture—no special permission was necessary. As one of Olsen's friends put it in a retrospective article, "In Hazelius's peasant rooms the fourth wall was open; in other words, one merely peeked into the room; one wasn't *actually* there. In contrast, at the Dutch display at the international exposition there was a *closed* peasant room, and Bernhard Olsen was not slow to distinguish between the good effect of the one and the far stronger effect of the other" (emphasis in original).[7]

Olsen saw the whole-room interior's power to transport to "another world, far in time and space from the teeming, modern exposition" as a great advantage over the voyeuristic half-room scene. The early Hazelian tableaux might have created a surreptitious desire to roam the display space, as the Swedish journalist was allowed to do, but the roped-off barriers and elevated stage platforms there always marked the scene as primarily off limits, making any imagined entry into the space akin to the trespassing scenarios of the wax-museum tableaux, where crossing the boundary always carried an imagined risk. The tableau, with its strict separation of "here" and "there," left museum visitors (like cinema spectators) on one side of the ontological gulf separating display from audience: "one wasn't *actually* there."

The whole-room interior, by contrast, enacted in official display practice what other living-picture media could only leave as a tantalizing fantasy, namely, a literal entry into the representational space, a space that in recording-based and screen-projection media always remains necessarily and ontologically out of reach. The barriers typical of those media, potentially fraught with separation and loss, dropped away at the folk museum when it adopted surround-style display rooms. This was especially true when the rooms were authentically reconstructed, as this Dutch room seems to have been (everything to "its proper place"), since in those cases the only difference between the folk space at the museum and the original space was its new location and increased visual availability.[8] The room had done the traveling, but by making the trip so elaborately intact, it could impute to the visitor the powers of virtual mobility. The "stirring" effect of the whole-room interior for Olsen was that he could walk right into authentic folk-cultural space and *be there*.

The question for spectators entering any surround-style room is, of course, how to negotiate the space; is the entire room available for inspection, or are there still implied or invisible lines separating off areas of display? Or, to take it further, is the room available for inhabitation? To what degree should one make oneself at home? Olsen encountered some of these paradoxes the next year, in 1879, when he implemented the technique for his own displays of Danish folk culture at the industrial exhibition in Copenhagen, where he, like the Dutch, created entire rooms by paneling the walls and ceilings of existing interior spaces with collected

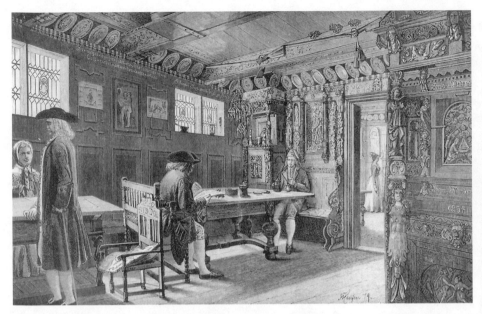

FIGURE 8.3. Bernhard Olsen's Hedebo interior from the 1879 Copenhagen Exhibition. Illustration by J. C. Hansen, included in Camillus Nyrop's exhibition catalogue. Photo Niels Elswing, courtesy of the National Museum of Denmark (Brede).

material and furnishing them with appropriate inventory. At the exhibition, some of these rooms were still inhabited by mannequins, as can be seen from a drawing of the Hedebo interior (fig. 8.3).[9] Therein lay a major paradox of the surround-style display space, namely, that spectator bodies and mannequins do not easily coexist. The shared space must be divided up almost imperceptibly for spectating and display (one can easily see how this might work in the illustration provided, where the side of the room with the seated mannequins might have been understood as a kind of de facto tableau).

The presence of these effigies at close range, however, exposes aspects of the mannequins that might otherwise be less noticeable. Though it is true that the tableau hindered a literal entry into the scene, it offered by way of compensation a more gathered perspective that gave the mannequin group a clear scenic quality, which along with various staging techniques could buttress the presence effects of the figures. Up close, sharing the space of the spectators, the mannequins in surround-style rooms ran the risk of exposing too much of their representational status, an effect that of course counteracted the "stirring" effect that Olsen wanted out his rooms. This may be what led Olsen to begin phasing out mannequins

when he opened his Danish Folk Museum six years later in the Panoptikon building. Most of the rooms there seem to have been cleared of figures, with the exception of two rooms where live "folk" guides helped mediate the displays, such as a girl from Skåne shown demonstrating weaving techniques and a costumed information guide from Amager who answered questions about the room from that district.

In Sweden, where Hazelius shifted his main energies from the Nordic Museum to his open-air museum at Skansen in the early 1890s, he, too, abandoned the tableau in favor of the surround-style principle of cultural immersion. Many of the early spectator accounts of visits to Skansen echo Olsen's experience with the Dutch display at the exhibition; visitors enjoyed being able to walk in and surround themselves with an authentic environment. Typical of these accounts is a description of Skansen, again by Claës Lundin. Here he articulates the advantages of immersion:

> "This is something quite different," expressed one of the members of our group, "than going around peeking into display cases and cabinets, as at the usual exhibitions."
>
> Yes, this is *living* instruction in familiarity with our country's various districts, a most pleasant instruction that is preserved the longest in memory. The small rooms at the Nordic Museum's location at Drottninggatan 71 A and B are also quite informative, but not nearly to such an extent as the exhibition at Skansen, for at the latter one can also view the entire exterior of the cottage and can enter inside and make one's observations in the midst of all the artifacts that were used in real life. (emphasis in original)[10]

We have come a step further here than the Danish Folk Museum's first experiments with whole-room interiors on its rented floor of the Panoptikon building. Visitors could now enjoy both exterior and interior views, moving between the inside and outside of the buildings in succession. It was this opportunity to experience rural space from all angles and positions that was a key attraction of the open-air museum experience.

As seems to have been the case at the Danish Folk Museum, the new display conditions at Skansen affected the perceived appropriateness of mannequin scenes. Given the new outdoor format, however, the remarkable thing is not that Hazelius moved more in the direction of folk-costumed tour guides or uninhabited interiors but that he persisted with the mannequins as long as he did. Five mannequins from the Mora tableau, that is, made the transition with Hazelius to the new outdoor museum in the early 1890s, as well as several of the Lapp figures, there to live out an odd, in-between sort of display life, a vestigial reminder of early practices.[11]

The Mora figures had been posed against the Lake Siljan scene at the exhibitions and the early Nordic museum, and probably had special resonance for Hazelius due to their connection to his influential trip to Da-

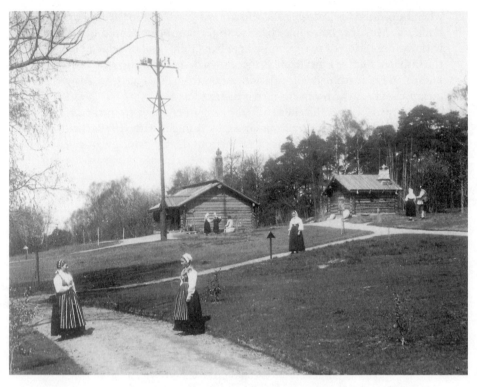

FIGURE 8.4. Exterior view of Skansen's Mora cottage, with live, costumed tour guides in the foreground and the two groups of Mora mannequins in the background. Photo Axel Lindahl, 1892, courtesy of the Nordic Museum (Stockholm).

larna in 1872. But they were also appropriate to one of the first buildings Hazelius had purchased and moved to Skansen, the Mora cottage from the same district. Throughout the first decade of Skansen's operation, the five Mora mannequins could at various times be found both inside and outside that cottage, moved back and forth depending on the weather, as Jonas Berg puts it.[12] In a photograph taken in 1892, soon after Skansen's opening, we see the mannequins in the distance, in groups of two and three, while in the foreground the living guides, temporarily immobilized by the photograph, provide an almost imperceptible contrast (fig. 8.4).

Since the five mannequins were often moved around, the staging of their interaction was a daily task, and apparently they would sometimes not end up correctly posed. In a reminder note to several women of Skansen's staff, dated July 10 of either 1899 or 1900, Hazelius emphasizes, "May I remind especially the morning inspectress to keep a careful eye on the displayed figures outside the Mora cottage so that they 'correspond'

with one another, that their looks are aimed at each other. *That was not the case today!"* (emphasis in original).[13] The continued portability of these mannequins, that is, kept them in a perpetual vacillation between collection and recontextualization; every day, the moment of posing by the staff re-created the mannequin continuity system of shared space, meaningfully reciprocal poses, and interactive sight lines (the parallels with cinematic continuity are compelling here). Only then could spectators happening upon the mannequins get the impression of encountering a living picture, as was the case with the indoor tableaux at the Nordic Museum.

The outdoor location gave that kind of scene a strange ambiguity, however, one that Hazelius apparently began to exploit with decoy effects quite similar to those that were popular at the wax museums. There is even a hint that Hazelius may have occasionally arranged to have living guides surprise tour groups by hiding among the mannequins, as Claës Lundin seems to indicate here:

> But look, there we have a group of people from Dalarna who have gathered out on the lawn, whose picturesque costumes create an excellent contrast to the green surroundings. It is a vivid sight, happy and charming in the sunshine. The Dala-men are steely figures, the Dala-women beautiful and wise-looking. But they appear to be unusually quiet. Oh, look a young man with an intelligent appearance just emerged from one of the groups. He is clothed in the Orsa costume with the white jacket, golden apron, and dark blue stockings. When the doctor [Hazelius] calls to Per, he comes up and listens to the director's orders. . . . The others stand there and could not do otherwise, because they are Söderman-figures, very accomplished, but without the faculty of motion.[14]

Setup or not, the moment of surprise outside the Mora cottage repeats itself as a trope in several spectator accounts that good-naturedly recount the experience of being fooled by the mannequins. This visitor account from 1892 is typical and sounds very much like the wax-museum discourse presented here in earlier chapters:

> Look, over there stand a man and woman outside in Mora dress talking to each other. We are just about to join in the conversation when we discover that what we have before us are merely effigies [*bilder*].
>
> Inside the cottage we look around and find everything to be just like in a rural home from Mora—at least, the way it was in some places a couple of decades ago. If only those women sitting on the bench were truly living people and not merely costumed wax effigies [*vaxbilder*]. Then we could start up a chat with them and hear about this and that from their beautiful home village.—But what is this? One of them is moving its eyes. Have they gotten so good at making effigies that they can somehow give them movable

eyes? While we stand there in that way looking at the effigy, it also starts to laugh. We had been duped; it was two women in the flesh [*två lifslevande kullor*] that were sitting in there.[15]

At the wax museum, the decoys that popped up taking tickets, directing traffic through the halls, or peering so intently into the displays often created uncertainty about the status of fellow spectators; fooled first by a mannequin, visitors were fooled next by a living person. Here in the folk-museum discourse, the two-part anecdote shows up again: first the setup when one mistakes the dead for the living, followed by the punch line of mistaking the living for the dead.

The moment of entry into a room in this way required visitors to sort things out, to probe the display for its live and dead spots. At the folk museum, there was perhaps an extra intended lesson, namely, that one should not be too quick to objectify the material on display and assume it to be dead and out of reach. Its status as a *living* picture, that is, could be underscored by creating the potential for certain elements of the display to "erupt" into life, like Per emerging unexpectedly from the scene. Such scenes restaged the idea of resurrection in strikingly literal terms each time the apparently "dead" parts of the display turned out to be alive after all.

Increasingly, however, the mannequin seemed not to be the right medium with which to make that point. A photograph of the Mora cottage interior from 1898 (fig. 8.5) shows the seated mannequin from the outdoor threesome in his indoor position at a worktable (a rainy day, perhaps?). An account from 1898 describes it thus:

> Inside we find only an old man in white homespun clothing with straggly hair, sitting at his workbench with an old Dala-watch in his hand. The old man has let his work drop and stares with a dreamy look out through the small leaded windows. Does he see in his thoughts Lake Siljan's blue mirror surface before him, or does he hear the whispering from a neighboring grove of trees at home, since his look is so sorrowful? Nobody can tell, since the old man is devoid of life, and the watch in his hand has been stopped for many years. The living being who inhabits the cottage room is named Frost-Maria, an engaging old woman from the same district as the old watchmaker. We see her dancing down at the open-air dance floor with Clever-Anna from the caretaker's cottage, even though it is the middle of the morning. Has she grown tired of the old man's company, the one who never says a word and never winds his watch?[16]

Spectators eventually tired of such company, at any rate, perhaps due to the uncanny aspects of having the mannequins so close at hand. The frozen mannequin scene—here noticed in the detail of the "dreamy" look and

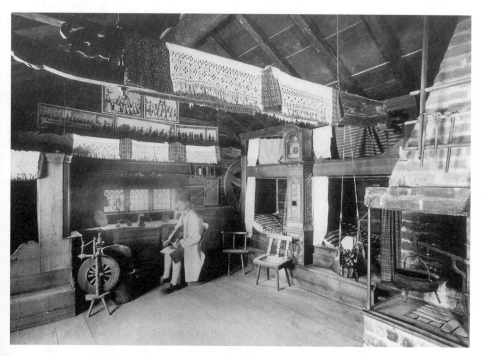

FigurE 8.5. Interior from the Mora cottage at Skansen, complete with mannequin watchmaker. Photo Axel Lindahl, 1898, courtesy of the Nordic Museum (Stockholm).

the stopped watch—ultimately hampered the living-picture potential of the scene at close range. Perhaps the expectation of experiencing an insider's relation to the cultural space of the open-air museum made the discovery of a lifeless mannequin at the core too disconcerting. Gradually, that realization may have contributed to the decision not to furnish other cottages with mannequins, nor to replace the Mora figures when they became worn out from exposure to the elements. Since that time, the rooms at Skansen and other open-air museums have generally been manned only with the living.[17]

In later years, the living have performed a second subtle function in the rooms. Inviting spectators into the display space, of course, creates an added security risk to the objects of the collection as well. If the room is left empty, there is always the possibility that something more than the folk body will turn up missing. Some museums, like the Open-Air Museum in Denmark, have reached a compromise in more recent times that involves securing objects to their environments with the help of small but

visible wires. Other museums less willing to break the illusion of the home-in-use have used the costumed guide as a combination native informant and museum guard, collapsing into a single figure the dual purpose of the folk museum—revivification and preservation.

Traces

The awkwardness of sharing space with mannequins led to the development of another technique for immersion displays, namely, to rely on the power of the metonymic trace to evoke a powerful sense of imaginary effigy. The chief architect at the Danish Open-Air Museum in more recent times, Arne Ludvigsen, gives a sense of how important this technique eventually became:

> In order to give the building as much life as possible it also helps to preserve the wear that has occurred through the years, both inside and outside. The doors show wear where the hand repeatedly has reached, the alcove-bed frames are worn smooth and the paint has vanished, the floors are especially worn near the doors, and the open hearthstones show clear marks from pots and kettles, bumps and blows. In the stalls the livestock have gnawed and rubbed themselves, and the stones have been worn smooth by their walking. Many more people than one thinks are especially receptive to these small effects, which taken together give a picture of the genuine and the convincing.[18]

Each mark, scrape, and worn plank bears mute metonymic witness to the absent body that imprinted itself on its environment, and the sense of former presence assures the viewer that the room is genuine.

The success of these "small effects," which have now become the dominant mode of display at open-air museums, suggests that curatorial restraint made for a better resurrection strategy, since that invited a collaborative contribution from the visitor's imagination. The gap-filling activity encouraged in the viewer by such corporeal clues confirms Topelius's suggestion, cited earlier, that the "glow on the cheeks" had to be added by the visitor himself. A similar view was expressed by Norwegian architect Carl Berner after a visit to Maihaugen in 1909, interestingly couched once again in terms of resurrection: "The people themselves can of course not come back from the dead [*gaa igjen*], even though some folk museums, such as Skansen in Stockholm, try with costumed wax figures to blow life into the dead. But when these homes are correctly displayed, are wax figures necessary? No, our own fantasy can much better than any wax figure conjure up the deceased, old and young."[19] Like Topelius, Berner empha-

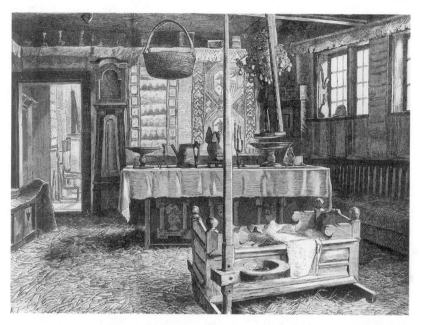

FIGURE 8.6. The Danish version of a cottage from Ingelstad in southern Sweden, one of the original surround-style rooms at the Danish Folk Museum. Illustration from *Illustreret Tidende* (20 September 1885). Photo courtesy of the Royal Library (Copenhagen).

sizes that the final stage of resurrection cannot be accomplished by the display figures alone; the "living" effect, he seems to recognize, is not in the mannequins themselves but in the overall sense of participatory effigy created in the spectator. That distinction makes the difference between an undead folk body grotesquely "walking again," and a resurrected effigy with the glow in its cheeks, an infusion of life borrowed from the subjectivity of the viewer.

Two kinds of participatory effigy conjuring can help illustrate how evocative the trace could be. The first is the kind added by backup narrative sources, and one of the early experiments with immersion rooms at the Danish Folk Museum on Vesterbrogade can serve as an example. The room depicted a rural interior from Ingelstad in southern Sweden (fig. 8.6). Olsen's reach across the sound for cultural-historical material was in part due to a calculated strategy to "win back" in display format the former Danish territory that had been lost to Sweden in reality, but it can also be explained by the fact that the Swede Georg Karlin, founder of Kulturen in Lund, did the guest curation for this room.[20] The visual record of this

display is especially valuable, because due to Sweden's and Denmark's for-tuitously overlapping historical-cultural claims on southern Sweden, we have contrasting versions of a similar room in two different museums, one with mannequins and one without (cf. fig. 8.1).

A close look at the Danish Folk Museum's Ingelstad room shows how different the stakes were when the mannequins were absent. The room there depicted a home outfitted for a holiday celebration, with Christmas straw on the floor, and a real smoked pig's head, lit candles, and a Bible opened up for reading on the table. Every part of the room seemed evoca-tive, one journalist reported, "with room [*Plads*] on the low couch by the stove for the master of the house, room in a chair by the couch for his spouse, room in a curious baby walker in the middle of the floor for the little baby, under the bed for the hens, and under a bench for the geese, who can poke their heads out through small holes to see it all."[21] While the Hazelian tableau filled its Ingelstad interior with mannequins, down to and including a taxidermic goose, for Karlin (and for this journalist), seeing the hole was enough to imagine the goose, the empty chair enough to imagine an occupant. The Danish museum's version of the room was filled with evocative concavities, body-shaped indentations in the space that encouraged imagination of the missing person—the baby in the walker, the wife in the chair, the husband on the low couch. The spatial effigy technique of the Ibsen table, discussed at the outset of my study, was now in full swing.

The details strewn around the room—metonymic signifiers all, testi-fying to both the shape and the proximity of folk bodies—helped visitors to populate the rooms with inhabitants of their own making. This effect shows up in narrative terms through an intriguing discrepancy in the opening-week press descriptions. Here is how one journalist reports the scene:

> The walls are draped and the table covered and set, the candles lit and the floor strewn with a thick layer of Christmas straw. The unusual gleam of light and the fresh straw have coaxed the hens from their nests under the bed, and they strut around the room, scraping with their feet and looking for grain. The baby has been taken up out of the cradle and placed in his practical walker, a wooden frame that can turn around a pole fixed through the ceiling. The little fellow sinks his bare toes with pleasure into the cozy straw and wanders contentedly around in his primitive carousel. But the older children have flocked around the table and divide their covetous glances between the colorful, golden candelabra hanging from the ceiling and the delicately smoked pig's head on the table. . . . When the household's grown-ups enter momentarily and seat themselves and with a word of scrip-ture have blessed the rich supper, Christmastime will make its quiet entry.[22]

One might think, if this were the only existing evidence, that Olsen had arranged a living-history theater piece with live actors depicting Christmas Eve in Ingelstad. The writer's use of present instead of past tense, of indicative rather than conditional mood, and of sensuous detail (the baby's toes sinking with pleasure into the straw) gives the impression that he actually sees the bodies before his eyes.

A comparison with the several other accounts from opening week, however, creates confusion about precisely this point. Was the room really as filled to bursting with bodies as this account claimed? Although there is one other article that seems to concur, mentioning that "the baby has come up from his cradle and is now tumbling around in his walker" and that "closest to the door sits the beggar on the 'poor man's bench' and gets his share of holiday cheer, and from the goose bench the geese stick their heads out through the small cut-out openings to see if there isn't somebody they can nip in the legs," the other newspaper articles written at the same time describe a room that is quite devoid of people.[23] When these other accounts do fasten attention on the room's evocative objects, they speculate instead about where all the bodies *would have been* if the scene *had been* real, or about the nature of the bodies that used to be there, but clearly are no longer.

The discrepancy cannot be resolved definitively in retrospect, of course. It is possible that a fully staged reenactment was presented to some of the journalists but not for others. But if business as usual at the Danish Folk Museum is any indication, it is unlikely that the Ingelstad room upstairs in Vesterbrogade 3 ever used such a cast of role-playing actors (and especially not live chickens and geese).[24] These two writers were presumably responding imaginatively to the clues in the scene, using them as a springboard to simply assert folk bodies into existence. It is precisely the narrative indeterminacy of these "indicative" accounts that is so fascinating. Their straightforward, contrary-to-fact assertions that they see the bodies before their eyes show the effigy effect at its most literal and indicate the degree to which that effect depends on narrative commentary, being located somewhere in between the contents of the actual display and its supporting discourse. It depends on the power of a subjective viewpoint to supplement the scene with bodies of its own making.

Why would it seem more fitting to complete the room with bodies? The impulse to supplement, I would offer, is created by the powerfully incomplete corporeal logic of the rooms themselves, especially when encountered by viewers predisposed to the resurrection of the rural dead. Painter Christian Krohg provides a hint in that direction when he compares other collections shown scientifically in more traditional house museums on the European continent to Anders Sandvig's evocatively arranged interiors:

One is told in every detail the members of the family, their names and ages. One knows who has slept in that bed and who has sat at that desk, and one has portraits showing them. But precisely for that reason the whole thing becomes so distant and foreign. All conclusions are already drawn. There is no personal contribution [*Selvarbejde*], in other words a great interest in the well-conserved funeral estate [*Dødsbo*], but nothing more.[25]

As is clear from this comment, when a precise corporeal reconstitution is provided ready-made to the spectator (as was the case with the manne-quins as well), it has the effect of killing some essential process of imagina-tive participation in body production. Krohg wants to paint in his own mind the person sitting at the desk, not to have him provided in the form of a portrait and narrative supplement.

In one of Sandvig's rooms, Krohg finds himself doing just that, conjur-ing up those original inhabitants as he looks at an old spinning wheel, thereby inadvertently providing his own ekphrastic supplement:

> Here the mother and her little girl have sat close together. It was so still, so still in there, and while I sat there, I thought that I saw them before me: The one wheel whirs and whirs evenly. The other goes less evenly, and the little girl with the light blond hair, which like that of the mother is tightly combed up under the embroidered cap, twists and twists on the thread as well as she can, spits on her fingers every time her mother does so, and thinks she is being very useful. And afterward, when the apron is finished, the mother will lead her to believe that exactly this and that piece were woven with the thread she has spun.
>
> It is so still, so still in there.[26]

The scene Krohg describes is the kind his impressionist painterly eye is especially good at creating, of course, but it is also interesting that it is yet another "absorbed" scene in Michael Fried's sense of the term, with both of his imagined effigies immersed in their task of spinning the thread, unlikely to notice his presence. Appropriately, he comes and goes from the room as a reverent, invisible observer.

A second kind of body conjuring is accomplished through literal revision of scenes in visual illustrations. One example, interestingly enough, comes from the early days of Hazelius's Stockholm museum, where, as noted, the rooms were more generally filled with literal manne-quin bodies. Within two weeks of the opening of the Scandinavian-Ethnographic Collection, however, this depiction appeared in one of the illustrated weeklies (fig. 8.7). Pictured in the illustration is the same inte-rior from Halland shown earlier (see figs. 7.6 and 8.2). The display ar-rangement in the other two images is nearly identical, but in this earlier illustration the figures are situated differently, the woman reading on

FIGURE 8.7. Early illustration of the cottage in Halland at the Scandinavian-Ethnographic Collection. Illustration by Hugo Peterson, *Ny Illustrerad Tidning* (8 November 1873).

the other side of the table, and the man over on the right tending the fire. The explanation for the difference comes from a note on the archival copy of this illustration at the Nordic Museum, which mentions that at this early point, the mannequins for the Halland interior had not yet been made, so the illustrator had simply gone ahead and populated the scene with figures of his own making. Since this was not a photograph, that is, the artist was not constrained indexically to what was actually there in the display.

Another more amusing example of the apparently irresistible urge to supplement empty folk scenes with imaginary effigies comes from Sandvig's collection in Lillehammer. The image is the Lykrestue (fig. 8.8), which was the first building Sandvig acquired and had moved to his garden in 1895. The building may be real, but the depicted scene is an invented one, produced by an unknown hand for a nonauthorized postcard that pirated an existing photograph of the building for its own purposes. The figures are all later additions, and as Tonte Hegard points out, the costumes shown were not even authentic to the building's region. The location of the museum is also listed incorrectly (it is in Lillehammer, not Skjåk, which was instead the building's original location).[27] A close look at the postcard does indeed show the traces of a cut-and-paste reworking of an original image. The resulting incongruities are exceptional only in

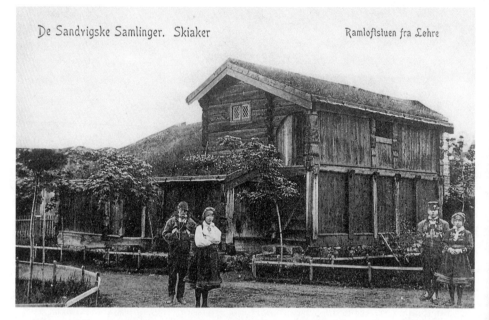

De Sandvigske Samlinger. Skiaker Ramloftstuen fra Lehre

FIGURE 8.8. A pirated postcard using a picture of Maihaugen's "Lykrestue" when it was part of Anders Sandvig's private building collection in his garden, ca. 1900. Photographer unknown, photo courtesy of Maihaugen—De Sandvigske Samlinger (Lillehammer, Norway).

their obviousness, however; in many ways this is merely a clumsier, more overt manifestation of the effigy production that folk-museum spectators have engaged in all along when imagining the space in corporeal terms, populating it with their own body-forgeries.

The postcard image's status as a revision opens another line of inquiry as well. A comparison with the original photograph from which the postcard was presumably produced (fig. 8.9) shows that the reworked image is interesting not only for what it adds but also for what it leaves out. Here we see the actual context of the building in Sandvig's crowded garden space, where it was not possible to get a view of the old building that was not also juxtaposed to that of nearby houses. To make the scene appear more coherently rural in the postcard, the addition of the folk bodies is backed up by the excision of the two modern villa houses behind the Lykrestue, accomplished by cutting the original photograph along the roofline. In the adjusted image, the building seems to be off by itself, rooted to natural ground and filled with original inhabitants; in the original, the facts of its collection and dislocation to relatively urban terrain are more clearly evident.

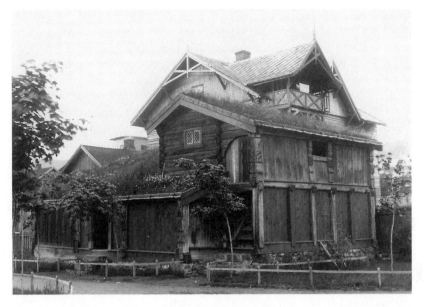

FIGURE 8.9. The original photograph before cropping for the postcard, showing the crowded juxtaposition of the rural building with those of Sandvig's neighbors. Photo courtesy of Maihaugen—De Sandvigske Samlinger (Lillehammer, Norway).

The relationship between these two photographs reminds one that the process of effigy production was part of a larger continuity project that involved both a remembering, in the recovery of living bodies to use the objects and the homes, and a forgetting, in the substitution of effigy for curator as the animating force of the display. That forgetting had to take place on a larger scale as well, if one was to have a successful cultural immersion rather than just another museum experience. Even in tiny Lillehammer, that is, one had to momentarily "forget" the proximity of more modern houses and the railroad station around the corner by performing a willful aversion of the eyes, the metaphorical equivalent of the more literal photo-cropping in the forged photograph. In fact, one might say that any imaginary participation in the creation of continuity pictures (Krohg's *Selvarbejde*) was only different in degree from that of the forger, the freehand illustrator, or the hallucinating journalist. All spectators revise the scene when they "enliven" it.

At Skansen and other museums in closer proximity to a large city, the forgetting perhaps had to be a little more willful. One visitor to Skansen in 1892 mentioned that as one entered the museum grounds, one had the opportunity "to experience a rustic evening stillness not generally available in the vicinity of a large city. The rumble from the city streets can

only be heard dully in the distance when one enters in through the gate."[28] That background noise is potentially a reminder that one's experience of rustic stillness is taking place through the medium of an urban museum. To ensure a convincing immersion in rural space, suggests another visitor, one should make a subtle substitution: "And the glorious nature out there at Skansen is so rustic that one soon forgets the proximity of the city and easily mistakes [*gerna förvexlar*] the barely penetrating rumble therefrom with the muddled roar of some distant rapids or a waterfall."[29] The willingness to exchange artificial sounds for natural ones in one's imagination is key to the folk museum's combination of urban access and scenic coherence.

The forged postcard's double movement of effigy production and building excision shows how crucial the combination of remembering and forgetting was to the immersion experience. Despite its claims to immediacy, immersion was still a highly meditated effect, one that required its own specific protocols. Visitors were allowed to inhabit the space, but in a certain prescribed way. In exchange, they were allowed the illusion of a more direct corporeal experience of the space that seemed to go beyond the idea of spectating (yet still fell short of a fully tactile experience). Interestingly, these are the criteria for our more contemporary sense of "theme space" as well—the promise of a closer, "inside," surround-style experience that turns viewers into participants yet does so not by eliminating the display boundary but simply by making it less conspicuous.

Home, Again

The potential contradictions of being inside the space of the reconstituted folk interior, yet not really belonging to it, needed careful management for this cultural immersion to be a successful mobility experience. To accomplish this, the discourse of the folk museums turned frequently to the rhetoric of the home in order to naturalize the display space. The interior was emphasized as being a real home, one that the viewer could imagine inhabiting. By encouraging spectators to think of each museum visit as a homecoming, the folk museums could cover over the representational basis of display and create a ready-made argument for the continuity of the depicted space.

Anders Sandvig at Maihaugen was perhaps the most articulate about this strategy, perhaps because of all the folk museums, his was the one most devoted to creating a picture of folk life unbroken by the marks of scholarly intervention. From the start, he wanted to find a way to help visitors feel quite literally at home: "Overall I have tried to emphasize as much as possible the impression of inhabitation, of dependability. . . . It

was the sense of the contrived, of museum-ness [*det musæumsagtige*] that I wanted to avoid; I wanted the visitor to forget that it was a collection he had in front of him, but instead to have the impression that it was a real home he was visiting."[30] He elaborated on this idea in a newspaper interview the same year:

> I have wanted to give the present generation a picture of the life of its forefathers. For that reason it was not to be a museum that I built, but homes, real homes. There is nothing like that word to bring our thoughts back to everything good, to Mom and Dad who have cared for us since we were small and given us the best impressions. There is nothing that strengthens our view of circumstances as much as the idea of home [*det Hjemlige*]. The home, that is something everyone understands, whether they are born on a farm, in the house of a government official, in a parsonage, or in a cotter's hut. One walks around a museum, cold and disinterested, and one gets a stiff neck. In a home one feels warm. Each of my houses is thus rebuilt as it was, and everything in the house is accordingly comfortable, cozy, filled with the objects and tools of daily life, as in the old days.[31]

From this statement, it is clear that a lost sensation of childhood was intended to do the cultural work of bridging the gap between the museum and the original milieu of the building. Much of the desired effect is wrapped up in the difficult-to-translate word *hygge*. Feeling "warm," as Sandvig puts it here, is one aspect of the term, but there are further connotations of comfort, of body fit to one's surroundings, and of the pleasure of company. The familial connotations of the term are reinforced further on in the interview by Sandvig's offhanded mention that every house in his museum was reconstituted with his own childhood home as an implicit model.[32]

The feeling of *hygge* could be conjured up by cultivating a sense of atmosphere in the rooms, using the missing-person techniques described earlier: crackling fires; lit candles; inviting, body-sized spaces implied by the furniture. Sandvig had a special talent for this effect, to judge from the pronouncements of the many enthusiastic visitors to his private building collection. When the old buildings were still located in his garden and the tours could be more personal, Sandvig could be quite accommodating. Here is how he responded to one traveling correspondent's request that he be allowed to sleep in one of the old rooms:

> Herr Sandvig is a kind and gracious man. He spreads out sheets and coverlets on the old bed up in the maiden's loft, and he lights candles in the magnificent candlesticks and lamps, pours a brisk drink in valuable drinking vessels, lays out ancient reading material on the gorgeous chest and places a weapon from Sinclair's time next to a golden leather chair by the bed. The loft is

light and cozy [*hyggeligt*]—the massive beams and the many beautiful objects—it is venerable and original. It is a fairy tale. . . . We dream; first awake; then asleep.[33]

Richly suggestive, this account of a traveler being afforded temporary lodging in a historically re-created scene can stand in metaphorically for the travel experience associated with living-picture media more generally, differing only in the degree of immersion attained. It is a "theme" experience for the writer, with an effect both convincing and momentary; the dream induced by Sandvig's careful efforts of mise-en-scène will fade with the morning light, but it allows this traveler to imagine himself for one night as an original inhabitant, using the bed, drinking from the cups, and reading from the books—display objects all. He, for a limited time, acts the part of the ultimate cultural insider.

Many accounts corroborate this guest's testimony of the palpable sense of *hygge* in Sandvig's old homes. Norwegian novelist Arne Garborg was one of the long list of prominent cultural figures who visited Sandvig's collection, and he, too, tried to articulate the elusive impression received in the rooms:

> It was especially these sitting rooms that gripped me. They have such a marked peculiarity; there is so much culture in them. And in the midst of a certain dignified severity a quite singular coziness [*Hygge*]. I wonder what accounts for it? What is actually so unusual about these altogether simple rooms? One wants to stay there, to settle in there [*slaa sig til der*]. It would seem perfectly natural to set about some work; at the same time one can hardly think of a better place for resting. It is so secure here. Such peace. And everything has such an impression of comfort [*Bekvemhed*], of being expressly intended for use.[34]

The attraction of the space for Garborg was that it had *hygge*; it demanded to be regarded as living space, as usable space, and thus invited the viewer "to settle in" to its evocative vacancies. As one woman, visiting Maihaugen in 1905, exclaimed upon entering one of the rooms, "Oh, but it's so cozy [*koseligt*]! Now here's a place I'd like to live!"[35] The great paradox of open-air museums like Sandvig's, of course, was that none of the buildings were themselves actually "at home" on the museum grounds, but they took on that quality through the careful cultivation of continuity effects. One visitor to Skansen wrote as much, enthusing about the naturalness of the depicted milieu: "The various cottages stand as if they were at home there, and not transported [*De olika stugorna stå som vore de hemma der och ej ditflytade*]."[36]

The persuasive power of the naturalized open-air collection was such that in a public debate in 1908 about the fate of one of the Maihaugen

buildings, the museum location could even be conceptualized as "origi-nal." The controversy concerned the parsonage from Vågå, which resi-dents of that town wanted to buy back from Maihaugen in order to start their own new, even smaller and more local folk museum there. An ardent defender of its then-current location contributed this letter to the editor:

> Say one took something now and tore it loose, say one moved the parsonage back to Vaage again. That would destroy the impression of coherence, one would no longer retain the overview that distinguishes this collection. It would seem as if a wall was missing in the room. The coherence would be broken and destroyed, a great thought killed, and that must never hap-pen; for we cannot afford it. It would be a kind of desecration to move the parsonage, it would be both a sin and a shame, and one has no moral right to do it.[37]

Emerging from the passionate rhetoric of the debate is the idea that the collection has been so successful in establishing its "homey" effects that the museum setting at Maihaugen has come to be regarded as the build-ing's rooted, natural ground, as its rightful place, to the point that even if it were returned to what was after all its first location, it would be seen as a desecration.

Much of this effect comes from the fact that folk-museum collectors like Sandvig had pulled off the hyperbolic feat of moving such massive, solid objects to the open-air museum. One might easily wonder upon entering such substantial homes there how they could *not* be rooted to place—their very size makes them seem resistant to any idea of circulation. Garborg again provides intriguing commentary:

> And suddenly one find the right term: *Homes* were what they built, these old ones. Not apartments; not something for rent; they built for themselves, and in order to dwell there. They wanted to live where they built. And their children should live there after them; they built for the generations. . . . When they built, it was in other words not such a "business" [English word in original]. The point was not to pile up as cheaply as possible and as styl-ishly and as quickly as possible a collection of conveniences, which for the least possible investment could give the greatest possible return. It was also not to scheme up a great showy villa [*en flot Reklame af en villa*], or some-thing amusing for summer use. For them it was a matter of building in such a way that they could feel at ease in that house for an entire long and eventful life. Add to that the fact that they could expect that their descendants would enjoy themselves there [*hygge sig der*] after them as well.[38]

The original inhabitants of this home, which Garborg imagines having built with future generations' *hygge* in mind, could scarcely have consid-ered the possibility that their solidly built home would end up in the back-

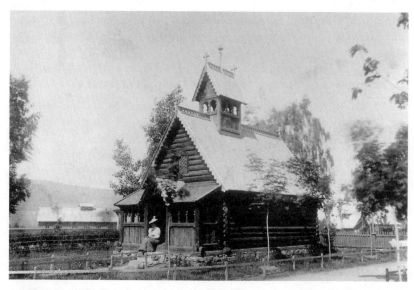

FIGURE 8.10. The Fisherman's Chapel from Faaberg, set up temporarily in Anders Sandvig's garden before being moved up to the Maihaugen museum grounds, ca. 1900. Photographer unknown, photo courtesy of Maihaugen—De Sandvigske Samlinger (Lillehammer, Norway).

yard collection of a dentist in Lillehammer, providing mimetic sensations of coziness and durability to museum visitors and day-trippers from Christiania. But therein lay the sleight of hand involved in moving such large pieces of folk culture intact—the scale of the enterprise made it possible to envelop oneself with authenticity, to "forget that it was a collection" one was experiencing because the size of the collected "piece" made it so easy to imagine oneself as completely *inside* it. In Barbara Kirschenblatt-Gimblet's terms, the ethnographic "cut" has been made at such a remove from the small, portable museum object that it encourages visitors to imagine the entire milieu as original, rooted, and uncollected.

But even in Sandvig's descriptions, there is a slight hint of discrepancy. His stated goal was to get the viewer to imagine "that it was a real home he was *visiting*," in other words, to experience the space still as a traveler in some crucial sense, and not as an original inhabitant. The visitor's relationship to the representational home is captured in a photograph of a modern visitor sitting on the steps of the Faaberg chapel, which Sandvig had moved to his backyard in 1897 (fig. 8.10). Striking a pose that is still common among picture-taking tourists at the folk museums today, the woman seated in the doorway records both a moment and a mode of

habitation in which the building serves as a kind of background stage set, with the poser acting the part of original inhabitant. The access to *hygge* is fundamentally theatrical at the folk museum.

Sandvig was fond of retelling the story of two returning emigrants who visited his collection. Although his point was to underscore the sentimental value of "home," the anecdote also conveys in a backhanded way the difficulty of completely closing the spatial and temporal gap separating the representational museum interior from the idea of the original home. Here is his version: "There were two returned Norwegian-Americans in to see the Løkre cottage one day. A man and a woman. They sat themselves down and looked around in silence. 'Yes, this is how it looked,' she says suddenly, and breaks into tears. It was the home that embraced her heart."[39] Here is a different version of the same kind of scenario by another commentator: "It has happened that returning Americans have cried like babies at the sight of this remarkable collection. 'We didn't find any old reminders up in the valley,' they say, 'but here it looks just like it did at Grandfather's house.' "[40]

Settling questions of accuracy in these accounts is not as interesting as the currency they apparently had. It is possible that those interested in circulating this kind of story sensed how appropriate the returning emigrant was as a metaphor for the folk-museum spectator. It is the one who has already left home who can recognize the visual authenticity of the interior scene, who can verify that it looks "just like it did at Grandfather's house," and yet can no longer authentically inhabit the space because of the intervening years and experience. The tears referred to in both anecdotes are in some senses the proof of dislocation and the passage of time. The dynamic of emigration and return reenacts the dynamic of loss (and death, and separation) that drives the folk museum's resurrection project and makes clear that the logic of the copy, with its intervening levels of spatiotemporal separation, still informs the experience of "home" in these displays in spite of the fact that the homes are, or at least have been, "real." It is difficult to imagine these returning emigrant spectators "waking up" to set about using the objects of the room once again, as Karlin imagined that the dead themselves should be able to do if a room were arranged correctly; in the emigrant notion there is the more accurate acknowledgment that the missing home might look exactly the same but cannot be fully recovered.

The system of primogeniture so fundamental to Scandinavian rural culture, the *odelsgård* property passed on from father to oldest son, provides another way of thinking about recovery of the home. This is, of course, exactly what Garborg seems to refer to earlier when describing the solidly built buildings at Maihaugen lasting for generations. A 1900 reaction to

Sandvig's collection is worth quoting at length for the way it deploys this metaphor while exploring many of the contradictions of living-picture display at the folk museums:

> For the common layman the swarm of shifting impressions flow together to form a large living, gathered picture [*et stort levende helheds-billede*] of the valley people's life in work and leisure, generation upon generation up until the current day. . . . And finally he gathers together this motley picture into a single strong impression of the power carrying on the life of this race; he peeks again into the Lykre cottage and lets its "air" fill his mind with the feeling of standing in a *home*, where the peasant and his wife and children lived securely and quietly one generation after the other down though the lineage, satisfied with their own common means, and making with their own hands everything that was needed from their own farm's harvest and yield. But he also sees the people slowly but surely gain the power to take on more, to want more than just to remain part of the contented herd on one's own farm; he sees the lineage grow away from its good old home. One who is healthy and vigorous can't help but eventually leave the farmyard behind, and out beyond to encounter conditions and thinking that loosens him from the soil of his inheritance. . . . But the one who has been out on the move finds himself in a singular mood when he sees Father's cottage again; and the generation that has grown up behind white curtains feels, in spite of everything that it has won, the loss it has suffered since a chimney grew up through the smoke-vent. With a melancholy mood, one tears one-self loose from the spell of these rooms—it is Father's farm one bids adieu. But there is a healthy power in having been a guest at Father's farm, even if it no longer is one's own inheritance [*selv om den ikke længer er ens odel*].[41]

The writer here touches on many of the themes I have been developing throughout the past few chapters. The "swarm" of individual impressions, for example, is intended to be gathered into an overall "living picture" of rural life, a picture loaded with grounded qualities of continuity through the generations, in which neither people nor the objects they make travel far from the site of production. The availability of that picture, however, depends precisely on literal movement of that entire milieu to a new location—the activity that gives wide public access to sensations of grounding and cultural coherence. This is fundamentally modern in its visual logic. Similarly, the writer here recognizes that the self-sufficient, static world depicted in the room has created the conditions for material progress and sociocultural development that eventually lead to modernity's break with traditional forms of life. New thoughts and experiences cause a leap in consciousness that turns the old soil and property into a farmyard left behind, an enclosure that cannot totally house the new conditions encountered abroad. The museum visitor finds himself on the other side of

a divide, no longer a firstborn son with access to the space through direct inheritance but instead as a visitor—or, shall we say, spectator. In a singular mood, that visitor temporarily finds himself under the "spell" of illusionistic display techniques, vacillating between satisfaction with modern conveniences and longing for the cultural integrity conveyed by the cottage interior, but clearly wanting elements of both. The writer's conclusion? There is still a healthy power in viewing a scene that one can no longer participate in, that is no longer one's true "inheritance."

The surround-style room's promise of an intimate relationship to the rural space of origin thus still encounters some ungiving barriers preventing total immersion in folk culture. Visitors play theatrically at being insiders. The rooms' temporary, "theme" sensation of *hygge* and belonging to a distant time or place inevitably gives way to melancholic side effects when one realizes that the cultural integrity on display will always remain just out of reach, separated from the viewer by gulfs of space and time every bit as stubborn as those of a recording. The material traces in the rooms were real, but the living aspect of the pictures could never quite be grasped, leaving spectators once again, after all, in a threshold space.

FARMERS AND *FLÂNEURS*

> The nineteenth century found its essential mytho-
> logical resources in the second principle of ther-
> modynamics. The present epoch will perhaps be
> above all the epoch of space. We are in the epoch
> of simultaneity: we are in the epoch of juxtaposi-
> tion, the epoch of the near and far, of the side-
> by-side, of the dispersed.
> —MICHEL FOUCAULT, "*Of Other Spaces*" (1967)

THE IDEA OF surrounding oneself with a total, living picture of folk life was of course destined to fall short in crucial ways. "Immersion" for folk-museum visitors could by definition only be an effect, an attraction for the already detached. For those rural dwellers who still slept in old buildings by necessity, it is hard to imagine anything seeming particularly magical or painterly about traditional culture, since actually being there in real life entailed living out the hard material side of country existence as well. By contrast, surrounding oneself with folk life at the open-air museums offered sensations of immersion in authentic space, but space whose very presence at the museum already testified to a portability that subtracted out crucial aspects of the physical world in which it was formerly nested. Like other late-century visual tourists, the folk-museum visitor was promised a *selectively* "full" experience of a dis-tant time or place—one without fatigue, dirt, or hunger. The offer was direct access to authentic rural space without experiencing many of the physical consequences of truly belonging to that space.

Danish author Martin A. Hansen was uneasy about the implications of that kind of access. When he visited one of the restored and relocated buildings at the Open-Air Museum at Sorgenfri, a building he had actually known in his youth when it was in its original location, he felt vaguely disquieted. Even though everything that was present seemed in order, he found that the aspects of the building that had been "subtracted" in order to make it portable and available as a museum object were the ones that had been most crucial to his experience of place: "The farm didn't smell.

The whiff of green feed, sour milk, rotting beets, of the livestock and manure, that was gone. Sure, there was smell, but from the preservative solutions with which they have conserved the old corpse's charms."[1] For this displaced rural dweller, who had himself in effect followed the building's path of circulation to the city, the musealized version of the farm did not reproduce the smells and working conditions exactly. Instead, it offered a version of the building that could be preserved through time, that would not be subject to the same forces of decay that it would in real life. But it is precisely the realistic elements that a rural dweller might deem most essential—the manure, the dirt, the garbage—that an urban visitor might be glad to be spared. The goal is folk culture on modern terms, one might say, with access back to the modern world always immediately available.

The emphasis in the last chapter was on the trajectory leading inside the display space and the contradictions one found once there. One of the more interesting features of the early spectator record, however, is that one does not find disappointed romanticists of folk culture there in the core space of the museum; instead, the visitors seemed attracted precisely to the in-betweenness of the experience, to the sense of temporary role-play the new museological system offered. In spite of greater access to interior space at the folk museums, spectators there were still in a way essentially threshold dwellers, attracted to the lure of greater authenticity, to be sure, but as an *option*. In this way, the visual logic of the folk museum was as modern as that of any other living-picture medium. In unexpected ways, the main attraction of these culturally conservative institutions was visual mobility and the "as-if" body of modernity.

In August 1885, a visitor to the Danish Folk Museum captured with an intriguing image the attraction of old things for an urban viewer:

> And if during your wandering past all of the old treasures, stopping in front of this or that rare showpiece—a tooled mug, a majestic four-post bed, or a precious, nicely-inlaid wardrobe—if you have for a moment been envious of the people back then who enjoyed and lived surrounded by such magnificence, then just look out the window in front of you. Over under the train station's open hall a train is about to depart. The bell rings, the locomotive whistles, the steam billows up beneath the ceiling's iron beams and flushes out the pigeons nesting up there. In great arcs they circle around in the sunlight that gilds their wings. But the train is already far away, the last wagon is now passing the last telegraph pole you can see. Reconsider and tell me then, if you want to trade. I didn't.[2]

Yet another image of the Vesterbro area, taken just three years after this account was written, can help map out the spatial dynamics of this scene (fig. 9.1). To the left in the picture, on one side of the new boulevard, is

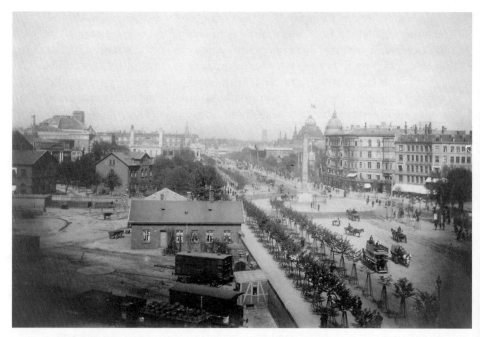

FIGURE 9.1. Vesterbrogade in 1888. Photographer unknown, photo courtesy of Copenhagen City Museum.

the end of the railway yard. Diagonally opposite to the right, past the obelisk, is Vesterbrogade 3, home of the Scandinavian Panoptikon and the Danish Folk Museum. The journalist stood at one of these windows on the second floor, looking out over the modern scene of the boulevard and the departing train. The striking juxtaposition of the rural interiors at the museum and the modern cityscape is intriguing enough, and speaks further to the rural vestiges of the "small big city." The most surprising aspect of the account, however, is that after what has generally been a quite enthusiastic evaluation of the folk museum's contents, the writer turns with an equally appreciative eye to the quintessentially modern sight of the train leaving the station, as if to say, "We moderns have our own sort of beauty." In fact, the descriptive stance he adopts with regard to the train's departure creates a competing, equally aestheticized tableau. The visitor should not be filled with longing for past glories, he seems to say; he, at any rate, would not trade to a premodern position.

The key point of this account is not simply that the journalist prefers the modern world outside; rather, the point is that he likes standing at the window. The city experience provides the potential to be in multiple

places and times. On the threshold between past and present, he can feel part of either world simply by turning one way or the other. Only in the urban folk museum, the writer seems to say, can one walk into other earlier times and settings on any afternoon and then return to the city, as easily as one enters and leaves a streetcar. By bringing the vestiges of rural life to the city and resurrecting them in a convincingly authentic space, the folk museum capitalized on one of the city's prime attractions: seemingly unlimited access.

The position available to this viewer, as I emphasized in chapter 6, was in part the product of a late nineteenth-century historical moment in which folk culture was not yet so remote as to be forgotten or simply idealized but was still perceived as available, even if rapidly vanishing. Tourists and collectors also took up the equivalent of this position at the window every time they discovered pockets of "untouched" traditional culture in situ. Although they thought they were preserving the scene itself in their depictions and collections, what they also captured was the experience of standing at the threshold, looking first this way, then that. In a similar sense, the folk museum curators offered an experience of juxtaposition when they moved traditional interiors intact and made them available to viewers in the city. The folk museum memorialized not only traditional culture but a viewing situation as well, and it is the latter that gives the institution such a modern spin.

As the process of modernization gathered momentum, the opportunity to take up that position at the window, to keep both the traditional and the modern in sight at once, was becoming less and less common in real life. In this light, it is worth speculating how an intervening twenty-five years may have shaped this later 1910 perspective on the suitability of having folk material on display in the city. At stake in this spectator comment is whether the existing Danish Folk Museum should be relocated to a more pastoral setting:

> There is really no reason that the metropolis should pile up so many attractions within its borders . . . there are collections that are poorly reconciled with the city's bustle and life. It is as if they have less right to exist above the drone of automobiles and the electric streetcar's clang and the crowd's busy footsteps. The Folk Museum is precisely the sort that should be a ways outside the capital. . . . the folk museum requires quiet and its own *historic* atmosphere.
>
> . . . Don't bring in tourist considerations here. We construct buildings for our collections at least partly for ourselves, and not as tourist bait. Those of our guests who have a speck of interest in it all will study the collection with far greater benefit and enjoyment when it requires a trip out of town

to visit it, which poses a certain requirement of thoroughness—when the whole thing cannot be done with a dash up from the street in fifteen minutes' time: "there are still a couple of museums to see afterwards!"[3]

A simple difference in temperament, perhaps—but the decreased enthusiasm for having the rural in the city may have a historical component here as well. That is, the "small big city" of 1880s Copenhagen had by 1910 developed a more respectable claim on the idea of "metropolis," having once again nearly doubled its population to over half a million inhabitants in that time.[4] The expected signs of modern urban life had become more ubiquitous as well, with automobiles and electric streetcars a more common sight, along with the accelerated patterns of circulation that accompanied them. One also sees the impact of the growing tourist industry on the folk museum in the concluding comment about the quick fifteen-minute pop-in tour. The ease of that entrance into and exit from folk culture was for this writer no longer remarkable and attractive, perhaps because in such rapidly urbanizing surroundings the display of folk culture no longer seemed able to hold its own ground as a potent alternative.

The disparity between these accounts raises a fundamental question about folk-museum spectators. To put it metaphorically, were they farmers or *flâneurs*? I pose the question so starkly because the tendency has been to think of folk-museum viewing as a simple continuation of the former, due to associations raised by the rural material contents of the collections. In a way it is easy to assume that folk-museum visitors had a fundamentally more grounded experience than those patronizing the neighboring visual attractions in the city, since the purpose of the institution seems, well, more *serious*. The term "folk-museum spectator" can easily separate off in one's mind as a discrete category of viewer, unrelated to the groups of people visiting other urban institutions of the visible. To imagine this kind of selective spectator, one has to picture traditional-culture aficionados threading their way gingerly through the other Vesterbro entertainments to find their way to the folk museum and its educational displays.

We have already had several indications that such a model of folk-museum spectatorship would be off the mark. From the start, it was clear that the folk-museum public would come primarily from the urban centers in which these institutions were located, drawing on both native city dwellers and the growing tourist stream for its audience. Not everyone perceived the folk museum so starkly as an island of rural sensibility in a sea of superficial visual entertainment; *flâneur* journalists such as Claës Lundin treated the folk museum with the same brush stroke as the panoptikon, the panorama, the exhibition, or the circus. As we have seen earlier, the folk muse-

ums showed up quite literally on the same tourist itinerary as other urban attractions when the international exhibitions were staged in Copenhagen and Stockholm. Throughout the folk-museum discourse as well, one finds hints of familiar living-picture themes of recording, condensation, availability, and authenticity that have emerged as tropes of a shared visual discourse. The mere fact that curators and commentators had to work so hard to pry the folk museum's identity loose from associations with the panoptikon is already evidence of important affinities between these and other popular visual-cultural institutions.

The kinds of charges contemporary critics brought against the folk-museum movement are interesting precisely for their nervousness about too-close ties to popular culture. The worry was that the populist appeal of the folk museum was contaminating and compromising the museum as a scientific form of cultural knowledge. One critic of the new Norwegian Folk Museum wrote in 1894 (the year of its founding) that it threatened to become a "a museum that seems halfway scientifically instructive and educational, and halfway like a more refined sort of variety-panoptikon institution, probably enlivened with Lapp families and a selection of the country's rarest animals!"[5] The references to the Hazelian model are unmistakable here, as they were in the attack three years later by the Dane Sophus Müller, whose defense of traditional museology has been discussed earlier. The relevant part of Müller's critique here, though, is that he, too, picks up on the hybrid practice of the folk museum when he says that instead of corrupting the term *museum*, the new institutions should invent some more accurate compound terms, such as "archaeological panoptikon" or "historical-ethnographic panorama," adding, "It is this mixture of science and art, of museum and panoptikon, that gives the new institutions, in those places where they have appeared, such a heterogeneous and motley character."[6]

By seeking out neologisms to capture the experience of being at these museums, terms that rely in particular on a perceived relationship to the panoptikon, the critics of the folk museum highlighted the modern hybridity of the new museology and the model of spectatorship it created. Perhaps in this light it would be best to allow that visitors to the folk museum were both farmers *and flâneurs*, in the sense that the experience included a crucial mix of traditional and modern sensibilities. Competing modes of viewing existed side by side at the folk museum, one tugging toward the embrace of grounding and authenticity effects, and the other toward the more urban tastes of access, availability, and variety. The spectator at the window, with a foot in both worlds, was the quintessential folk-museum spectator.

Cultural-Historical Intoxication

Visitors to the folk museum experienced many of the same sensations of modern space and time as those visiting the panoptikon, which likewise held out the dual promise of convincing scenic spaces and wide variety. A visitor to the Danish Folk Museum in the fall of 1886 put it this way:

> One does not leave the museum with an impression of having wandered "in the fog"; one has received so much solid information, so many deep impressions of reality [*Virkelighedsindtryk*], such a many-sided instruction in the life of the bourgeois and farmer classes of the last two hundred years, that one comes away with a complete cultural-historical intoxication [*kultur-historisk Rus*], that manifests itself in the fact that one might almost wish to visit the museum eight days in a row, as did a Swede last spring.[7]

The combination of reality impressions and "cultural-historical intoxication" is of most interest here because it indicates that the museum's claims on realism (the actual objects and rooms, the historical claims, the scholarly collection method) freed up viewers to experience the intoxication of so many authentic spaces back-to-back. Arranged in succession, real spaces create the sensation of travel, crediting the spectator with the mobility that more properly belongs to the rooms and the objects themselves, which of course have actually done the traveling during the process of their collection.

Another way of putting this is that in the early phases of folk-museum collection and display, traditional notions of time and space were still sufficiently intact that visitors to the museum could marvel at the juxtaposition of authentic spaces that would rightfully be expected to be separated by insurmountable spatial and temporal barriers. Not everyone regarded this mobility as cost-free; Sophus Müller saw the idea of portability as fatal to an old building's monumental characteristics. A structure's connection to original place was so fundamental for Müller that he would claim even painstakingly reconstructed, relocated buildings to be only "imitations" (*Efterligninger*), making them ineligible for serious museum display: "These institutions [the folk museums] are in fact based on the displacement of houses to urban terrain [*Byterræner*]. They defile monuments in order to gain museum objects."[8] By linking his discomfort with the idea of portable buildings to questions of urban availability, as he does here, Müller reveals that what he is really defending is a notion of noncirculating, premodern space in which the objects, especially objects as large as buildings, generally stayed put and visitors did the traveling.

If one compares his view with Claës Lundin's enthusiastic appraisal of Skansen, which was in fact the more typical response, it becomes clear that

Müller's position was swimming against the stream of popular taste for living pictures:

> What stands before us now is not some more-or-less faithful imitation [*efter-bildning*], but *full reality* [*full verklighet*]. Dr. Hazelius has namely purchased this cottage himself in Bleking, which at that time was still inhabited by the souls who first moved out when it was disassembled and transported to Stockholm. Here it has been painstakingly joined together again piece by piece by experts from its home district, and with the exception of several rotten timbers replaced by sound wood, the three-part cottage stands at Skansen in exactly the same condition as it did in Bleking. (emphasis in original)[9]

Lundin's dismissive use of the term *efterbildning*, the Swedish equivalent of Müller's *Efterligning*, reveals that both writers have tapped into the same issue but with diametrically opposed assessments. For Lundin, the relocated building does not become an imitation when it is moved but remains "full reality" even when presented on the urban Stockholm terrain of Skansen. His investment in notions of original place is negligible, which allows him to celebrate the authentic interior space from Bleking that is suddenly available so close to the city.

As opposed as these two perspectives appear on the issue of spatial conflation, both of them can be contrasted to later twentieth-century sensibilities, which have a much weaker commitment to the idea of authentic place. That is, both Müller's defense of rootedness and Lundin's pleasure at the marvelous juxtaposition of "fully realistic" space depend on a shared notion of grounding—the one fearing that it has been destroyed, and the other marveling that it has been moved intact. The question of "authentic" space and time, that is, has a historical dimension that requires a bit of recovery work to appreciate from a current perspective. One need not posit a completely naive initial folk-museum viewer to do so—the point is not that early viewers were "fooled" into mistaking the museum grounds for the actual locations. Instead, claims like Lundin's should be seen as hints of a shifting horizon of expectation regarding the availability of authentic space in the city.

The enthusiasm the majority of early folk-museum visitors expressed for this spatiotemporal play would indicate that of the two, Lundin was more in touch with the general public's visual cultural tastes. Especially evident is the way spectators could borrow imperceptibly from the museum's powers of collection and juxtaposition in order to amuse themselves with the impression of their own travel through time and space. Descriptions of entering the rural rooms are peppered with phrases such as "all at once one is removed to the very spot" (*man är med ens försätt till ort och ställe*), "one is led right into the life of the past" (*man føres lige ind i Fortidens*

Liv), and "we are conveyed several centuries back in time" (*vi flyttes nogle Aarhundreder tilbage i tiden*).[10] Other spectators enthuse about the sensation of "really finding oneself in a country home from the past" (*att verkligen befinna sig i et fornt dannehem*) or of "in such a vivid way to be transported to bygone days" (*saa levende at hensættes til svundne Tider*).[11] The language in such accounts is that of the time machine, an idea that clearly had wider cultural currency as well; H. G. Wells's novel of that title from the same period (*The Time Machine*, 1895) comes to mind. It, too, was imbricated in the wider logic of living-picture media more generally, as Anne Friedberg has suggested.[12] The important point here is that the ability to be "transported" through time, to be presented with a scene in which one might "feel at home," depends just as much on a supporting technology at the folk museum as it does in Wells's novel, but a technology of collection and reconstructed display.

The impression of conflated time was in some senses a by-product of the folk museum's evolutionary logic of display. Curators such as Anders Sandvig, for example, were especially interested in showing the development of domestic architecture from primitive styles to the more recent developments in order to inscribe a progressive, nation-building logic into the folk museum.[13] When visitors confronted authentic interiors from such a wide temporal spread, they could very well feel a strong effect of juxtaposition. Christian Krohg makes the witty observation that his tour guide at Maihaugen held in her hands "a bunch of keys with one key from the seventeenth, one from the sixteenth, and three from the fifteenth century."[14] After taking the tour, which ended up in Sandvig's own modern villa, Krohg muses on the museum experience as if it were in fact a form of virtual time travel, even if the analogy closest at hand for him comes from Norwegian folklore instead of science fiction:

> It was remarkable, this sudden transition, this leap through three or four centuries, from the simple and the solid to the soft and the varnished, which one went through by entering in here. . . . I felt almost a stranger in the milieu of my own age, so much had I thrown myself into and felt at ease in the ones I had just left. I had the feeling of the man in the fairy tale, who had been lured into the mountain [*bergtatt*] for ten minutes, but when coming out discovered that 100 years had passed. Everything I saw here seemed new and unknown. But this tremendous contrast [*denne voldsomme Modsætning*] between the atmosphere of different periods [*Tidsstemninger*] has its own great interest, and because of that I changed my opinion, which was the general one that holds that bringing these old remnants into the middle of the city is mistaken. . . . If I had any say in the matter, I would vote against it [that general opinion], precisely because the comparison with the new is so interesting and the juxtaposition so striking.[15]

Krohg's taste for the modern effects of the folk museum's metonymic dis-play techniques was discussed earlier; here one gets a similar sense of his enjoyment of juxtaposition and the folk museum's manipulation of time and space as well. It is clearly the impression of virtual mobility that appeals to him the most.

A variant of the same idea can be found in accounts that describe the folk museum as a miniature nation, which image in essence conflates the spatially dispersed locations of the country to a single site. Outside the museum setting, of course, expanded transportation networks seemed to be working the same magic, shrinking formerly prohibitive distances. But if Norway or Sweden seemed smaller with the expansion of rail lines, they seemed smaller still at the folk museums. A typical remark called the Nor-wegian Folk Museum "a place where Norway makes an appearance in con-centrated form, where by wandering from the one cottage to the other, from the one exhibition hall to the other, one is given a living picture [*et levende Billede*] of Norwegian culture."[16] Another from Skansen mentions the feeling of having traveled through all of Sweden, having talked with all its inhabitants, and received an intimate peek into their family life in the course of a couple of hours.[17] A third concludes that it is a question of "nothing more or less than depicting a Sweden in miniature, or rather: our *old* Sweden in miniature."[18] Of interest in all these expressions is the intertwined relationship between space and time: one knows the space has shrunk because of the shortened time span required to see it all, even though each individual experience of space remains convincing and au-thentically intact.

Another way of getting at this seemingly paradoxical combination of grounding and mobility, which I have emphasized as the precondition for all living-picture media, is to recognize the modern potential of the 1890s' project of neoromanticism. As Michelle Facos has emphasized in *Nation-alism and the Nordic Imagination*, the forward-looking aspects of the movement—its ties to fledgling social-democratic politics, its incorpora-tion of modern relationships to time and space—have been less conspicu-ous in academic discussion.[19] Skansen and other folk/open-air museums are in some ways a particularly well-suited litmus test for the 1890s' para-doxical uses of the past, since they, too, have often been understood as driven by a simple romantic longing for the past.[20]

An account of a Skansen visit by the Swedish author Gustaf af Geijerstam is a good illustration of this point.[21] His appraisal of Skansen seems on the face of it straightforwardly romanticist in its desire for an escape from city life:

> This exhibition of ancient Swedish life acted upon me like a dream, like a great folk-poem transformed into reality, which in its arrangement sets all

of the powers of fantasy in motion. And all who have been born in the rural village or who love country life will surely experience something similar when they visit this spot, which preserves memories from the simple past. . . . For why do we city dwellers love to visit the country for a period during the year? We need fresh air, we want to rest up from the city's racket, the noise of the street, the ringing of telephones and streetcars, and steam whistles. . . . I believe that every person, no matter how civilized or over-refined he might be, internally hides a deeper need for calm than that which mere physical rest can grant. And without exactly preaching Rousseau, I am certain that this need for calm is connected to the heartfelt feeling for the primitive that conceals itself in every person, under a life that in external respects is as different from this as possible.[22]

A visit to Skansen is here seen as the antidote to modern life, providing the same rest for the nerves that a trip out to the country provides. Although Geijerstam claims not to preach Rousseau, his reference to the universal need for the primitive comes quite close, with the addition that the urban landscape *he* is fleeing has become still more hectic and nervous by the end of the nineteenth century.

He follows up on that line of thought later in the same article by developing the claim that it is the accelerating circulation of information that is the cause of modern unease and pessimism. By contrast, he imagines the people who made Skansen's buildings, objects, and costumes to have been a simple people, "completely untouched by most of that which has produced the current generation, with its restless enthusiasm for development and rapid information from all corners of the world."[23] For Geijerstam in this passage, the circulation of information means primarily news of faraway crime, misfortune, and ugliness; when the world gets smaller, he feels, it brings misery to his doorstep, not excitement or wonder. Something like the panoptikon's scenes of world events would, in other words, hold little attraction for Geijerstam, who instead valorizes an imagined time when simple Swedes did not have access to depictions of the French president Carnot's assassination, or the death of the German kaiser, but only to the impressions of life that were immediately at hand: "Neither had they experienced the vexing stimulation [*den äggande retelse*] that lies in the feeling of being able to transport oneself quickly [*att hastigt kunna förflytta sig*] from one end of the earth to the other. They stayed put on their little acre and without thought of leaving it, had formed and worked everything in such a way that it fit them and their life."[24]

Geijerstam's escape into the world of his imagined stationary Swede seems to rely on an uncomplicatedly romanticist view of undisturbed, innocent space available as a healing refuge for overcivilized city dwellers. The question is complicated, though, by Geijerstam's own mobility as a

spectator. He himself says that he needs an impression of calm the way a summer guest needs a week in the country, so he constructs (with Skansen's help) a fantasy picture of an unmoved cultural sphere completely prior to the notion of circulation. And yet in almost the same breath as he identifies "something sublime in this feeling of powerful naiveté," he also celebrates his own ability to travel in just a few steps the "long way from south to north," represented by the various regional cottages, mentioning that the depiction of northern Sweden feels like a trip to a foreign country. His access to the primitive and "untouched" scenes depends at every step on the modernity of the museum's powers of scenic juxtaposition. Competing with the power of any single impression of rootedness, that is, is the fact that so many are available *together*.

Most telling is Geijerstam's conclusion, which like many other spectator accounts stages the contrast between immersion and reentry into the modern world. He takes as his point of departure Skansen's depiction of Lapland:

> And with this memory one leaves Skansen, with the memory of the wilderness's light summer nights, where the cuckoo calls and the loon mirrors itself in the clear mountain lake, where the streams flow white-frothed down the mountain slopes, and where the eternal snow blushes in the glow of the hidden sun.
>
> One walks slowly down the steep slope. Spread out down below is Stockholm, bathed in the autumn sun's colorful light with the telephone tower dominating, or else sunken in hazy darkness, out of which thousands of flames shine with their dazzling, civilized glow. (27)

The unexpectedly positive evaluation of the city in the conclusion reminds one of the journalist at the window of the Danish Folk Museum, turning first one way, then the other, and finding beauty in both. And in spite of the nervous energy and pessimism Geijerstam attributes to modern urban life elsewhere in the article, the final image is just as beautiful as his vision of northern Sweden, with both scenes "glowing" in their own way. One might simply say that Skansen's rest cure has allowed him once again to see beauty in the city, but the conflation of country and city in the final vision also makes a connection between urban spectatorship and the activity that takes place at the folk museums.

All of this suggests that the addition of modern travel capabilities to the idea of romantic escape is in part what puts the "neo" in the Swedish neoromanticism of the 1890s. The modernity of 1890s cultural nostalgia, that is, lies in the encounter between traditional notions of escape or nostalgia and the sudden access to distant space made possible by new media and modes of convenient travel. Flight from the modern world in the early nineteenth century was a more laborious process, and immersion then

came with fewer guarantees of a speedy return; later in the century, this flight was just another form of convenient travel. Modern life had upped the ante with expanded powers of juxtaposition, promising to get viewers both into and out of authentic space so that they could experience a sense of momentary stasis and grounding without giving up their mobility. Geijerstam has what he experiences as a powerful encounter with the primitive at Skansen, but it is primitivism with variety as well, with a return to the beckoning city always just a few steps away.

A newspaper debate about Skansen in 1899 highlighted this important sense of access. At issue was the introduction of electric lights to parts of the museum. Somewhat predictably, opposition to the measure saw such anachronistic improvements as a corruption of the purity of Skansen's rural landscape. The memories and associations of that landscape, one writer argued, should not be "framed in by modern culture, which destroys and kills exactly that primitiveness which is so necessary in order to awaken feeling to life in the spectator," but instead Skansen should remain "a coherent whole, a free space for old memories away from modern industrialism."[25] A follow-up letter, which another respondent suspected to be from the same person, emphasized the appeal of Skansen's coherent picture of folklife, presented as if "cast in one piece," which the writer imagined to refer to "a by-gone time without steam and electricity, when people were still people and not cogs in a huge, rumbling machinery. And now these venerable memories from ancient times are supposed to stand there ashamed in the cold and sharp electric light of the present!"[26] The ascription of primitive qualities to the eight-year-old museum grounds is interesting in itself here, since Skansen's very existence already owed quite a debt to the idea of modern convenience and visibility through transportation. The mere fact that folklife appeared in museum form at Skansen meant that it was of course already "framed in by modern culture," but the open-air museum generally made that frame as invisible as possible. Perhaps the addition of electric lights made the implicit too conspicuous.

A rebuttal to this nostalgic position appeared a week later in the same paper, taking the point of view that although Skansen's representation of traditional culture was indeed important, it did not need to be a "demonstration against the modern age's real accomplishments," one of which would be the convenience electricity offered. Besides, the writer continued, just because one has electric capabilities at Skansen does not mean one always needs to use them: "An electric wire can, all according to whether one feels it called for by the situation, be turned on or off."[27] On days when Hazelius wanted to create a particular "historical" mood, that is, the lights would remain off and make way for torches and bonfires; when comfort and convenience around the restaurant areas or tourist rest

stops were desired instead, the switch could be turned on. The addition of electric lighting as an invisible-but-ready capability at Skansen is merely another example of spectatorship at the threshold, since it puts the traditional world's authenticity and the modern world's convenience equally within reach. In some important ways, the electric switch at Skansen is a condensed metaphor for several kinds of background technology that made the museum experience of "grounding" available to spectators in the first place.

Goldi-Locks

My earlier discussion of threshold spaces at the wax museum showed how display boundaries were protected, sometimes quite literally, from rogue spectators who might be tempted to enter the display. The contrasting claim about the folk museum, as outlined in the last chapter, was that by giving official sanction to the spectator's entry into the depicted space, the folk museum could cultivate a relationship to the display material that was at once more intimate and participatory, in keeping with that material's added resonances with ideas of cultural origin. That immersion in display space made it easier to forget the traces of the representational in the museum and make oneself "at home." In the early days of the folk museums, that meant that visitors could finger the objects, try out the chairs, and maybe even sleep in the beds, as Sandvig arranged for his visitor to do.

The parallels with a more familiar cautionary tale about body fit and immersion, the traditional story of "Goldilocks and the Three Bears," are both amusing and unexpectedly productive. The fairy tale actually addresses a remarkable number of folk-museum issues: the evocative power of metonymic corporeal traces, the sense of boundary transgression, the visitor's irresistible urge to experience private space as an original inhabitant, the temptation to use items that should only be observed, and the tendency to measure one's body against those of the missing persons while in the space. Goldilocks is nothing if not a naughty spectator, and with minor adaptations, her story could serve as a negative example of museum spectatorship in surround-style displays. If every folk-museum visitor behaved like Goldilocks, that is, it would be impossible to preserve the collected materials; they would be subjected to all of the usual wear and tear that everyday dwelling necessarily entails. If there were to be a successful folk-museum spectator pedagogy, it would have to teach spectators how to be in the space without making it fully theirs.

Much of this, interestingly enough, circles around the image of the locks on the door. Perhaps spectators carried with them an internalized sense of boundary from other forms of performance and display that still

made the crossing of thresholds feel fraught, akin to opening a previously locked-off space. Hans Aall used that metaphor in a positive light in his conceptualization of display philosophy at the Norwegian Folk Museum. Although Aall had been influenced by Hazelian display techniques early on—"false, imitated half-interiors," as he later recalled with embarrassment—he eventually hit on the technique that he came to describe in this way: "We never strive for illusionism. The more one seeks after that kind of thing, the more the public feels the unreality of any museum. Far better to keep the interiors slightly distant from reality, something like locked-off rooms in an old house. They always get our fantasy going, so that we ourselves try to create pictures for ourselves of the real life that has pulsated there before."[28] Aall favored caution against overuse of supplementary techniques, preferring, like Bernhard Olsen, to stage evocatively empty interiors. That aesthetic finds expression here in the metaphor of the locked-off room and its implicit model of historical melancholy. While the other folk museum founders threw themselves into the project of resurrection, Aall chose memorialization instead, preferring to preserve a degree of loss and absence.

The idea of the locked-off room carried extra resonance for Aall, whose wife had died young, in 1908, after just seven years of married life. He took the loss quite hard and never remarried. Tonte Hegard mentions in passing that when his Emma died, Hans Aall had her writing desk locked off and preserved as it was, and it apparently remained that way until after his own death many years later.[29] A small, perhaps irrelevant personal detail, but also a hint at a relationship to death and memory, which, as has been shown, was so central an issue to the folk-museum movement. Whatever the reason, Aall was inclined toward models of absence and loss, and he preserved his rural interiors as if they were shrines to the missing persons, "a quiet place of memories," as he writes elsewhere in his history.[30] In that kind of display, the key that opens the locked-off room also opens access to the past, to the (lost) world of the former inhabitant, a world that seemingly leaps across the historical gap to confront the viewer directly by having the appearance of having "recorded" the precise moment in which it was closed off from view.

Christian Krohg's comment about his tour guide's keys to the different centuries at Maihaugen seems relevant here as well, an indication that even at folk museums that were more given over to compensatory modes of display and performance, like Maihaugen and Skansen, the image of the lock on the door seems to have captured the imagination. One of the most common comments from spectators across the board, in fact, one that is attested in countless examples at each of the museums, is that the rooms gave the impression that the real inhabitants had just stepped out, leaving everything as it was the moment before they left. One visitor writes, "We

go further into the bedroom; here it looks as if people are expected home at any moment. The clock on the wall mumbles its tick-tock with satisfaction, the old Bible lies open on the table with Mother's glasses on top. The sun filters in through the little lead-lined window with the small greenish brown panes and shines on the pipe and the knife used for carving tobacco."[31] Because the imagined inhabitants have stepped out so the visitors can step in, the visit takes place with the background thought that the original owners will be back at any moment. This puts an interesting pressure on the visit, again implying a slightly transgressive, Goldilocks sort of quality to the viewing.

Other visitors hinted at having a vague impression of trespassing as well; one says it seemed as if the original inhabitants "had forgotten to lock up after themselves," adding that perhaps it is only modern cultural conditions that make such security precautions necessary.[32] Another visitor conveys a similar sense of guilty pleasure: "It almost seems as if one has sneaked in [*smugit sig dit*] while the people of the house have momentarily stepped out."[33] If tableau viewers had the impression of sneak-peeking through the invisible fourth wall, at least they could also feel protected by that invisible barrier. By walking into a space loaded with clues and traces indicating current inhabitation, folk-museum visitors might feel more exposed, as likely as a trespasser to be caught in space where they did not really belong.

Clearly, this was a potentially paradoxical experience of space for folk-museum visitors. In order to appear as functional, living space, objects had to appear to be in current use. Given the awkwardness of shared space, however, it seemed best to vacate the whole-room interiors to make way for the visitor's body and its animating presence and subjectivity. But if one is to imagine the inhabitants as still alive, then their absence has to be explained as temporary; otherwise, the still-smoldering fires and dropped objects might just as easily be taken to be signs that the dwelling has been deserted and the inhabitants vanished and gone—like a village suddenly stricken by the plague, or the estate room of a recently deceased person. A perhaps unintended effect of the imagined return of the inhabitants, however, is the subtle pressure exerted on the visit, which might be cut short at any moment. Although the idea of the carelessly unlocked room provides a way of thinking about why the room seems so alive, why one has access to it, and why one can only visit and not assume ownership, it also injects an air of unauthorized access into the experience.

The discussion so far has touched on locked-off and unlocked spaces. As a final thought, it is worth considering what being locked in might say about folk-museum spectatorship. If the special access to the display space at the open-air museums was like providing a key that opened previously unavailable space, the background anxiety of the immersion

experience might be that one might not be able to get out again. The desire to have it both ways at the folk museum—being fully inside the space like a farmer, but still having the *flâneur*'s access in and out at will—raises issues of entrapment similar to the midnight scenarios at the wax museum that were discussed earlier. One might get caught in the role-play, stuck in the imagined part, trapped in the space and time of the representational field.

Visitors to Sandvig's building collection seem to have been more inclined to link immersion and role-play, perhaps because his museum more than the others was given over to a sense of theatricality. Even before his collection was moved up to its current location at Maihaugen, Sandvig liked to arrange folk festivals with an element of participatory community theater, in which the scenes implied by the old houses and buildings were brought to life. Sandvig's talents of mise-en-scène were already indicated in little arrangements like the one described earlier for the overnight guest, but he exploited those inclinations more fully as his museum became more established. Lillehammer's decision to make a permanent museum out of Sandvig's collection required extra funding, for example, so at midsummer in 1902 Sandvig put on a mock farmer wedding and historical pageant, for which Lillehammer citizens dragged out their own old folk costumes and took part in a kind of spontaneous amateur theater by conducting a traditional bridal procession that ended up at the buildings in Sandvig's garden (fig. 9.2).

In the role-play situation, the farmer and the *flâneur* again appear in hybrid form. The players themselves assume the identity of a rural inhabitant, but they do so temporarily, with Lillehammer citizen and farmer-wedding participant coexisting for the duration of the role-play. The spectators, too, participate in the in-betweenness, since they stand there lining the streets and leaning out of windows in modern dress, acting as if they were watching a real traditional wedding procession while inadvertently proving the theatricality of the scene. Any performance of folk culture out of place is, of course, a threshold kind of experience, as much about availability as it is about authenticity.

But what would happen if the actor got trapped in the role? That was the scenario in an anecdote from Maihaugen's opening festivities that Sandvig included in his memoirs. This midsummer arrangement in 1904 repeated the role-play from two years before, with added features intended to mark the opening of the new grounds. As Sandvig describes it, the festivities began with a procession from the town up to the hill where the old buildings had been relocated so that the role-players—the "Maihaug-folk," as they were called—could "move in" and reclaim possession of the relocated buildings on the new museum grounds. This involved first a staged ritual expulsion of the hills' "primitive residents" (*urbeboere*), cos-

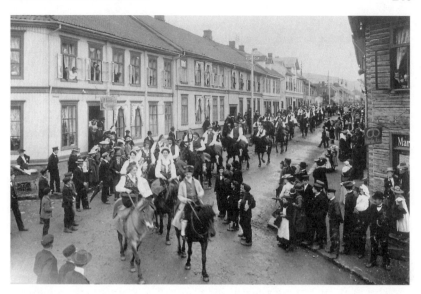

FIGURE 9.2. Lillehammer citizens parading through town in costume for the mock farmer wedding on St. Hans Day (Midsummer's Eve) in June 1902. Photo courtesy of Maihaugen—De Sandvigske Samlinger (Lillehammer, Norway).

tumed elves and trolls who were chased away by the ringing of church bells and a procession of role-playing choir boys and monks on their way to Maihaugen's old restored church. A speech and more historical role-play followed, after which all the various cottages and buildings were populated with citizen-actors who performed in character for visitors the rest of the day.

One of these, a young man who had been playing a uniformed officer at the captain's manor, apparently celebrated far into the night and fell asleep on a sofa upstairs in the old house. Sandvig says that the story that circulated after the festivities, told with "a claim of reliability," had the young man awakening the morning after the party, only to become disoriented and panicked at not recognizing himself or his surroundings in the re-created interior of the old building. As Sandvig tells the story, the young man finally collects himself momentarily:

> Oh, of course, now he remembered. There had been an opening-day festival at Maihaugen. Not a person was in sight, but how was it that he could have been "forgotten" here in the Captain's manor? He shuddered there where he stood at the thought of all the old stuff surrounding him. In a flash he was down on the ground floor, he had just one thought—to get away from all the old things as quickly as possible. But now he received a new shock in the pit of his stomach. The door was locked![34]

Trapped in the role-play, the young man searches desperately for a way out. Most of the second-floor balcony was too high off the ground for him to jump safely from it, but at the end of the gallery was the traditional toilet location opening out onto the hillside below. Finding no other exit, the officer removed his uniform, dropped it through the hole, and wriggled his way down after it, reporting later that "it was the hardest job he had ever been in on."[35]

Well. One would be hard-pressed to insist on the literal truth of the account; even Sandvig conveys a good-natured skepticism of its veracity, nevertheless clearly relishing the telling of the tale to cap off his description of Maihaugen's opening day. If the story's historical value is slight, its worth as a founding myth of spectatorship at the open-air museum is enormous. Sandvig tells it, I would offer, because its makes a pedagogical point about spectating in the newly dedicated space. As was the case in the rube scenarios at the wax museum and in early film, the humor comes at the expense of a viewer who cannot negotiate the representational space successfully; here, it is a case of someone managing the entrance into the role-play but not the exit therefrom. The story sets the paradigm for appropriate folk-museum spectatorship as a knowing and strategic *theatrical* use of space, in which one may momentarily be caught up in a scene, but where one should also be ready to find one's way back to more modern grounding at any moment. The actor—and the museum visitor—should ideally remain in control of the scene, inhabiting it in an in-between way.

If not, one becomes subject to a kind of immersion gone mad. The same antique objects that elicited warm feelings of *hygge* and cultural continuity for most other spectators are here in this inverted tale depicted as menacingly claustrophobic. His desperate and humiliating escape reinforces the point of the joke: the role-playing soldier has been swallowed alive by the house, and the only way out is to be defecated through the sewer onto the hillside. Locked inside the representational field and trapped in his own role-play, the young man experiences the space a bit too authentically for comfort; the panic seems to rise precisely from the idea that he might "actually be there," in such "full reality" that he would not have access back to his own time, space, and identity. Like Claës Lundin, he "found himself" elsewhere, but lacking the guarantee of return, he experienced the space as a nightmare, not as "cultural-historical intoxication."

Rubes and Gypsies

The circulation of pedagogical anecdotes through the folk-museum discourse can be read symptomatically for what it shows about the difficulties of negotiating this new kind of museum space. As mentioned, there is a

striking similarity in intent between this kind of folk-museum anecdote and the rube scenarios used in the panoptikon and early cinema, but with an intriguing reversal of the implied value of country and city. When Uncle Josh visits the cinema, or when Rube and Mandy visit Coney Island, to name two well-known examples from early film,[36] their rural origins are an impediment to their smooth and unnoticed insertion into the urban spectatorial regime. They gesticulate, overreact, make perceptual errors, and generally appear in caricatured form as an ill fit to city space and properly voyeuristic viewing practices. The rural spectator at the wax museum is likewise portrayed as the gawker who cannot get enough of each display, unable to move on to the next sight because he is too engrossed at the peephole. In both cases the pedagogical point for spectators wishing to be more savvy and sophisticated is to hold back, to hover at the threshold, to become invisible if they do not want to betray themselves as rubes.

There is a powerful exclusionary logic at work in urban entertainment like the wax museum and the cinema at the turn of the century, a logic that would expel the country from the city by use of powerful satirical examples. Easier said than done, of course; as I argued earlier, life in the turn-of-the-century Scandinavian capitals was never so far from rural origins that it could emerge as the full equivalent of the cosmopolitan life imagined to be taking place in Paris or other European capitals. The folk-museum material presented so far in this study adds the consideration that any negative depiction of farmers as rubes lost in the city would be contradicted by the powerful cultural currents in the Scandinavian 1880s and 1890s that made rural life a precious commodity as well. Farmers were not *only* rubes in turn-of-the century urban Scandinavian culture; they were also a sought-after source of imaginary grounding and national pride. The folk museums' contribution to the redemption of rural life makes it difficult to imagine any role for rubes at those institutions.

If the point of the rube anecdote is primarily a pedagogical one, then the new spatial arrangements in the walk-in interior would alter the configuration as well. In their usual incarnation, rubes are typically unschooled in representational practices that require aesthetic distance and discreet forms of watching; by contrast, they betray premodern attitudes toward space and time. Uncle Josh's mistake is not only to misjudge the status of the screen image but also to treat representational space as real by trying to enter it—an opportunity literally available to every visitor at the open-air museum. The rube's typical perceptual error is, in fact, crucial to a successful visit to the open-air museum. Viewers were actually encouraged to imagine themselves as farmers, of all things, and not as the sophisticated *flâneurs* that they have been taught to be at other types of contemporary visual entertainment.

There was still a need for spectator instruction, but given these altered spectating conditions and institutional assumptions, how should it be ac-

complished? Opening-day accounts, for one, tried to give the public a general sense of how to act in a museum space that appeared functional and everyday. A comment in passing from opening day at the Danish Folk Museum, for example, gives a hint of problems with protocol: "If there is anything we miss in this excellent museum, it is signs placed here and there forbidding people to touch the displayed objects. But that is a lack that will probably be rectified, especially if the visitors continue so unabashedly to finger everything [*hvis de besøgende bliver ved saa ugenert at pille ved alting*] as one could see them do on the first day."[37] The promise of closer contact with the display object was, of course, part of the inherent appeal of the new folk-museum experience—or, as another visitor put it, "to feel, study, and look through all of the past's curiosities, which up until now only dry letters and dead woodcuts have told about."[38] As the museums became more institutionalized and the volume of visitor traffic grew, this kind of access to objects had to be curtailed for the sake of the objects' preservation alone, but these comments make clear that a central understanding that viewers had to assimilate as they gradually turned into "folk-museum spectators," along with the other roles they might play in the broader visual-cultural cityscape, was how to inhabit a space from the inside without using it.

Interestingly, Sandvig tells another opening-day anecdote from Maihaugen that addresses exactly this problem. After the main parade onto the new museum grounds and a day full of cultural role-play, this scene unfolded in the museum's parsonage building: "Later in the evening we received an unexpected visit of a band of gypsies that had set up its tent on the lower part of Maihaugen. On occasions when many people are gathered together, those kinds of people usually pop up suddenly. They had a horse and wagon, and were in general equipped as traveling people tend to be."[39] After speculating on the life histories of several members of the band and trotting out the usual Gypsy stereotypes, Sandvig focuses his account on one female figure in particular:

> The fortune teller with the baby on her back attracted much attention wherever she went. She possessed a wonderful eloquence and had a pair of dangerous eyes. When she came into the parsonage and noticed the empty cradle in the bedroom, she took her child and placed it right away into the cradle; she lit her clay pipe and started rocking the cradle while she crooned and sang.
>
> Director Grosch and several others came in at exactly that moment; appalled, he clapped his hands and shouted indignantly, "Well, if that isn't the most audacious thing I've seen."[40]

The cradle in question was likely the one shown in a photograph of the room from around the same time (fig. 9.3). The fact that it was located

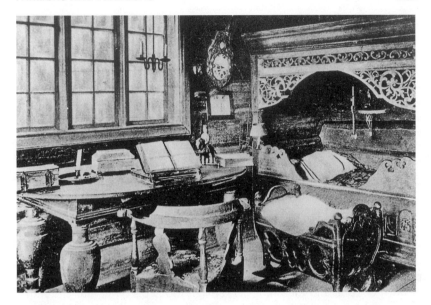

FIGURE 9.3. The parsonage from Vågå, as arranged at Maihaugen in 1906. Photo courtesy of Maihaugen—De Sandvigske Samlinger (Lillehammer, Norway).

in the *parsonage* bedroom, of all places, of course only adds to the perceived sense of blasphemy when the museum cradle is usurped by a Gypsy for a Gypsy child.

When I shared this anecdote with my colleague Katie Trumpener, she saw in it the perfect expression of work she had been doing on Gypsies as a literary trope, in which they serve the Western imagination as the people without history, memory, or culture. Gypsies "pop up" on literary occasions, Trumpener has shown, as a marker of boundaries that define cultural insiders and outsiders. As she points out in her own insightful analysis of Sandvig's anecdote, the visit of the Gypsies to the opening festivities at Maihaugen fits the pattern only too well:

> When a national culture stops to celebrate and take stock of itself, it is only the "Gypsies" who keep moving and who persist as interlopers. Long after the Maihaug people have settled into their rightful place . . . it is "Gypsies" (characteristically given, it is believed, to stealing children from their homes) who attempt to usurp the cradle—preserved on behalf of the Norwegian people as a symbol of their own origins—to fill it instead with their own offspring.[41]

The director's blustering protest and presumed expulsion of the Gypsy crone, Trumpener points out, is a clear example of the policing of cultural boundaries that Gypsy figures facilitate more generally in narrative.

It is also significant in terms of the development of museum space, how-
ever, that the transgression for which the Gypsy mother is symbolically
punished is also nonobservance of older museum protocol. She takes a
museum object—the cradle—to be a useful social object when she uses it
to rock her child. Like the opening-day visitors fingering objects at the
Danish Folk Museum, the Gypsy mother crosses the last remaining mu-
seum boundary at the open-air museum, the line between simulated use
and real use, between being in the space and *really* being in the space.
Visitors are expected to think in terms of imagined use only, to walk a fine
line between spectating and participation, a distinction made all the more
difficult to define by the open-air museum's invitation to share space with
the display. The Gypsy mother, in short, is marked not just as a cultural
outsider but as a bad museum visitor as well.

The pedagogical intent of the whole incident becomes even more clear
when Sandvig reveals his narrative's punch line: the Gypsies who "popped
up" were not real Gypsies but yet more costumed citizens from Lilleham-
mer performing the role of the outsiders in a deliberate theatricalization
of both cultural and museological transgression. Everyone but the audi-
ence—and, temporarily, the reader of Sandvig's narrative—was in on the
joke, including the "angry" director. A picture from 1904 shows the up-
standing citizens of Lillehammer, dressed as Gypsies (fig. 9.4). In other
words, Sandvig's staging of Gypsy culture and Gypsy space at the open-
air museum was not so spontaneous as to preclude having the troupe pose
for a photograph. Moreover, the Gypsy act was repeated at the annual
Maihaugen festival for years to come, providing a cultural counterpoint
against which to measure the solidity and continuity of the traditional
cultural forms on display at the museum. Most telling is that the Gypsy
performance has proved to be one of the midsummer festival's most popu-
lar attractions.[42]

It strikes me that by staging this incident on the museum's opening day
(and by recycling this anecdote in his memoirs), Sandvig is providing yet
another foundational narrative for visitors that gives them a key to the
appropriate mode of spectatorship at the open-air museum. Like Sandvig's
entrapment anecdote, this scenario encourages viewers to adopt a com-
plexly inconspicuous relationship to display space, a position even more
difficult to maintain when surrounded by space seemingly laid out for
one's use. The lesson goes beyond the wax museum's admonition not to
cross the boundary; here the point is that after having done exactly that,
one must become invisible in order to maintain the interior's status as
display space even when experienced from the inside. What earns the
Gypsy mother expulsion from the space, that is, is not that she enters the
space, since that alone would simply have placed her elbow to elbow with
the other more discreet spectators inside the parson's bedroom. Instead,

FIGURE 9.4. Photograph of Lillehammer "Gypsies" taken at the 1904 opening-day folk festival at Maihaugen. Photo courtesy of Maihaugen—De Sandvigske Samlinger (Lillehammer, Norway).

her mistake is to cross the line separating simulated use from real use, and to replace the invisible hand at the cradle with her own. The scandal is precisely that, at that moment, she is no longer missing.

Greater Skansen

The folk museum's combination of traditional cultural materials and modern notions of space and time makes it especially difficult to tease apart the terms "country" and "city" when evaluating modes of spectatorship

at that institution. By assuming the temporary role of the farmer, visitors got "cultural-historical intoxication" in return. By taking up residence in authentic rural spaces, they experienced time travel and marvelous access to a particularly grounded sort of "place," even as the social forces of modernity put real access to those worlds increasingly out of reach. Promoted as a refuge from urban life, these museum spaces on the margin of the city nevertheless took part in that more general logic by putting rural space in series with so many other "realistic" spaces available as part of the city experience.

A sharply pointed satire of Skansen from 1901, appearing in the Stockholm paper *Söndags Nisse*, helps make explicit this intimate connection between the rural and the urban.[43] Here the most immediate target of the satire is Hazelius's collecting mania and seemingly endless ambitions for Skansen's expansion, but along the way an amusing reversal of country and city emerges as well. The sketch imagines a time far off in the future, in 1950, when children might gather round their uncle to hear him tell stories about Stockholm. His tale begins with an old unnamed professor (Hazelius) who begins collecting everyday objects in the 1800s. When he reaches a total of one hundred chests and one thousand candlesticks, the story goes, he rents a locale on Drottninggatan in Stockholm. When he doubles that number of chests and candlesticks, he rents twelve more locales. When animals are added to his growing furniture collection, the storyteller continues, the professor purchases land out on Djurgården to display everything, buying up the entire peninsula piece by piece to form an "open-air museum."

"This catchword, open-air museum, turned out to be a disaster for Stockholm," the uncle goes on to tell the children, because whenever it was decided that some part of the city should be historically preserved, it, too, was called an open-air museum and eventually annexed by Skansen:

> Afterward it went in rapid succession. City-quarter by city-quarter was incorporated by Skansen, until the point in 1930 when the entire capital was enclosed and put under the professor's jurisdiction. All of the city's inhabitants moved out to the countryside and could only visit the capital city for an entry fee of 50 öre (25 öre on special Sundays, yearly pass 100 kronor). But the temptation was not *so* great. All of the former glories had disappeared.

Or, rather, they had been replaced—the story goes on to list how characteristic urban attractions like cafés, the latest fashionable drinks, boulevards, and city squares are all replaced by rural-culture equivalents. The imagined result is shown in this intriguing illustration accompanying the article (fig. 9.5). City dwellers have turned to role-playing country folk,

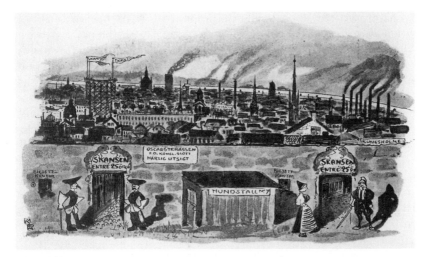

FIGURE 9.5. Satiric drawing of "Greater Skansen" in *Söndags Nisse* (17 March 1901).

and the folk museum's rural respite has become the main urban attraction in Stockholm, now renamed "Greater Skansen."

This shot at 1890s historicism and its inflated reverence for Swedish folk culture is not brilliant satire, but the idea of collectibility gone wild is a provocative one. Implicit in the critique is the suspicion that the folk museum's ever-expanding circles of contextualization, which aimed to make Skansen seem to be a natural, "found" space, inadvertently give it the logic of a metropolis instead. What was once the island of rural culture in the city has become the frame, a point conveyed in the illustration by the wall surrounding the factories and the folk-costumed ticket takers standing guard at the gates of the ultimate urban attraction. In this image, we find an indirect confirmation that the logic of the city is inextricably bound up in Skansen, and Skansen in the city.

So who would buy tickets to come and visit Greater Skansen, farmers or *flâneurs*? The storyteller claims that there are no more urban dwellers—all have fled to the country, inverting the actual nineteenth-century social migration *into* the city. The satiric inversion has hopelessly entangled the two groups, with farmers (or role-playing farmers) at the gates of a city without real city dwellers, and a potential audience of former rural inhabitants first displaced to the city by the process of industrialization, then forced back to the country by the process of musealization. By imagining a future in which a clear sense of the "folk-museum spectator" is lost in this complicated relationship between the folk museum and the city, this author was not far off the mark.

Chapter 5 of this book developed the idea that the panoptikon, an insti-
tution of visual culture more readily associated with the city and other
"urban" forms of entertainment, was nevertheless tied to ideas of rurality
and provincialism. Gestures in that direction were not to be found only
in the content of joke displays (the old-woman decoy mannequin from
Dalarna rising from the toilet to surprise unsuspecting visitors, or the
country bumpkin at the windowpane of the "Practice in Patience" dis-
play) or in spectator reactions to the hall of mirrors but also in the inclu-
sion of reconstructed rural rooms that one might expect to find at the folk
museum instead. At the Swedish Panoptikon in 1897, one such room was
arranged to resemble a rural interior from Småland, or rather, as the cata-
logue narrative indirectly confirms, a musealized version of it: "The walls
are covered with these old-fashioned, mostly Biblical pictures, whose like
one can now only find at Skansen," with all of the furniture pieces ar-
ranged "as they had them back in time, and perhaps some places still."[44]

As it turns out, however, this room also served as the panoptikon's re-
freshment café, and visitors were encouraged to take their lemonade there
while enjoying the view of Kungsträdgården out the balcony window—
the quintessential landscape of urban Stockholm life. The parallels with
the Danish journalist looking out the Danish Folk Museum's window are
striking; both are positioned inside re-created rural space but are encour-
aged to take full advantage of their modern positions. The urbanism built
into the panoptikon's old Småland interior is further reinforced by the
strange fact that the old rural interior turns out to have been the panopti-
kon's "illusion room" as well, where in the darker part of the year, pro-
jected images (probably lantern slides) of Galatea, Fantasma, Zaira, and
other phantasmagoric figures could be viewed. This most unlikely of set-
tings for optical illusions and projection tricks takes the overlap between
panoptikon and folk museum even further than Sophus Müller would
charge three years later in his 1897 critique. The use of "authentic rural
space" for protocinematic practices either shows a brashness in panoptikon
practice that went far beyond what was acceptable to the folk museum
founders or indicates that perhaps the folk-museum interior was not expe-
rienced as so unrelated to modern forms of spectatorship as might first be
assumed.

That suspicion is confirmed when one discovers that a similar incongru-
ity of place governed the breakthrough of early film projection at the 1897
Stockholm Exhibition. Moving-picture images had been projected for the
Stockholm public throughout the previous summer, but it was the exhibi-
tion—and especially King Oscar's encounter with them there—that intro-
duced such images to the broader Swedish public. The fascinating detail
of their presentation there was that the projection site was located specifi-
cally in "Old Stockholm," the popular re-created medieval city out at the

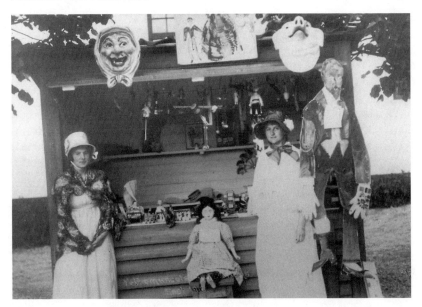

FIGURE 9.6. Market booth used to raise funds for the Norwegian Folk Museum in 1916, showing the composite Hans Aall effigy used as a jumping jack. Photo courtesy of the Norwegian Folk Museum.

Djurgården exhibition site, at a temporary cinema with the paradoxical title the Cinematograph in Old Stockholm.[45] Film in a medieval city? Exhibition historian Anders Ekström speculates that this and other "contrast-creating and progress-endorsing" juxtapositions in the Old Stockholm area (such as the exhibition of X rays) had the effect of underlining the distance traveled by modern civilization and the Swedish nation in particular.[46] But the fact that cinema was given a home in this theme space on Djurgården also underscores the essential similarity in logic between the living pictures on screen and the living picture of medieval Stockholm, not to mention Skansen's own re-created living pictures just up the hill. The contrast, that is, was only with the content of "Old Stockholm," not with the medium of surround-style theme space that made it possible, which was as modern in conception as the cinema itself.

A final image drives home the point that folk-museum spectatorship was experienced in hybrid terms. The image is again somewhat accidental and arbitrary, perhaps intended originally to make other points, but it serves to capture much of what I have argued in this chapter and throughout this section. A photograph from the Norwegian Folk Museum shows a market booth set up for fund-raising in 1916 (fig. 9.6). To the right in the picture is a jumping-jack effigy of museum founder Hans Aall, which

according to Tonte Hegard was painted by Henrik Rung and used to raise money at ten öre a pull on the string.[47] As Hegard also points out, the fascinating thing about the effigy is its hybrid status; one of its hands is covered with a white city glove, the other with a traditionally embroidered knitted mitten, and in reverse order one foot with a dress shoe and pants, the other with a boot and country clothing.

A partial explanation for this is, of course, that unlike some of the other founders, Aall was from the start a collector of historical artifacts from both rural and urban settings; early on, the Norwegian Folk Museum had a re-created town street with buildings and interiors along with the stave churches and rural cottages. But the mishmash of country and city in this representation of the founder's body is also a remarkable statement on the perceived cultural function of the folk museum. It recognizes that the activity of collecting old homes for use in the city involved both rural and urban worldviews. What goes for the founder's body, I would submit, is even more relevant to conceptualizing the bodies on display and those of the spectators themselves. All of them participated in exploring the properties of the "as-if" body of modernity, a body that was neither here nor there, and yet both here and there at the same time.

MATERIAL MOBILITY

THE THEORETICAL TENSION between voy-
eurism and immersion, which must be confronted at some level by all
display practice, became flesh in a particular way in the historical moment
of Scandinavian modernity. Broader questions, which might take up the
phenomenology of display more generally, or perhaps examine the long-
view, variable cultural history of carefully demarcated viewing space, have
here been embodied in a local practice in which spectators poised at
thresholds reenacted the special circumstances of rapid cultural transition.
Of all the possible investments in vicarious access to a scene, that is, the
Scandinavian museums have presented us with a certain kind, a useful
"then" and "there" in which to examine more familiar ideas of modern
circulation and visual availability. What has emerged is a sense of Scandina-
via's special attachment to the materiality of display, to travel and effigy
systems built on objects instead of recorded traces or simulation. The im-
plications of this practice reach beyond Scandinavian cultural history; in
the distinction between material and virtual mobility lies a crucial cross-
roads for modernity's visual culture more generally, for its relation to the
idea of recording, and for cinema as a special variety of the same.

What is it that understanding these material systems of mobility helps
us see? For one, the tableaux and re-created museum interiors reveal the
practical limit of the actual circulation and recontextualization of objects.
While there was a remarkable similarity between museum visitors and cin-
ema spectators in the way they experienced sensations of mobility and
displacement (often using precisely the same "living-picture" phrases to
describe it), the crucial difference was the sheer energy that was necessary
to assemble a convincing environment in the museum. There, the interior
technique's suture of things (rather than cinematic shots) challenged
more directly the inertia of the physical world every time it created the
impression of a seamless world transported to the spectator's feet.[1] Put
another way, the strand of display practice that stands out in the late nine-
teenth century's nascent culture of visual ubiquity is the one that remained

dependent on the physical choreography of authenticated objects—the museological version of mobility.

As has been shown, the two museum types discussed here, while united in their investment in entire scenes as the unit of visual currency, tended to part company on questions of authentication. The wax museum tilted more toward popular forms of simulation, its designers being as open to painted backdrops and other theatrical effects as to rigorously collected environments per se. When given full play, such concessions to illusionism placed the panoptikon in the orbit of visual entertainment like panoramas and dioramas, institutions more interested in visual persuasion than in the certification of their inventory.

Despite the popular-entertainment profile, however, the wax museums still engaged the principles of material mobility whenever they got into the relic business to outfit their theatrical scenes. The authentication, collection, and careful arrangement of relics-turned-props (like hair samples, signed documents, original clothing, or scenic elements like the sand collected off distant fishing beaches) entailed a fidelity to physical objects that kept the goods of display flowing by traditional means of transportation. Indeed, to talk of the "circulation" of such materials sounds too effortless, too much like the more modern media of recording; "freight" is perhaps the better term, capturing as it does the physical activity of moving objects that were unique in space and time to the site of the museum. The result was a wax-museum scene that was part simulation, part collection. That potent combination of theatricality and portability gave its mobility effects an extra whiff of the authentic, even as it enacted the tension between mobility and stasis in the museological scene.

Still, the more insistent form of material mobility, as has been shown, was to be found at the folk museum, especially in its open-air format. The hyperbolic dislocation of furniture, buildings, plants, and animals represents in many ways the outer conceptual limit of physical collection, in which the "surgical issue" of the ethnographic is deferred as far as it reasonably can be.[2] Scandinavia's charged nineteenth-century social context of rescue and last-chance preservation gave this continuing deferral its necessary cultural motivation, with each expanding concentric circle of collection serving to naturalize and suture over the cut at the previous level. Effigy effects that were previously concentrated in the mannequins themselves thus expanded to an effigy system of a much larger order, including the now familiar missing-person techniques and the collection and recontextualization of thousands of objects large and small in total environments. To make a living body out of a collection, to perform this project of cultural mise-en-scène, the folk museum collectors were pushed to include ever-expanding contexts along with more traditional objects of collection.

It is worth repeating my earlier emphasis on the sheer scale of this activity: in order to become "mobile," buildings had to be carefully documented, disassembled log by log, shipped to the museum piece by piece, and then painstakingly reassembled on the museum site so as to seem as if they had never been moved. The energy expended on this project is itself the best measure of material mobility's requirements, with the last possible expanded circle of collection serving to mark its limit as a practical project—at some point, the extended context simply became too large to transport by traditional means, or was too "living" to survive detachment. Even if the folk museum at that point reached the "cut" inevitably shared by all representational systems, the bulk and weight of the collected materials—these seemingly immovable environments that had been moved nevertheless—made possible for museum visitors an unusually powerful sense of personal mobility. The immersive environment allowed spectators to imagine striding across entire geographies and to engage directly with large, seemingly unmanipulated physical environments.

This perspective puts a more interesting spin on these material forms of display than is customary when thinking about turn-of-the-century visual entertainment. The museological practice presented in the preceding chapters, that is, calls into question a central assumption of traditional film historiography, namely, that these material forms of display had reached a developmental limit and were thus simply waiting to be liberated from their physical constraints by the more supple mobility of cinema recording. That model places the museum in the company of other visual practices commonly seen as springboards to the cinema: the theater, zoos, expositions, shopping arcades, and so forth. These, too, have been characterized as hampered by their confinement, as single versions, to unique space and time. Cinema (and other forms of recording), the argument goes, introduced an entirely new form of collection that could take its visual samples unobtrusively. It provided spectators with the convincing indexical trace that nevertheless kept the original world intact, and thereby left many dominant nineteenth-century forms of entertainment in the (material) dust.

My suggestion here is to question the implied metaphysics of this "precinema" model, the notion that cinema proved its superiority by transcending the material practices of collection and display from which it emerged. This, after all, is itself an interested historiographical model, one that emerged quite early on in cinema history as a way of establishing cultural legitimacy for film. (The notion of film's technological transcendence of the material world, for example, helped pry the institution loose from persistent associations with "dirty" working-class audiences.) One might conclude from some traditional film-historical accounts that cinema simply subsumed or vanquished competing display practices on

its way to becoming the dominant entertainment form of the twentieth century.

That such progress should be defined at the expense of the material world ignores the enduring appeal of display practices based on bodies and objects in real space and time. Cinema's visual paradigm was in fact not the only successful one to emerge from the period. It is probably accurate to claim that cinema became the twentieth century's most successful form of voyeuristic viewing. But we have seen from the museum practices outlined here that the idea of visual immersion was an equally powerful strand of turn-of-the-century spectating experience, one that leads historically and conceptually into a wide variety of late twentieth-century forms of "virtual" popular entertainment, such as theme parks, theme restaurants, ride simulations, and virtual-reality gaming. Interestingly, the recent commercial resurgence of wax museums in the 1990s (in Las Vegas and Times Square, for example) has taken place in exactly this shared public space of contemporary entertainment complexes. From this perspective, it is the late nineteenth century's museological innovations of surround-style environments that seem particularly prescient. The enduring appeal of this kind of visual experience suggests that the materiality of the immersive display space was not at all "done in" by the advent of cinema or other forms of recording; it was simply prompted to develop in directions less noticeable to film history. Only in cinema-specific accounts does the immersive strand of visual culture fall off the map.

Now, of course, in a visual culture where the idea of recording itself has become "clunky" in the face of new digital media, there is a certain intellectual appeal in emphasizing these material display practices that cinema "left behind," practices even more insistently referential than the photographic medium. For instance, this genealogy of current forms of "theme" experience helps sort out hidden lines of continuity, as well as significant ruptures, in the development of twentieth-century display practices. A closer look at these hundred-year-old attempts to cultivate the logic of the immersive environment reveals an ongoing interest in the sensations of spatiotemporal mobility that occur inside a scene, in a spectator experience dependent on the coordinated theatrical arrangement of tangible objects in haptic space. Such attention to historical practice helps in turn to throw our own preoccupations into sharper relief, since the more recent forms of immersive visual experience have distanced themselves from the late nineteenth-century museum's imperative of verification. Scattered exceptions exist, like Planet Hollywood's displayed celebrity relics, but in general, contemporary promotion of theme space seems far less concerned with principles of verification and authenticity than the museum environments of one hundred years ago. That recognition makes it possible to reconstruct modernity's earlier, more powerful experience

of dislocation, since objects and bodies at that point could still seem *newly moved*, more likely to drag along with them impressions of authentic original space.

There is another yield from this emphasis on a competing trajectory of immersive entertainment in the twentieth century, namely, that it suddenly seems possible to recover a new view from which cinema seems the "stuck" medium, hindered as it is by the insurmountable limitation of the screen. Unlike the physical, walk-through scenic environments of museums and theme attractions, that is, cinema space is forever marked as other, separated from the viewer by the ontological gulf of recording. In fact, many of cinema's continuing innovations in film form and technology (continuity editing, deep-focus photography, 3-D projection, wide-screen format, surround sound, IMAX technology) have been attempts to overcome the limits of the screen that condemn cinema to the perpetual depiction of no more than half a world, one always out of reach on *that* side of the invisible fourth wall. In that sense, the later history of cinema throughout the twentieth century might be understood as repeatedly measuring itself against its lost nineteenth-century counterpart of immersive visual culture.

A series of images from a 1911 Danish film can make this point more vividly at the level of concrete example. The film in question, produced by Nordisk Films Kompagni and directed by Eduard Schnedler-Sørensen, was called *Those Eyes*, or *The Break-in at the Actress's House* (Øjnene; aka Indbrud hos Skuespillerinden). Like many films from early international cinema history, this short crime film (722 feet) allegorizes the phenomenology of the screen quite overtly by treating thematic scenarios of voyeurism, visual trespass, and boundary supervision. There are unfortunately few traces left to work with; there is no surviving print, only two prose plot descriptions, a newspaper review, and six publicity stills (not actual frame enlargements). The film sold a mere forty copies, slightly on the lean side for Nordisk's highly successful international sales that year.[3] A typical lost film in many respects, it nevertheless seems to have made a visual argument against the idea of immersion that can serve to mark the separation of two strands of turn-of-the-century visual practice.[4]

As near as I have been able to reconstruct, the plot of this little cautionary tale goes something like this: as an actress prepares to leave her apartment to go perform in the theater, a thief positioned outside her window watches her receive a gift of jewelry from her fiancé (fig. 10.1). As he does this, the actress gets the uncomfortable feeling that she is being watched, and asks her fiancé to check the balcony outside. Gun drawn, her beau opens the window but finds no one—the thief has hidden himself by hanging from the railing out of sight in the darkness (fig. 10.2). After the couple leaves for the theater, the thief makes his way in. As he rifles

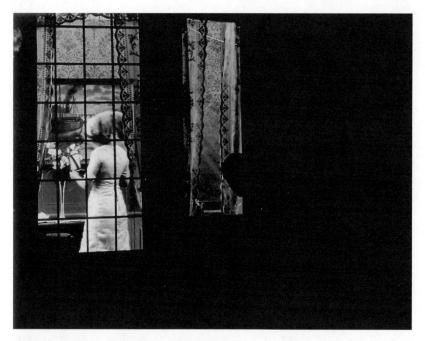

FIGURE 10.1. An unseen observer on the balcony, in *Those Eyes* (Øjnene, Nordisk
Films Co., 1911). Photo courtesy of Nordisk Film.

through the actress's possessions, however, he, too, gets the feeling that
he is being watched: "It seems constantly as if invisible eyes are observing
him," states the plot description. He attributes the watching to the eyes
of a painted portrait, which, we are told, depicts the actress's mother.
Outraged at the "hypnotic effect" of the eyes, the thief attacks the paint-
ing with his knife and slashes them out.

The actress soon returns from the theater, and the thief must find a
place to hide. Desperate, he steps behind the portrait and places his own
eyes behind the holes he has cut in the painting (here one might say that
the film's allegorizing impulse exceeds the narrative motivation). Now it
is the actress's turn to be disturbed by the painting, equipped as it pres-
ently is with the living, moving eyes of the thief (fig. 10.3). She edges
toward the telephone to call for help and manages to get through to her
fiancé just as the intruder springs out from behind the portrait. The fiancé
rushes to her apartment with police in tow, and they apprehend the inter-
loper just in time (fig. 10.4).

This seems to have been a richly multivalent filmic text, overdetermined
with possible readings in the way that popular-culture texts often are.
Competing for interpretive attention are Oedipal issues, endlessly revers-

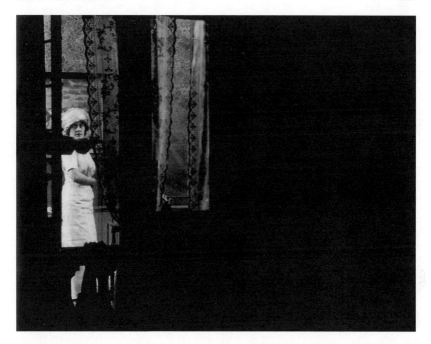

FIGURE 10.2. A resourceful hiding place, from *Those Eyes* (Øjnene, Nordisk Films Co., 1911). Photo courtesy of Nordisk Film.

ible gazes, uncanny artworks, and a narrative contest between crime and moral containment, or perhaps between cinema and the more legitimate theater. Given the incomplete evidence, all such readings will of course have to remain quite tentative. But I would like to suggest a line of interpretation relevant to the larger argument of this book, namely, that this film conveys the process at work in the larger historical moment, when cinema consolidated its model of spectatorship around the voyeuristic model by stigmatizing the idea of immersive visual experience.

Such a reading would seize on the many moments of weak narrative motivation in this strange plot and claim that they reveal a self-conscious primer in screen spectating. The first two surviving images stage the screen-within-the-screen quite deliberately, framing the smaller rectangle of light in surrounding darkness, which is in turn the screen's relation to the darkness of the cinema hall. The film spectator is equated visually with the intruder holding back voyeuristically from the scene, the dark silhouette of his head on screen echoing those of actual spectators sitting up front in the hall. The narrative format of film by 1911 discouraged direct acknowledgment of the audience's presence before the image (a connection ultimately made impossible by recording anyway), which gives sig-

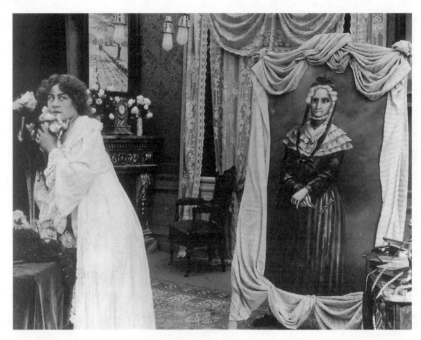

FIGURE 10.3. The living-dead of the representational surface, in *Those Eyes* (Øjnene, Nordisk Films Co., 1911). Photo courtesy of Nordisk Film.

nificance to the actress's claim of being watched by invisible eyes. The reference resonates in this way on both diegetic and extradiegetic levels (the thief's unseen eyes doubled over by those of the audience watching the scene from an even safer and darker vantage point). Further, the actress is said to be off to a performance in the theater—a "live" medium of shared physical space in which she would be accustomed to being watched by the audience, and perhaps (depending on the theatrical style) to looking back. Here, at this moment before the live performance, she is by contrast being watched cinematically, voyeuristically. Is someone really there or not, out on the balcony, out in the cinema hall?

After the first sequence, the visual hierarchy of watcher and watched is displaced to the fictional world of the apartment. Now it is the painting that serves as the screen substitute, the framed representation-within-the-frame. The plot toys with the possibility of visual reciprocity, first with an imagined look back from the painting, then with its unnerving combination of flat representational surface and living eyes. At this point, the uncanny presence that activates the image is significantly that of an interloper who should have remained outside the scene, off the screen, but has in-

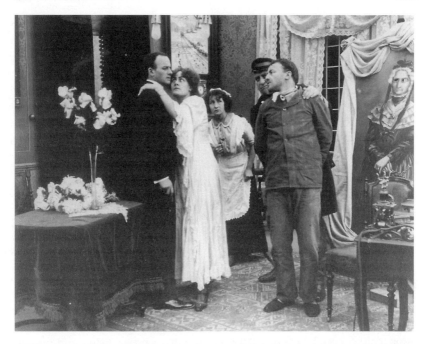

FIGURE 10.4. Apprehending the spectator-turned-visitor, in *Those Eyes* (Øjnene, Nordisk Films Co., 1911). Photo courtesy of Nordisk Film.

stead found his way to the very center of the representational field in the eyes of the portrait.

Reciprocity and immersion can only be thought of as transgressive or horrific in this scenario: reciprocity between classes, between audience and performative space, between object and subject of vision. The gun pointing out on the balcony, the slashing of the portrait's eyes, the overdetermined rescue at the end—these narrative turns all serve to police the boundaries of display by criminalizing the ideas of shared space and reciprocal looks. What is restored at the end of this film is the very voyeuristic spectating position that cinema was busy consolidating in 1911, in which the darkened silhouettes of viewers keep their distance, and are in turn rewarded with uninterrupted visual pleasure. Faced with its own ultimate limitation (the screen's radical separation from spectator in space and time), this film makes a preemptive strike against the idea of shared space by pathologizing it.

As was shown earlier in this study, one could find similar supervision of display borders at the wax museums themselves; they, too, had their rube mannequins, trick umbrellas, voyeur vignettes, and doubly enframed tab-

leaux. Were that the only kind of museum practice under examination here, the result would be a clear but predictable model of precinematic spectatorship. An apparently straight-line trajectory could be drawn from wax-museum spectatorship to that of early cinema, since both seem to have been interested in teaching the same lesson: hold back, remain invisible, experience the field of display vicariously as a provisional space accessed only through vision.

The addition of the folk museum to the constellation, however, brings the competing strand of immersive viewing to the fore as well. When the folk museum invited spectators across the line by dropping the velvet ropes, surrounding them instead with re-created and relocated environments, it gave visitors a nonpathologized alternative to voyeurism. Though visitors were still held in check from full participation in the environment—as has been shown, the folk museum had its own rubes and Gypsies who went too far in using the space—they were nevertheless encouraged to pretend to experience the scene from the inside, in tantalizing proximity to tangible objects and the evocative traces of missing bodies. The mutual historical imbrication of the wax and folk museums in Scandinavia thus suggests a more complex model of visual alternatives at the turn of the twentieth century, one that helps us recover a fuller sense of modernity's visual culture as alternating between voyeurism and immersion, between virtual and material mobility.

Turn-of-the-century museum experience yields another beneficial insight into the idea of mobility. The heft of museum objects, the very quality that makes them stubborn and recalcitrant, also serves as a useful reminder of the spatial and temporal relations that governed the original context. This may be an inadvertent honesty, one forced on still higher illusionistic aspirations by the physical nature of the medium, but one that nevertheless provides a certain retrospective leverage on subsequent forms of recording- or simulation-based media. The open-air museum is especially interesting, that is, because it aspires to total material mobility *and* because it inevitably falls short; that failure reminds us of real-world relations of size, weight, and substance in a way that recordings cannot.

A final photograph illustrates this crucial difference between material and virtual mobility, suggesting an unexpected virtue of the former. The wax tableau, entitled "à Porta's Café," dates from the Scandinavian Panoptikon of the late 1880s or early 1890s (fig. 10.5). At the time, Peter à Porta's actual café on Gammeltorv in Copenhagen was a well-known gathering place for writers, theater people, artists, and other cultural figures. It presented an obvious choice of subject matter for the wax museum, combining as it did the idea of concentrated local celebrity and contemporary urban scene.[5] The resulting display at the Copenhagen wax museum thus included effigies of then-famous Nordic writers such as Georg Bran-

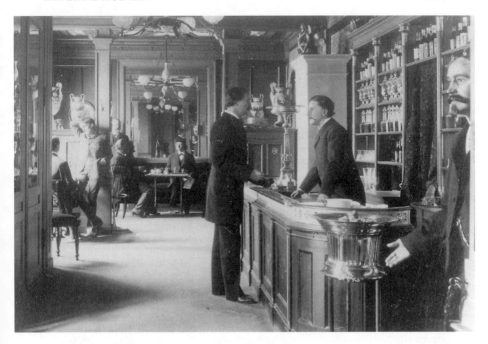

FIGURE 10.5. Peter à Porta's café on Gammeltorv, as represented at the Scandinavian Panoptikon in Vesterbro in the early 1890s. Photographer unknown, photograph courtesy of the Royal Library (Copenhagen).

des, August Strindberg, Erik Skram, Herman Bang (posed effeminately to the left in the picture), and Jonas Lie (seated to the right at the rear table), for a total of seventeen figures.

In a departure from the usual practice at this wax museum, it seems to have been a walk-through display, to judge from the printed program's diagram.[6] The first implication of this immersion format is that it required a more substantial, materially detailed representation of the café than what would have been necessary for a half-room tableau—something more akin to the full-paneled effect of rooms at the Danish Folk Museum upstairs in the same building. This wax-museum café had to hold up to visual inspection close at hand when spectators walked into the scene, and therefore could not rely on illusionistically painted theater backdrops, as did some of the other wax tableaux (see figs. 4.8 and 4.17, for example). The invitation to enter the scene, captured in the gesture of the mannequin at the extreme right in the photograph, thus commits the wax museum to the more hyperbolic world of material mobility, in which the Panoptikon in Vesterbro constructs a painstakingly solid version of the real Copenhagen café located in all its reality just a few blocks away, all for the express

purpose of helping spectators to feel momentarily and authentically as if they were (in this case, slightly) elsewhere.

A detail in the background of this photograph further complicates the issue. Like the maze salons and the royal family display at the Swedish Panoptikon (see fig. 4.20), this scene included a reflective mirror as part of its game of effigy. Here it shows up as a motivated element of the café's decor instead of as the visual punch line of the scene, as it was in Stockholm. We might even be disinclined to notice the mirror here at all, were it not for the sight it reveals at the photograph's focal point. Directly to the left of the Jonas Lie effigy, that is, one can make out the inadvertently reflected image of the hooded photographer and camera responsible for the photograph. Without that mirror, this photograph, like the others included in this book, would present itself as a transparent medium through which to enter a depicted scene, invisibly, voyeuristically. With the mirror, however, the camera is necessarily caught depicting itself. A normally mobile system of vision is thereby suddenly mired in the material world, forced to betray the physical preconditions of its apparatus and its location at the scene of production. The mirror image cannot constrain itself, reflecting back the field of vision not only in front of the camera but behind it as well, hinting at the reversal of field that would match the photographed world to its missing half. That "total" view, however, necessarily comes at the price of revealing the camera's real presence at the scene.

The mobility experience made available by the photographed scene is thus quite different from that of a personal visit. Most obviously, what one would find thrown back from the focal point of the scene upon entering the actual room at the panoptikon would be the image not of a camera but of one's own mirror image among the effigies. Like the viewer in the mirror opposite the royal family scene in Stockholm, the real-life visitor to this display would find his or her image interpolated among the reflections of the other effigies, once again flattered into a celebrity scene. That spatial proximity between the bodies of the viewer and the viewed is of course impossible in the photographic medium—self-reflexive strategies there, no matter how sophisticated, can never reveal the eventual viewer of a photograph, only the photographic apparatus itself. Moreover, the visitor's subsequent walk into and through the scene at the panoptikon creates a variable perspective and dynamic relation to the representational world unavailable to viewers of the framed images of photography or cinema. Here, as in the folk-museum interiors, one could imagine oneself completely inside the effigy effect, with the "cut" between body and surrounding space deferred beyond the room itself.

The binary alternative raised by the simple presence of this mirror—the body or the camera at the scene—maps the crucial conceptual shift from

material display practices to a more photographic mobility. Because museum spectatorship insisted then and continues to insist now on the viewing body's presence at the scene of display, in one sense it tells a truth that recording finds impossible to convey. The museum demands physical reciprocity between viewer and viewed in real space and time, while recorded media do not. The corporeal ubiquity that the camera seems to promise the spectator is thereby exposed as a fiction, since it depends on the apparatus remaining in hiding. In this sense, each of the photographed museum scenes included as evidence throughout this book enacts the conceptual shift between the material and the virtual, with one medium of mobility layered upon the other. Our visual access to the experience of museum visitors of one hundred years ago is necessarily virtual; as retrospective photographic viewers of the tangible museum scenes, we are as absent from the scene as the imagined "lost" inhabitants.

The essentially photographic relationship to this earlier spectating experience explains both the retrospective lure and the frustration of material mobility systems for later residents of a more virtual world. Looking back on that time, we risk getting caught in the ever-receding search for "thingier, denser things," as A. S. Byatt's main character puts it in her recent novel.[7] In that story, as in the present study, a deliberately therapeutic search for "things" must soon settle for "facts," then metonymic traces, and finally the irreducible truth of missing persons. There, the search for presence in a more reliable physical world, for a face-to-face encounter with the lost biographical subject, ends in the representational abyss of a photograph depicting an empty boat swirling at sea in the Maelstrøm off the Norwegian coast.

Here, my retrospective interest in the real-world mobility of objects and bodies at the turn-of-the-century museum, if it were only a product of my own critical desire, could fall victim to a similar *mise-en-abîme*. After all, these museums were already at their inception many-layered media, the products of collection, arrangement, and presentational rhetoric. The objects on display in late nineteenth-century museums, despite their (for us in retrospect) appealing physical presence, never did speak "directly" to viewers. Even deferral to a putative moment before collection does not reduce the object to terms elemental enough to satisfy the need for a phenomenological anchor—indeed, nothing can. Complicating the picture still further is the fact that the surviving institutions from this period cannot avoid becoming museums of museums, as much a collective monument to the modernity projects of the 1890s as to the timeless folk culture they originally intended to commemorate, as Adrian de Jong and Mette Skougaard have emphasized.[8] After a hundred years of display, the scuff marks visible on the thresholds of folk-museum interiors now evoke

the former presence of thousands of tourist shoes as much as original farmer boots.

What remains, however, is the conception of a museological project as understood by its historical participants. When we see the confidence with which they moved mountains, driven by a secular faith in the mobility of the material world, we glimpse a long-lost confidence in the power to transport sights intact to a viewer, piece by piece and scene by scene. In the space of the museum, spectators stood before mobile yet contextualized bodies and objects, before scenes mixing simulation and documentation, taking up positions at boundaries both carefully demarcated and strategically ignored. In that mix of voyeurism and immersion, of access and belonging, the public space of modernity was enacted.

NOTES

CHAPTER ONE
THE IDEA OF EFFIGY

1. I thank my colleague Carol Clover for noticing and suggesting to me this evocative contemporary example of a missing person, as well as Kristin Ørjasæter of the University of Oslo for providing me with a detailed verbal description of the Ibsen display at the Grand Café. I am also grateful to Bjarne Skramstad of the Grand Hotel's current administration for meticulous documentation of the history of the Ibsen display there (personal correspondence to author, 7 June, 22 June, and 16 August 2000). A. S. Byatt's latest novel, *The Biographer's Tale* (London: Chatto and Windus, 2000), also deals interestingly with this Ibsen chair (79–95), a treatment that I will return to in this book's concluding chapter.

2. Bjarne Skramstad informs me that the chair, an original gift from the hotel to Ibsen in the 1890s, is now the property of the Oslo City Museum, which has loaned it back to the hotel for display purposes. The cane and hat are also Ibsen's original possessions.

3. The Skramstad correspondence mentioned earlier includes snapshots of the Ibsen role-player from the 1994 opening, with captions like this from the hotel scrapbook: "Ibsen is served his dark beer and port wine," or "Ibsen has taken his seat." In the hotel's substantial file on the Ibsen chair, there are also several illustrated newspaper clippings describing the 9 May 1978 living-history event.

4. The reference to Wells is not gratuitous; the date of publication for his "grotesque romance" of invisibility (1897) is contemporary with many of the historical discourses of disembodiment, recording, and corporeal mobility that are central to the museological imagination of the late nineteenth century. As for the bodies of Pompeii, an interesting theoretical treatment of their "ghostly" impressions can be found in Anthony Vidler, *The Architectural Uncanny: Essays in the Modern Unhomely* (Cambridge, Mass.: MIT Press, 1992), 49–50.

5. During my visit to the National Museum archives in the summer of 1992, designer Karen Jacobi showed me the process by which she created these unusually present invisible bodies. Constructed from a combination of chicken wire pressed out to fill the interior shape of the garment, several layers of plaster of Paris, shellac, and rice paper on the interior dyed to match the clothing's color, the resulting "mannequin" provides an impression of substance and support while blending

completely into the garment itself. Personal correspondence to author, 20 December 1995.

6. A useful long-historical view of effigy practice can be found in Wolfgang Brückner, *Bildnis und Brauch: Studien zur Bildfunktion des Effigies* ([Berlin]: Erich Schmidt Verlag, 1966). More specific treatments of nineteenth-century mannequin practice will be referenced in following chapters.

7. Wolfgang Schivelbusch's influential cultural history of railroad perception includes an extended discussion of this refrain in nineteenth-century railroad discourse; see *The Railway Journey: The Industrialization of Time and Space in the Nineteenth Century* (Berkeley: University of California Press, 1986), 33ff. Thomas Edison repeats the phrase, mentioning his new invention's ability "to annihilate time and space" in his 1878 essay on the phonograph, "The Phonograph and Its Future," *North American Review* 262 (May–June 1878): 536.

8. Stephen Kern, *The Culture of Time and Space, 1880–1918* (Cambridge, Mass.: Harvard University Press, 1983), 1.

9. The Leo Charney and Vanessa Schwartz anthology, *Cinema and the Invention of Modern Life* (Berkeley: University of California Press, 1995), conveys that sense in both its title and content, proceeding as many of the authors do from assumptions that modernity introduced a radically new visual-cultural paradigm.

10. Paul Valéry, "Conquête de l'Ubiquité," in *De la musique avant toute chose,* . . . (Paris: Editions du Tambourinaire, 1929), 1.

11. Walter Benjamin, "The Work of Art in the Age of Mechanical Reproduction," in *Illuminations,* ed. Hannah Arendt, trans. Harry Zohn (New York: Schocken Books, 1968), 221.

12. Anne Friedberg, *Window Shopping: Cinema and the Postmodern* (Berkeley: University of California Press, 1993), 38.

13. One of the most insightful treatments of the museum object's status in circulation can be found in Barbara Kirshenblatt-Gimblett's chapter "Objects of Ethnography," in her *Destination Culture: Tourism, Museums, and Heritage* (Berkeley: University of California Press, 1998), especially 17–51. See also Susan M. Pearce, *Museums, Objects, and Collections: A Cultural Study* (Washington, D.C.: Smithsonian Institution Press, 1992).

14. Several interesting treatments of the natural history museum's turn to the life group as the unit of presentation are Alison Griffiths, "Origins of Ethnographic Film" (Ph.D. diss., New York University, 1998), 28–74, on realistic life groups and their critics; on dioramas, Karen Wonders, "The Illusionary Art of Background Painting in Habitat Dioramas" *Curator* 33.2 (June 1990): 90–118; and on taxidermy, Donna Haraway, *Primate Visions: Gender, Race, and Nature in the World of Modern Science* (New York: Routledge, 1989), 35–42. The sense of scene at the wax museum and folk museum will be dealt with at length in following chapters of the current study.

15. See Eric C. Ames, "Where the Wild Things Are: Locating the Exotic in German Modernity" (Ph.D. diss., University of California, Berkeley, 2000), especially chap. 3, "The Primitive Edge."

16. For a treatment of the early precedents of the nineteenth-century tradition, see Kristen Gram Holmström, *Monodrama, Attitudes, Tableaux Vivants: Studies on Some Trends of Theatrical Fashion 1770–1815* (Stockholm: Almqvist & Wiksell,

1967); for the American history of the same, see Jack W. McCullough, *Living Pictures on the New York Stage*, Theater and Dramatic Studies 13 (Ann Arbor, Mich.: UMI Research Press, 1983). Interestingly, the generic term for early film in Germanic countries was "living pictures" (in German, *lebende Bilder*; in Scandinavian languages, closely related variants on *levende Bilder*), which emphasized life over the motion implicit in the term "movies."

17. Yuri Tsivian, *Early Cinema in Russia and Its Cultural Reception*, ed. Richard Taylor, trans. Alan Bodger (Chicago: University of Chicago Press, 1998), 5–10.

18. Maxim Gorky, "The Lumière Cinematograph (Extracts)," in *The Film Factory: Russian and Soviet Cinema in Documents 1896–1939*, ed. Richard Taylor and Ian Christie (London: Routledge and Kegan Paul, 1988), 25.

19. Tom Gunning reminds us of this general first reaction to the living image in his foreword to Tsivian's *Early Cinema in Russia*, xix.

20. "Kinematografen," *Fotografisk Tidskrift*, 15 March 1896, 86. It is unclear from the wording of the article, which describes "coming across" this account in a newspaper, whether the reporter here is Swedish or French. The very fact that it gets plucked up and emphasized by the Swedish journal, however, shows an interest in technology's immortalizing effects.

21. "Kinoptikon," *Politiken*, 7 June 1896.

22. "En uppseendeväckande nyhed," *Skånska Dagbladet*, 29 June 1896.

23. Griffiths, "Origins of Ethnographic Film," 30–32.

24. Roland Barthes, *Camera Lucida: Reflections on Photography*, trans. Richard Howard (New York: Hill and Wang, 1981), 87.

25. Marshall Berman, *All That Is Solid Melts into Air* (New York: Simon and Schuster, 1982), 17.

26. The Danish cinema of the silent period 1910–14 was especially committed to a model of spatial integrity, developing an extensive repertoire of mirror effects that introduced visual variety without compromising coherence. See Ron Mottram, *The Danish Cinema before Dreyer* (Metuchen, N.J.: Scarecrow Press, 1988), 88, 138–40. According to John Fullerton, early Swedish narrative films were even more embedded in this naturalist tradition, being "overwhelmingly concerned with the autonomy of pro-filmic space." See "Spatial and Temporal Articulation in Pre-classical Swedish Film," in *Early Cinema: Space Frame Narrative*, ed. Thomas Elsaesser and Adam Barker (London: British Film Institute, 1990), 375. The passion for material authenticity in Scandinavian film practice can further be seen in Carl Theodore Dreyer's famously substantial sets in *Master of the House* (1925) and *The Passion of Joan of Arc* (1927), which consisted of working parts and dimensionality beyond that which was visible on-screen.

27. "Panoptikon" (and close variants of that word) was the preferred term for wax museums in all Germanic-language countries throughout northern Europe. The term's usage in Scandinavia was class-driven, indicating a shift in wax display toward a more culturally ambitious version of the "wax cabinet," one pitched at middle-class audiences, as I shall discuss at length later. In this book, however, the terms "panoptikon" (with its original Scandinavian spelling) and "wax museum" will be understood as mostly synonymous.

28. For instance, in what is now the definitive biography of Bernhard Olsen, Holger Rasmussen devotes only a small, six-page section to Olsen's participation in the wax-museum project. See *Bernhard Olsen: Virke og Værker*, Folkelivs Studier 6 (Copenhagen: Nationalmuseet, 1979), 83–88.

29. Although the location of the folk museum on Vesterbrogade was originally considered temporary in 1885, Olsen's museum in fact drew on the built-in audience of Copenhagen's new middle-class entertainment district and, as it turned out, even outlived its more obviously cosmopolitan neighbor downstairs in that building, not moving to a new location until 1926, two years after the Skandinavisk Panoptikon closed its doors.

30. As Alison Griffiths discusses in some detail, a similar debate developed in the wake of the habitat group's introduction to the natural history museum, with Franz Boas leading the critique of illusionistic display. See Griffiths, "Origins of Ethnographic Film," 46–63. Stockholm's Nordic Museum also underwent a reevaluation of its more theatrical display techniques after the turn of the century, with more "scientific" principles of display reasserting themselves. See Staffan Carlén, *Att ställa ut kultur: Om kulturhistoriska utställningar under 100 år*, Acta Ethnologica Umensia 3 (Stockholm: Carlsson Bokförlag, 1990), 104–6.

31. See Georg Simmel, "The Metropolis and Mental Life," in *On Individuality and Social Forms: Selected Writings*, ed. Donald N. Levine (Chicago: University of Chicago Press, 1971), 331–33.

CHAPTER TWO
Upstairs, Downstairs at the Wax Museum

1. For a useful bibliography of scholarly work on wax museums, see Vanessa Schwartz, *Spectacular Realities: Early Mass Culture in Fin-de-Siècle Paris* (Berkeley: University of California Press, 1998). Foundational historical acounts can be found in Richard D. Altick, *Shows of London* (Cambridge, Mass.: Harvard University Press, 1978); Pauline Chapman, *Madame Tussaud's Chamber of Horrors: Two Hundred Years of Crime* (London: Constable, 1984); and Leonard Cottrell, *Madame Tussaud* (London: Evans Brothers, 1965). Useful surveys in French are Michel Lemire, *Artistes et Mortels* (Paris: Chabaud, 1990), and Claude Cézan, *Le Musée Grévin* (Paris: Editions Rombaldi, 1947); in German, Brückner's, *Bildnis und Brauch* is useful. More recent, theoretically inclined historical work, in addition to that of Schwartz, can be found in Marina Warner, "Waxworks and Wonderlands," in *Visual Display: Culture beyond Appearances*, ed. Lynne Cooke and Peter Wollen (Seattle: Bay Press, 1995), 178–201; Stephan Oettermann, "Alles-Schau: Wachsfigurenkabinette und Panoptikon," in *Viel Vergnügen: Öffentliche Lustbarkeiten im Ruhrgebiet der Jahrhundertwende*, ed. Lisa Kosok and Mathilde Jamin (Essen, Germany: Ruhrlandmuseum Essen, 1992), 36–56; and on wax anatomy modeling, Giuliana Bruno, *Streetwalking on a Ruined Map: Cultural Theory and the City Films of Elvira Notari* (Princeton, N.J.: Princeton University Press, 1993).

2. Although my approach is not primarily psychoanalytic, I am of course interested in the way these two display possibilities resonate with Jacques Lacan's idea of the "body in bits and pieces" in his writings on ego formation ("Some Reflec-

tions on the Ego," *International Journal of Psychoanalysis* 34 [1953]: 13). In *The Threshold of the Visible World* (New York: Routledge, 1996), 20–22, Kaja Silverman provides both an elegant examination of Lacan's phrase and a cautionary observation that the very idea of bits and pieces can mislead by implying a false priority of the whole.

3. The first to open (in 1770) was his Salon de Cire at the Palais Royale, which displayed the more "legitimate" subject matter. The second, the Caverne des Grands Voleurs (opened 1783), was located on the more raucous Boulevard du Temple. See Chapman, *Madame Tussaud's Chamber of Horrors*, 2–8.

4. Quoted in ibid., 51.

5. Ibid., 53–54; and Altick, *Shows of London*, 336. The name was apparently tried out by the museum itself in a special-exhibit catalogue from 1843 but did not catch on until 1846, when it had been featured in an article in *Punch*.

6. Chapman, *Madame Tussaud's Chamber of Horror*, 83–85.

7. Swedish Panoptikon program from 1904, reproduced in Erik Lindorm, *Oskar II och hans tid*, vol. 1 of *Ny Svensk Historia* (Stockholm: Wahlström & Widstrand, 1937), 453.

8. For descriptions of earlier forms of wax display, see Altick, *Shows of London*, 50–58; Hillel Schwartz, *The Culture of the Copy: Striking Likenesses, Unreasonable Facsimiles* (New York : Zone Books, 1996), 101–2; and Oetterman, "Alles-Schau," 36–37.

9. *Madame Tussaud and Son's Exhibition Catalogue* (London, 1873), 47. An account of Madame Tussaud's sons bargaining with Sanson's grandson for the guillotine artifacts can be found in Chapman, *Madame Tussaud's Chamber of Horrors*, 68.

10. Schwartz, *Culture of the Copy*, 102. During a visit to the current Tussaud affiliate wax museum in Copenhagen in the early 1990s, I saw a reproduction of this kind of scene in the chamber of horrors there, with Madame Tussaud stationed right next to the guillotine making a plaster mask. A more accurate account of Marie's access to the severed heads would place her either at the cemetery after the execution or in the wax cabinet itself. See Chapman, *Madame Tussaud's Chamber of Horrors*, 10–19, and Cottrell, *Madam Tussaud*, 60–74.

11. All these examples are taken from the 1902 catalogue for Hartkopf's Museum.

12. *Katalog öfver H. Düringers Museum* (Gefle, Sweden, 1894), 16.

13. Altick characterizes one seventeenth-century waxworks in terms that could easily apply to Castan's as well: "In time, the wax figures came to be surrounded with all kinds of oddments, from a whale skeleton to a perpetual motion machine. There was the usual miscellany of fish, birds, shells, skulls, skeletons, fossils, and so forth, as well as a mummy (said to be of Pharaoh's daughter), two stuffed crocodiles, a rhinoceros hide, a pair of snow shoes, and Cromwell's and Newton's death masks." Altick, *Shows of London*, 55.

14. Oettermann even claims that the live "specialty" shows were the real attraction at Castan's Panoptikum, and that the wax figures and curiosities served merely as the frame. "Alles-Schau," 41, 50.

15. Ibid., 49 n. 50.

16. The Cooke and Wollen anthology, *Visual Display*, chooses just such a back-room photo of "severed" wax heads for its cover, perhaps to underscore the subtitle: *Culture beyond Appearances*.

17. Cézan (*Le Musée Grévin*) devotes a chapter to this, and newspaper articles around opening day in both Copenhagen and Stockholm make a special point of "demystifying" for readers the illusory powers of wax display.

18. "Svenska Panoptikon," *Svenska Familj-Journalen Svea*, 3 August 1889, 246.

19. Altick, *Shows of London*, 334.

20. Schwartz, *Spectacular Realities*, 103.

21. Ibid., 98–108.

22. I owe this information and other overall impressions of the crucial influence of the Musée Grévin to Vanessa Schwartz, who in both her written work and stimulating collegial exchange has provided me with an important comparative context for my own study.

23. Ibid., *Spectacular Realities*, 90–91.

24. Ibid., 124–27 (includes full photographic reproduction of the series). I deal in chapter 4 with the almost complete serialization of the wax tableaux at the Copenhagen wax museum in later years. Chapman mistakenly attributes the innovation of the serial tableaux to John Theodore Tussaud (*Madame Tussaud's Chamber of Horrors*, 105); since his museum's display appeared eight years after the series debuted at the Musée Grévin and even shared the same title, it is clear that he did not invent the technique. Rather, this quick emulation of the serial tableaux should be seen as evidence of the increasingly frequent circulation and mutual borrowing of display techniques among the late-century wax museums.

25. These are some of the cities mentioned by König and Ortenau as having wax museums supplied by Paul Zieller, a German wax sculptor around the turn of the century—he was apparently hired to create the museum in St. Petersburg as well. See Hannes König and Erich Ortenau, *Panoptikum: Vom Zauberbild zum Gaukelspiel der Wachsfiguren* (Munich: Isartal Verlag München, 1962), 95. Oettermann's account, a more historically rigorous study, documents several wax-museum openings in German-speaking cities: the Passage-Panoptikum in Berlin, Castan's main competitor, opened in 1889; the Internationale Handels-Panoptikum und Museum in Munich from 1895 to 1906; Hermann Präuscher's Panoptikum, which had settled into a permanent locale in Wiener Prater as early as 1871; and another in Vienna, opened by Veltee in 1890. In addition, Oettermann mentions the several Castan affiliates that opened in Cologne (1879), Brussels (1891), and Frankfurt (1905). See "Alles-Schau," 45–49. A current guidebook from the Panoptikum in Hamburg mentions as well that the original museum there, the Hanseatisches Panopticum, opened in 1879. See *Panoptikum: Das Wachsfigurenkabinett*, 11th ed. (Hamburg, 1997). (My thanks to Eric Ames for this information.)

26. *Katalog over Skandinavisk Panoptikon* (Copenhagen, 1885), 2.

27. Olsen may simply have been unaware of other examples, although his failure to mention the Amsterdam panoptikon seems more calculated, given that he had visited Amsterdam along with Paris, Berlin, and London in the early 1880s while researching existing European wax museums. This trip is mentioned in Carl Muus-

mann, "Udendørs Forlystelser," in *Tiden 1870–1914*, vol. 5 of *Danmark i fest og glæde*, ed. Julius Clausen and Torben Krogh ([Copenhagen]: C. Erichsen, 1935–36), 158.

28. For background on Arthur Meyer and Alfred Grévin and the cultural repertoire they brought to their wax museum, see Schwartz, *Spectacular Realities*, 98–102.

29. *Katalog over Skandinavisk Panoptikon* (Copenhagen, 1885), 4.

30. Herman Bang, "Forlystelser og Forlystelsessteder," in *Københavnske Skildringer: "Vekslende Themaer" 1879–1883*, ed. Cai M. Woel (Copenhagen: Gyldendal, 1954). Bang (1857–1912) was one of Denmark's most prominent novelists of the 1880s and 1890s. His relationship to the modern urbanization of Copenhagen was mixed. On the one hand, his journalistic affection for the city is evident in a wonderful collection of essays from the early 1880s, which, in addition to this piece on the coming of the panoptikon, includes descriptions of the city morgue and a fashion show as stops on the urban tour. On the other hand, his most famous city novel, *Stuk* (Stucco, 1887), is a scathing indictment of Copenhagen's construction boom of the early 1880s, the very one that led to the development of the Vesterbro area and the panoptikon. For Bang, the reigning metaphor for the new development was the idea of the stuccoed false facade.

31. The attendance for the first three years was 500,000, according to Olsen's printed program guide from 1888. Copenhagen, the largest of the Scandinavian capitals, had a total population of 235,000 in 1880. Compared with London (4,770,000), Paris (2,269,000), and Berlin (1,122,00) the same year, Copenhagen was clearly still more of a regional capital than a "metropolis" at the time of the panoptikon's opening, and Stockholm even more so (1880 population, 169,000). Christiania in Norway was smaller still (119,000). See B. R. Mitchell, *International Historical Statistics: Europe 1750–1988*, 3d ed. (New York: Stockton Press, 1992), 72–75.

32. *Svenska Panoptikons Katalog* (Stockholm, 1890), 2.

33. "Svenska Panoptikon," *Svenska Familj-Journalen Svea*, 3 August 1889, 242.

34. "Svenska Panoptikon," *Dagens Nyheter*, 1 August 1889, 2.

35. "Svenska Panoptikon," *Svenska Familj-Journalen Svea*, 3 August 1889, 242.

36. *Svenska Panoptikons Katalog* (Stockholm, 1890), 1.

37. Claës Lundin (1825–1908), best known in literary circles for his collaboration with August Strindberg on *Gamla Stockholm: Anteckningar ur tryckta och otryckta källor, framletade, samlade och utgifna af Claës Lundin och August Strindberg* (Stockholm, [1882]).

38. Claës Lundin, "Vägen till odödlighet," in *Stockholmstyper förr och nu* (Stockholm: Fr. Skoglunds Förlag, 1889), 294.

39. Ibid., 296–97.

40. Zakarias Nielsen, "Kjøbenhavns Panoptikon," *Husvennnen* 13 (1885–86): 262.

41. Bernhard Olsen, "Notitser om den ceroplastiske Kunst og Vokskabinetterne" (Copenhagen, n.d.), 7.

42. Allan Pred also calculates food costs as a percentage of daily wages, which averaged between 2 and 5 kronor a day in 1890. See *Lost Words and Lost Worlds: Modernity and the Language of Everyday Life in Late Nineteenth-Century Stockholm* (Cambridge: Cambridge University Press, 1990), 54. In Copenhagen, working-class wages for tradesmen and unskilled workers ranged from 50 to 100 kroner a month in 1893. A servant girl got around 15 kroner a month plus lodging. See Jens Engberg, "Stilstand og vækst:" København 1807–1914," in *Københavnernes historie: Fra Absalon til Weidekamp*, ed. Helge Paludan et al. (Copenhagen: Hans Reitzels Forlag, 1987), 131. According to advertisements in a Swedish Panoptikon catalogue, the admission price for Stockholm's aquarium was 50 ore (half a krone); for the zoo 1 krone, like the Panoptikon. The majority of attractions in this class cost less than a krone, however. See *Vägvisare genom Svenska Panoptikon* (Stockholm, 1894).

43. Jens Engberg calculates the class identity of the total Copenhagen population by extrapolating from general divisions in employment recorded in the 1890 census. He estimates the upper-class percentages of the total Copenhagen population in 1890 to be 15,000 (4 percent), the middle class to be 78,000 (21 percent), the lower class to be 259,000 (71 percent), and the *pjalteproletariat* to be 15,000 (4 percent). See "Stilstand og vækst," 132.

44. The catalogues for the Skandinavisk Panoptikon bragged regularly about the cumulative number of visitors to the museum. Although this does give some indication of the Danish panoptikon's popularity, the attendance still pales in comparison to the attendance at the Musée Grévin, which pulled in five hundred thousand visitors a year in Paris, compared with the three million visitors at Skandinavisk Panoptikon over its entire life span (1885–1924). In the first six months of its existence, the Musée Grévin had four hundred thousand visitors; the Skandinavisk Panoptikon took three years to reach a total of five hundred thousand. Still, given the disparity in native population and tourism levels in the two cities, the Copenhagen wax museum did remarkably well during the time of its operation. See Vanessa Schwartz, "The Morgue and the Musée Grévin: Understanding the Public Taste for Reality in Fin-de-Siècle Paris," *Yale Journal of Criticism* 7.2 (1994): 151, 161; and the Skandinavisk Panoptikon catalogue *En af Kjøbenhavns største Seværdigheder er Skandinavisk Panoptikon* (Copenhagen, 1888), [2].

45. There was a similar disparity between the Musée Grévin's target and actual audiences in Paris, as Schwartz discusses in *Spectacular Realities*, 106, but without quite so pressing a need to enlist the support of the lower classes there because of a larger middle-class base.

46. *Svenska Panoptikons Katalog* (Stockholm, 1890), 3.

47. Ibid., 2, 19.

48. "Svenska Panoptikon," *Svenska Familj-Journalen Svea*, 3 August 1889, 243.

49. One of these, the "Interrupted Idyll" display (see fig. 4.17), started out upstairs in 1898 until complaints from the public "censored" the display by having it moved downstairs with the criminals.

50. Gunnar Broberg, "Entrébiljett till en skandal," *Tvärsnitt* 1–2 (1991): 121.

51. *Svenska Panoptikons Katalog* (Stockholm, 1890), 1.

52. Schwartz, *Spectacular Realities*, 71–76.

53. Ibid., 66.

54. See Björn Hodell, "Gamla svenska panoptikon," *Såningsmannen* 5 (1957): 6, 366; "Söndag på Panoptikon," *Dagens Nyheter*, 9 July 1939, 45.

55. Gunnar Sandfeld's history of early cinema exhibition in Denmark includes several references to the Skandinavisk Panoptikon, mentioning an operating loss of 11,000 kroner in 1898 and further economic problems in 1906–7. See *Den Stumme Scene: Dansk Biografteater indtil Lydfilmens Gennembrud* (Copenhagen: Nyt Nordisk Forlag, 1966), 12, 42–45. See also Schwartz, *Spectacular Realities*, 193–99, on the fate of the moving image at the Musée Grévin.

56. There are conflicting claims from Swedish historians about the actual closing date of the Swedish Panoptikon. Broberg claims an eighteen-month lag time between a closing in September of 1922 and the inventory auction on 18 March 1924. Hans Lepp offers an equally precise closing date of 9 March 1924, only nine days before the auction. The latest surviving catalogue is from 1922, but since the catalogue collection is missing other years as well, nothing can be concluded about the closing from that evidence. See Broberg, "Entrébiljett till en skandal," 122; Lepp, "Svenska Panoptikon," *St. Eriks Årsbok* (1978): 180.

57. The original article from 27 May 1924 is reproduced in the retrospective newspaper article "To landes panoptikoner genopstaar i Aalborg," *Berlingske Tidende*, 5 June 1960, 17. Schwartz charts a similar course for the Musée Grévin, which also moved from including moving pictures as an extra attraction in the wax museum to regarding cinema as a threatening competitor in the larger "actuality" business. The Parisian wax museum survived the challenge; lacking the large Parisian population base, the two Scandinavian panoptika did not. See Vanessa Schwartz, "Le Musée Grévin," *1895* 11 (December 1991): 46–48.

58. Oettermann, "Alles-Schau," 53–54.

59. Tom Gunning's "cinema of attractions" model is the obvious point of departure here, with its helpful emphasis on the layered, mixed mode of most narrative cinema. See "The Cinema of Attractions: Early Film, Its Spectator and the Avant-Garde," in *Early Cinema: Space Frame Narrative*, ed. Thomas Elsaesser (London: British Film Institute, 1990), 60. The historical trajectory of the wax museum presented in this chapter simply helps to emphasize the corporeal implications of the "attractions" model (its reliance on the logic of the body in pieces).

CHAPTER THREE

THE WAX EFFIGY AS RECORDING TECHNOLOGY

1. Edward H. Johnson, "A Wonderful Invention—Speech Capable of Indefinite Repetition from Automatic Records," *Scientific American*, n.s., 37.20 (17 November 1877): 304.

2. "Voices of the Dead," *Phonoscope* 1.1 (15 November 1896): 5.

3. "Panoptikon," *Illustreret Tidende*, 2 August 1885, 550.

4. Jules Lemaître and Jules Claretie, both quoted in Schwartz, *Spectacular Realities*, 89, 110.

5. The cost of renting a phonograph was twenty kroner, quite a bit steeper than the admission price to the panoptikon (one krone), suggesting that its availability

on site at the wax museum gave new, broader access to recording technologies. Rasmussen, *Bernhard Olsen*, 86–87.

6. *Katalog over Skandinavisk Panoptikon* (Copenhagen, [1906]), n.p. Vilhelm Pacht's Panorama offered the same—"Edison's phonographs" and American gramophones "which play so loudly that over 100 people at a time can hear them," as well as "Bosco" automatic photographs delivered to the customer in three minutes (all this in addition to the early "kinoptikon" motion pictures shown there). See *Katalog over Københavns Panorama og Kinoptikon* (Copenhagen, 1898), 9.

7. *Vägvisare genom Svenska Panoptikon* (Stockholm, 1897), 44.

8. *Katalog over Skandinavisk Panoptikon* (Copenhagen, 1885), 3.

9. *Svenska Panoptikons Katalog* (Stockholm, 1890), 2.

10. "Panoptikon," *Illustreret Tidende*, 2 August 1885, 549.

11. For a thorough treatment of the idea of modern corporeal preservation, see Christine Quigley, *Modern Mummies: The Preservation of the Human Body in the Twentieth Century* (Jefferson, N.C.: McFarland and Company, 1998).

12. The most thorough historical study of the wax effigy and its uses in funeral rites and ceremonial displays (including mock executions) is Brückner, *Bildnis und Brauch*. Warner touches on similar aspects of embalming in wax display practice in "Waxworks and Wonderlands."

13. Modern embalming practices, in fact, owe their start to the need for a very practical combination of preservation and portability, namely, the transportation of Civil War dead from Southern battlefields back to the North. See Gary Laderman, *The Sacred Remains: American Attitudes toward Death, 1799–1883* (New Haven, Conn.: Yale University Press, 1996), 103–16.

14. Many articles in the illustrated press circulated freely in translation from country to country; judging from the authors' names, many of the articles in the Scandinavian weeklies, like this one, came from England.

15. "Forvandling af Lig til Marmor," *Ny Illustreret Tidende*, 14 December 1889, 499.

16. Quoted in Sandfeld, *Den Stumme Scene*, 160.

17. Schwartz, "The Morgue and the Musée Grévin," 158–59.

18. Panoptikon pamphlet: *La Morgue* (Copenhagen, [1902]).

19. Particularly informative is a book by the head embalmer's son, Ilya Zbarsky, and Samuel Hutchinson, *Lenin's Embalmers*, trans. Barbara Bray (London: Harvill Press, 1998), and sections in Quigley, *Modern Mummies*, that deal with the display of political corpses lying in state.

20. Warner, "Waxworks and Wonderlands," 187.

21. *Hartkopfs Musæum* (Copenhagen, [1902]).

22. Thomas N. Haviland and Lawrence Charles Parish, "A Brief Account of the Use of Wax Models in the Study of Medicine," *Journal of the History of Medicine and Allied Sciences* 25.1 (January 1970): 61.

23. Lundin, "Vägen till odödlighet," 298.

24. *Katalog over Skandinavisk Panoptikon* (Copenhagen, [1890]), n.p.

25. For more on religion and early film, see Roland Cosandey, André Gaudreault, and Tom Gunning, eds., *An Invention of the Devil? Religion and Early Cinema* (Sainte-Foy, Québec : Presses de l'Université Laval, 1992).

26. Ad in *Christiania Nyheds- og Avertissements-Blad*, 21 November, 1889, 1.

27. Altick, *Shows of London*, 333.

28. *Vägvisare genom Svenska Panoptikon* (Stockholm, 1894), 35, 37.

29. *Svenska Panoptikons Katalog* (Stockholm, 1890), 20. Tjerneld documents the date the display opened as 10 June 1890 in *Stockholmsliv: Hur vi bott, arbetat och roat oss under 100 år*, vol. 1 (Stockholm: Norstedt & Söner, 1949), 160.

30. *Katalog over Skandinavisk Panoptikon* (Copenhagen, 1885), 2.

31. A useful and interesting essay on the general historical development of death-mask modeling has been written by Susanne Regener, translated into Danish as "Synliggørelsen af væsenet: Dødsmasker fra henrettede," in *Masken som repræsentation*, ed. Jørgen Østergård Andersen and Charlotte Engberg (Aarhus, Denmark: Aarhus Universitets Forlag, 1994), 39–51.

32. Bernhard Olsen's history of wax modeling, "Notitser om den ceroplastiske Kunst og Vokskabinetterne," 4–5, provides evidence of the practice from traditional sittings in royal courts as far back as the late seventeenth century.

33. Brückner, *Bildnis und Brauch*, 175.

34. Chapman points out that the fall in fixed income for executioners made it financially advantageous for them to provide Curtius with regular access to the heads of execution victims, even before the Revolution. *Madame Tussaud's Chamber of Horrors*, 4–20.

35. Ibid., xiv–xv.

36. Warner, "Waxworks and Wonderlands," 185. This account is singular in the technique described, with the wax impression here presumably serving as the initial mold for a positive clay squeeze, from which could be made another negative mold, into which would be poured the hot wax. The necessary generations of positive and negative take us already far afield from "touching" the corpse directly.

37. It should be noted that my perspective emphasizes follows the "mimetic" strand of the nineteenth-century wax-museum discourse. From this point of view, the connection to the original body was of highest value, and its increasing distance from the wax effigy troubling. A competing, less dominant discursive strand proceeds from the opposite assumption that artistic intervention, not technical mimesis, makes an effigy successful. From this point of view, it was not the accurate duplication of features but the artistic flair and intervention that gave the effigies "character" and distinguished the good figures from the mediocre.

38. Chapman, *Madame Tussaud's Chamber of Horrors*, 33.

39. Altick, *Shows of London*, 333.

40. Quoted in Chapman, *Madame Tussaud's Chamber of Horrors*, 45.

41. Quoted in ibid., 46.

42. Ibid., 143.

43. A possible exception to this was a display at the Copenhagen panoptikon in 1885, which depicted the death of the Swedish king Carl XII. The catalogue from that year relates that the modeling was done "from the plaster mask taken after his death and which is now found in Stockholm," but it is unclear whether the mask served as a mold or a simple likeness for the sculptor. It is clear at any rate from the introduction to the same catalogue that the usual process at the Danish wax museum involved starting with a plaster bust modeled in traditional fashion.

44. The current Hamburg Panoptikum contains a few displays preserved through the destruction of the collection in the World War II bombings, anatomical displays that were direct castings of diseased body parts. The guidebook emphasizes the unusual value of these indexical castings saved from the bombings, since such castings are no longer made: "Diese medizinischen Wachsmodelle, auch Moulagen genannt, sind heute nicht mehr herzustellen, da es keine Moulageure mehr gibt, die Direktabdrücke an Patienten machen und selbst modellieren können." *Panoptikum: Das Wachsfigurenkabinett*, [22], program guide to the current Hamburg wax museum. My thanks to Eric Ames for source material.

45. Nielsen, "Kjøbenhavns Panoptikon," 262. At this point in time, the phrase "modeled from Nature" would mean that it was done in a live sitting.

46. Neil Harris, *Humbug: The Art of P. T. Barnum* (Boston: Little, Brown, 1973), 61–89.

47. Warner pursues this argument in "Waxworks and Wonderlands," providing the best theoretical exploration of this sustained reworking of revolutionary trauma at Madame Tussaud's.

48. Based on a visit by the author to Louis Tussaud's wax museum at Copenhagen's Tivoli, June 1998.

49. *Katalog over Skandinavisk Panoptikon* (Copenhagen, [1890]), n.p.

50. Quoted. in Rasmussen, *Bernhard Olsen*, 86. It remains unclear from this whether Olsen was looking to buy original death masks or simply to have copies made.

51. *Svenska Panoptikons Katalog* (Stockholm, 1890), 15.

52. John Theodore Tussaud, *The Romance of Madame Tussaud's* (New York: George H. Doran, 1920), 31.

53. *Katalog over Skandinavisk Panoptikon* (Copenhagen, 1897), 8.

54. The Tussaud catalogue from 1873 includes sworn testimony of the artist, the painting's purchaser, and Napoleon's surgeon for one full-length portrait of the emperor, all attesting to the quality of the likeness and the authenticity of the portrait. See *Madame Tussaud and Son's Exhibition Catalogue*, 35. This obsession with certification extended to the Tussauds' collection of relics as well, which were likewise accompanied by sworn statements.

55. Altick, *Shows of London*, 334.

56. *Katalog over Skandinavisk Panoptikon* (Copenhagen, 1885), 3.

57. Tussaud, *Romance of Madame Tussaud's*, 157–58.

58. Ibid., 157.

59. The book was Tjerneld's *Stockholmsliv*, published in 1949.

60. André de Toth, dir., *House of Wax*, videocassette, dist. Warner Home Video, 1991.

61. König and Ortenau, *Panoptikum*, 47.

62. *Katalog over Skandinavisk Panoptikon* (Copenhagen, 1885), 2.

63. Ibid. Oettermann reports a similar effort to use the same tailors as had the person on display when authentic clothing could not be found. "Alles-Schau," 42.

64. Quoted in Rasmussen, *Bernhard Olsen*, 86.

65. *Svenska Panoptikons Filial* (Malmö, 1896), 6. This display turns out to have jumped the gun, making a faulty forecast of the departure, since, as will be discussed later, the trip was actually postponed until the following year.

66. *Katalog öfver H. Düringers Museum* (Gefle, 1894), 14.
67. *Vägvisare genom Svenska Panoptikon* (Stockholm, 1894), 24.
68. *Illustreret Katalog. Panoptikon* (Copenhagen, [1923]), 21.
69. "Söndag på Panoptikon," *Dagens Nyheter*, 9 July 1939, 45.
70. Ibid., 46.
71. Ibid., 45–46. The average price of an effigy at the auction was quite low, bottoming out at 1 krona in some cases—no more than the former admission price—and with most effigy prices staying below 10 kronor. The total intake from the auction was 4,494.90 kronor.
72. This line of thinking reaches an absurd conclusion in Orange County's Movieland Wax Museum, which in 1997 featured a display taken from the film *The Invisible Man*. The display, of course, has only the clothes wrapping the invisible figure from the movie, showing that the impression of corporeal substance can make an actual wax effigy superfluous, even in a museum supposedly devoted to waxen bodies.
73. Swedish author Per Olof Sundman's historical novel based on Andrée's voyage includes several references to the panoptikon's display of Andrée, including one in which the narrator muses about the prospects of achieving a similar waxen celebrity status and immortality for himself. The book has been translated by Mary Sandbach as *The Flight of the Eagle* (New York: Pantheon, 1970).
74. See note 65.
75. Altick, *Shows of London*, 335.
76. Oettermann, "Alles-Schau," 43.
77. *Katalog. Skandinavisk Panoptikon.* (Copenhagen, [1903]), n.p.
78. Chapman, *Madame Tussaud's Chamber of Horrors*, 106.
79. *Vägvisare genom Svenska Panoptikon* (Stockholm, 1894), 35; *Katalog öfver P. Haggrens Panoptikon* (Wimmerby, Sweden, 1894), 6.
80. See Chapman, *Madame Tussaud's Chamber of Horrors*, 193–94. The damage to Madame Tussaud's museum during the Blitz of World War II was more irreversible, since over 350 original molds were destroyed in the bombing (215).
81. Tom Gunning, " 'Animated Pictures,' Tales of Cinema's Forgotten Future," *Michigan Quarterly Review* 34.4 (fall 1995): 481.
82. *Svenska Panoptikons Filial*, 6.

CHAPTER FOUR
FIGURE AND TABLEAU

1. *Svenska Panoptikons Katalog* (Stockholm, 1890), 1–2.
2. Gunning, "Cinema of Attractions," 57.
3. *Catalog over Møllers Musæum* (Copenhagen, 1867), 9.
4. *Katalog over J. Eppmanns Verdens-Udstilling* (Copenhagen, 1877), 2. Interestingly, this particular traveling show was temporarily located at the eventual address of the Scandinavian Panoptikon before the new building was constructed. Its curiosity-cabinet format provides a most instructive contrast to the respectable panoptikon that would take up residence there eight years later.
5. Altick, *Shows of London*, 52.

6. Gunning, "Cinema of Attractions," 60.

7. For a discussion of tableaux in the melodramatic stage tradition, see Peter Brooks, *The Melodramatic Imagination: Balzac, Henry James, Melodrama, and the Mode of Excess* (New York: Columbia University Press, 1985). A more recent, superbly detailed study of the pictorial tradition in early film is Ben Brewster and Lea Jacobs, *Theatre to Cinema: Stage Pictorialism and the Early Feature Film* (Oxford: Oxford University Press, 1997).

8. Lepp, "Svenska Panoptikon," 176.

9. *Svenska Panoptikons Vägvisare* (Stockholm, 1907), 41.

10. Schwartz, *Spectacular Realities*, 146–47.

11. *Katalog over Skandinavisk Panoptikon* (Copenhagen, 1897), 1–7.

12. The only such tableau series to appear in Stockholm, "Brott och Straff" (Crime and Punishment), seems to have been a direct copy of the Musée Grévin series.

13. The four series in 1903 were Napoleon, Pizzaro, Hogarth, and "From Fall to Salvation." It should be remembered that most of the remaining tableaux at the museum, in addition to the twenty-three total panels in these four series, were still mostly "contextualized" displays—they just were not linked together consecutively. *Katalog. Skandinavisk Panoptikon* (Copenhagen, [1903]).

14. Ibid., [24].

15. *Katalog over Skandinavisk Panoptikon* (Copenhagen, 1897), 23.

16. *Vägvisare genom Svenska Panoptikon* (Stockholm, 1897), 16.

17. *Svenska Panoptikons Katalog* (Stockholm, 1890), 17.

18. One catalogue for a mechanical wax museum mentioned, "All figures make movements, which will be explained orally during the presentation." *Konst- och Vaxfigur-Kabinett, med figurer i menniskostorlek* (Carlshamn, Sweden, 1882). Although oral presentation at a traveling show of that sort seems more typical of itinerant exhibition practices more generally, there is also evidence that even the established panoptika retained vestiges of the guided tour format. Another writer recalls this from his childhood visit to the panoptikon: "With whispering voice but clear diction the accompanying tour guide or the oldest in the group read from the dearly purchased catalogue." See "Söndag på Panoptikon," *Dagens Nyheter*, 9 July 1939, 43. Several other passing comments in the archival material about orally guided narration make clear that even though some visitors might walk around with noses buried in the catalogue, there were also examples of live guides providing narrative information.

19. Chapman, *Madame Tussaud's Chamber of Horrors*, 96.

20. Ibid., 105.

21. *Katalog over Skandinavisk Panoptikon* (Copenhagen, [1906]).

22. Carl Muusmann, *Firsernes Glade København: Erindringer og Oplevelser*, ed. Bo Bramsen (Copenhagen: Politikens Forlag, 1974 [1920]), 106.

23. "Söndag på Panoptikon," *Dagens Nyheter*, 9 July 1939, 44.

24. "Förstudier i 'Svenska Panoptikon,' " *Ny Illustrerad Tidning*, 15 December 1888, 430.

25. *Katalog over Skandinavisk Panoptikon* (Copenhagen, 1885), 3.

26. Ibid., 3–4.

27. "Förstudier i 'Svenska Panoptikon,'" *Ny Illustrerad Tidning*, 15 December 1888, 430.

28. Ibid.

29. Freddie Rokem, *Theatrical Space in Ibsen, Chekhov and Strindberg: Public Forms of Privacy*, Theater and Dramatic Studies 32 (Ann Arbor, Mich.: UMI Research Press, 1986), 11–12.

30. A scene depicting Carl Michael Bellman is one such example, in *Vägvisare genom Svenska Panoptikon* (Stockholm, 1897), 15.

31. *Svenska Panoptikons Katalog* (Stockholm, 1890), 14. The renowned polar expedition by the *Vega* had taken place in 1878–80.

32. *Illustreret Katalog. Panoptikon* (Copenhagen, [1918]), 10.

33. Michael Fried, *Absorption and Theatricality: Painting and Beholder in the Age of Diderot* (Chicago: University of Chicago Press, 1980), especially chap. 1, "The Primacy of Absorption," 7–70.

34. "Panoptikon," *Illustreret Tidende*, 2 August 1885, 549.

35. Nielsen, "Kjøbenhavns Panoptikon," *Husvennnen* 13 (1885–86): 262.

36. Ibid.

37. *Illustreret Katalog. Panoptikon* (Copenhagen, [1923]).

38. *Vägvisare genom Svenska Panoptikon* (Stockholm, 1897), 32.

39. *Vägvisare genom Svenska Panoptikon* (Stockholm, 1912), 23.

40. Jay Caplan, *Framed Narratives: Diderot's Genealogy of the Beholder*, Theory and History of Literature 19 (Minneapolis: University of Minnesota Press, 1985), 23, 18.

41. There are tempting parallels between the gender economy of the panoptikon's tableau technique and the classical Hollywood narrative in this regard, since more often than not the sacrificial victim carrying the burden of lack in the wax tableau is female, and the mannequins benefiting from the resulting presence-by-default are in many cases male. Kaja Silverman makes that argument about the gender economy of cinematic sound in *The Acoustic Mirror: The Female Voice in Psychoanalysis and Cinema* (Bloomington: Indiana University Press, 1988). The observation resonates at an even more general level in Western tradition, according to the argument in Elisabeth Bronfen's *Over Her Dead Body: Death, Femininity and the Aesthetic* (New York: Routledge, 1992). The wax museum's choices of Sleeping Beauty, Snow White, a female corpse in the "Crime and Punishment" series, a female sleepwalker, and a female fainting victim all seem highly suggestive of this tendency, although there are enough counterexamples of dead males at the Scandinavian panoptika—Romeo, Wilhelm, Fredrik, the stabbed farmhand at the rural wedding, and the assassinated President Carnot—to complicate a straightforward application of this thesis.

42. *Vägvisare genom Svenska Panoptikon* (Stockholm, 1897), 9. The mural itself turns out to be a sort of visual joke, however. The word *fabriksmärke* (trademark) appears at lower left, and various soaps and perfume bottles float up and around the central female figure, who is draped in classical dress. According to a later journalist's account ("Söndag på Panoptikon," 44), the "elegant mural" was actually a poster donated by a factory to advertise its toiletry products.

43. *Vägvisare genom Svenska Panoptikon* (Stockholm, 1894), 33.

44. Lundin, "Vägen till odödlighet," 299.

45. For a summary of the relatively sketchy Norse source material on Balder's Garden, see John Lindow, *Murder and Vengeance among the Gods: Baldr in Scandinavian Mythology,* FF Communications 263 (Helsinki: Academia Scientiarum Fennica, 1997), 132–33.

46. *Vägvisare genom Svenska Panoptikon* (Stockholm, 1894), 24.

47. Ibid., 20.

48. "Söndag på Panoptikon," *Dagens Nyheter,* 9 July 1939, 44.

49. Lindorm, *Oskar II och hans tid,* 55.

50. This effect was intensified by its display space at the National Museum in Stockholm during my visit there a decade ago, where it was given an imposing position at the top of a stairwell along an atrium balcony.

51. *Katalog over Skandinavisk Panoptikon* (Copenhagen, [1899]), 15.

52. *Katalog over Skandinavisk Panoptikon* (Copenhagen, 1897), 18–19.

53. *Vägvisare genom Svenska Panoptikon* (Stockholm, 1894), 9.

54. *Katalog over Skandinavisk Panoptikon* (Copenhagen, [1903]); "Svenska Panoptikon," *Dagens Nyheter,* 1 August 1889, 2; "Panoptikon," 548.

55. Nielsen, "Kjøbenhavns Panoptikon," *Husvennnen* 13 (1885–86): 262.

56. Ibid., 263.

57. "Bland Panoptikons vaxgubbar," *Aftonbladet,* 3 August 1889, 3.

58. "Söndag på Panoptikon," *Dagens Nyheter,* 9 July 1939, 44–45.

59. Lundin, "Vägen till odödlighet," 299–300.

60. Miriam Hansen, *Babel and Babylon: Spectatorship in American Silent Film* (Cambridge, Mass.: Harvard University Press, 1991), 25.

61. Lynne Kirby, *Parallel Tracks: Railroad and the Silent Cinema* (Durham, N.C.: Duke University Press, 1997), 63–68.

62. Nielsen, "Kjøbenhavns Panoptikon," *Husvennnen* 13 (1885–86): 262–63. His use of the word "cabinet" instead of "panoptikon" or "museum" is one of the few instances where the older terminology for wax display shows up in the Scandinavian wax-museum discourse of the 1880s.

63. Clipping and still photo files for *Christian Schrøder i Panoptikon* are available at the Danish Film Museum archive in Copenhagen. Marguerite Engberg's index of Danish silent films includes sales information as well (it sold sixty-eight copies internationally), indicating that it was a relatively successful little film, the third most popular Nordisk comedy of 1910. The most-sold comedy of the year, interestingly, was another self-reflexive film, *Jens ser Levende Billeder* (Jens Sees Moving Pictures). See Engberg, *Dansk Stumfilm,* 2 vols. (Copenhagen: Rhodos, 1977), 395–97.

64. *Chr. Schrøder i Panoptikon* plot description, Danish Film Museum, Copenhagen.

65. Close examination of these surviving still photos also requires that we once again engage with the ontology of the photograph, since the "mannequins" depicted in the film are all actually live actors doing living-statue routines to simulate the various wax-museum tableaux.

66. Carol Clover, *Men, Women and Chainsaws: Gender in the Modern Horror Film* (Princeton, N.J.: Princeton University Press, 1992), 231–36.

67. Film review quoted on video jacket cover of *Waxwork* (Vestron Pictures, 1988) and attributed to Tim Timpone, editor of *Fangoria.*

68. The original argument along these lines, of course, was made by Laura Mulvey in "Visual Pleasure and Narrative Cinema," *Screen* 16.3 (autumn 1977): 6–18.

69. Christian Metz, *The Imaginary Signifier: Psychoanalysis and the Cinema*, trans. Celia Britton et al. (Bloomington: Indiana University Press, 1982), 63–66.

CHAPTER FIVE
PANOPTIKON, METROPOLIS, AND THE URBAN UNCANNY

1. Jonathan Crary, *Suspensions of Perception: Attention, Spectacle, and Modern Culture* (Cambridge, Mass.: MIT Press, 1999), 51.

2. Nielsen, "Kjøbenhavns Panoptikon," *Husvennnen* 13 (1885–86): 263.

3. Friedberg, *Window Shopping*, 37–38.

4. The term is especially appropriate for the Scandinavian situation, I believe, because the rhetoric of urbanization there so often demanded a progressive logic that could only see persistent coexistence with the substantial traditional or rural social structures as *vestigial*, an encounter with that which "ought to have remained . . . secret and hidden but has come to light," as Freud quotes in his famous essay on the uncanny ("The Uncanny," in *The Standard Edition of the Complete Psychological Works of Sigmund Freud*, ed. and trans. James Strachey [London: Hogarth Press, 1953], 7: 224). For a persuasive extension of Freud's idea of psychic estrangement to the sociohistorical stakes of modernity and urbanization, see Vidler, *The Architectural Uncanny*, 3–14.

5. For consistency's sake, the city population figures in the following discussion are all taken from Mitchell, *International Historical Statistics*, 72–75.

6. Martin Zerlang writes, "Copenhagen was a very cramped city. In 1850, 133,600 inhabitants lived within the walls in an area covering only 274 hectares. Thus, the density of the population was higher than in contemporary Paris or London." See "Orientalism and Modernity," *Nineteenth-Century Contexts* 20 (1997): 107. The original version of the article in Danish is slightly longer: "Bagdad i København: Om modernisering i orientalske gevandter," *Kultur og Klasse* 24.2 (1996): 155–85.

7. The idea of Copenhagen as cultural center of the North was bolstered by the Scandinavianism movement throughout the 1850s, which fostered the idea of cultural and even political solidarity between Norway, Sweden, and Denmark. The abandonment of the Danes by Norway and Sweden in the Dano-Prussian War in 1864 essentially brought such illusions to an end. For a summary of Scandinavianism's three main phases in the nineteenth century, see Bo Grandien, "Tiden före 1891: Grogrunden," in *Skansen under hundra år*, ed. Arne Biörnstad (Höganäs, Sweden: Wiken, 1991), 18–21.

8. Zerlang, "Bagdad i København."

9. A Danish king had ruled over Norway for nearly five centuries until 1814, when as a result of the defeat of Napoleon and the treaty of Kiel, Norway was ceded over to Sweden in what proved to be an increasingly uncomfortable political union. Norway was allowed to form its own parliament but was ruled over by the Swedish king until full independence was achieved in 1905.

10. The emigration totals from the three Scandinavian countries between 1850 and 1900, according to Mitchell (*International Historical Statistics*, 124), are as follows: Sweden, 774,000; Norway, 501,000; and Denmark, 180,000.

11. For a summary of Hausmann's project and its effects, see Berman, *All That Is Solid*, 148–55.

12. Caspar Jørgensen, *Vestervold falder*, vol. 9 of *København før og nu—og aldri: En billedkavalkade om København indenfor voldene og søerne*, ed. Bo Bramsen (Copenhagen: Palle Fogtdal, 1987), 100, 102.

13. The architect of the plan was Albert Lindhagen, who had made a detailed study of Hausmann's Parisian renewal project. Although the Swedish solution was not as drastic as Hausmann's razing of entire neighborhoods, it was motivated by similar concerns of cleanliness, order, and police accessibility. The entire 1867 urban renewal plan is reproduced in Gösta Selling, *Esplanadesystemet och Albert Lindhagen: Stadsplanering i Stockholm åren 1857–1887* (Stockholm: Stockholms-kommunalförvaltning, 1970). For an ideological critique of the *gaturegulering* program, see Allan Pred, "Languages of Everyday Practice and Resistance: Stockholm at the End of the Nineteenth Century," in *Reworking Modernity: Capitalisms and Symbolic Discontent*, ed. Allan Pred and Michael John Watts (New Brunswick, N.J.: Rutgers University Press, 1992), 118–54.

14. Muusmann, *Firsernes Glade København*, 268.

15. In reality, the international exhibitions were coming fast and furious in the smaller European cities in the 1880s and 1890s, which likely lessened the international impact of the Danish exposition.

16. Nielsen, "Kjøbenhavns Panoptikon," *Husvennnen* 13 (1885–86): 261.

17. "Panoptikon," *Illustreret Tidende*, 2 August 1885, 548.

18. Muusmann, *Firsernes Glade København*, 106.

19. In 1880, at the beginning of the decade of the Scandinavian panoptika's respective foundings, Copenhagen's population of 235,000, as well as Stockholm's 169,000 and Christiania's 119,000, was dwarfed by the populations of London (4,770,000), Paris (2,269,000), and Berlin (1,122,000) the same year. The other cities that opened new wax museums in the 1890s (with the exception of Vienna and St. Petersburg) were generally small regional cities ranging in population between 100,000 and 300,000.

20. Staffan Tjerneld uses the idea of a magnetic-geographic center point for cultural life and claims that in Stockholm it shifts from Norrbro and Gustav Adolfs Torg in the first half of the century northeastward to Kungsträdgården in the last half of the century. See *Stockholmsliv*, 1:115–22.

21. "Förstudier i 'Svenska Panoptikon,' " *Ny Illustrerad Tidning*, 15 December 1888, 430.

22. "Bland Panoptikons vaxgubbar," *Aftonbladet*, 3 August 1889, 3.

23. "Svenska Panoptikon," *Svenska Familj-Journalen Svea*, 3 August 1889, 242.

24. "Ett storstadsetablissement," *Svenska Familj-Journalen Svea*, 5 April 1890, 110.

25. This, of course, is exactly what Anne Friedberg is arguing in *Window Shopping*, so it is no surprise to find the discourse of the wax museum and cinema overlapping with that of the department store.

26. *Svenska Panoptikons Vägvisare, Utställningsåret 1897* (Stockholm, 1897).

27. *Skandinavisk Panoptikon* (Copenhagen, 1888).

28. *Katalog over Skandinavisk Panoptikon* (Copenhagen 1885), 4.

29. "Svenska Panoptikon," *Dagens Nyheter*, 1 August 1889, 3.

30. "Fra Panoptikons Tag," *Illustreret Tidende*, 10 May 1885, 408.

31. The title, "Från Mälardrottningens tron," refers to the large lake in central Sweden, Mälaren, that reaches to Stockholm, the "queen" of Mälar. In the story, the would-be journalist dreams of starting a newspaper with the same title as the story: *From the Throne of the Mälar Queen*. See *Stockholmstyper förr och nu* (Stockholm: Fr. Skoglunds Förlag, 1889), 99–134.

32. Carl Muusmann, *Halvfemsernes glade København: Erindringer og Oplevelser*, ed. Bo Bramsen (Copenhagen: Politikens Forlag, 1974 [1920]), 161.

33. Martin Zerlang, "The City Spectacular of the Nineteenth Century," Arbejdspapir 9 (Copenhagen: Center for Urbanitet og Æstetik, 1995), 19.

34. Zerlang, "Bagdad i København," 162.

35. Zerlang, "Orientalism and Modernity," 95.

36. Ibid., 101.

37. Claës Lundin, "Den sagolika Paschaen," in *Stockholmstyper förr och nu* (Stockholm: Fr. Skoglunds Förlag, 1889), 155.

38. Zerlang, "Orientalism and Modernity," 95.

39. *Orientaliska Irrgång-Salongen, Nya Panoptikon, Grott-Salongen, Eden-Salongen* (Stockholm, 1893), 15–18. This catalogue reproduces contemporary press commentary on these attractions.

40. *Söndags-Nisse*, 30 November 1890, in *Orientaliska Irrgång-Salongen*, 16–18; *Söndags-Nisse*, 19 January 1890, in *Orientaliska Irrgång-Salongen*, 12.

41. Nielsen, "Kjøbenhavns Panoptikon," *Husvennnen* 13 (1885–86): 263. Zakarias Nielsen was a Gruntvigian populist author of the 1880s and 1890s, so his elevated investment in rural and folk perspectives surely contributes to this search for grounding in urban experience.

42. "Svenska Panoptikon," *Aftonbladet*, 1 August 1889, 2.

43. "Bland Panoptikons vaxgubbar," *Aftonbladet*, 3 August 1889, 3.

44. Vidler, *The Architectural Uncanny*, 11.

45. Zerlang, "Bagdad i København," 182.

46. Hans Vilhelm Kaalund, "Da de rev Voldende ned," in *Samlede Digte* (Copenhagen: Gyldendal, 1898), 321.

47. Ibid., 322. The entire stanza translated literally reads: "So in the meantime we are driven by current and wind— / there's no danger in that! / When we give the whole world free access, / they will spare us. / It would be dishonorably done / to storm with weapons / a city that doesn't have ramparts or gates, / but which is completely open!"

48. The verse in question can be translated this way in its entirety: "Now they have decided, those wise men, / that you may not keep / the green belt that garlands your waist, / your old ramparts. / Now you are to be freed, my dear city, / from your tight armor; / Your city moats, mottled with duck food, / have offended our senses."

49. "To landes panoptikoner genopstaar i Aalborg," *Berlingske Tidende*, 5 June 1960, 17.

50. "Söndag på Panoptikon," *Dagens Nyheter*, 9 July 1939, 46.

51. Berman, *All That Is Solid*, 232. His take on the phenomenon of Russian modernity does not strictly apply to the Scandinavian capitals, which did not share with Russia the problems of a vast illiterate peasantry, but his distinction between modes of modernity developing "naturally" in Europe's population centers and those that developed in less obvious peripheral sites is a useful one.

52. Ibid., 37.

53. Walter Benjamin includes a catalogue excerpt from *Castans Irrgarten* that seems to refer to this maze in his *Das Passagen-Werk*, ed. Rolf Tiedemann (Frankfurt: Suhrkamp Verlag, 1982), 1:517. A Swedish reporter signed "X." mentions that the mirror maze in Berlin was much smaller and less luxurious than the new one in Stockholm; see "En modern labyrint," *Aftonbladet*, 2 January 1890, 2. Hermann Präuscher's Panoptikum in Wiener Prater is also reported in 1896 (and possibly earlier) to have featured an "Irrgarten" and "Kaleidoskop" very much like the Scandinavian ones. See Oettermann, "Alles-Schau," 49 n. 50. The Musée Grévin in Paris also added a mirror maze somewhat later in 1907 (my thanks to Vanessa Schwartz for this information).

54. This hall of mirrors is, incidentally, the one referred to by Karen Blixen (Isak Dinesen) at the very beginning of her gothic tale "The Roads round Pisa," in *Seven Gothic Tales* (New York: Random House, 1934), 165–66. When the hall of mirrors makes its literary appearance here, it is no longer amusing: "With a shudder of disgust he remembered how he had been taken, as a child, to see the mirror-room of the Panoptikon, in Copenhagen, where you see yourself reflected, to the right and the left, in the ceiling and even on the floor, in a hundred mirrors, each of which distorts and perverts your face and figure in a different way—shortening, lengthening, broadening, compressing their shape, and still keeping some sort of likeness—and thought how much this was like real life."

55. This newspaper review from Copenhagen's *Avisen* and many of the other Danish accounts that follow (all of them undated, unfortunately) are taken from the panoptikon's own printed collection of press reactions to the new hall of mirrors ("Pressens Udtalelser om Panoptikons Spejlgemakker"), which was included as a supplement to its 1890 catalogue.

56. "Skandinavisk Panoptikon," *Berlingske Tidende*, n.d., in *Katalog* [1890], n.p.

57. "Palmehuset i Skandinavisk Panoptikon," *Illustreret Tidende*, 16 November 1890, 75.

58. "Spejlgemakkerne i Skandinavisk Panoptikon," *Dagbladet*, n.d., in *Katalog* [1890], n.p.

59. "Forfængelighedens Marked," *Politiken*, n.d., in *Katalog* [1890], n.p.

60. "Spejlgemakkerne i Skandinavisk Panoptikon," *Dagbladet*, n.d. in *Katalog* [1890], n.p.

61. *Social-Demokraten*, n.d., in *Katalog* [1890], n.p.

62. "Den s.k. irrgångsalongen," *Stockholms Dagblad*, 13 December 1892, and "Orientaliska irrgångsalongen," *Stockholms Dagblad*, 2 January 1890, in *Orientaliska Irrgång-Salongen*, 23, 5.

63. Pred, "Languages," especially 135–48.

64. "Ändtligen i Orientaliska irrgångsalongen," *Figaro*, 11 January 1890, in *Orientaliska Irrgång-Salongen*, 11.

65. "Panoptikons Spejlkabinet," *Dagens Nyheder*, n.d., in *Katalog* [1890].

66. "Ändtligen i Orientaliska irrgångsalongen," *Figaro*, 11 January 1890, in *Orientaliska Irrgång-Salongen*, 11.

67. "Spejlgemakkerne i Skandinavisk Panoptikon," *Dagbladet*, n.d., in *Katalog* [1890].

68. *Aftenbladet*, n.d., in *Katalog* [1890].

69. "Ändtligen i Orientaliska irrgångsalongen," *Figaro*, 11 January 1890, in *Orientaliska Irrgång-Salongen*, 11–12.

70. *Social-Demokraten*, n.d., in *Katalog* [1890], n.p.

71. "Spejlgemakkerne i Skandinavisk Panoptikon," *Dagbladet*, in *Katalog* [1890], n.p.

72. "Skandinavisk Panoptikon," *Berlingske Tidende*, n.d., in *Katalog* [1890], n.p.

73. "Eden-salongen och Nya Panoptikon," *Dagens Nyheter*, 25 November 1890, in *Orientaliska Irrgång-Salongen*, 18.

74. *Aftenbladet*, n.d., in *Katalog* [1890].

75. *Söndags-Nisse*, 30 November 1890, in *Orientaliska Irrgång-Salongen*, 17.

76. "Forfængelighedens Marked," *Politiken*, n.d., in *Katalog* [1890], n.p.

77. *Söndags-Nisse*, 30 November 1890, in *Orientaliska Irrgång-Salongen*, 17.

78. Bernhard Olsen does in fact rehearse with his customary thoroughness a long and detailed history of mirror halls and their precedents in his introduction to the hall of mirrors in the 1890 printed program guide, "Spejlgemakkerne i Panoptikon." Beginning with Horace in classical times and continuing through the Middle Ages to the present, the history of mirrored rooms seems to have incorporated the idea of optical illusions.

79. "Ser jer i Spejl," *Morgenbladet*, n.d., in *Katalog* [1890].

CHAPTER SIX
VANISHING CULTURE

1. Alfred Bauer, "Dansk Folkemuseum," *Dagbladet*, 8 August 1885.

2. One thinks again of Herman Bang's "stucco" critique of Vesterbro's atmosphere of financial speculation in the 1880s, in which context the "solidity" of the folk museum's traditional, handcrafted objects might appear to be the antidote to the modern cultivation of appearances and fashion. See chapter 2, note 30.

3. An article that grapples with the various levels of continuity and their relationship to both narrative and questions of film genre is Tom Gunning, "Non-continuity, Continuity, Discontinuity: A Theory of Genres in Early Films," in *Early Cinema: Space Frame Narrative*, ed. Thomas Elsaesser (London: British Film Institute, 1990), 86–94.

4. For a thorough treatment of nineteenth-century world exhibitions as precursors of the 1897 Stockholm Exhibition, see Bjarne Stoklund, "International Exhibitions and the New Museum Concept in the Latter Half of the Nineteenth Century," trans. Alan Crozier, *Ethnologia Scandinavica* 23 (1993): 87–113; and

296　　　　　　　　　　　　　　　　　　　　　　　　NOTES TO CHAPTER SIX

Anders Ekström, *Den utställda världen: Stockholmsutställningen 1897 och 1800-talets världsutställningar*, Nordiska museets Handlingar 119 (Stockholm: Nordiska Museet, 1994), 18–61.

5. Stoklund, "International Exhibitions," 91.

6. Anders Sandvig, *I praksis og på samlerferd*, 2d ed. (Oslo: Johan Grundt Tanum, 1969), 135.

7. Eva Nordenson, "Förord," in *Skansen under hundra år*, ed. Arne Biörnstad (Höganäs, Sweden: Wiken, 1991), 7.

8. Ekström's masterful sociohistorical contextualization of the 1897 Stockholm Exhibition argues that the mythologizing cultural-historical aspects of the exhibition were intended to position the rhetoric of progress in an even more favorable comparative light. See especially pages 170–77 on Gamla Stan as the site for modern technology.

9. The following summary relies on founder Georg Karlin's own historical account of his museum, published in a 1918 guidebook. See *Kulturhistoriska Museet i Lund: En handbok för besök och självstudium* (Lund: Kulturhistoriska Förening för Södra Sverige, 1918), 5–12.

10. Like the word "Skansen," the name of Karlin's museum has become a place-name of sorts and is usually not translated in English, even though both names have literal meanings: "skansen" means "the redoubt" or "entrenchment," in reference to the strategic military position of the hill overlooking Stockholm harbor. "Kulturen i Lund" means simply "the culture in Lund." Most common now are the names Skansen and Kulturen, which will be retained (along with the Norwegian "Maihaugen") in their original languages in the English text of the following chapters.

11. Georg Karlin, "Museumssystem," *Kulturhistoriska Meddelanden* 3 (1894–1911): 4. Stoklund further points out that Karlin's term ("pavilion system") already shows his debt to the Parisian exhibition's earlier display system anyway. See Stoklund, "International Exhibitions." 107.

12. Tonte Hegard, *Romantikk og fortidsvern: Historien om de første friluftsmuseene i Norge* (Oslo: Universitetsforlaget, 1984), 32–88.

13. Ibid., 55.

14. Ibid., 79.

15. The definitive biography of this Norwegian museum founder is another, more recent book by Tonte Hegard, *Hans Aall—mannen, visjonen og verket* (Oslo: Norsk Folkemuseum, 1994).

16. Ibid., 45–46.

17. Tord Buggeland and Jakob Ågotnes have written a splendid history of Maihaugen, published for its centenary celebrations, entitled *Maihaugen: De Sandvigske Samlinger 100 år* ([Oslo]: J. W. Cappelens Forlag, 1987).

18. The best overview of the various Danish museums and their history can be found in Holger Rasmussen, *Dansk museums historie: De kultur-historiske Museer* (Hjørring, Denmark: Dansk Kulturhistorisk Museumsforening, 1979); Olsen's career is likewise given a substantial treatment by the same author in *Bernhard Olsen*.

19. Alhed Schou, "Sandvigs Samlinger," *Intelligenssedlerne*, 14–15 June 1901.

20. "Ramloftstuen paa Lillehammer," *Verdens Gang*, 26 July 1895.

21. An unusually rich record of visitor reactions to the new folk museums exists in the form of newspaper accounts, articles, and letters to the editor, many of them archived painstakingly by the public relations–savvy folk-museum founders themselves. Further citations of articles from these clipping collections will follow standard citation format for newspapers, except in cases where publication information is incomplete, in which case the archive location will be noted.

22. Jonas Frykman and Orvar Löfgren, *Culture Builders: A Historical Anthropology of Middle-Class Life*, trans. Alan Crozier (New Brunswick, N.J.: Rutgers University Press, 1987), 4.

23. J. A. Lundell, "Turisten och folklivet," in *Svenska Turistföreningens Årsskrift 1900*, ed. Mauritz Boheman (Stockholm: Wahlström & Widstrand, 1900), 9.

24. Stephen J. Walton, *Ivar Aasens kropp* (Oslo: Det Norske Samlaget, 1996), 250.

25. Nils-Arvid Bringéus, "Artur Hazelius och Nordiska Museet," *Fataburen: Nordiska Museets och Skansens Årsbok* (1972): 7.

26. The Norwegian Tourist Association (Den norske Turistforening), established in 1868, was the first Nordic organization for tourists (mainly hikers and mountain climbers); the Swedish equivalent (Svenska Turistförening) was founded in 1885, and the Danish (Den danske Turistforening) in 1888.

27. Frykman and Löfgren, *Culture Builders*, 24.

28. "Folkemuseet paa Bygdø," *Aftenposten*, 27 May 1902.

29. Frykman and Löfgren, *Culture Builders*, 59.

30. Quoted in Hans Aall, *Norsk Folkemuseum, 1894–1919: Trekk av dets historie* (Kristiania: Kirstes Boktrykkeri, 1920), 4.

31. Bernhard Lotmann, "Gammel Kultur," *Christiansand Tidende*, 16 March 1902.

32. Artur Hazelius, "Ur Nordiska museets historia," In *Meddelanden från Nordiska Museet 1898* (Stockholm: Norstedt & Söner, 1900), 271.

33. Gustaf Näsström is especially helpful in providing views from Dalarna itself that contradict Hazelius's romanticization of the traditional lifestyle, which of course also entailed physical hardship, disease, and discomfort. Far from panicking at the arrival of modernity, Näsström claims, most Dala-folk embraced the material improvements that new styles of architecture brought to daily life. See *Dalarna som svenskt ideal*, 2d ed. (Stockholm: Wahlström & Widstrand, 1937), 61–87.

34. Claës Lundin, *Samling af Svenska Folkdrägter* (Stockholm: Associations-Boktryckeriet, 1872), n.p. (This is a pamphlet reprint of one of Lundin's newspaper articles for *Stockholms Dagblad*.)

35. Bernhard Olsen, "Stuen fra Magleby paa Amager paa Konst- og Industriudstillingen," *Illustreret Tidende*, 27 July 1879, 449.

36. Bauer, "Dansk Folkemuseum," *Dagbladet*, 8 August 1885.

37. Hegard, *Hans Aall*, 75.

38. Adriaan de Jong and Mette Skougaard, "The Hindeloopen and the Amager Rooms: Two Examples of an Historical Museum Phenomenon," *Journal of the History of Collections* 5.2 (1993): 167.

39. Olsen, "Stuen fra Magleby," 449.

40. James Clifford, *The Predicament of Culture: Twentieth-Century Ethnography, Literature, and Art* (Cambridge, Mass.: Harvard University Press, 1988), 231.

41. "Våra norska bilder," *Svenska Familj-Journalen Svea*, 15 March 1890, 87.

42. Using a "wide" definition of urbanization, Bo Öhngren places the percentage of urbanized Swedes at 45 percent of the total population in 1920. See "Urbanisering i Sverige 1840–1920," in *Industrialiserings første fase*, ed. Grethe Autheen Blom, Urbanisersingsprocessen i Norden 3 (Oslo: Universitetsforlaget, 1977), 262.

43. Buggeland and Ågotnes, *Maihaugen*, 47.

44. Walton explains the panic in Norway's case as arising from the perceived need to give that nation cultural content that would legitimize its drive toward separate statehood. *Ivar Aasens kropp*, 250.

45. See my discussion of the aesthetics of sacrifice in chapter 4.

46. This collection of travel sketches was originally published in 1849 and can also be found in H. C. Andersen's collected works. See "I Sverrig," in *H. C. Andersens Samlede Skrifter*, 2d ed. (Copenhagen: C. A. Reitzels Forlag, 1878), 8:125–256.

47. Ibid., 204.

48. H. C. Andersen, *Mit Livs Eventyr*, ed. H. Topsøe-Jensen (Copenhagen: Gyldendalske Boghandel, Nordisk Forlag, 1951), 2:90.

49. Swedish author Gustaf af Geijerstam, for example, includes in an account of a visit to Skansen his reaction to seeing the house from the Mora district, which calls up for him in memory a nearly identical Leksand church scene. See "Hur tankarna komma och gå: Intryck från Skansen," *Ord och bild* 1.1 (1892): 24.

50. Charles Loring Brace, *The Norse-Folk, or A Visit to the Houses of Norway and Sweden* (New York: Scribner, 1857), 289–91.

51. Quoted in Fredrik Böök, *Artur Hazelius: En levnadsteckning av Fredrik Böök* (Stockholm: Norstedt & Söner, 1923), 264–65.

52. Theodor Oppermann, *Wilhelm Marstrand: Hans Kunst og Liv i Billeder og Tekst* (Copenhagen: G.E.C. Gads Forlag, 1920), 31.

53. Gunnar Andersson, in "Svenska Turistföreningens Program," in *Svenska Turistföreningens Årsskrift 1903*, ed. Mauritz Boheman (Stockholm: Wahlström & Widstrand, 1903), 1–14.

54. Lundell, "Turisten och folklivet," 8.

55. Gunnar Andersson, "Till Svenska Turistföreningens 25-års Jubileum," in *Svenska Turistföreningens Årsskrift 1910*, ed. Ruben Gustaffson Berg (Stockholm: Wahlström & Widstrand, 1910), 2.

56. William Eleroy Curtis, *Denmark, Norway and Sweden* (Akron, Ohio: Saalfield Publishing, 1903), 449.

57. This according to Sven Hammarlund, who calls Lindegren one of Sweden's most popular artists after the midcentury, with her paintings from Dalarna having been especially frequently reproduced. See *Glimtar ur konstnärslivet: Från Apelles till Månsson* (Stockholm: Carlsson, 1995), 89–91. Jonas Berg claims that this particular painting was Lindegren's best known and most frequently reproduced composition. See his "Dräktdockor—Hazelius' och andras," *Fataburen: Nordiska Museets och Skansens Årsbok* (1980): 22. (Even so, it is actually not the one most

frequently mentioned in published necrologies at the time of the artist's death in 1891.)

58. Marianne Zenius, *Genremaleri og Virkelighed: En kildekritisk analyse over billeder af Chr. Dalsgaard, J. Exner og F. Vermehren*, Lokalhistorisk Afdeling 6 (Copenhagen: Lokalhistorisk Afdeling, 1976), 12–21.

59. Ibid., 9. There are at least two versions of this painting, the one in the Hirschsprung Collection, shown here, and a somewhat larger painting that is now in Statens Museum for Kunst in Copenhagen. It was the larger painting that was given the longer title when it was first shown at the Charlottenborg exhibition in 1853. Exner himself later used the shorter title in correspondence. My thanks to Jens Peter Munk of the Hirschsprung Collection in Copenhagen for this information; letter to author 29 June 1999.

60. The painting is reproduced in Zenius, *Genremaleri og Virkelighed*, 112.

61. Zenius sums up this trajectory as follows: "Exner was not a documentarian, even though he faithfully visited the areas depicted in his art, which is why we see so many composite interiors in his pictures. But he traveled away from modern progress. Instead of incorporating the new, he would search out a new place and in this way he reached outward from Sjælland's rural cities around Copenhagen to Amager and then on to Fanø, finally giving up in 1909" (ibid., 156–57).

62. The Norwegian painter Adolph Tidemand takes up the theme in a panel called *Family Sorrow* in his frieze *Norwegian Rural Life* at Oscarshall on Bygdøy; later examples, some of which move the motif to an urban bourgeois setting, are Carl Sundt-Hansen's *The Visitation* (Hjemsøgelsen, 1873) and *The First Sorrow* (Den første Sorg, 1874); Albert Edelfeldt's *A Child's Funeral Journey* (Ett barns likfärd, 1879); and Hans Heyerdahl's *The Dying Child* (Det døende barn, 1882).

63. Comparative statistics for infant mortality, broken down by European country, are available in Mitchell, *International Historical Statistics*, 116–23. Sweden's infant mortality rate in 1858 was 143 per thousand, about half the rate of Germany and Austria, and much of that was due to the disease caused by Stockholm's polluted water supply prior to the hygiene projects that began in 1865. Norway had one of the lowest rates and biggest decreases of all, dropping dramatically between 1836 and 1860 from around 140 to 101 per thousand. See Sima Lieberman, *The Industrialization of Norway, 1800–1920* (Oslo: Universitetsforlaget, 1970), 27–42.

64. K.M., "Folkemusæet," *Politiken*, 8 August 1885.

65. Zenius, *Genremaleri og Virkelighed*, 21.

66. The mannequins at the 1867 exhibition in Paris were arranged mainly in pairs without theatrical backdrops or extensive props, although in at least one case, cited by Berg, a mannequin couple was modeled from two figures in a genre painting from the early 1860s. See Berg, "Dräktdockor," 10, 23.

67. Quoted in ibid., 13.

68. Jonas Berg reproduces several versions of *The Little Girl's Last Bed* in his article, including the ones from Philadelphia, Paris, and a 1951 commemorative reconstruction of this important tableau. "Dräktdockor," 20, 25–26. Another version of the Parisian tableau can be found reproduced in *Illustreret Tidende*, 20 October 1878, 30.

CHAPTER SEVEN
DEAD BONES RISE

1. The inventory of several of the Scandinavian folk museums quickly reached impressive figures. At the twenty-five-year mark of each museum, the Nordic Museum had acquired 130,000 individual objects; Kulturen in Lund, 60,000; the Norwegian Folk Museum, 33,000; and Maihaugen, 20,000. See Hazelius, "Ur Nordiska museets historia," 281; Karlin, *Kulturhistoriska Museet i Lund*, 9; Hegard, *Hans Aall*, 201; Buggeland and Ågotnes, *Maihaugen*, 104.

2. Jørgensen, *Vestervold falder*, 308.

3. Pearce, *Museums, Objects, and Collections*, 207.

4. Two stray examples: a later director of Skansen mentions in his history of the museum that a single building collected without the entire farmyard's complex of buildings was only a "torso" awaiting fuller constitution of the body with further acquisitions; (Gustaf Upmark, "Skansen 25 år," *Fataburen: Nordiska Museets och Skansens Årsbok* [1916]: 116). Similarly, describing the first steps toward an open-air museum in Denmark, Georg Karlin tells Swedish readers that the Swedish buildings Olsen purchased and had moved to Copenhagen's Rosenborg gardens in 1897 were "flesh of our flesh" ("Museumssystem," 4).

5. Pearce, *Museums, Objects, and Collections*, 208.

6. I follow the lead here of the film scholars who have taken pains of late to develop models of early cinema spectatorship that depart from notions of naive, childlike viewers. Most useful in this regard are Hansen, *Babel and Babylon*, 60–89, and Tom Gunning's ongoing examination of the horizons of viewing experience available to early film viewers in articles such as "An Aesthetic of Astonishment: Early Film and the (In)Credulous Spectator," in *Viewing Positions: Ways of Seeing Film*, ed. Linda Williams (New Brunswick, N.J.: Rutgers University Press, 1995), 14–33. A crucial observation coming out of this kind of historical reconstruction of spectatorship is that visual institutions in their "infancy" could nevertheless have sophisticated spectators who made sense of new demands on them in terms of visual practices already in place.

7. Topelius (1818–98) was an important cultural figure in nineteenth-century Finnish-Swedish culture; he was a journalist, researcher, professor, and author of influential fairy tales and children's literature. The comments here are taken from a German-language account of his visit to the Nordic Museum in 1885, published in a foreign-language guide to the museum. See Zachris Topelius, "Hauszeichen," in *Das Nordische Museum in Stockholm: Stimmen aus der Fremde* (Stockholm: Norstedt & Söner, 1888), 93–94.

8. Karlin, "Museumssystem," 8.

9. The first Swedish folk mannequins at the international exhibitions were made by C. August Söderman in 1867, not under Hazelius's direction but under that of Fritz von Dardel, the commissioner assigned responsibility for the exhibition. The success of the figures in that venue established Söderman's international reputation, so that when Hazelius decided to incorporate mannequins into his displays at the Scandinavian-Ethnographic Collection in the early 1870s, as well as when he prepared tableaux for the other international exhibitions that decade, he hired

Söderman for the job. "Söderman figures" which became synonymous with "mannequins" in Swedish, never referred to wax figures but to painted plaster mannequins. For a summary of Söderman's role in the development of mannequin display, see Berg, "Dräktdockor," 12–15.

10. Edvard Hammarstedt, "Några museifrågor," in *Meddelanden från Nordiska Museet 1897* (Stockholm: Norstedt & Söner, 1898), 180. One of Hazelius's most trusted assistants at Skansen, Edvard Hammarstedt was author of many of the museum's scholarly articles in its annual publication. Interestingly, he had been educated early on as a genre painter in Düsseldorf before turning to scholarly pursuits in botany and natural history. See Arne Biörnstad, "Artur Hazelius och Skansen," in *Skansen under hundra år*, ed. Arne Biörnstad (Höganäs, Sweden: Wiken, 1991), 56–57.

11. Pearce, *Museums, Objects, and Collections*, 4–6.

12. Karlin, *Kulturhistoriska Museet i Lund*, 343.

13. Kirshenblatt-Gimblett, *Destination Culture*, 18.

14. Upmark, "Skansen 25 år," 100.

15. An example of the potential for territorial conflicts can be found in Sandvig's memoirs, where he restages an incident where Hazelius is spotted in Lillehammer on a collecting trip by one of Sandvig's associates, who extracts a promise from Hazelius not to do any more collecting in Gudbrandsdalen, since there was "so little left." Sandvig himself takes the apologist position with respect to Hazelius's acquisition of Norwegian material, claiming that if he had not collected it when he did, it would not exist anywhere any longer. *I praksis og på samlerferd*, 134–35.

16. "Gudbrandsdalens Folkemuseum paa Maihaugen: En Seværdighed," *Aftenposten*, 31 May 1903.

17. Pearce, *Museums, Objects, and Collections*, 66.

18. Older forms of collection in Scandinavia included royal art and coin collections, displays of military weapons and uniforms, the natural history and botanical collections of Ole Wurm and Carl Linnaeus, as well as collections of archaeological material from premodern times. For summaries of earlier museum history in Scandinavia, see Carlén, *Att ställa ut kultur*, 28–40, and Rasmussen, *Dansk museums historie*, 23–68.

19. "I Folkemuseet," *Illustreret Tidende*, 2 August 1885, 578.

20. Jørgen Olrik, "Dansk Folkemuseums Jubilæum," *Illustreret Tidende*, 7 August 1910, 558.

21. Carlén, *Att ställa ut kultur*, 86.

22. Karlin, "Museumssystem," 15.

23. Grandien, "Tiden före 1891," 11.

24. Ekström, *Den utställda världen*, 58–59.

25. Bernhard Olsen, "Dansk Folkemuseum," *Illustreret Tidende*, 2 August 1885, 573.

26. Camillus Nyrop, *Fra den Kunstindustrielle Udstilling: Erindringsblade* (Copenhagen: J. H. Schubothes Boghandels Forlag, 1879), 94–95.

27. "Sigurd" [pseud.], "En vacker hänförelse, som bör—stäfjas," *Smålandsposten*, 27 December 1895.

28. Ibid.

29. Jakob Ågotnes, "The Ideology of the Folk Museums," in *Skansen 1891–1991*, ed. Mats Janson (Stockholm: Association of European Open-Air Museums, 1991), 80–81.

30. Buggeland and Ågotnes, *Maihaugen*, 50.

31. Upmark, "Skansen 25 år," 99.

32. *Svenska Panoptikons Katalog* (Stockholm, 1890), 1–2.

33. "I anledning af—Dansk Folkemusæum," *Nationaltidende*, 10 August 1910.

34. I thank W. J. T. Mitchell for pointing out this parallel to me.

35. Several interesting studies of habitat groups make this point about the theatricality of the "found" animal scene. See Wonders, "Illusionary Art," 90–118; Allan Ellenius and Karen Wonders, "Verklig eller blott målad?" *Tvärsnitt* 13.1–2 (1991): 21–29; and Haraway, *Primate Visions*, 26–58. All of these point to the turn of the century as a period of crucial transition to a scenographic sensibility in natural history museums, but Haraway's treatment of taxidermy and wildlife dioramas is especially illuminating when juxtaposed to the museum material at the folk museums; her emphasis on the implied organicism of the representational model there resonates strongly with the folk museum's resurrection project.

36. Sophus Müller, "Museum og Interiør," *Tilskueren* (1897): 683–700.

37. Christian Krohg, "Lillehammer," *Verdens gang*, February 1901. This series of articles is collected in Maihaugen's archive of press clippings, vol. 3: 47. (Hereafter abbreviated as MPC—Maihaugen Press Clippings.)

38. Karlin, "Museumssystem," 14.

39. Karlin, *Kulturhistoriska Museet i Lund*, 5.

40. Lars Landgren, "Stugo i Delsbo Socken i Helsingland," in Artur Hazelius, *Minnen från Nordiska Museet*, vol. 1 (Stockholm: P. B. Eklunds Förlag, 1892), n.p.

41. "A travers les pays Scandinaves," *Le Rappel*, 6 August 1878.

CHAPTER EIGHT
INSIDERS

1. For a thorough technical history of lighting in the theater, with a particular emphasis on Scandinavian theater history, see Gösta M. Bergman, *Lighting in the Theatre* (Stockholm: Almqvist & Wiksell International, 1977). For a recent examination of Antoine's groundbreaking naturalist staging techniques, see Jean Chothia, *André Antoine*, Directors in Perspective (Cambridge: Cambridge University Press, 1991). In Scandinavian theater history, of course, the manifesto of naturalist staging is usually considered to be August Strindberg's preface to his 1889 play *Miss Julie*. Evert Sprinchorn's translation of the preface is a useful one: August Strindberg, Preface to *Miss Julie*, in *Selected Plays*, vol. 1, trans. Evert Sprinchorn (Minneapolis: University of Minnesota Press, 1986), 204–17.

2. Emmanuel Gonzalès, "La Rue de Norwège," in *L'Exposition Universelle Illustrée de 1867* ed. François Ducuing (Paris: Commission Impériale, 1867), 123.

3. Allard, "Exposition d'ethnographie scandinave," quoted in J. H. Kramer, *Le Musée D'Ethnographie Scandinave à Stockholm. Fondé et Dirigé par le Dr. Artur Hazelius. Notice Historique et Descriptive*, 2d ed. (Stockholm: Norstedt & Söner, 1879), 44.

4. F. A. Wulff, "Skandinavisk-etnografiska museet på verldsutställningen i Paris (Bref till Aftonbladet)," *Aftonbladet*, 12 October 1878.

5. There were four fully staged tableaux at the 1878 Paris Exhibition, as well as mannequins presented individually and in groups. The four large mannequin scenes included this one of the churchgoers, a version of the Lindegren cradle tableau (see fig. 6.8), an exterior scene from Lapland, and the interior from the cottage in Halland (see fig. 7.6).

6. Olsen, "Dansk Folkemuseum," *Illustreret Tidende*, 2 August 1885, 573.

7. Emil Hannover, "Bernhard Olsen ved hans 70-aarige Fødselsdag den 9. September," *Tilskueren* (1906): 706–7.

8. Many, but not all, of the rooms at the Danish Folk Museum were faithful reconstructions. One account mentions that "some of the rooms are completely genuine, others are partially reconstructed." See "Folkemusæet," *Politiken*, 8 August 1885.

9. The same archival problem arises here as with the wax-museum photographs presented earlier, namely, that it is sometimes difficult to know in retrospect whether a depicted figure is a mannequin or a costumed living guide. In illustrations, the status of bodies is even more difficult to determine, since illustrators could embellish rooms more freely with imagined figures. In this case, comparison with another illustration of the interior suggests that the two figures seated vis-à-vis at the table are mannequins (since they have identical poses in both illustrations).

10. Claës Lundin, "I svenska allmogehem, bland dalfolk och lappar: Nutidsbild från Stockholms Djurgård," *Stockholms Dagblad*, 27 September 1891.

11. Berg, "Dräktdockor," 26–27.

12. Ibid., 26.

13. Quoted in Biörnstad, "Artur Hazelius och Skansen," 69. My thanks to Mr. Biörnstad for personal correspondence providing extra contextual information on the date and situation of this reminder note.

14. Lundin, "I svenska allmogehem, bland dalfolk och lappar: Nutidsbild från Stockholms Djurgård," *Stockholms Dagblad*, 27 September 1891.

15. "Vyer från Skansen," *Hemlandsvännen* 14.43 (1892): 1.

16. "Kullorna på Skansen," *Svenska Dagbladets Söndagsbilaga* (Stockholm), 23 October 1898.

17. In fact, I am told that several years ago at Skansen, when a curator attempted to place mannequins back in one building at the modern museum as a historical retrospective, public response was so negative that the staff decided to remove them again. Mats Jansson, personal conversation with author at Skansen, July 1992.

18. Arne Ludvigsen, "Om Flytning af gamle Bygninger," in *Fra Nationalmuseets Arbejdsmark 1940* (Copenhagen: Nationalmuseet, 1940), 46.

19. Carl Berner, "De Sandvigske Samlinger paa Lillehammer," *Morgenposten*, 8 March 1909.

20. Rasmussen discusses in detail how important it was to the Danes to find compensatory forms of nationhood for the one that suffered such blows with the defeat of 1864 and the loss of Slesvig and Holstein to the Prussians. Olsen had a particularly keen sense of national loss, and he saw in the symbolic territory of the folk and open-air museum an opportunity to reclaim lost provinces through the act of display at a Danish cultural-historical museum. See *Bernhard Olsen*, 92–94.

21. "Folkemusæet," *Politiken*, 8 August 1885.

22. "I Folkemuseet," *Illustreret Tidende*, 2 August 1885, 578.

23. The quoted passage is from Bauer, "Dansk Folkemuseum," *Dagbladet*, 8 August 1885; the contrasting newspaper accounts can be found in L. Lund, "Mere om Dansk Folkemuseum," *Morgenbladet*, 10 August 1885; and "Folkemusæet," *Politiken*, 8 August 1885; as well as Zakarias Nielsen, "Dansk Folkemusæum," *Husvennen* 13 (1885–86): 326–28. While illustrations do not offer as convincing proof as photographs, the drawing showing the unpopulated Ingelstad room in figure 8.6 is from the same time as these articles, having been published one month later on September 20.

24. Outside the confines of the urban location, of course, the folk museums in their open-air versions would do exactly that. The Danish Open-Air Museum, which Olsen founded, is currently quite accomplished in creating effects of inhabitation by allowing poultry and other animals to wander the grounds, as if tended by unseen folk hands. But it is quite unlikely that Olsen tried such tricks in single-room interiors at his museum in the Panoptikon building.

25. Krohg, "Lillehammer," *Verdens gang*, February 1901.

26. Ibid.

27. Hegard, *Romantikk og fortidsvern*, 94.

28. "Vyer från Skansen," *Hemlandsvännen* 14.43 (1892): 1.

29. "Några råd för renåkare på Skansen," *Nya dagligt allehanda*, 30 December 1892.

30. Anders Sandvig, speech, 2 July 1904, MPC 4:127.

31. Anders Sandvig, "Tandlæge A. Sandvig: Manden og hans Gjerning," interview by Magnus Brostrup Landstad, *Forposten*, 14 July 1904.

32. The quotation from the interview in its entirety reads: "I'll never forget the day I said farewell to my mother to go out into the world to earn my daily bread. And with each home I have restored, I have thought of her good home. And have considered that I have paid back some of my gratitude to her." Ibid.

33. "Sjumil" [pseud.], *Akershus Budstikke*, 10 September 1896.

34. Arne Garborg, "Sandvigs Samlinger paa Lillehammer," *Morgenbladet*, 20 August 1900.

35. "Kvinderne paa Maihaugen," *Gudbrandsdølen*, 18 April 1905.

36. "På Skansen," *Vårt land*, 5 October 1891.

37. Gisle Midttun, "Flytning af Prestegaarden," *Dale-Gudbrand*, 28 February 1908.

38. Garborg, "Sandvigs Samlinger paa Lillehammer," *Morgenbladet*, 20 August 1900.

39. Sandvig, "Tandlæge A. Sandvig: Manden og hans Gjerning," interview by Magnus Brostrup Landstad, *Forposten*, 14 July 1904.

40. Schou, "Sandvigs Samlinger," *Intelligenssedlerne*, 14–15 June 1901.

41. Christian Brinchmann, "Sandvigs Samlinger på Lillehammer," *Kringsjaa* 16 (1900): 616–17.

CHAPTER NINE

FARMERS AND FLÂNEURS

1. Quoted in Gösta Berg, "Friluftsmuseer och Kulturreservat," *Fataburen: Nordiska Museets och Skansens Årsbok* (1965): 16.

2. "I Folkemuseet," *Illustreret Tidende*, 2 August 1885, 578.

3. "I anledning af—Dansk Folkemusæum," *Nationaltidende*, 10 August 1910.

4. As mentioned earlier, the Copenhagen population essentially doubled between 1850 and 1880 (going from 129,000 to 235,000); in the next thirty years between 1880 and 1910, it doubled again, rising to 559,000. By that same year, Stockholm and Oslo had reached 342,000 and 243,000, respectively. See Mitchell, *International Historical Statistics*, 72.

5. Quoted in Rune Kjellberg, *Et halvt århundre: Norsk Folkemuseum 1894–1944* (Oslo: Tanum, 1945), 7.

6. Müller, "Museum og Interiør," 697–98.

7. Nielsen, "Dansk Folkemuseum," *Husvennen* 13 (1885–86): 328.

8. Müller, "Museum og Interiør," 687.

9. Lundin, "I svenska allmogehem bland dalfolk och lappar: Nutidsbild från Stockholms Djurgård," *Stockholms Dagblad*, 27 September 1891.

10. "Skansen. Sveriges enda kulturlifs-museum," *Upsala*, 3 September 1896; Garborg, "Sandvigs Samlinger paa Lillehammer," *Morgenbladet*, 20 August 1900; Balthazar Schnitler, "Sandvigs Samlinger," *Folkebladet*, 26 December 1901.

11. "På Skansen," *Vårt land*, 5 October 1891; Schnitler, "Sandvigs Samlinger." *Folkebladet*, 26 December 1901.

12. Friedberg, *Window Shopping*, 104–6.

13. Buggeland and Ågotnes, *Maihaugen*, 65–68.

14. Krohg, "Lillehammer," *Verdens gang*, February 1901.

15. Ibid.

16. "Folkemuseet paa Bygdø," *Aftenposten* (Christiania), 27 May 1902.

17. *Das Nordische Museum in Stockholm: Stimmen aus der Fremde* (Stockholm: Norstedt & Söner, 1888), 65.

18. "På Skansen," *Vårt land*, 5 October 1891.

19. Michelle Facos, *Nationalism and the Nordic Imagination: Swedish Art of the 1890s* (Berkeley: University of California Press, 1998), especially 181–94.

20. Tonte Hegard's study of Norwegian folk museums takes this tack, with a main title that translates as "Romanticism and the Preservation of the Past."

21. Gustaf af Geijerstam was a leading writer of the 1880s and 1890s in Sweden. His authorship includes long, realistic novels early in his career, quite successful rural dramas, and later, more psychological and mystical works. Geijerstam, like many Scandinavian writers of the 1890s, arrived at his "romanticism" via natural-

ism, giving it a complexity and modernity quite in line with that of the folk museums themselves.

22. Geijerstam, "Hur tankarna komma och gå: Intryck från Skansen," *Ord och bild* 1.1 (1892): 18–19.

23. Ibid., 20.

24. Ibid., 21.

25. "Elektriciteten och Skansen," *Dagens Nyheter*, 2 May 1899.

26. "Skansens utveckling," *Svenska Dagbladet*, 24 August 1899.

27. "Elektriciteten och Skansen: Ett genmäle till 'En Skansvän,' " *Dagens Nyheter*, 10 May 1899.

28. Aall, *Norsk Folkemuseum*, 36.

29. Hegard, *Hans Aall*, 65.

30. Aall, *Norsk Folkemuseum*, 10.

31. "Sandvigs Samlinger," *Kristiania Dagsavis*, 31 July 1901.

32. "Gudbrandsdalens Folkemuseum paa Maihaugen. En Seværdighed," *Aftenposten*, 31 May 1903.

33. "På Skansen," *Vårt land*, 5 October 1891.

34. Sandvig, *I praksis og på samlerferd*, 185.

35. Ibid., 186.

36. The Uncle Josh film was discussed earlier in chapter 4; the other film's full title is *Rube and Mandy at Coney Island* (Edison, 1903).

37. Lund, "Mere om Dansk Folkemusæum," *Morgenbladet*, 10 August 1885.

38. "I Folkemuseet," *Illustreret Tidende*, 2 August 1885.

39. Sandvig, *I praksis og på samlerferd*, 183.

40. Ibid., 184.

41. Katie Trumpener, "The Time of the Gypsies: A 'People without History' in the Narratives of the West," in *Identities*, ed. Kwame Anthony Appiah and Henry Louis Gates Jr. (Chicago: University of Chicago Press, 1995), 341.

42. I thank Jakob Ågotnes for this information about the continuation of the Gypsy performance through the years, as well as his tip that the arrival of the Gypsies was recorded on film in 1920 in a documentary made about Maihaugen by the crew filming Carl-Theodore Dreyer's *Parson's Widow* there on the grounds.

43. Joker [pseud.], "Storskansen," *Söndags Nisse*, 17 March 1901.

44. *Vägvisare genom Svenska Panoptikon* (Stockholm, 1894), 35.

45. Leif Furhammar, *Filmen i Sverige: En historia i tio kapitel* (Stockholm: Wiken, 1991), 11–12.

46. Ekström, *Den utställda världen*, 170–71.

47. Hegard, *Hans Aall*, 76.

CHAPTER TEN
MATERIAL MOBILITY

1. My use of the term *suture* deliberately invokes its widespread use within film studies to describe the cinema's technique of spectator interpolation that creates impressions of coherent scenic space and plenitude out of cuts, bits, and visual fragments of individual film shots. The best summary of the Lacanian basis for

cinematic suture can be found in Kaja Silverman, *The Subject of Semiotics* (New York: Oxford University Press, 1983), 194–236.

2. Kirshenblatt-Gimblett, *Destination Culture*, 18.

3. Engberg, "Stilstand og vaekst," 417.

4. The idea that this may have been a more general, deliberate institutional strategy of cinema is supported by other examples; another Danish film from the same year, *Christian Schrøder at the Panoptikon*, discussed in chapter 4, makes much the same point about immersive spectating.

5. The café is mentioned in Carl Muusmann's memoir of 1880s Copenhagen in his chapter on Robert Watt, the director of Tivoli who succeeded Bernhard Olsen in that position in 1886. Watt's effigy was included in the panoptikon's tableau but is not visible in this photograph (it would be off to the foreground left). Also included in Muusmann's book is a xylographic illustration of an interior scene from à Porta's café in the 1880s, exactly contemporary with the date of this photograph. Muusmann, *Firsernes Glade København*, 169–71.

6. If the viewing position for the museum visitor were as frontally static as in the photograph, several of the listed figures would remain hidden in unseen niches to the left; moreover, the diagram in the program seems to indicate an entrance and exit on opposite ends of the display.

7. Byatt, *The Biographer's Tale*, 130. Interestingly, Byatt is also interested in the Grand Café's Ibsen chair, and incorporates it into her novel as a key part of the embedded biographical fragment on Ibsen. She, like the original folk-museum curators, is keenly interested in the power of an object like a chair to evoke a missing body, but in her many-layered novel that process is anything but secure.

8. de Jong and Skougaard, 176.

WORKS CITED

The following archival abbreviations are used to aid in locating rare materials:

United States
 LC = Library of Congress, Washington, D.C.

Denmark
 CCM = Copenhagen City Museum (Københavns Bymuseum)
 DFM = The Danish Film Museum, Copenhagen (Det Danske Filmmuseum)
 DRL = Danish Royal Library, Copenhagen (Det Kongelige Bibliotek)
 NMB = The National Museum, Brede (Nationalmuseet i Brede)

Sweden
 SCM = Stockholm City Museum (Stockholms Stadsmuseum)
 SRL = Swedish Royal Library, Stockholm (Kungliga Bibliotek)

Norway
 MPC = Maihaugen Press Clipping files, Lillehammer

CATALOGUES AND PROGRAMS

Catalog over Møllers Musæum. Copenhagen, 1867. (DRL, Smaatryk 17–263)
Chr. Schrøder i Panoptikon (plot description). (DFM)
En af Kjøbenhavns største Seværdigheder er Skandinavisk Panoptikon. Copenhagen, 1888.
Hartkopfs Musæum. Copenhagen, 1902. (DRL)
Illustreret Katalog. Panoptikon. Copenhagen, [1918], [1923]. (CCM)
Katalog öfver H. Düringers Museum. Gefle, Sweden, 1894. (SRL)
Katalog öfver P. Haggrens Panoptikon eller Vaxkabinett. Wimmerby (Sweden), 1894. (SRL)
Katalog over J. Eppmanns Verdens-Udstilling. Copenhagen, 1877. (DRL, Smaatryk 17–263)
Katalog over Københavns Panorama og Kinoptikon. Copenhagen, 1898. (DRL)
Katalog over Skandinavisk Panoptikon. Copenhagen, 1885, [1890], 1897, [1899], [1906]. (DRL)
Katalog. Skandinavisk Panoptikon. Copenhagen, [1903]. (DRL)

Konst- och Vaxfigur-Kabinett, med figurer i menniskostorlek (advertising bill). Carlshamn (Sweden), 1882. (SRL)

La Morgue. Copenhagen, [1902]. (DRL)

Madame Tussaud and Son's Exhibition Catalogue. London, 1873.

Olsen, Bernhard. "Notitser om den ceroplastiske Kunst og Vokskabinetterne." N.d. (NMB)

Orientaliska Irrgång-Salongen, Nya Panoptikon, Grott-Salongen, Eden-Salongen (collection of contemporary press commentary on these attractions). Stockholm, 1893. (SRL)

Panoptikum: Das Wachsfigurenkabinett. 11th ed. Hamburg, 1997.

Skandinavisk Panoptikon (publicity flyer published for the exhibition). Copenhagen, 1888. (CCM)

Skandinavisk Panoptikon, ordnet af Bernhard Olsen. Copenhagen, 1886. (LC)

Svenska Panoptikons Filial. Malmö (Sweden), 1896. (SRL)

Svenska Panoptikons Katalog. Stockholm, 1890. (SCM)

Svenska Panoptikons Vägvisare. Stockholm, 1907. (SCM)

Svenska Panoptikons Vägvisare, Utställningsåret 1897. Stockholm, 1897. (SCM)

Vägvisare genom Svenska Panoptikon. Stockholm, 1894, 1897, 1912. (SCM)

NEWSPAPER AND PERIODICAL COMMENTARY

"A travers les pays Scandinaves." *Le Rappel,* 6 August 1878.

Aftenbladet, n.d. In *Katalog* [1890], n.p.

"Ändtligen i Orientaliska irrgångsalongen." *Figaro,* 11 January 1890. In *Orientaliska Irrgång-Salongen,* 5–12.

Bang, Herman. *Københavnske Skildringer: "Vekslende Themaer" 1879–1883.* Edited by Cai M. Woel. Copenhagen: Gyldendal, 1954.

Bauer, Alfred. "Dansk Folkemuseum." *Dagbladet* (Copenhagen), 8 August 1885.

Berner, Carl. "De Sandvigske Samlinger paa Lillehammer." *Morgenposten* (Kristiania), 8 March 1909.

"Bland Panoptikons vaxgubbar." *Aftonbladet* (Stockholm), 3 August 1889.

Brinchmann, Christian. "Sandvigs Samlinger på Lillehammer." *Kringsjaa* 16 (1900): 481–89, 609–17.

"Den s.k. irrgångsalongen." *Stockholms Dagblad,* 13 December 1892. In *Orientaliska Irrgång-Salongen,* 22–23.

"Eden-salongen och Nya Panoptikon." *Dagens Nyheter,* 25 November 1890. In *Orientaliska Irrgåang-Salongen,* 18.

"Elektriciteten och Skansen." *Dagens Nyheter* (Stockholm), 2 May 1899.

"Elektriciteten och Skansen: Ett genmäle till 'En Skansvän.' " *Dagens Nyheter* (Stockholm), 10 May 1899.

"En modern labyrint." *Aftonbladet* (Stockholm), 2 January 1890.

"En uppseendeväckande nyhed." *Skånska Dagbladet* (Malmö, Sweden), 29 June 1896.

"Ett storstadsetablissement." *Svenska Familj-Journalen Svea,* 5 April 1890.

"Folkemusæet." *Politiken* (Copenhagen), 8 August 1885.

"Folkemuseet paa Bygdø." *Aftenposten* (Christiania), 27 May 1902.

"Forfængelighedens Marked." *Politiken,* n.d. In *Katalog* [1890], n.p.

"Förstudier i 'Svenska Panoptikon.' " *Ny Illustrerad Tidning*, 15 December 1888, 430.

"Forvandling af Lig til Marmor." *Ny Illustreret Tidende*, 14 December 1889, 499.

"Fra Panoptikons Tag." *Illustreret Tidende*, 10 May 1885, 408.

Garborg, Arne. "Sandvigs Samlinger paa Lillehammer." *Morgenbladet* (Christiania), 20 August 1900.

Geijerstam, Gustaf af. "Hur tankarna komma och gå: Intryck från Skansen." *Ord och bild* 1.1 (1892): 18–27.

Gonzalès, Emmanuel. "La Rue de Norwège." In *L'Exposition Universelle de 1867 Illustrée*, edited by François Ducuing, 123–26. Paris: Commission Impériale, 1867.

"Gudbrandsdalens Folkemuseum paa Maihaugen: En Seværdighed." *Aftenposten* (Christiania), 31 May 1903.

Hodell, Björn. "Gamla svenska panoptikon." *Såningsmannen* 5 (1957): 6, 36.

"I anledning af—Dansk Folkemusæum." *Nationaltidende* (Copenhagen), 10 August 1910.

"I Folkemuseet." *Illustreret Tidende*, 2 August 1885, 576–78.

Joker [pseud.]. "Storskansen." *Söndags Nisse*, 17 March 1901.

"Kinematografen." *Fotografisk Tidskrift* (Stockholm), 15 March 1896.

"Kinoptikon." *Politiken* (Copenhagen), 7 June 1896.

K.M. "Folkemusæet." *Politiken* (Copenhagen), 8 August 1885.

Krohg, Christian. "Lillehammer." *Verdens gang* (Christiania), February 1901 (MPC 3:29–55).

"Kullorna på Skansen." *Svenska Dagbladets Söndagsbilaga* (Stockholm), 23 October 1898.

"Kvinderne paa Maihaugen." *Gudbrandsdølen* (Lillehammer, Norway), 18 April 1905.

Lotmann, Bernhard. "Gammel Kultur." *Christiansand Tidende* (Kristiansand, Norway), 16 March 1902.

Lund, L. "Mere om Dansk Folkemuseum." *Morgenbladet* (Copenhagen), 10 August 1885.

Lundin, Claës. "I svenska allmogehem, bland dalfolk och lappar: Nutidsbild från Stockholms Djurgård." *Stockholms Dagblad*, 27 September 1891.

———. *Samling af Svenska Folkdrägter*. Stockholm: Associations-Boktryckeriet, 1872. (Pamphlet reprint of a newspaper article in *Stockholms Dagblad*.)

Midttun, Gisle. "Flytning af Prestegaarden." *Dale-Gudbrand* (Lillehammer, Norway), 28 February 1908.

"Några råd för renåkare på Skansen." *Nya dagligt allehanda* (Stockholm), 30 December 1892.

Nielsen, Zakarias. "Kjøbenhavns Panoptikon." *Husvennnen* 13 (1885–86): 261–63.

———. "Dansk Folkemusæum." *Husvennen* 13 (1885–86): 326–28.

Olrik, Jørgen. "Dansk Folkemuseums Jubilæum." *Illustreret Tidende*, 7 August 1910, 558–59.

Olsen, Bernhard. "Dansk Folkemuseum." *Illustreret Tidende*, 2 August 1885, 573–76.

———. "Stuen fra Magleby paa Amager paa Konst- og Industriudstillingen." *Illustreret Tidende*, 27 July 1879, 449.

"Orientaliska irrgångsalongen." *Stockholms Dagblad*, 2 January 1890. In *Orientaliska Irrgång-Salongen*, 5.

"På Skansen." *Vårt land* (Stockholm), 5 October 1891.

"Palmehuset i Skandinavisk Panoptikon." *Illustreret Tidende*, 16 November 1890, 75–77.

"Panoptikon." *Illustreret Tidende*, 2 August 1885, 548–50.

"Panoptikons Spejlkabinet," *Dagens Nyheder*, n.d. In *Katalog* [1890].

"Ramloftstuen paa Lillehammer." *Verdens Gang* (Christiania), 26 July 1895.

Sandvig, Anders. "Tandlæge A. Sandvig: Manden og hans Gjerning." Interview by Magnus Brostrup Landstad. *Forposten* (Christiania), 14 July 1904.

"Sandvigs Samlinger." *Kristiania Dagsavis* (Christiania), 31 July 1901.

Schnitler, Balthazar. "Sandvigs Samlinger." *Folkebladet* (Lillehammer, Norway), 26 December 1901.

Schou, Alhed. "Sandvigs Samlinger." *Intelligenssedlerne*, 14–15 June 1901.

"Ser jer i Spejl." *Morgenbladet* (Copenhagen), n.d. In *Katalog* [1890].

"Sigurd" [pseud.]. "En vacker hänförelse, som bör–stäfjas." *Smålandsposten* (Kronoberg läns, Sweden), 27 December 1895.

"Sjumil" [pseud.]. *Akershus Budstikke*, 10 September 1896.

"Skandinavisk Panoptikon." *Berlingske Tidende*, n.d. In *Katalog* [1890].

"Skansen. Sveriges enda kulturlifs-museum." *Upsala* (Uppsala, Sweden), 3 September 1896.

"Skansens utveckling." *Svenska Dagbladet* (Stockholm), 24 August 1899.

Social-Demokraten, n.d. In *Katalog* [1890], n.p.

"Söndag på Panoptikon." *Dagens Nyheter* (Stockholm), 9 July 1939.

Söndags-Nisse, 30 November 1890. In *Orientaliska Irrgång-Salongen*, 17.

"Spejlgemakkerne i Skandinavisk Panoptikon," *Dagbladet*, n.d. In *Katalog* [1890].

"Svenska Panoptikon." *Aftonbladet* (Stockholm), 1 August 1889.

"Svenska Panoptikon." *Dagens Nyheter* (Stockholm), 1 August 1889.

"Svenska Panoptikon." *Svenska Familj-Journalen Svea*, 3 August 1889.

"To landes panoptikoner genopstaar i Aalborg." *Berlingske Tidende* (Copenhagen), 5 June 1960.

Topelius, Zachris. "Hauszeichen." In *Das Nordische Museum in Stockholm: Stimmen aus der Fremde*, 91–96. Stockholm: Norstedt & Söner, 1888.

"Våra norska bilder." *Svenska Familj-Journalen Svea*, 15 March 1890, 87.

"Voices of the Dead." *Phonoscope* 1.1 (15 November 1896): 5.

"Vyer från Skansen." *Hemlandsvännen* 14.43 (1892): 1.

Wulff, F. A. "Skandinavisk-etnografiska museet på verldsutställningen i Paris (Bref till Aftonbladet)." *Aftonbladet* (Stockholm), 12 October 1878.

OTHER SOURCES

Aall, Hans. *Norsk Folkemuseum, 1894–1919: Trekk av dets historie*. Kristiania: Kirstes Boktrykkeri, 1920.

Ågotnes, Jakob. "The Ideology of the Folk Museums." In *Skansen 1891–1991*, edited by Mats Janson, 73–83. Stockholm: Association of European Open-Air Museums, 1991.

Altick, Richard D. *Shows of London*. Cambridge, Mass.: Harvard University Press, 1978.

Ames, Eric C. "Where the Wild Things Are: Locating the Exotic in German Modernity." Ph.D. diss., University of California, Berkeley, 2000.

Andersen, H. C. "I Sverrig." In *H. C. Andersens Samlede Skrifter*, 2d. ed., 8: 125–256. Copenhagen: C. A. Reitzels Forlag, 1878.

———. *Mit Livs Eventyr*. Edited by H. Topsøe-Jensen. Copenhagen: Gyldendalske Boghandel, Nordisk Forlag, 1951.

Andersson, Gunnar. "Svenska Turistföreningens Program." In *Svenska Turistföreningens Årsskrift 1903*, edited by Mauritz Boheman, 1–14. Stockholm: Wahlström & Widstrand, 1903.

———. "Till Svenska Turistföreningens 25-års Jubileum." In *Svenska Turistföreningens Årsskrift 1910*, edited by Ruben Gustafsson Berg, 1–33. Stockholm: Wahlström & Widstrand, 1910.

Bang, Herman. *Stuk*. Copenhagen: J. H. Schubothe, 1887.

Barthes, Roland. *Camera Lucida: Reflections on Photography*. Translated by Richard Howard. New York: Hill and Wang, 1981.

Baudrillard, Jean. *Selected Writings*. Edited and with an introduction by Mark Poster. Stanford, Calif.: Stanford University Press, 1988.

———. *Simulations*, translated by Paul Foss, Paul Patton, and Philip Beitchman. New York: Semiotext[e], 1983.

Benjamin, Walter. *Das Passagen-Werk*. 2 vols. Edited by Rolf Tiedemann. Frankfurt: Suhrkamp Verlag, 1982.

———. "The Work of Art in the Age of Mechanical Reproduction." In *Illuminations*, edied by Hannah Arendt, 217–51. Translated by Harry Zohn. New York: Schocken Books, 1968.

Berg, Gösta. "Friluftsmuseer och Kulturreservat." *Fataburen: Nordiska Museets och Skansens Årsbok* (1965): 7–21.

Berg, Jonas. "Dräktdockor—Hazelius' och andras." *Fataburen Nordiska Museets och Skansens Årsbok* (1980): 9–28.

Bergman, Gösta M. *Lighting in the Theatre*. Stockholm : Almqvist and Wiksell International, 1977.

Berman, Marshall. *All That Is Solid Melts into Air*. New York: Simon and Schuster, 1982.

Biörnstad, Arne. "Artur Hazelius och Skansen." In *Skansen under hundra år*, 33–76.

———, ed. *Skansen under hundra år*. Höganäs, Sweden: Wiken, 1991.

Böök, Fredrik. *Artur Hazelius: En levnadsteckning av Fredrik Böök*. Stockholm: Norstedt & Söner, 1923.

Brace, Charles Loring. *The Norse-Folk, or A Visit to the Houses of Norway and Sweden*. New York: Scribner, 1857.

Brewster, Ben, and Lea Jacobs. *Theatre to Cinema: Stage Pictorialism and the Early Feature Film*. Oxford: Oxford University Press, 1997.

Bringéus, Nils-Arvid. "Artur Hazelius och Nordiska Museet." *Fataburen: Nordiska Museets och Skansens Årsbok* (1972): 7–32.

Broberg, Gunnar. "Entrébiljett till en skandal." *Tvärsnitt* 1–2 (1991): 118–25.

Bronfen, Elisabeth. *Over Her Dead Body: Death, Femininity and the Aesthetic*. New York: Routledge, 1992.

Brooks, Peter. *The Melodramatic Imagination: Balzac, Henry James, Melodrama, and the Mode of Excess.* New York: Columbia University Press, 1985.

Brückner, Wolfgang. *Bildnis und Brauch: Studien zur Bildfunktion der Effigies.* [Berlin]: Erich Schmidt Verlag, 1966.

Bruno, Giuliana. *Streetwalking on a Ruined Map: Cultural Theory and the City Films of Elvira Notari.* Princeton, N.J.: Princeton University Press, 1993.

Buggeland, Tord, and Jakob Ågotnes. *Maihaugen: De Sandvigske Samlinger 100 år.* [Oslo]: J. W. Cappelens Forlag, 1987.

Byatt, A. S. *The Biographer's Tale.* London: Chatto and Windus, 2000.

Caplan, Jay. *Framed Narratives: Diderot's Genealogy of the Beholder.* Theory and History of Literature 19. Minneapolis: University of Minnesota Press, 1985.

Carlén, Staffan. *Att ställa ut kultur: Om kulturhistoriska utställningar under 100 år.* Acta Ethnologica Umensia 3. Stockholm: Carlsson Bokförlag, 1990.

Cézan, Claude. *Le Musée Grévin.* Paris: Editions Rombaldi, 1947.

Chapman, Pauline. *The French Revolution as Seen by Madame Tussaud, Witness Extraordinary.* London: Quiller Press, 1989.

———. *Madame Tussaud's Chamber of Horrors: Two Hundred Years of Crime.* London: Constable, 1984.

Charney, Leo, and Vanessa Schwartz. "Introduction." In *Cinema and the Invention of Modern Life,* edited by Leo Charney and Vanessa Schwartz, 1–12. Berkeley: University of California Press, 1995.

Chothia, Jean. *André Antoine.* Directors in Perspective. Cambridge: Cambridge University Press, 1991.

Clifford, James. *The Predicament of Culture: Twentieth-Century Ethnography, Literature, and Art.* Cambridge, Mass.: Harvard University Press, 1988.

Clover, Carol J. *Men, Women and Chainsaws: Gender in the Modern Horror Film.* Princeton, N.J.: Princeton University Press, 1992.

Cooke, Lynne, and Peter Wollen, eds. *Visual Display: Culture beyond Appearances.* Seattle: Bay Press, 1995.

Cosandey, Roland, André Gaudreault, and Tom Gunning, eds. *An Invention of the Devil? Religion and Early Cinema.* Sainte-Foy, Québec: Presses de l'Université Laval, 1992.

Cottrell, Leonard. *Madame Tussaud.* London: Evans Brothers, 1965.

Crary, Jonathan. *Suspensions of Perception: Attention, Spectacle, and Modern Culture.* Cambridge, Mass.: MIT Press, 1999.

Curtis, William Eleroy. *Denmark, Norway and Sweden.* Akron, Ohio: Saalfield Publishing, 1903.

Das Nordische Museum in Stockholm: Stimmen aus der Fremde. Stockholm: Norstedt & Söner, 1888.

de Jong, Adriaan, and Mette Skougaard. "The Hindeloopen and the Amager Rooms: Two Examples of an Historical Museum Phenomenon." *Journal of the History of Collections* 5.2 (1993): 165–78.

Dinesen, Isak. "The Roads round Pisa." In *Seven Gothic Tales,* 165–216. New York: Random House, 1934.

Edison, Thomas. "The Phonograph and Its Future." *North American Review* 262 (May–June 1878): 527–36.

Ekström, Anders. *Den utställda världen: Stockholmsutställningen 1897 och 1800-talets världsutställningar.* Nordiska museets Handlingar 119. Stockholm: Nordiska Museet, 1994.

Ellenius, Allen, and Karen Wonders. "Verklig, eller blott målad?" *Tvärsnitt* 13.1–2 (1991): 21–29.

Engberg, Jens. "Stilstand og vækst: København 1807–1914." In *Københavnernes historie: Fra Absalon til Weidekamp*, edited by Helge Paludan et al., 107–58. Copenhagen: Hans Reitzels Forlag, 1987.

Engberg, Marguerite. *Dansk Stumfilm.* 2 vols. Copenhagen: Rhodos, 1977.

Facos, Michelle. *Nationalism and the Nordic Imagination: Swedish Art of the 1890s.* Berkeley: University of California Press, 1998.

Foucault, Michel. "Of Other Spaces." *Diacritics* 16.1 (spring 1986): 22–27.

Freud, Sigmund. "The Uncanny." In *The Standard Edition of the Complete Psychological Works of Sigmund Freud*, edited and translated by James Strachey, 17:217–52. London: Hogarth Press, 1953.

Fried, Michael. *Absorption and Theatricality: Painting and Beholder in the Age of Diderot.* Chicago: University of Chicago Press, 1980.

Friedberg, Anne. *Window Shopping: Cinema and the Postmodern.* Berkeley: University of California Press, 1993.

Frykman, Jonas, and Orvar Löfgren. *Culture Builders: A Historical Anthropology of Middle-Class Life.* Translated by Alan Crozier. New Brunswick, N.J.: Rutgers University Press, 1987.

Fullerton, John. "Spatial and Temporal Articulation in Pre-classical Swedish Film." In *Early Cinema: Space Frame Narrative*, edited by Thomas Elsaesser and Adam Barker, 375–88. London: British Film Institute, 1990.

Furhammar, Leif. *Filmen i Sverige: En historia i tio kapitel.* Stockholm: Wiken, 1991.

Gorky, Maxim. "The Lumière Cinematograph (Extracts)." In *The Film Factory: Russian and Soviet Cinema in Documents 1896–1939*, edited by Richard Taylor and Ian Christie, 25–26. London: Routledge and Kegan Paul, 1988.

Grandien, Bo. "Tiden före 1891: Grogrunden." In *Skansen under hundra år*, edited by Arne Biörnstad, 9–31. Höganäs, Sweden: Wiken, 1991.

Griffiths, Alison Margaret. "Origins of Ethnographic Film." Ph.D. diss., New York University, 1998.

Gunning, Tom. "An Aesthetic of Astonishment: Early Film and the (In)Credulous Spectator." In *Viewing Positions: Ways of Seeing Film*, edited by Linda Williams, 114–33. New Brunswick, N.J.: Rutgers University Press, 1995.

———. " 'Animated Pictures,' Tales of Cinema's Forgotten Future." *Michigan Quarterly Review* 34.4 (fall 1995): 464–85.

———. "The Cinema of Attractions: Early Film, Its Spectator and the Avant-Garde." In *Early Cinema: Space Frame Narrative*, edited by Thomas Elsaesser, 56–62. London: British Film Institute, 1990.

———. "Foreword." In Yuri Tsivian, *Early Cinema in Russia and Its Cultural Reception*, edited by Richard Taylor, xv–xxii. Translated by Alan Bodger. Chicago: University of Chicago Press, 1998.

Gunning, Tom. "Non-continuity, Continuity, Discontinuity: A Theory of Genres in Early Films." In *Early Cinema: Space Frame Narrative*, edited by Thomas Elsaesser, 86–94. London: British Film Institute, 1990.

Hammarlund, Sven.*Glimtar ur konstnärslivet: Från Apelles till Månsson*. Stockholm: Carlsson, 1995.

Hammarstedt, Edvard. "Några museifrågor." In *Meddelanden från Nordiska Museet 1897*, 176–81. Stockholm: Norstedt & Söner, 1898.

Hannover, Emil. "Bernhard Olsen ved hans 70-aarige Fødselsdag den 9. September." *Tilskueren* (1906): 704–22.

Hansen, Miriam. *Babel and Babylon: Spectatorship in American Silent Film*. Cambridge, Mass.: Harvard University Press, 1991.

Haraway, Donna. *Primate Visions: Gender, Race, and Nature in the World of Modern Science*. New York: Routledge, 1989.

Harris, Neil. *Humbug: The Art of P. T. Barnum*. Boston: Little, Brown, 1973.

Haviland, Thomas N., and Lawrence Charles Parish. "A Brief Account of the Use of Wax Models in the Study of Medicine." *Journal of the History of Medicine and Allied Sciences* 25.1 (January 1970): 52–75.

Hazelius, Artur. *Minnen från Nordiska Museet*. 2 vols. Stockholm: P. B. Eklunds Förlag, 1892.

———. "Ur Nordiska museets historia." In *Meddelanden från Nordiska Museet 1898*, 271–314. Stockholm: Norstedt & Söner, 1900.

Hegard, Tonte. *Hans Aall—mannen, visjonen og verket*. Oslo: Norsk Folkemuseum, 1994.

———. *Romantikk og fortidsvern: Historien om de første friluftsmuseene i Norge*. Oslo: Universitetsforlaget, 1984.

Holmström, Kirsten Gram. *Monodrama, Attitudes, Tableaux Vivants: Studies on Some Trends of Theatrical Fashion 1770–1815*. Stockholm: Almqvist & Wiksell, 1967.

Johnson, Edward H. "A Wonderful Invention—Speech Capable of Indefinite Repetition from Automatic Records." *Scientific American*, n.s., 37.20 (17 November 1877): 304.

Jørgensen, Caspar. *Vestervold falder*. Vol. 9 of *København før og nu—og aldri: En billedkavalkade om København indenfor voldene og søerne*. Edited by Bo Bramsen. Copenhagen: Palle Fogtdal, 1987.

Kaalund, Hans Vilhelm. "Da de rev Voldende ned." In *Samlede Digte*, 320–26. Copenhagen: Gyldendal, 1898.

Karlin, Georg. *Kulturhistoriska Museet i Lund: En handbok för besök och självstudium*. Lund: Kulturhistoriska Förening för Södra Sverige, 1918.

———. "Museumssystem." *Kulturhistoriska Meddelanden* 3 (1894–1911): 3–16.

Kern, Stephen. *The Culture of Time and Space, 1880–1918*. Cambridge, Mass.: Harvard University Press, 1983.

Kirby, Lynne. *Parallel Tracks: Railroad and the Silent Cinema*. Durham, N.C.: Duke University Press, 1997.

Kirshenblatt-Gimblett, Barbara. *Destination Culture: Tourism, Museums, and Heritage*. Berkeley: University of California Press, 1998.

Kjellberg, Rune. *Et halvt århundre: Norsk Folkemuseum 1894–1944*. Oslo: Tanum, 1945.

König, Hannes, and Erich Ortenau. *Panoptikum: Vom Zauberbild zum Gaukelspiel der Wachsfiguren.* Munich: Isartal Verlag München, 1962.

Kramer, J. H. *Le Musée D'Ethnographie Scandinave à Stockholm. Fondé et Dirigé par le Dr. Artur Hazelius. Notice Historique et Descriptive.* 2d ed. Stockholm: Norstedt & Söner, 1879.

Lacan, Jacques. "Some Reflections on the Ego." *International Journal of Psychoanalysis* 34 (1953): 11–17.

Laderman, Gary. *The Sacred Remains: American Attitudes toward Death, 1799–1883.* New Haven, Conn.: Yale University Press, 1996.

Landgren, Lars. "Stugo i Delsbo Socken i Helsingland." In Artur Hazelius, *Minnen från Nordiska Museet,* vol. 1, n.p. Stockholm: P. B. Eklunds Förlag, 1892.

Lemire, Michel. *Artistes et Mortels.* Paris: Chabaud, 1990.

Lepp, Hans. "Svenska Panoptikon." *St. Eriks Årsbok* (1978): 165–80.

Lieberman, Sima. *The Industrialization of Norway, 1800–1920.* Oslo: Universitetsforlaget, 1970.

Lindorm, Erik. *Oskar II och hans tid.* Vol. 1 of *Ny Svensk Historia.* Stockholm: Wahlström & Widstrand, 1937.

Lindow, John. *Murder and Vengeance among the Gods: Baldr in Scandinavian Mythology.* FF Communications 263. Helsinki: Academia Scientiarum Fennica, 1997.

Ludvigsen, Arne. "Om Flytning af gamle Bygninger." In *Fra Nationalmuseets Arbejdsmark 1940,* 43–54. Copenhagen: Nationalmuseet, 1940.

Lundell, J. A. "Turisten och folklivet." In *Svenska Turistföreningens Årsskrift 1900,* edited by Mauritz Boheman, 1–21. Stockholm: Wahlström & Widstrand, 1900.

Lundin, Claës. "Den sagolika Paschaen." In *Stockholmstyper förr och nu,* 167–96. Stockholm: Fr. Skoglunds Förlag, 1889.

———. "Från Mälardrottningens tron." In *Stockholmstyper förr och nu,* 99–134. Stockholm: Fr. Skoglunds Förlag, 1889.

———. *Gamla Stockholm: Anteckningar ur tryckta och otryckta källor, framletade, samlade och utgifna af Claës Lundin och August Strindberg.* Stockholm, [1882].

———. "Vägen till odödlighet." In *Stockholmstyper förr och nu,* 287–300. Stockholm: Fr. Skoglunds Förlag, 1889.

McCullough, Jack W. *Living Pictures on the New York Stage.* Theater and Dramatic Studies 13. Ann Arbor, Mich.: UMI Research Press, 1983.

Metz, Christian. *The Imaginary Signifier: Psychoanalysis and the Cinema.* Translated by Celia Britton et al. Bloomington: Indiana University Press, 1982.

Mitchell, B. R. *International Historical Statistics: Europe 1750–1988.* 3d ed. New York: Stockton Press, 1992.

Mottram, Ron. *The Danish Cinema before Dreyer.* Metuchen, N.J.: Scarecrow Press, 1988.

Müller, Sophus. "Museum og Interiør." *Tilskueren* (1897): 683–700.

Mulvey, Laura. "Visual Pleasure and Narrative Cinema." *Screen* 16.3 (autumn 1977): 6–18.

Muusmann, Carl. *Firsernes Glade København: Erindringer og Oplevelser.* Edited by Bo Bramsen. Copenhagen: Politikens Forlag, 1974 [1920].

———. *Halvfemsernes glade København: Erindringer og Oplevelser.* Copenhagen: Forlaget Danmark, 1939.

Muusmann, Carl. "Udendørs Forlystelser." In *Tiden 1870–1914.* Vol. 5 of *Danmark i fest og glæde*, edited by Julius Clausen and Torben Krogh, 121–192. [Copenhagen]: C. Erichsen, 1935–36.

Näsström, Gustaf. *Dalarna som svenskt ideal.* 2d ed. Stockholm: Wahlström & Widstrand, 1937.

Negroponte, Nicholas. *Being Digital.* New York: Knopf, 1995.

Nordenson, Eva. "Förord." In *Skansen under hundra år*, edited by Arne Biörnstad, 7. Höganäs, Sweden: Wiken, 1991.

Nyrop, Camillus. *Fra den Kunstindustrielle Udstilling: Erindringsblade.* Copenhagen: J. H Schubothes Boghandels Forlag, 1879.

Oettermann, Stephan. "Alles-Schau: Wachsfigurenkabinette und Panoptikon." In *Viel Vergnügen: Öffentliche Lustbarkeiten im Ruhrgebiet der Jahrhundertwende*, edited by Lisa Kosok and Mathilde Jamin, 36–56. Essen, Germany: Ruhrlandmuseum Essen, 1992.

Öhngren, Bo. "Urbanisering i Sverige 1840–1920." In *Industrialiserings første fase*, edited by Grethe Autheen Blom, 261–356. Urbanisersingsprocessen i Norden 3. Oslo: Universitetsforlaget, 1977.

[Olsen, Bernhard]. "Spejlgemakkerne i Panoptikon." In *Katalog* [1890], n.p.

Oppermann, Theodor. *Wilhelm Marstrand: Hans Kunst og Liv i Billeder og Tekst.* Copenhagen: G.E.C. Gads Forlag, 1920.

Pearce, Susan M. *Museums, Objects, and Collections: A Cultural Study.* Washington, D.C.: Smithsonian Institution Press, 1992.

Pred, Allan. "Languages of Everyday Practice and Resistance: Stockholm at the End of the Nineteenth Century." In *Reworking Modernity: Capitalisms and Symbolic Discontent*, edited by Allan Pred and Michael John Watts, 118–154. New Brunswick, N.J.: Rutgers University Press, 1992.

———. *Lost Words and Lost Worlds: Modernity and the Language of Everyday Life in Late Nineteenth-Century Stockholm.* Cambridge: Cambridge University Press, 1990.

Quigley, Christine. *Modern Mummies: The Preservation of the Human Body in the Twentieth Century.* Jefferson, N.C.: McFarland and Company, 1998.

Rasmussen, Holger. *Bernhard Olsen: Virke og Værker.* Folkelivs Studier 6. Copenhagen: Nationalmuseet, 1979.

———. *Dansk museums historie: De kultur-historiske Museer.* Hjørring, Denmark: Dansk Kulturhistorisk Museumsforening, 1979.

Regener, Susanne. "Synliggørelsen af væsenet: Dødsmasker fra henrettede." In *Masken som repræsentation*, edited by Jørgen Østergård Andersen and Charlotte Engberg, 39–51. Aarhus, Denmark: Aarhus Universitets Forlag, 1994.

Rokem, Freddie. *Theatrical Space in Ibsen, Chekhov and Strindberg: Public Forms of Privacy.* Theater and Dramatic Studies 32. Ann Arbor, Mich.: UMI Research Press, 1986.

Sandfeld, Gunnar. *Den Stumme Scene: Dansk Biografteater indtil Lydfilmens Gennembrud.* Copenhagen: Nyt Nordisk Forlag, 1966.

Sandvig, Anders. *I praksis og på samlerferd.* 2d ed. Oslo: Johan Grundt Tanum, 1969.

———. Speech at Maihaugen opening ceremonies, 2 July 1904. MPC 4:127.

Schivelbusch, Wolfgang. *The Railway Journey: The Industrialization of Time and Space in the Nineteenth Century.* Berkeley: University of California Press, 1986.

Schwartz, Hillel. *The Culture of the Copy: Striking Likenesses, Unreasonable Facsimiles.* New York : Zone Books, 1996.

Schwartz, Vanessa. "Le Musée Grévin et le Cinematographie." *1895* 11 (December 1991): 19–48.

———. "The Morgue and the Musée Grévin: Understanding the Public Taste for Reality in Fin-de-Siècle Paris." *Yale Journal of Criticism* 7.2 (1994): 151–73.

———. *Spectacular Realities: Early Mass Culture in Fin-de-Siècle Paris.* Berkeley: University of California Press, 1998.

Selling, Gösta. *Esplanadesystemet och Albert Lindhagen: Stadsplanering i Stockholm åren 1857–1887.* Stockholm: Stockholmskommunalförvaltning, 1970.

Silverman, Kaja. *The Acoustic Mirror: The Female Voice in Psychoanalysis and Cinema.* Bloomington: Indiana University Press, 1988.

———. *The Subject of Semiotics.* New York: Oxford University Press, 1983.

———. *The Threshold of the Visible World.* New York: Routledge, 1996.

Simmel, Georg. "The Metropolis and Mental Life." In *On Individuality and Social Forms: Selected Writings,* edited by Donald N. Levine, 324–39. Chicago: University of Chicago Press, 1971.

Stoklund, Bjarne. "International Exhibitions and the New Museum Concept in the Latter Half of the Nineteenth Century." Translated by Alan Crozier. *Ethnologia Scandinavica* 23 (1993): 87–113.

Strindberg, August. Preface to *Miss Julie.* In *Selected Plays,* vol. 1, translated by Evert Sprinchorn, 204–17. Minneapolis: University of Minnesota Press, 1986.

Sundman, Per Olof. *The Flight of the Eagle.* Translated by Mary Sandbach. New York: Pantheon, 1970.

Tjerneld, Staffan. *Stockholmsliv: Hur vi bott, arbetat och roat oss under 100 år.* 2 vols. Stockholm: Norstedt & Söner, 1949.

Trumpener, Katie. "The Time of the Gypsies: A 'People without History' in the Narratives of the West." In *Identities,* edited by Kwame Anthony Appiah and Henry Louis Gates Jr., 338–79. Chicago: University of Chicago Press, 1995.

Tsivian, Yuri. *Early Cinema in Russia and Its Cultural Reception.* Edited by Richard Taylor. Translated by Alan Bodger. Chicago: University of Chicago Press, 1998.

Tussaud, John Theodore. *The Romance of Madame Tussaud's.* New York: George H. Doran, 1920.

Upmark, Gustaf. "Skansen 25 år." *Fataburen: Nordiska Museets och Skansens Årsbok* 3 (1916): 97–194.

Valéry, Paul. "Conquête de l'Ubiquité." In *De la musique avant toute chose, . . . ,* 1–5. Paris: Editions du Tambourinaire, 1929.

Vidler, Anthony. *The Architectural Uncanny: Essays in the Modern Unhomely.* Cambridge, Mass.: MIT Press, 1992.

Walton, Stephen J. *Ivar Aasens kropp.* Oslo: Det Norske Samlaget, 1996.

Warner, Marina. "Waxworks and Wonderlands." In *Visual Display: Culture beyond Appearances,* edited by Lynne Cooke and Peter Wollen, 178–201. Seattle: Bay Press, 1995.

Wonders, Karen. "The Illusionary Art of Background Painting in Habitat Diora-
mas," *Curator* 33.2 (June 1990): 90–118.

Zbarsky, Ilya, and Samuel Hutchinson. *Lenin's Embalmers.* Translated by Barbara
Bray. London: Harvill Press, 1998.

Zenius, Marianne. *Genremaleri og Virkelighed: En kildekritisk analyse over billeder
af Chr. Dalsgaard, J. Exner og F. Vermehren.* Lokalhistorisk Afdeling 6. Copen-
hagen: Lokalhistorisk Afdeling, 1976.

Zerlang, Martin. "Bagdad i København: Om modernisering i orientalske gevand-
ter." *Kultur og Klasse* 24.2 (1996): 155–85.

———. "The City Spectacular of the Nineteenth Century." Arbejdspapir 9. Co-
penhagen: Center for Urbanitet og Æstetik, 1995.

———. "Orientalism and Modernity." *Nineteenth-Century Contexts* 20 (1997):
81–110.

INDEX